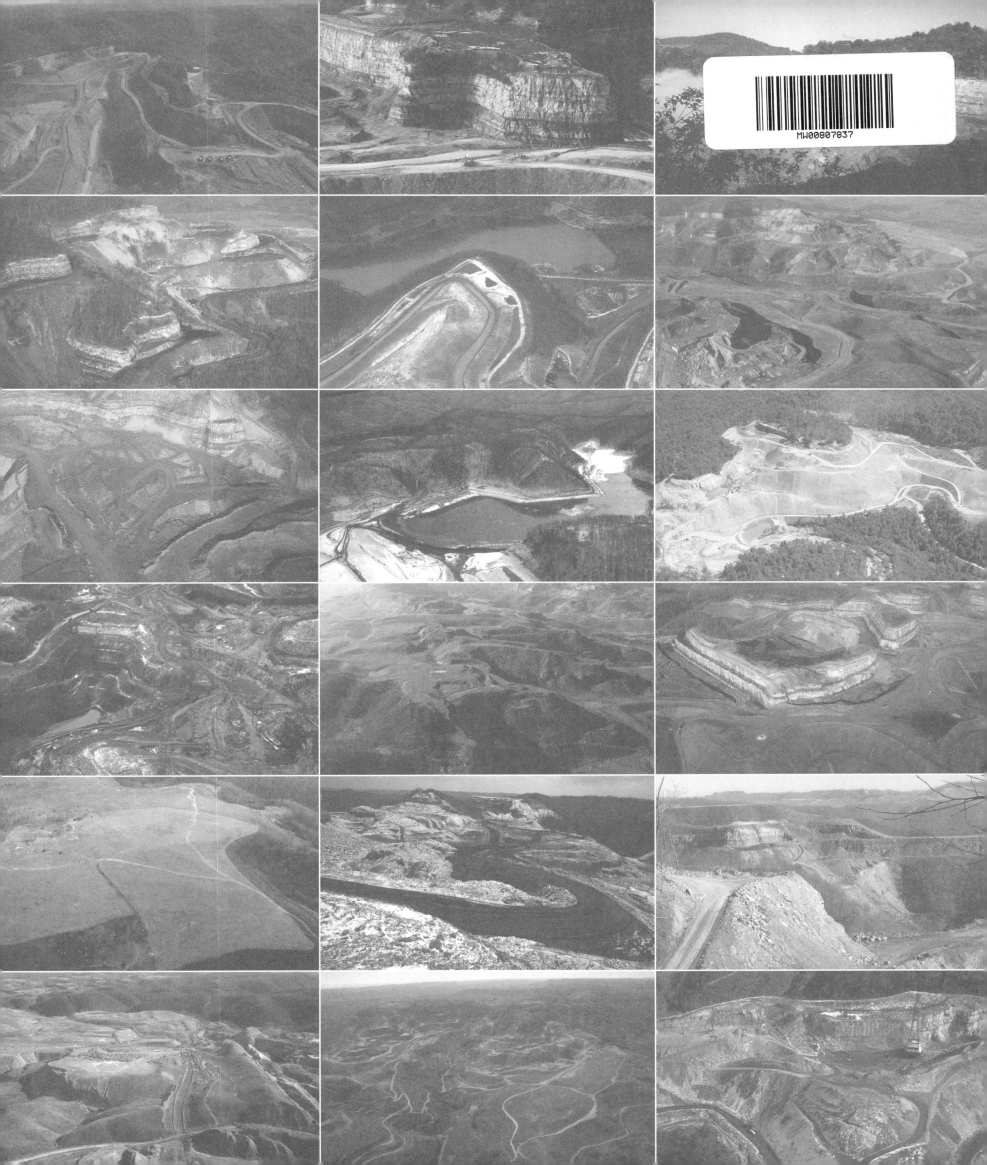

PLUNDERING APPALACHIA
THE TRAGEDY OF MOUNTAINTOP-REMOVAL COAL MINING

Tom Butler and George Wuerthner, editors

EARTH AWARE

Grateful acknowledgment is made to the following for permission to reprint copyrighted material. Erik Reece's "The Power to Move Perceptions" is adapted from his book *Lost Mountain: A Year in the Vanishing Wilderness: Radical Strip Mining and the Devastation of Appalachia*, © 2006 by Erik Reece, used by permission of the author and Riverhead Books. "Agents of Destruction" is excerpted from *Night Comes to the Cumberlands: A Biography of a Depressed Area*, © 1962 by Harry M. Caudill, reprinted by permission of Anne F. Caudill. "Buffalo Creek, West Virginia" is excerpted from *Everything in its Path: Destruction of Community in the Buffalo Creek Flood*, © 1976 by Kai T. Erikson, used by permission of the author and Simon and Schuster, Inc. "My Life is on the Line" by Maria Gunnoe is adapted from *Like Walking Onto Another Planet: Stories About the True Impacts of Mountaintop Removal Mining*, edited by Carol Warren and produced by the Ohio Valley Environmental Coalition. "We Can't Live Without Water," "Flooding Us Out," and "They Do What They Want" are reprinted from *The Artist as Activist*, © 2009 by Rebecca Howell, used by permission of the author and the University Press of North Georgia. "Power Down" is adapted from Richard Heinberg's *Blackout: Coal, Climate, and the Last Energy Crisis*, © 2009 by Post Carbon Institute, reprinted by permission of the author and New Society Publishers. "Compromise, Hell!" is reprinted from *The Way of Ignorance*, © 2006 by Wendell Berry, and used by permission of the author and Counterpoint. "A Call to Action" by Jerry Hardt is excerpted with permission from "Don't Just Stand There, DO SOMETHING" in *Missing Mountains: We Went to the Mountaintop But it Wasn't There*, © 2005 by Kentuckians For The Commonwealth.

Photo of breaker boys (following page) by Louis Hine, 1911. Library of Congress, Prints & Photographs Division, National Child Labor Committee Collection, LC-DIG-nclc-01139.

Book design by Kevin Cross

ISBN 978-1-60109-054-6

Library of Congress Cataloguing-in-Publication Data available.

10 9 8 7 6 5 4 3 2 1

EARTH AWARE

Published by Earth Aware Editions
3160 Kerner Blvd., Unit 108
San Rafael, CA 94901
800.6882218 • Fax: 415.526.1394
info@earthawareeditions.com
www.earthawareeditions.com

ROOTS of PEACE REPLANTED PAPER

Palace Press International, in association with Roots of Peace, will plant two trees for each tree used in the manufacturing of this book. Roots of Peace is an internationally renowned humanitarian organization dedicated to eradicating land mines worldwide and converting war-torn lands into productive farms and wildlife habitats. Together, we will plant two million fruit and nut trees in Afghanistan and provide farmers there with the skills and support necessary for sustainable land use.

Printed in China by Palace Press International

DEDICATION

To the missing mountains, their ancient curves and folds scarred by needless greed. And to the courageous individuals across Appalachia who are working to protect the integrity and beauty of the landscape they love.

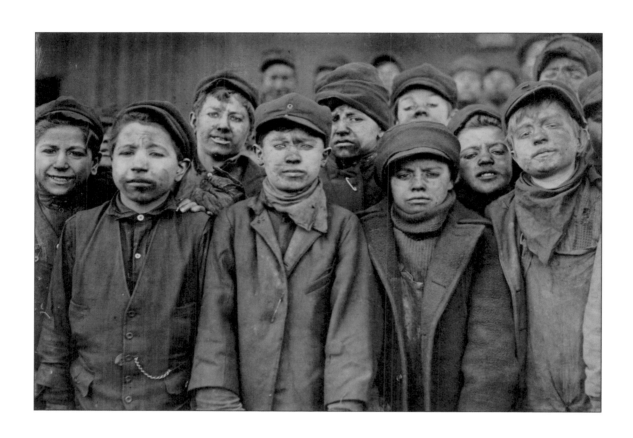

Coal has always cursed the land in which it lies. When men begin to wrest it from the earth it leaves a legacy of foul streams, hideous slag heaps, and polluted air. It peoples this transformed land with blind and crippled men and with widows and orphans. It is an extractive industry which takes all away and restores nothing. It mars but never beautifies. It corrupts but never purifies.

—Harry M. Caudill, from *Night Comes to the Cumberlands*

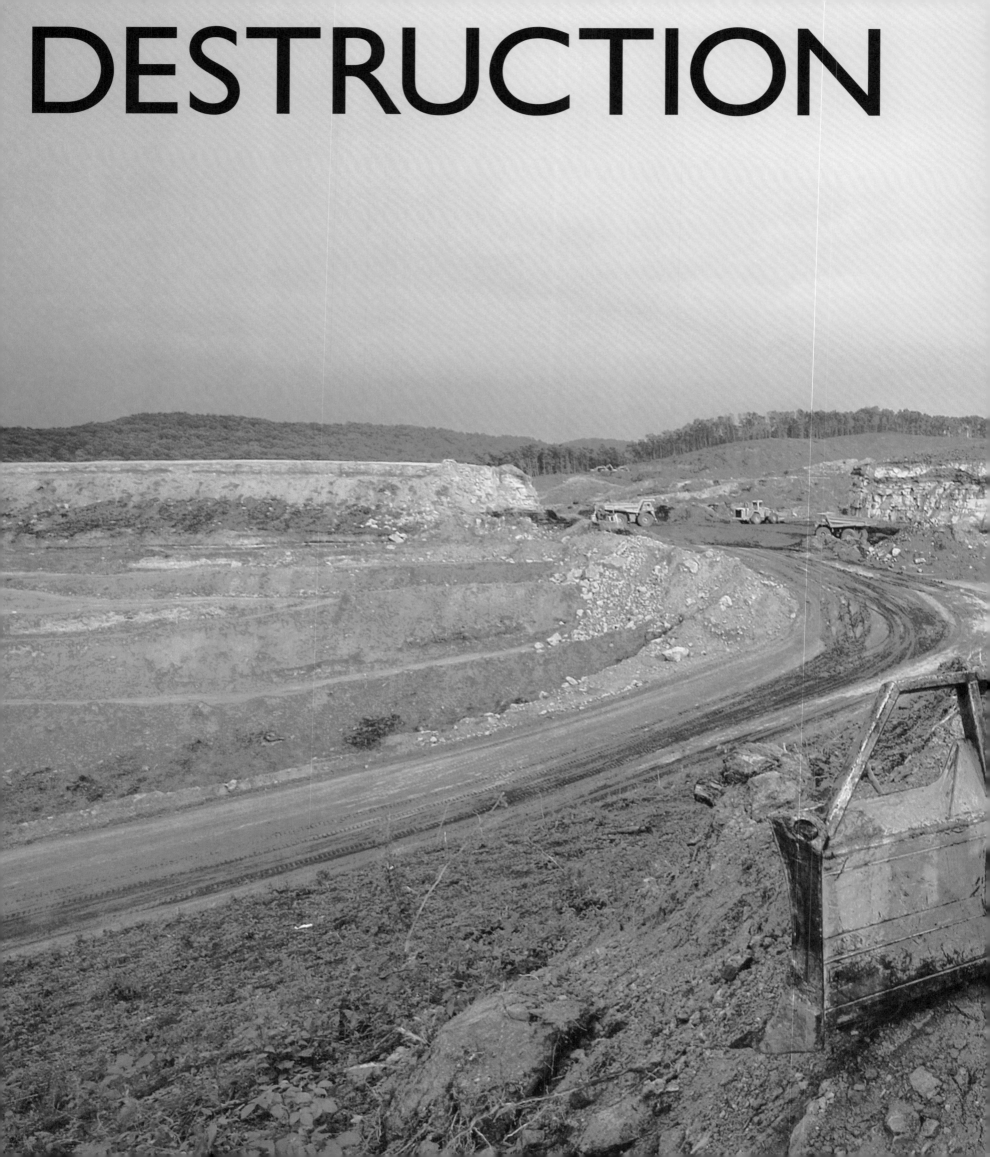

DESTRUCTION

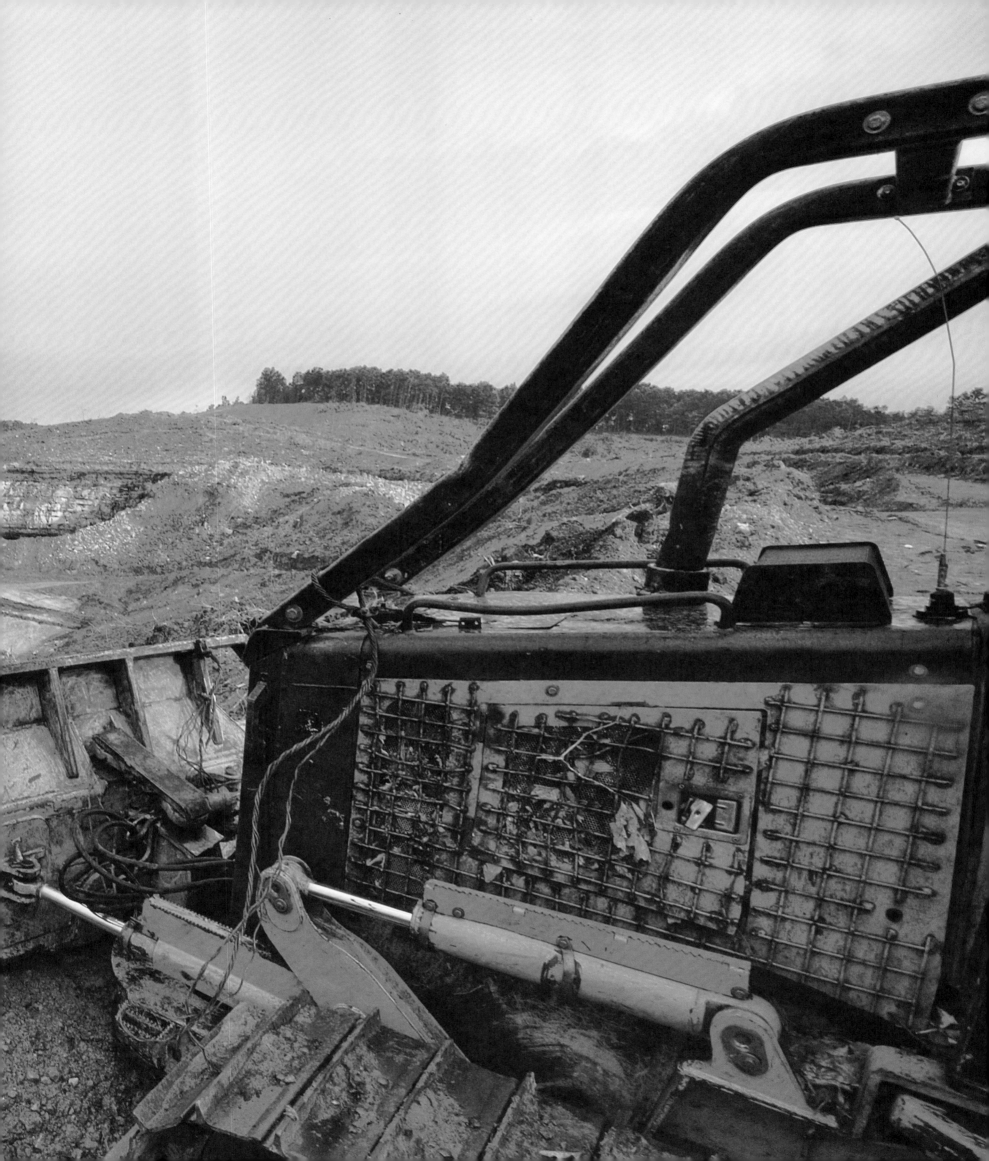

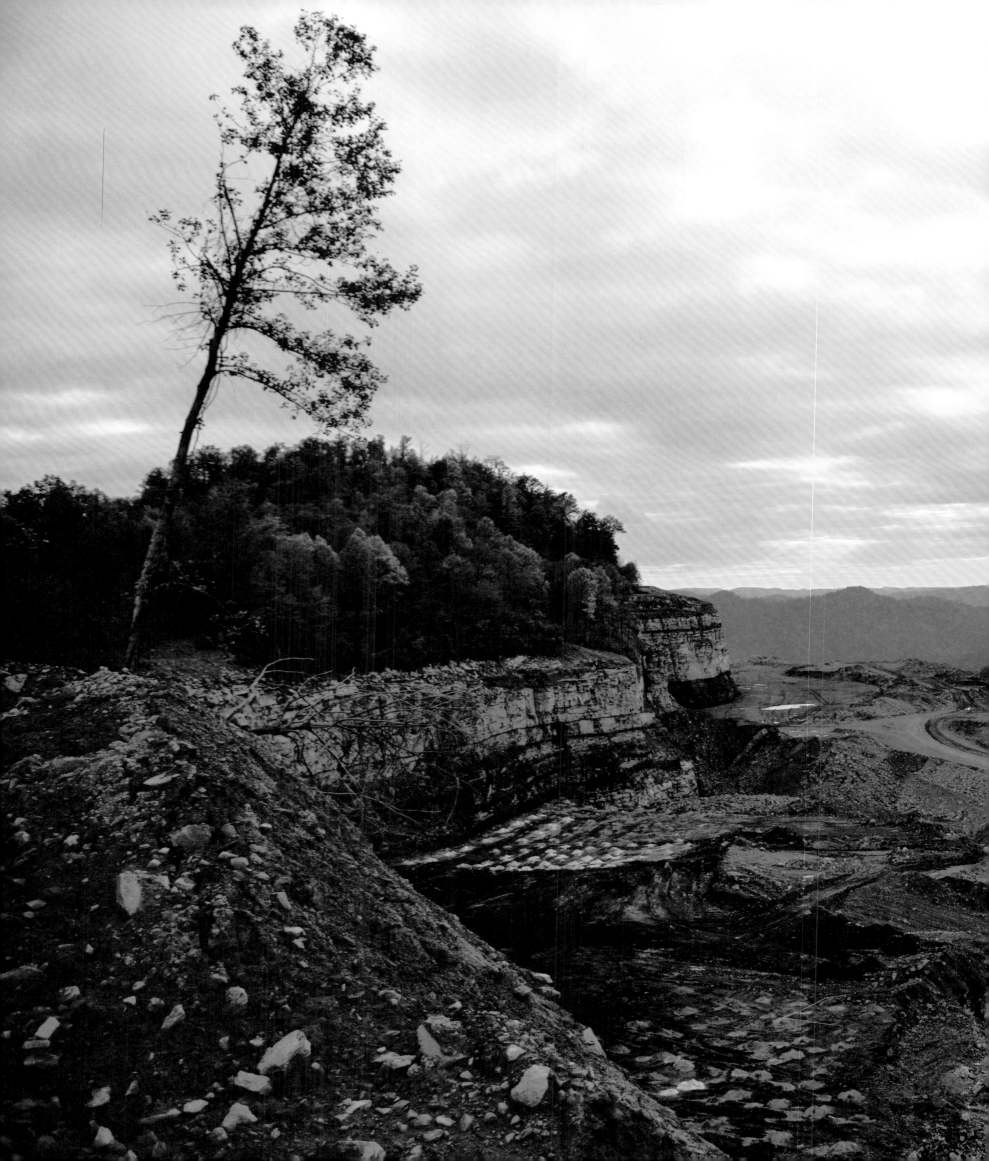

DEVASTATION

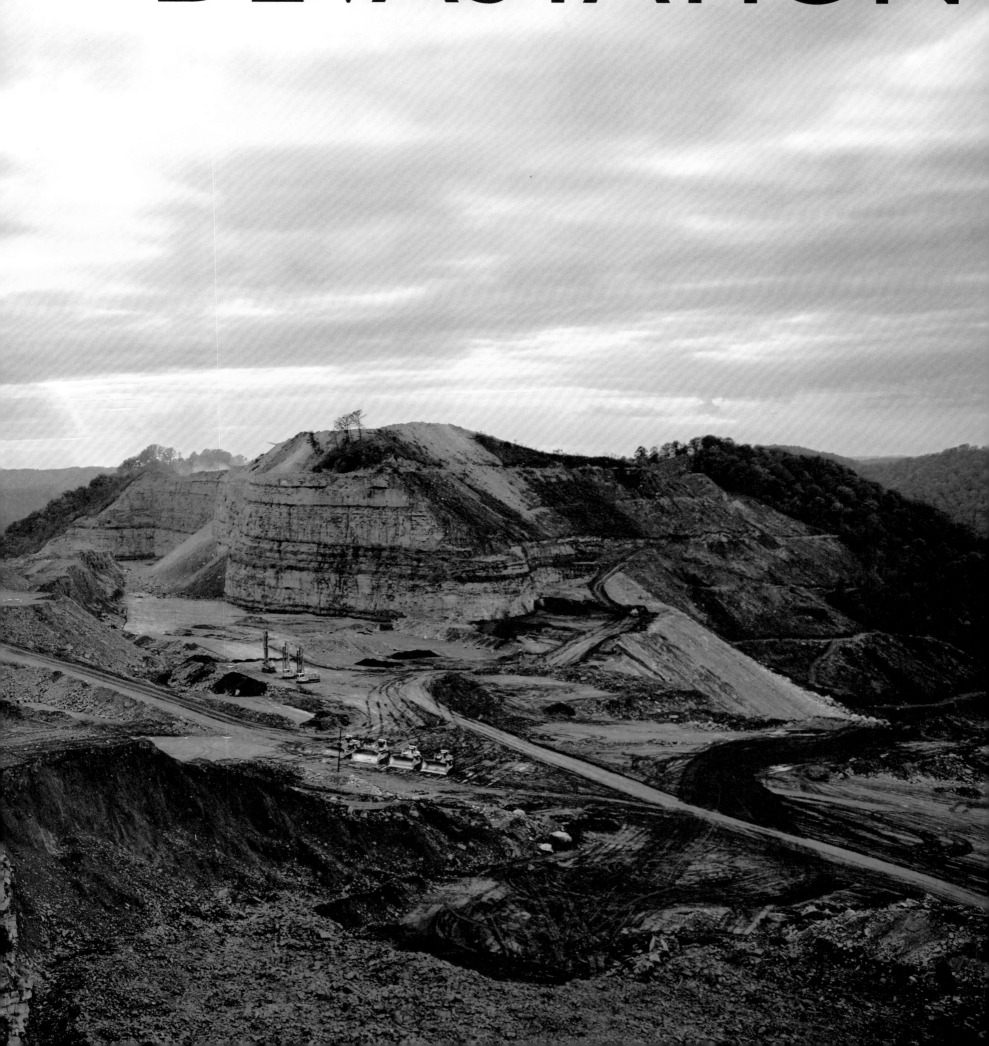

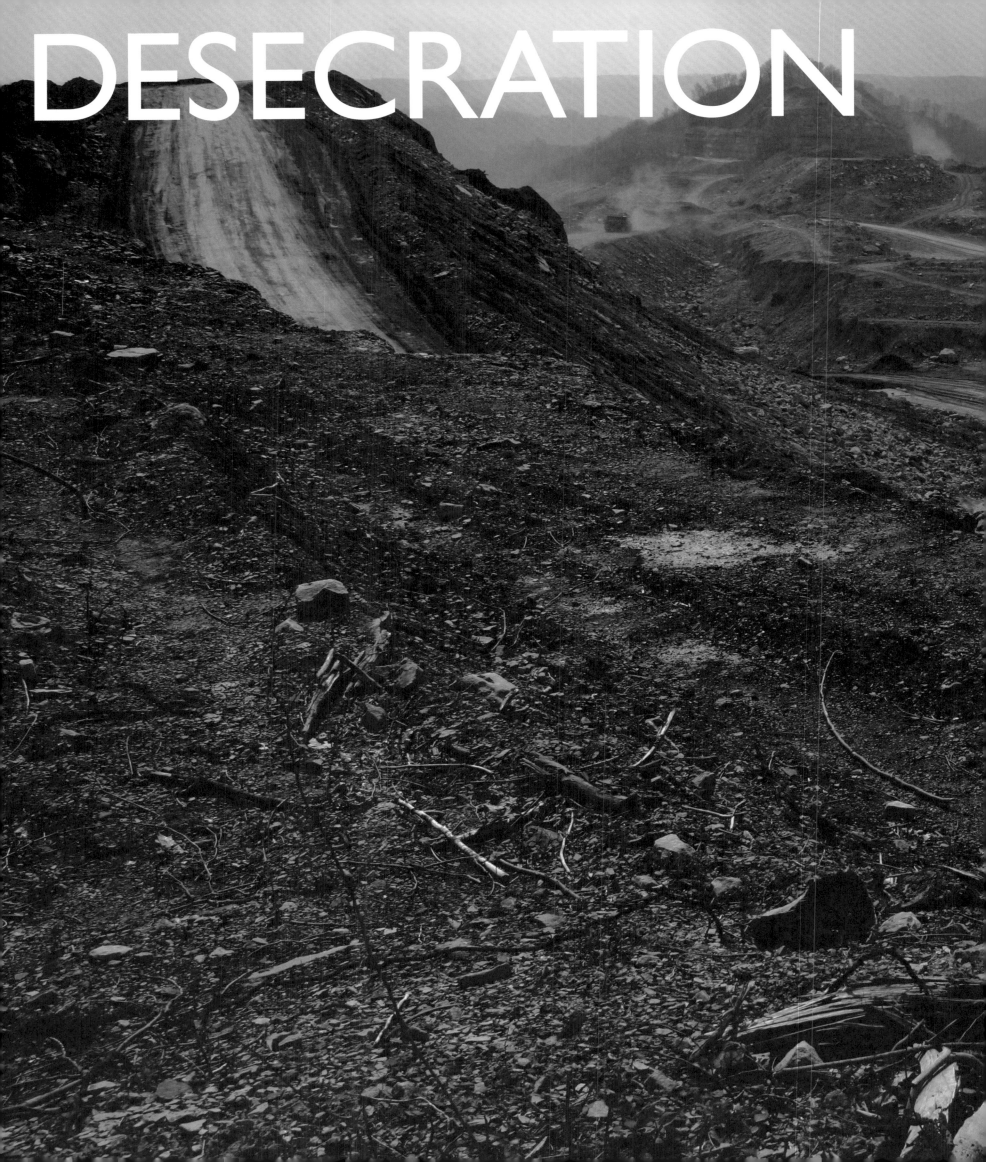

DESECRATION

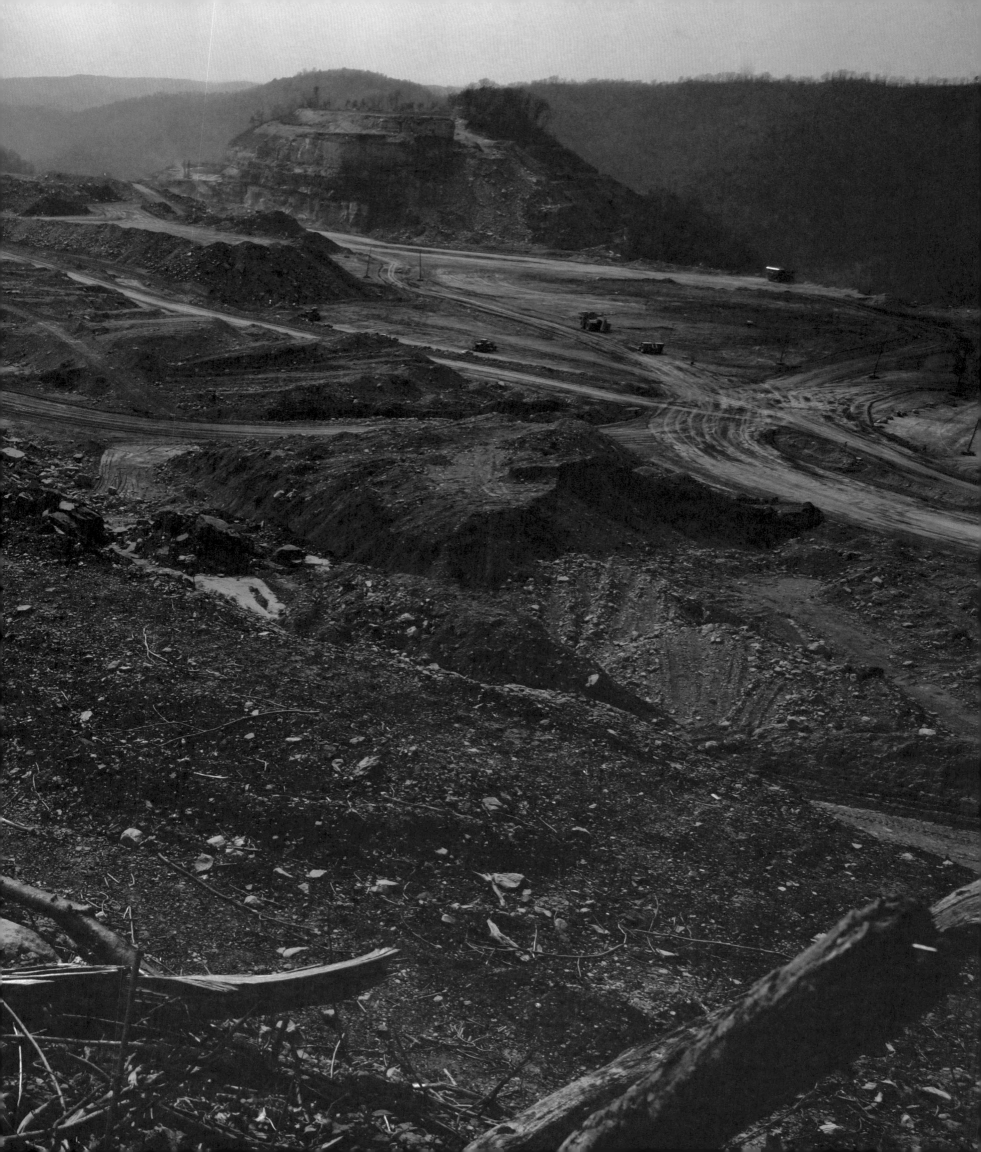

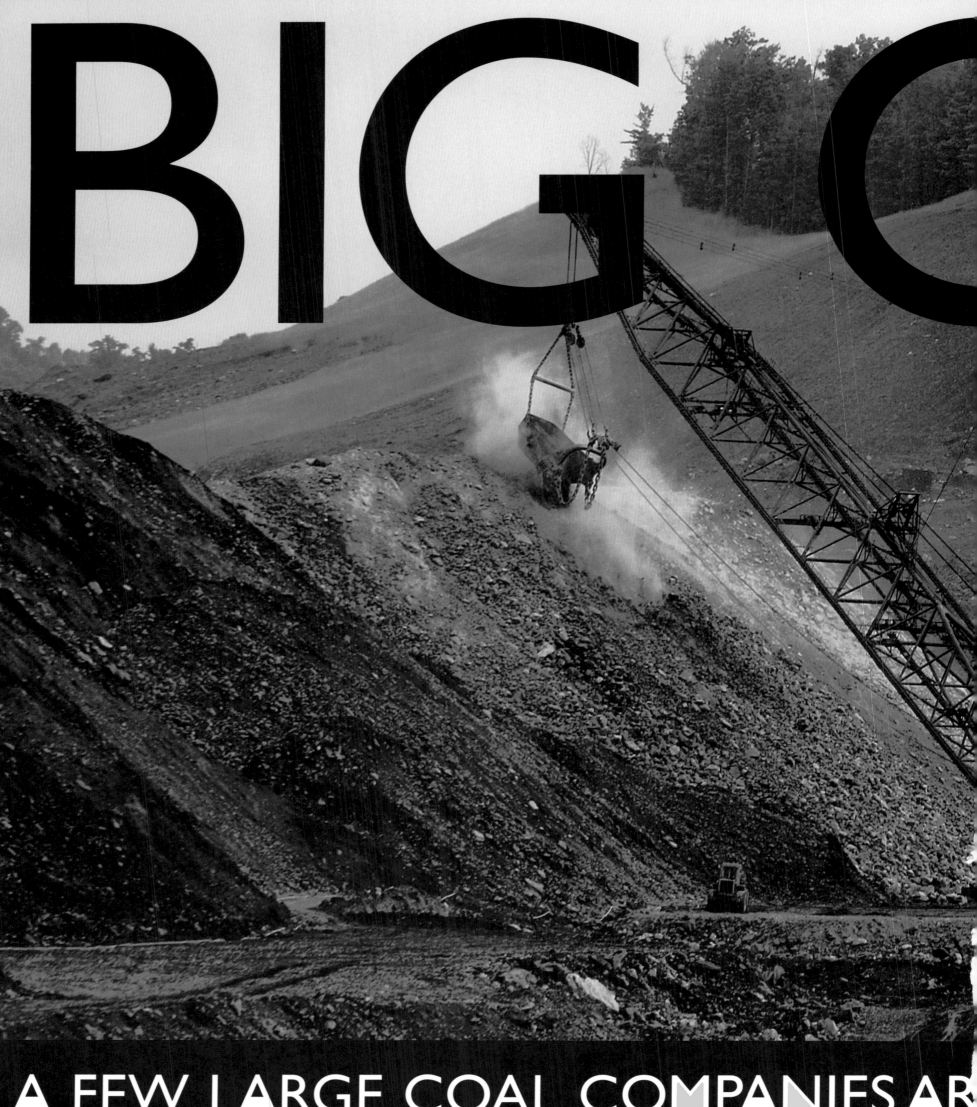

BIG C

A FEW LARGE COAL COMPANIES AR

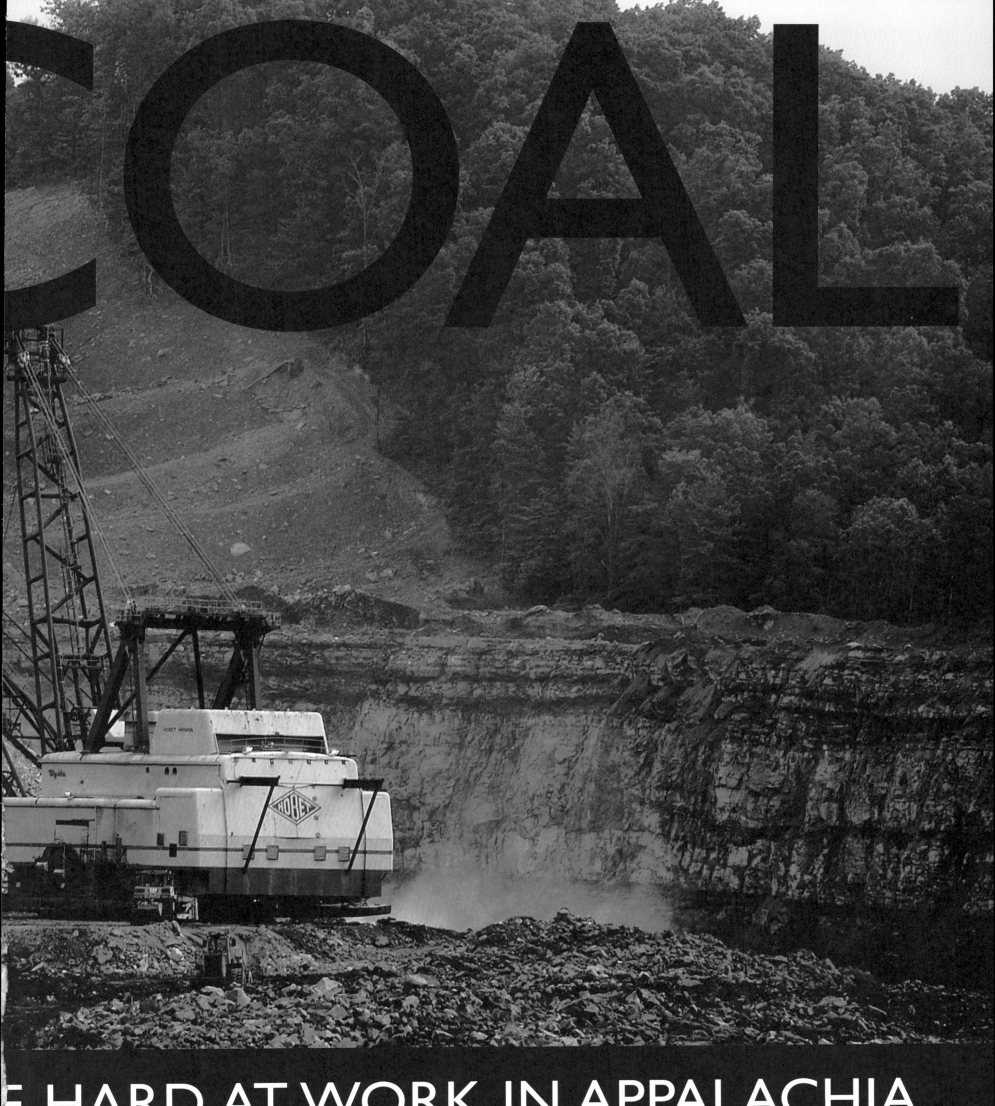

COAL

HARD AT WORK IN APPALACHIA...

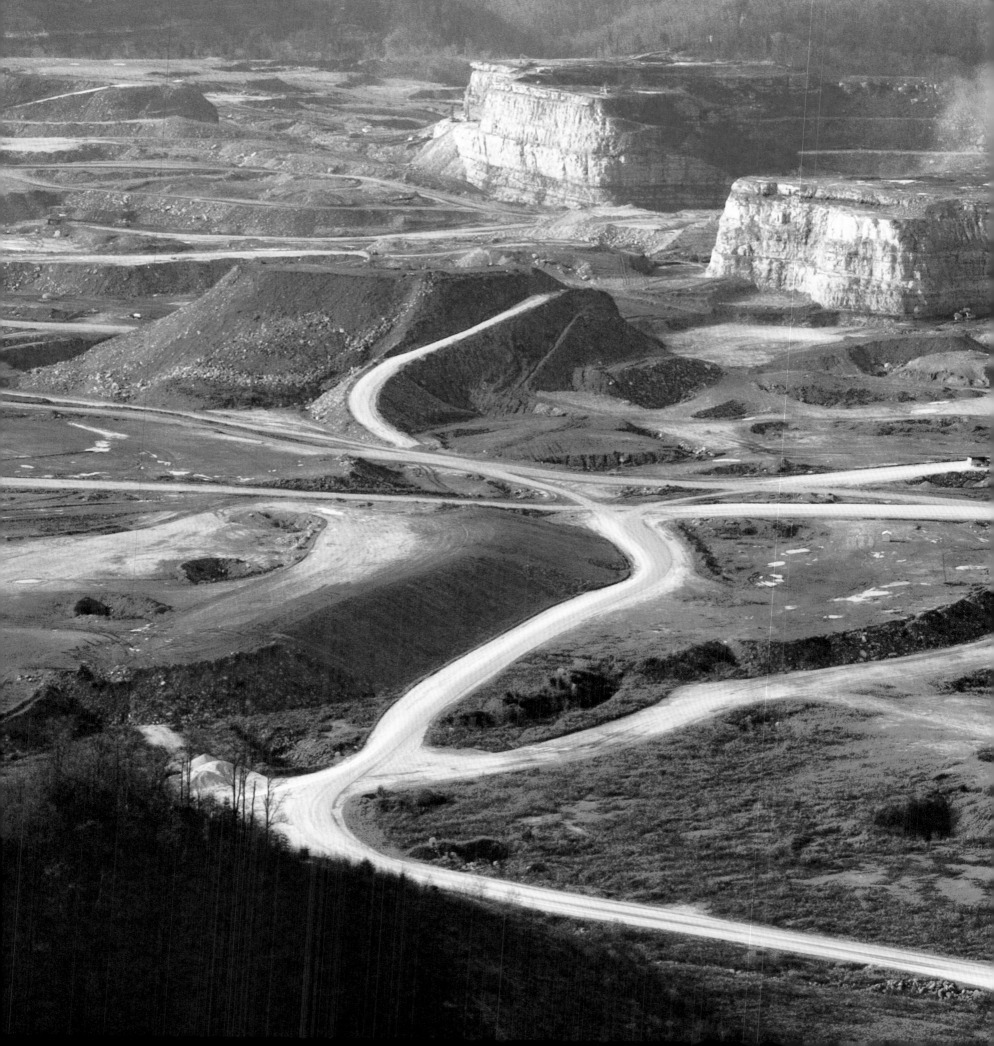

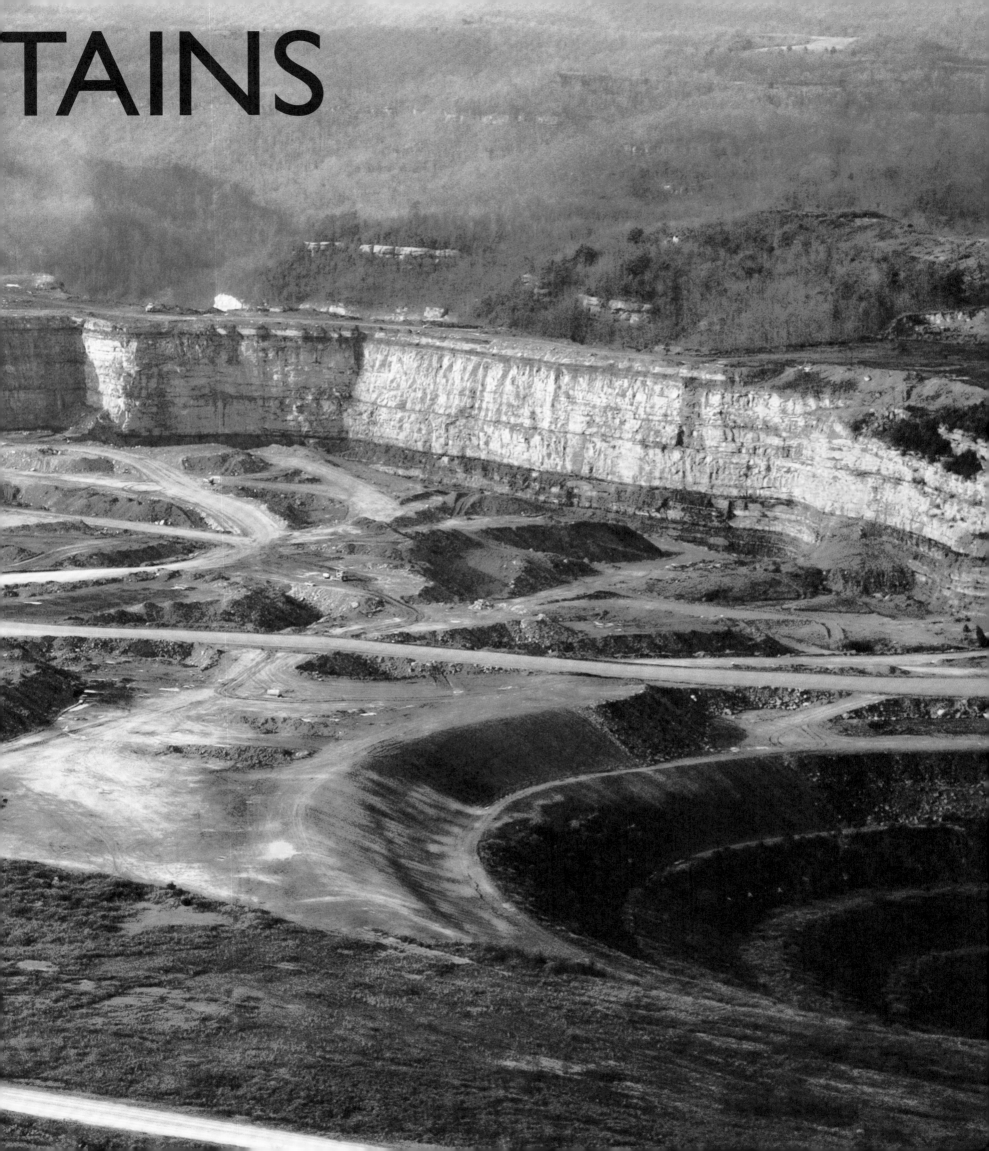

TAINS

PO

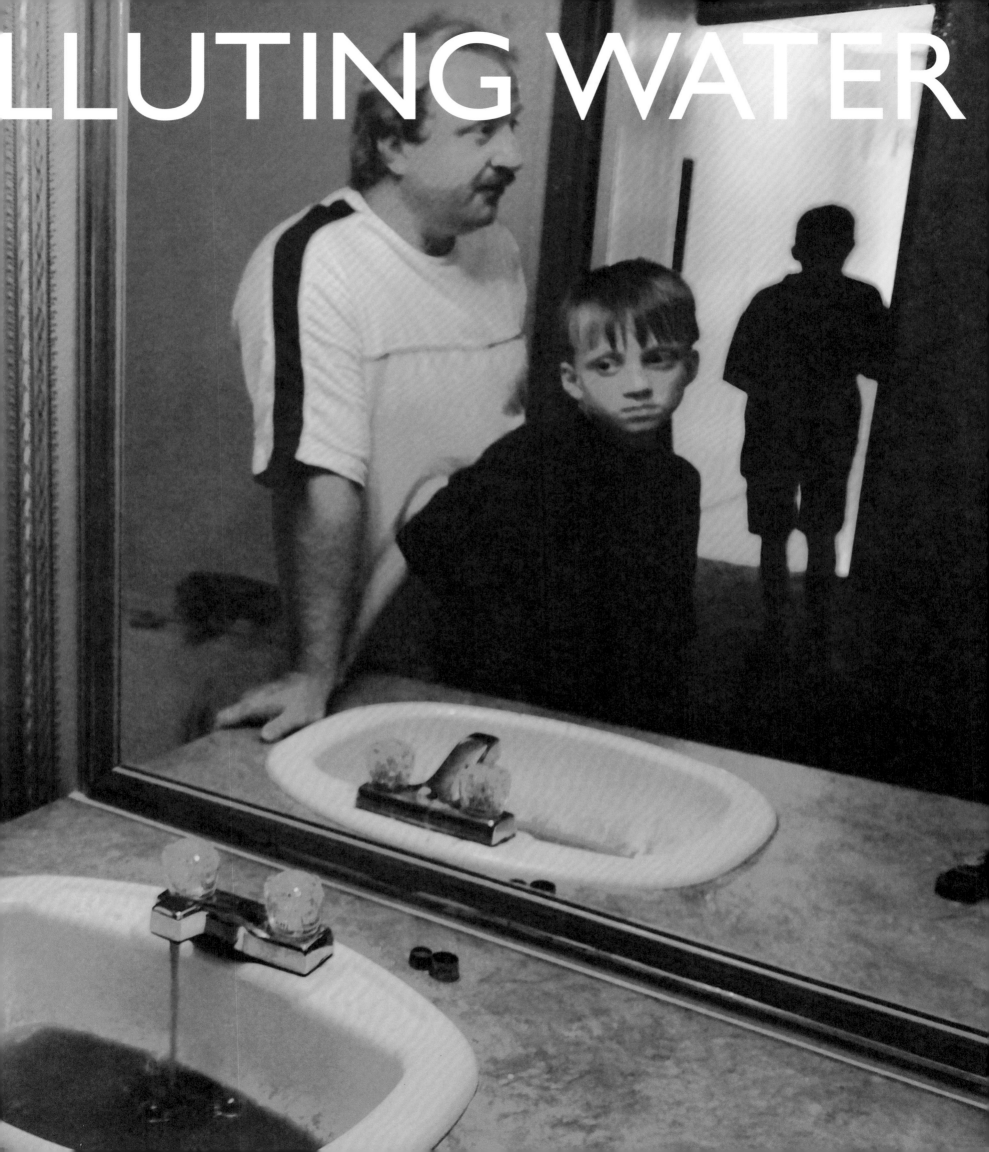

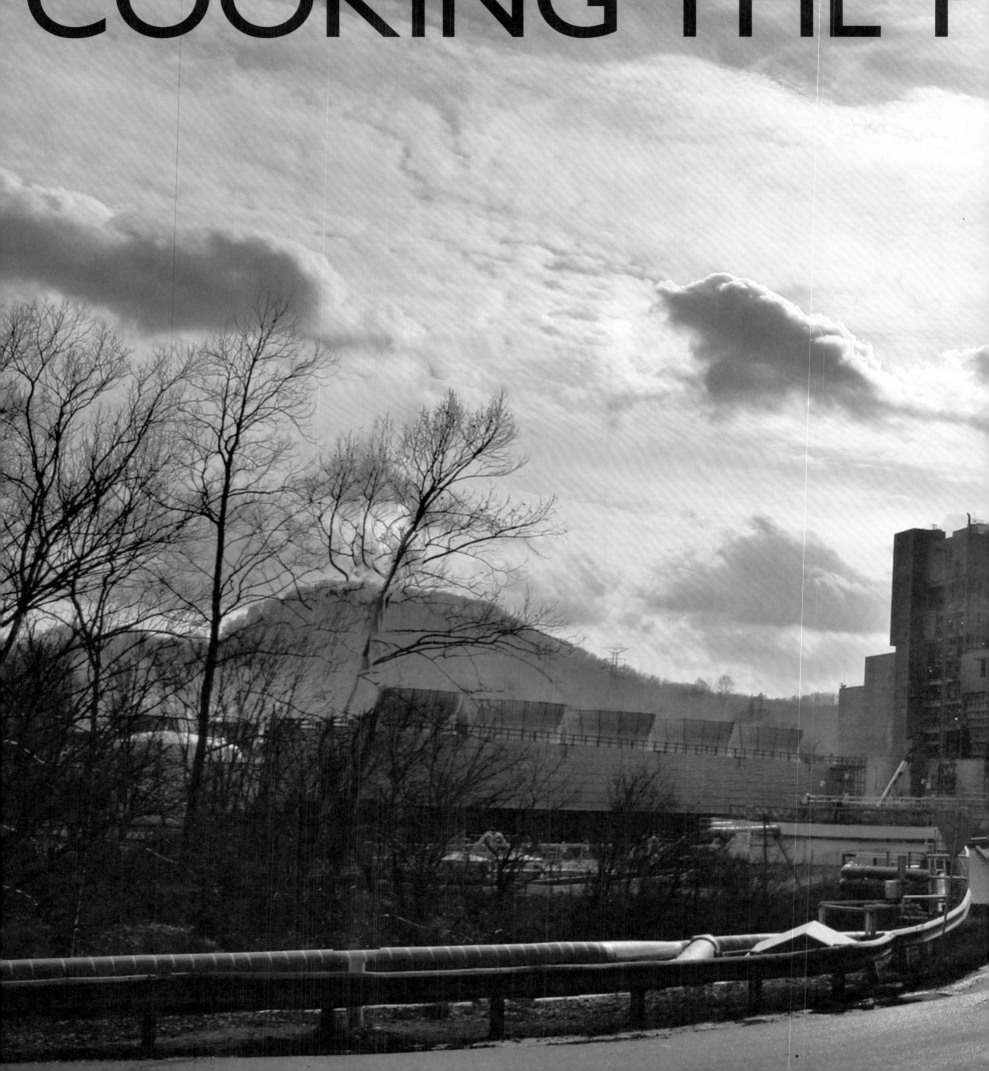

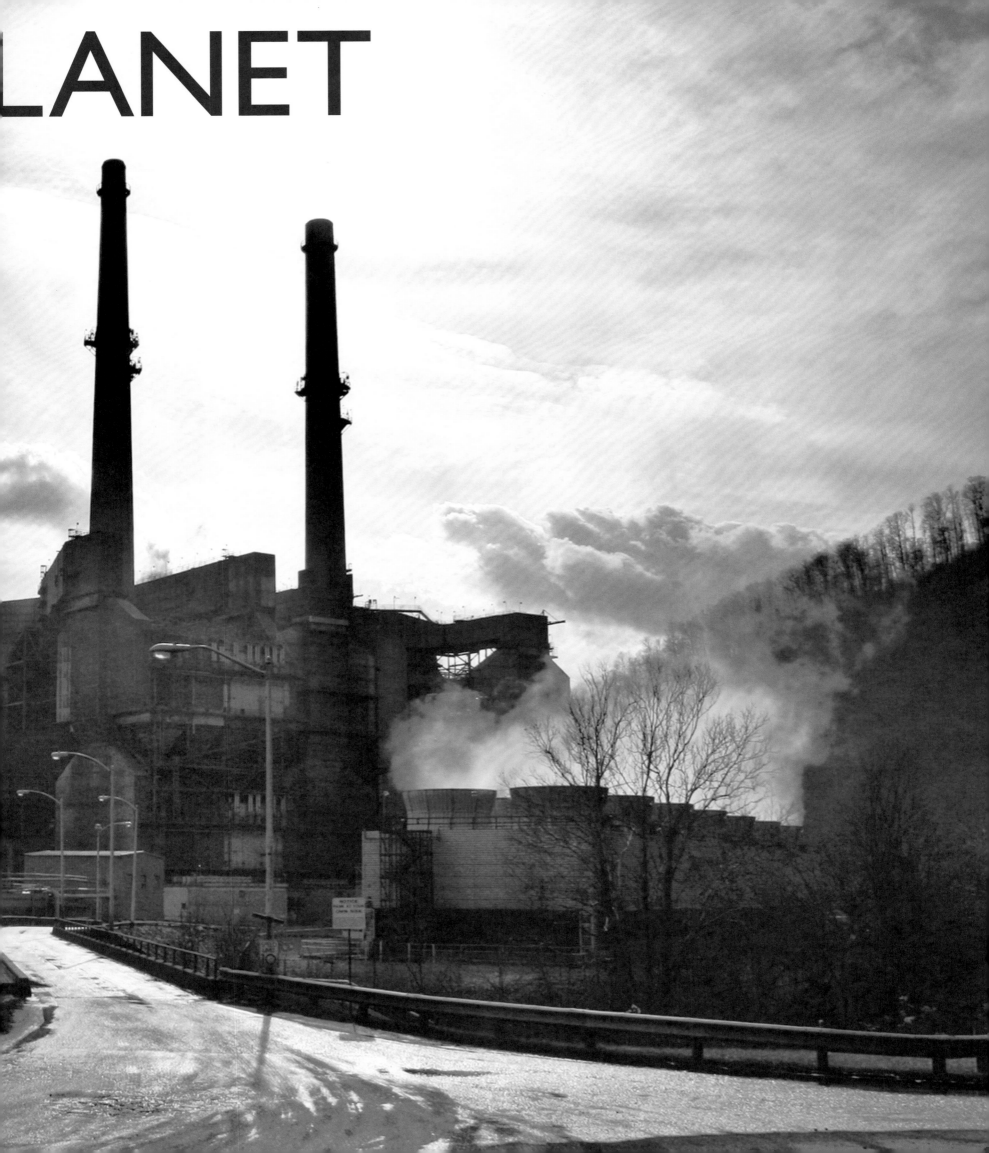

LANET

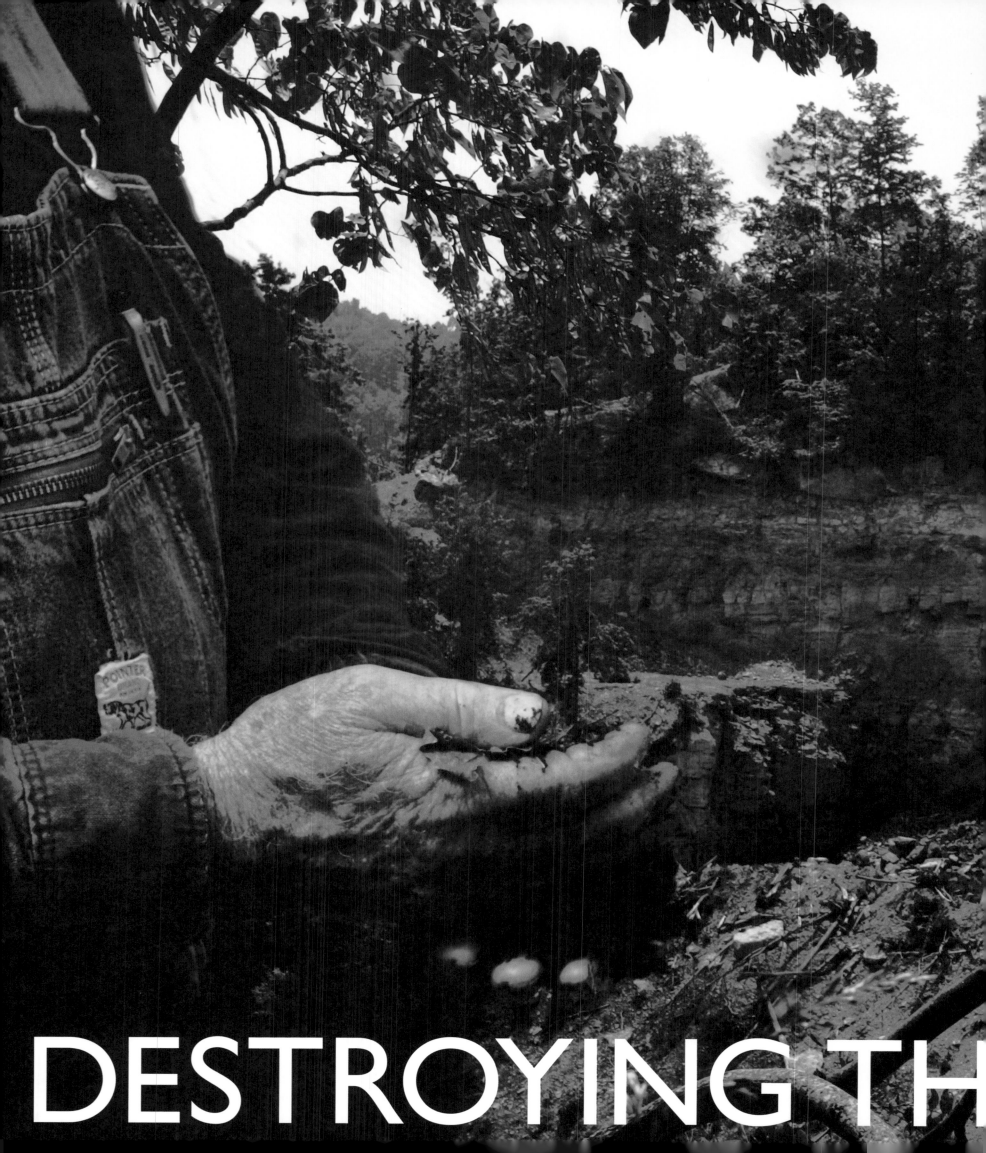

DESTROYING TH

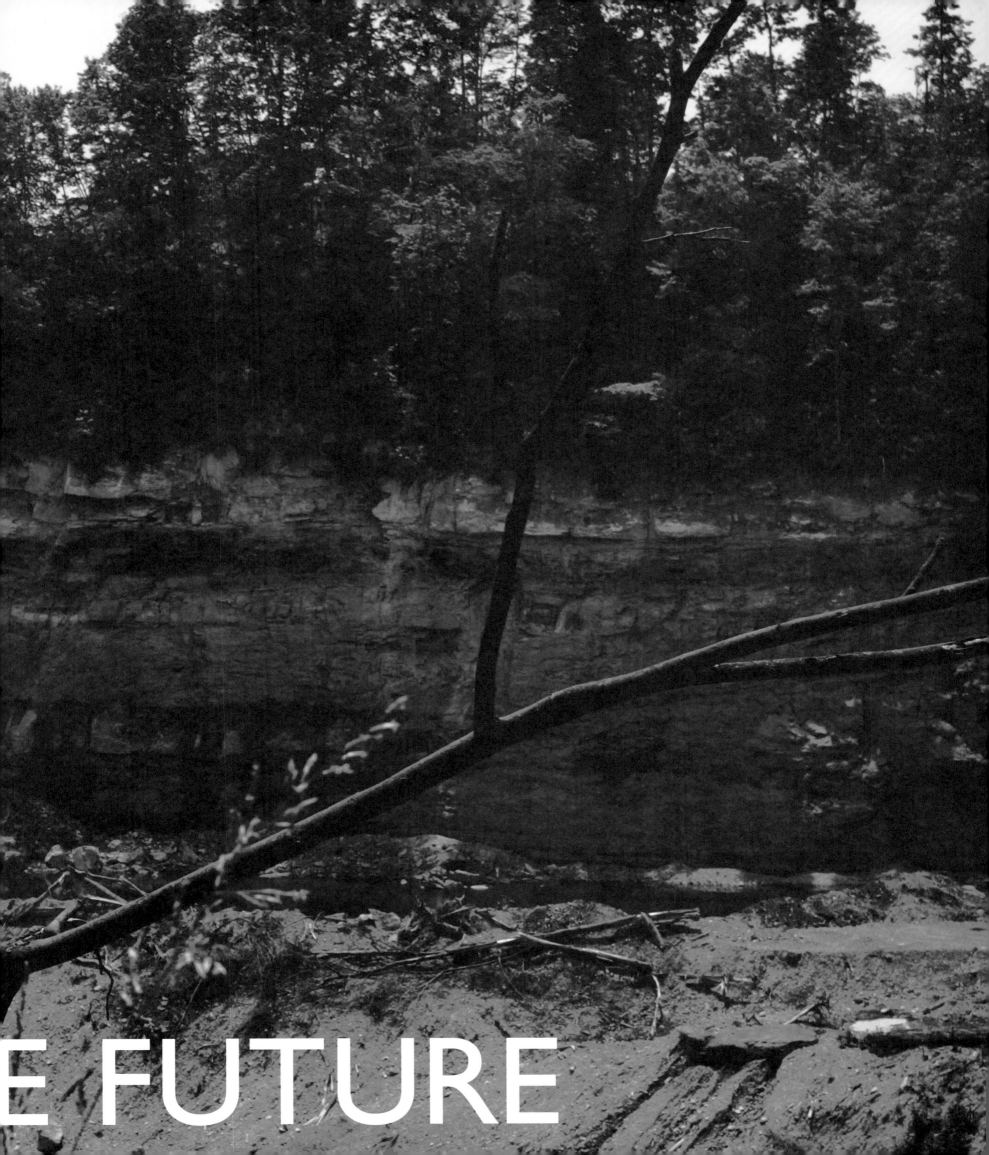

E FUTURE

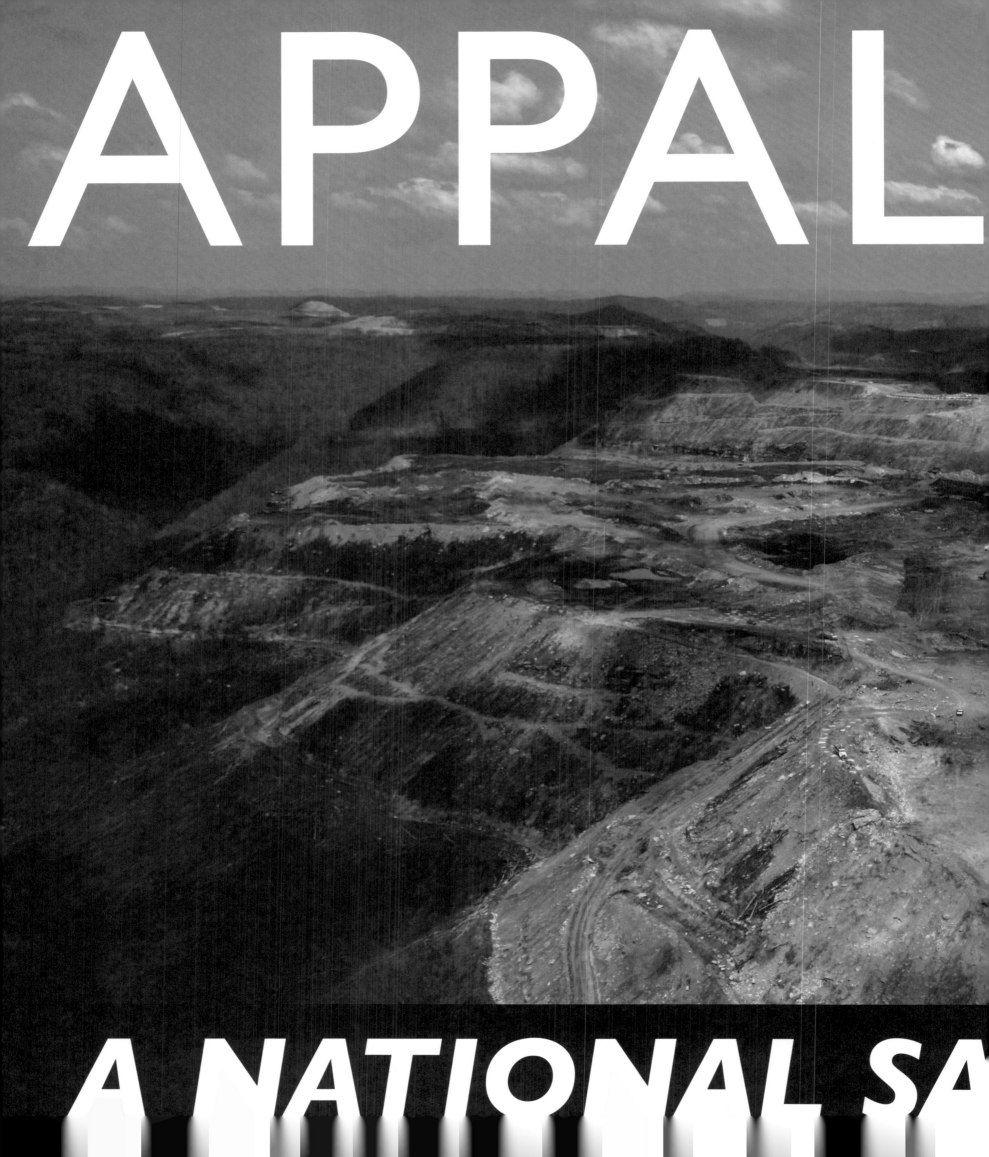

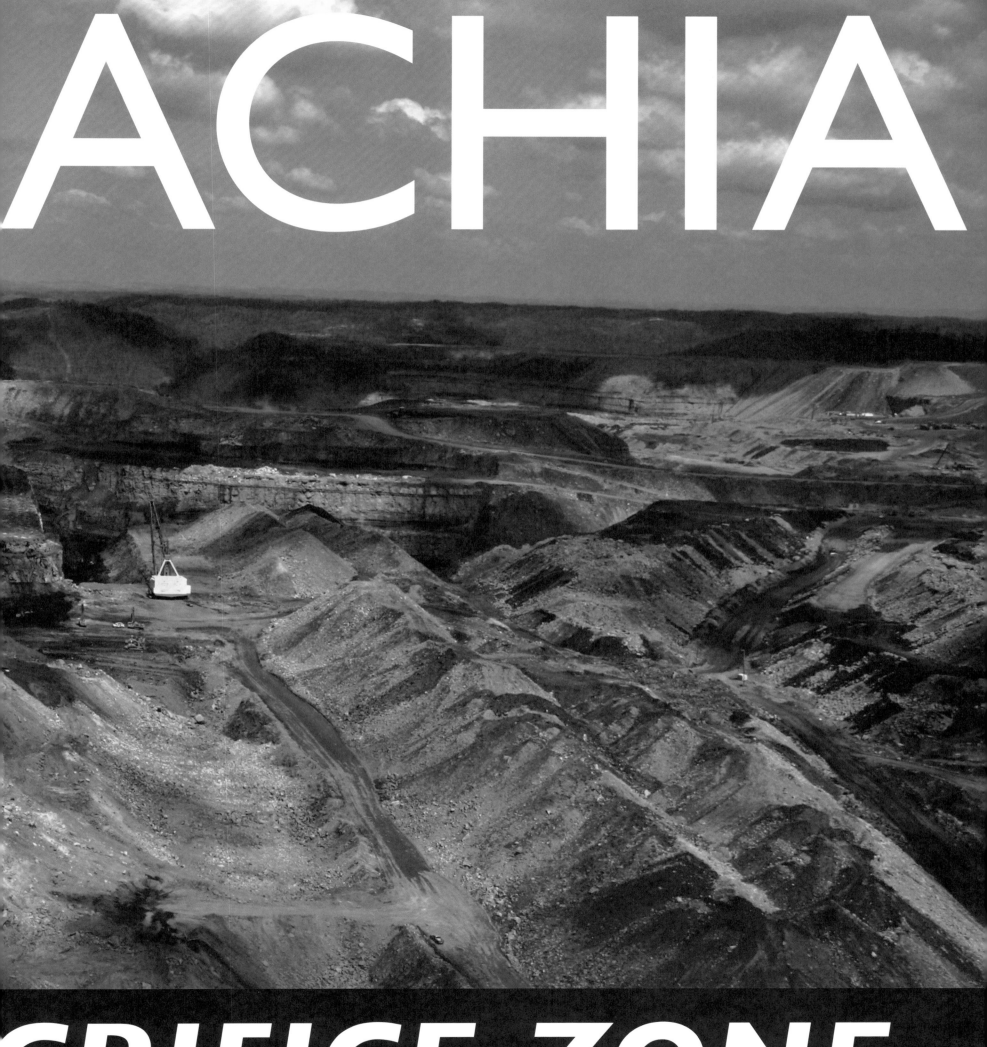

CONTENTS

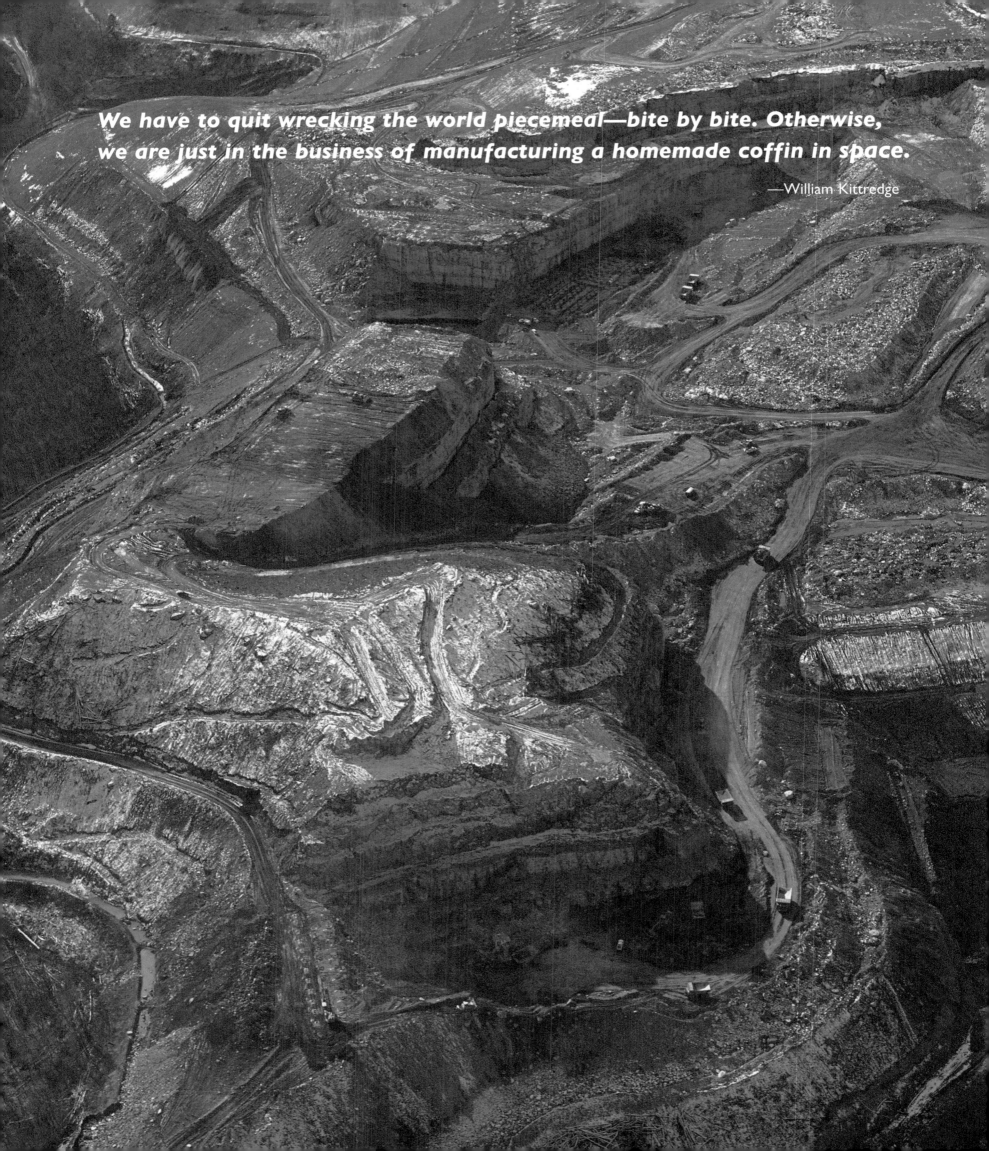

We have to quit wrecking the world piecemeal—bite by bite. Otherwise, we are just in the business of manufacturing a homemade coffin in space.

—William Kittredge

BUILDING A COFFIN

DOUGLAS R. TOMPKINS

Even a casual reader glancing at the photos in this book will readily understand the devastation caused by mountaintop-removal coal mining in Appalachia. The manner in which the region's natural and cultural attributes are under attack is plain enough, although the reality is far worse than these shocking pictures can convey.

One could look at these images merely as picture postcards of destruction from a region that has been treated as a resource colony for more than a century, with profits from timber and coal extraction flowing to distant interests. But *Plundering Appalachia* also challenges readers to see mountaintop-removal mining as a symptom of deeper problems with our economy, society, and relationship to nature. What is the hidden message behind every picture of shredded landscapes in this book? That we face a crisis—and not just in the way we mine and burn coal.

How did this attack on Appalachia come to be? What does it say about us as a society? What are the implications for the future? What drives the seemingly implacable "march of progress" that in the case of the coal industry eats up landscapes as if they were apple pie? How long can this go on?

The answers to these questions go to the root causes of a global crisis, manifested in unraveling ecosystems, species extinctions, climate change, and massive social dislocation. Look at a photo of a decapitated mountain in Harlan County, Kentucky, and challenge yourself to see beyond the actual physical reality shown in the picture. Yes, a formerly beautiful, forested habitat has been ruined by the coal industry—but why? Beyond the obvious answers of corporate profit and a perverse energy economy are deeper matters of philosophy—how we view the world—and the practical ways we structure our political and commercial relationships that spring from the dominant worldview.

We are told that the economy can and must grow continuously. But how can economic expansion continue forever on a finite planet? This totally contradicts our knowledge and logic. How can a continuous contamination of the atmosphere by ever-growing carbon emissions possibly be sustainable? What are the environmental, social, and economic implications of pursuing such a dangerously self-destructive path? Are we in fact, to use Bill Kittredge's phrase, just "building ourselves a homemade coffin in space"?

These deep systemic issues affect our families, our friends, our civilization, and the future. This is not so much about a single polluting industry as it is about the very system that provides the vision and incentives to cut off entire mountains and push the rocks and earth—including topsoil and vegetation—into the valleys, destroying the streams and living organisms that previously existed there. The scale of this carnage prompts one to reflect on the present economic model of unbridled, megaeconomic technology that permits and encourages the absolute desecration of landscapes, heedless of the people or wild creatures within them. This so-called free enterprise system deploys private capital to maximize short-term return, even while destroying natural capital—the earth's living infrastructure upon which all life depends. We must ask ourselves: Is this a system that works for the long-term stability of human society and nature? Is it sensible or sustainable? Will every mountain with a coal seam fall victim to this relentless system before we act to change it?

The answers to these questions of course will come from each individual. But every thoughtful citizen who takes the time to understand the tragedy of mountaintop-removal coal mining will be as outraged as the good citizens of Appalachia who are calling for a halt to this destructive practice. The individuals and organizations in the region that are fighting surface mining clearly value nature and community, and envision a future based on a sane economic model that brings prosperity without destroying the beauty and ecological integrity of the landscape or destroying the region's distinctive culture. For Americans outside the region, particularly those whose "cheap" energy comes at the high cost of leveled mountains and buried streams, there is a moral imperative to support the peoples of Appalachia in their struggle.

To paraphrase the late great environmentalist David Brower, there will be no jobs, no culture, no society, and no prosperity on a dead planet. The practices depicted in the following pages are helping kill the Earth. When you put down this book, we hope that you will join the growing ranks of American citizens who are demanding an end to mountaintop-removal coal mining.

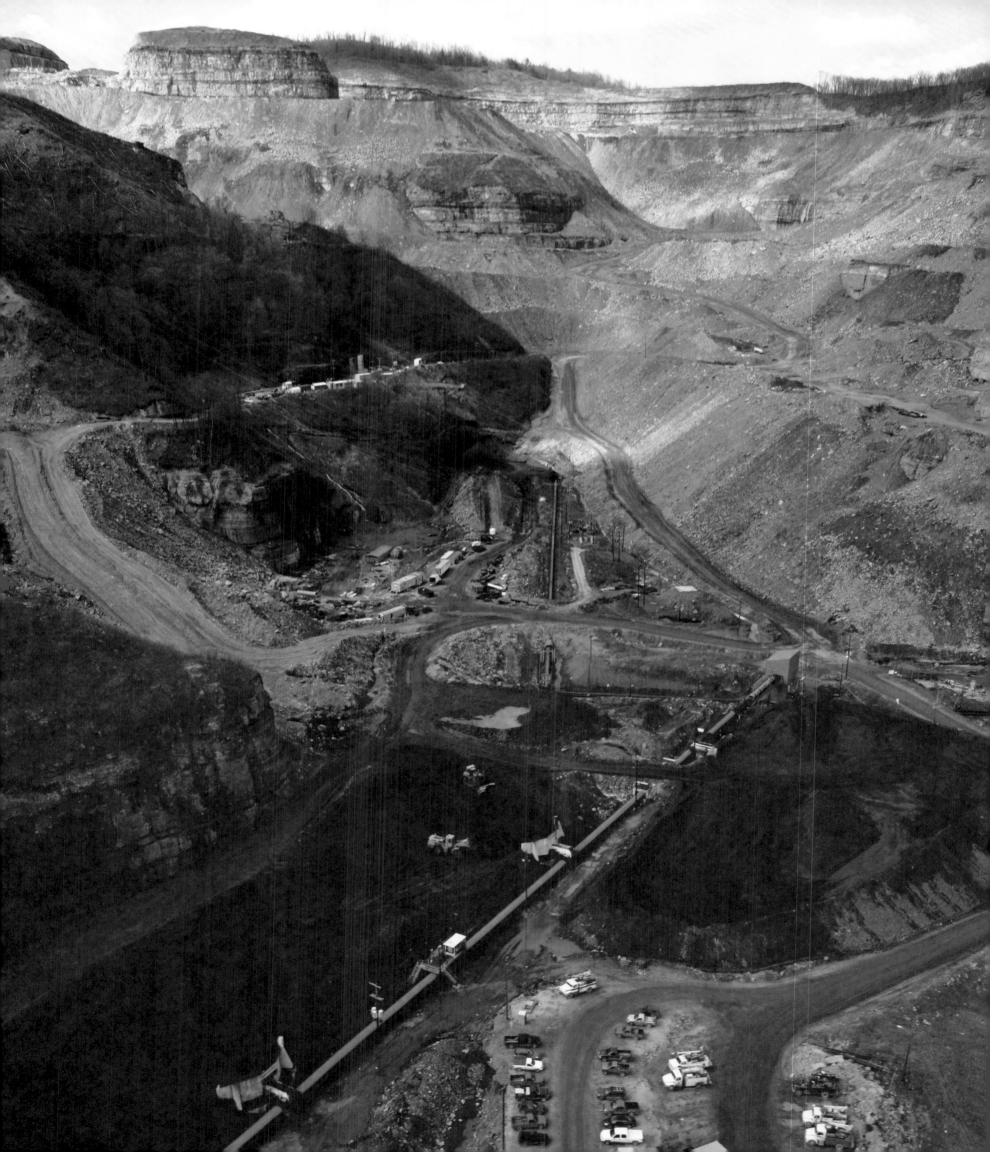

INTRODUCTION

THE MINE AS METAPHOR

TOM BUTLER

Imagine a mountain in Appalachia, cloaked in green. A spring morning, with mist rising and the air alive with birdsong. A riot of wildflowers splashes the forest floor. In the canopy of a massive tulip poplar, male warblers flit among gauzy leaves, singing to potential mates. Black bears amble about the woods, seeking calories to replace those consumed during a long winter's nap.

This is a community powered by sunlight. Ecologists have lately become adept at tracking energy as it flows through ecosystems, but even the most sophisticated schematic of food webs presents only a partial picture of reality. The energy economy of nature is amazingly elegant. There is no waste, only food for another organism. Not quantifiable by any data set or scientific analysis, however, is the beauty of life. The mountain in mind—the one I've asked you to imagine—is a glorious place, typical of myriad real places in the southern Appalachians now being obliterated by surface coal mining. The temperate forest ecosystem covering these ancient Appalachian ridges is among the biologically richest and most aesthetically pleasing parts of North America.

We—human beings—are not the author of this wondrous beauty and ecological vitality. The land's richness is of itself, and for itself. We did not make it—but we are unmaking it with a brutality that is breathtaking to behold. There is a name for this unmaking of the wild world: *efficiency*. The horror that is mountaintop-removal coal mining—an ecological and social tragedy—is, by the logic of the marketplace, an efficient utilization of resources, a normal and predictable consequence of an economy based on converting natural capital into commodities and then into monetary wealth.

Return again to the mountain in your mind's eye, the one alive with creatures going about their business. Now the forest is bulldozed into a pile and set ablaze. The topsoil, source of all life, is scraped away and buried under rubble, wasted. Now a series of holes are drilled into the earth, filled with explosives, and detonated. Picture the mountain blown apart piece by piece, dismantled systematically, to expose the thin veins of dark, carbon-rich rock. The rock we burn to keep the lights on.

It seems to me deeply ironic that the peril now facing the biosphere—a radically disrupted climate due to modern industrial humans transferring molecules of carbon from underground repositories into the atmosphere—stems from perfectly benign natural processes. Long ago, in a time so far removed from human history as to be unimaginable except to a few odd cranks called geologists, the sun shone. Plants grew and died, and the organic detritus accumulated. Over eons, geological processes shaped and squeezed that detritus into various forms of carboniferous matter. Much, much later, when humans appeared on the scene, these dark rocks would fuel the fires of the Industrial Revolution, befoul the skies of London and other cities of the newly "developing" world, and power up our iPods.

Coal: the fused, carbonized bodies of plants fueled by ancient sunlight. Coal: a boon to humankind, and also a curse. Coal-related air pollution was bad enough in London by 1285 that various commissions were formed to address the problem, and coal was England's dominant fuel source, surpassing wood, by 1600. Initially, muscle power from people and domestic animals was adequate to reach coal seams near the surface. But deeper mining was limited until the invention of the steam engine allowed mechanical pumps to clear mine shafts of pooling water. Coal-powered engines and pumps, introduced in the early 1700s, allowed workers to dig deeper and access more coal.

Thus fossil-fuel exploitation set in motion a positive feedback loop whereby technological innovation spurred additional fossil fuel use, and the resulting energy powered economic growth and further technological innovation. Coal, and the engines it could power, helped set society on a course toward ever-greater technology, specialization, globalization, and economic expansion.

Humanity's adoption of coal power didn't just make possible a particular kind of economy and the social organization that went with it, but also helped create a worldview, a philosophy of unlimited economic growth based on ever more complex technology. And this was the greatest lingering curse from the original sin of coal mining—the further estrangement of people from nature. Instead of our rightful place as "plain member and citizen of the biotic community," as the great conservationist Aldo Leopold phrased it, humans would assume the role of Lord Man, conqueror of the Earth. The power of burning rocks was not solely responsible for the schism between humanity and non-human nature, but

certainly helped fuel anthropocentric hubris and the swath of destruction it would wreak across the globe.

The mountaintop-removal mine may be the ultimate manifestation of modern industrial people's ideology of conquest. It symbolizes a toxic culture, a culture so thoroughly divorced from humanity's roots in wild nature that it views the living Earth merely as a smorgasbord of "resources" for exploitation and profit. Blowing up mountains and burying streams in pursuit of coal is a practice that could only be conceived by people who have forgotten—or rejected—our species' kinship with all life. It is a form of violence against the land so rapacious that it literally condemns mountains to death. It ignores the fundamental need for health. It promotes sickness. It is utterly contemptuous of the future. It is one generation of humans saying to other members of the land community, *you don't matter*, and to our own descendants, *screw you, I got mine*.

The radiological poisons humans have created during the nuclear age may be deadly ten thousand years from now, but the geographical engineering that is presently being accomplished in Appalachia by coal companies operating mountaintop-removal mines is essentially permanent. The corporations that are scalping mountains and helping turn an entire region into an undeclared national energy sacrifice zone are powered by greed. On behalf of their shareholders, on behalf of the electric utilities that are the major customers for the coal, on behalf of every American who believes in the myths of "cheap" energy and "clean" coal, the mining companies are waging war on the wildlife and people of Appalachia. And they are winning.

The more than 470 mountains that have already been blown apart as surface coal mining has gotten more and more radical in its destructive power will not grow back. Erosion, deposition, tectonic action—it is for geological processes now, over the course of deep time, to soften the scars on the land. The damage will be visible as long as humans walk the earth.

WHILE THE MOUNTAINTOP-REMOVAL MINE may be an apt metaphor for a society based on cancerous growth, the practical effects of surface coal mining on the ecosystems and human communities of Appalachia are anything but symbolic. They are everyday realities for people living throughout the coalfields of Kentucky, West Virginia, Tennessee, and Virginia. Air and water pollution, overloaded coal trucks traveling narrow mountain roads, forest fragmentation, excessive levels of coal dust, massive coal-slurry impoundments perched over communities, degradation of headwater streams—these and other effects are suffered by people and wildlife across the region.

There is, of course, a diversity of opinion within coalfield communities about the necessity of surface mining. Many families rely on coal-related jobs. The long history of coal mining in Appalachia has helped define the regional culture. People are rightfully proud of the camaraderie, courage, skill, and, at times, outright heroism that past generations of deep miners displayed as they dug coal for a growing nation.

The centrality of coal mining in the heritage, culture, and economy of the region makes it difficult for citizens to speak out against modern coal-industry practices that are destructive to the land and people. Those who do are often shunned, harassed, or worse. It can be dangerous to oppose the dominant industry in a community. Friendships may fracture. And this is another tragedy of mountaintop-removal coal mining—that it not only ravages the physical landscape, but can also destroy the bonds within communities, among friends, and even within families.

One need not endorse any particular viewpoint or have even given much thought to deeper systemic issues regarding energy policy, industrial growth, global climate change, or the erosion of democracy to be concerned about mountaintop removal. For activists who become engaged on the issue, these larger questions may come later. The key point is to become engaged. Grassroots organizations throughout Appalachia are leading the fight to oppose the practice. The amazing individuals from coalfield communities who have founded these efforts have diverse opinions and differing emphases—but share remarkable solidarity on one point: Steep-slope surface coal mining in Appalachia is fundamentally destructive. It must end. And they share a unified hope that the region's economic fortunes need not be forever tied to a dominant extractive industry.

The need for a sensible, ecologically informed economic development policy in Appalachia is great. At present, there is a strong correlation between the counties in the region with the greatest amount of surface-coal-mining activity and the highest rates of poverty. There will be a future beyond coal—for the planet, and for the land and people of Appalachia. The challenge before us as a nation is to move there quickly, before more mountaintops are blasted away, steering the economic transition toward local, sustainable, durable relationships that are environmentally sound and promote social equity. There is plenty of work to be done, and a key initial step is alerting Americans from every part of the country about mountaintop-removal coal mining and inviting their participation in the effort to stop the plunder of Appalachia.

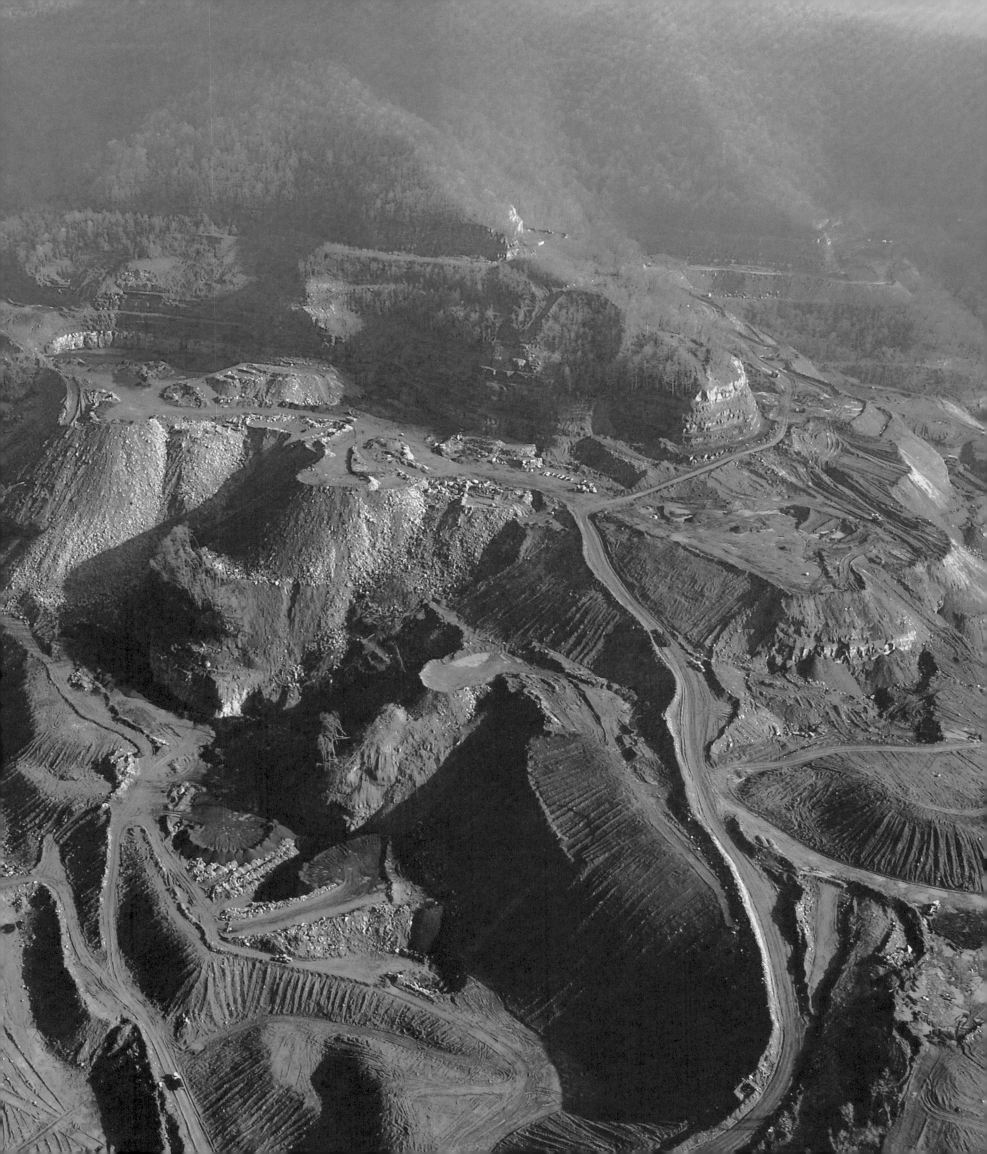

PART I

APPALACHIA
BEAUTY, BIODIVERSITY, AND CULTURE IMPE

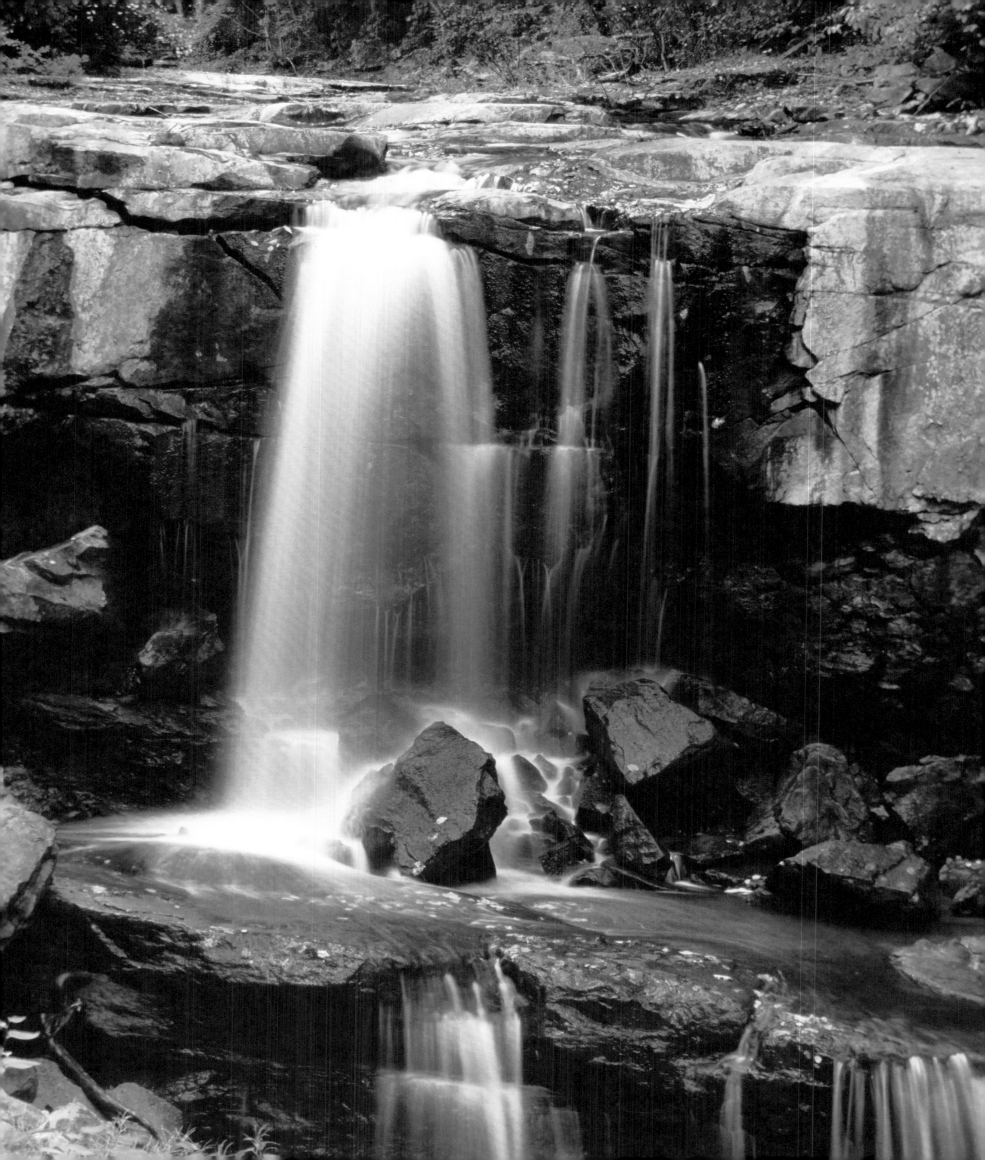

APPALACHIA

Land of Diversity

GEORGE WUERTHNER

The southern Appalachian Mountains are a global biodiversity hotspot and arguably the most biologically important region in the United States. Geology and climate are responsible for the variety of life here. The climate is generally mild, with an abundance of moisture. Some parts of the landscape are temperate rainforest, with precipitation exceeding one hundred inches annually.

An astounding one hundred thousand species of plants and animals are thought to inhabit the Great Smoky Mountains National Park alone. Similar biological richness is believed to occur throughout the southern Appalachians. Both salamanders and fungi reach their greatest diversity here. There are fifty-five known salamander species, with twenty-two endemic to the region; an estimated twenty-five hundred species of fungi have been identified, but as many as ten thousand are thought to exist in the region. Common species such as whitetail deer, black bear, and turkey thrive here, and elk, a native species long absent, have been successfully reintroduced in Kentucky.

Much of this biological diversity is a consequence of geology. The Appalachian range is the oldest uplands region in the United States. The Appalachians began to rise some 450 million years ago while part of Pangaea, the supercontinent that included most of Africa and North America. About 300 million years ago, during what is known as the Alleghenian orogeny, sediments were deposited in shallow seas and swampy areas—leading to the formation of sedimentary rock interspersed with coal beds. Plate collision drove these layers upward, severely folding rock strata near the plate margin creating the Blue Ridge province and the Valley and Ridge province, while pushing up nearly level geological beds in the Appalachian Plateau farther from plate edges.

The Appalachian Plateau, lying along the western margin of the Appalachian chain, makes up a large part of West Virginia, eastern Kentucky, and small portions of southwest Virginia and eastern Tennessee. The Appalachian Plateau averages about 50 miles wide and is 450 miles long. It is further subdivided into the Cumberland Mountains, Cumberland Plateau, and Alleghany Plateau. The plateau is highly dissected by rivers into narrow, steep-walled valleys referred to locally as hollows.

Different bedrock resulting from this geological history created strikingly different soils over short horizontal distances. Pines, for instance, are common on the droughty sandstone ridges, while the rich carbonate soils derived from limestone are favored habitat for luxuriant cove hardwood forests. Another factor that contributes to the region's superlative biodiversity is that it was never glaciated during the last ice age; at that time many species with more northern ranges found refuge here. As the climate warmed again following the ice age, many of those northern species migrated upslope or found cool microclimates where they could persist.

The generally north-south orientation of the uplands and ridges also permits free migration of species north and south in response to climate change. Plants and animals can move north if the climate warms or retreat southward if the climate cools. The elevation gradient from river gorges to peaks also permits migration in response to climate change. Thus northern species such as red spruce, sugar maple, and yellow birch have found refuge at the highest elevations, while trees more representative of the South such as oaks, sweet gum, black cherry, ash, hickory, and yellow poplar dominate valley floors and moist coves. This incredible diversity survives despite the fact that nearly all of the forest cover was cut at one time. Mountaintop removal, by eliminating all forest cover, threatens to set back ecological recovery further.

The aquatic systems also harbor outstanding biodiversity. Because major rivers flowed southward to the Gulf of Mexico and remained free-flowing during the last glaciation, rivers such as the Cumberland and Tennessee are home to the highest aquatic diversity and endemism in North America. The World Wildlife Fund has nominated the Cumberland River drainage as one of three southeastern U.S. rivers deserving special protection due to its aquatic diversity, which includes 186 species of fish, 87 species of mussels (only 55 remain extant), and 60 species of crayfish. Many of these creatures are imperiled, and more than a few species are already extinct. One estimate suggests that sedimentation is responsible for 40 percent of the fish imperilment in the Southeast—and mountaintop removal is a growing contributor to this water quality impairment.

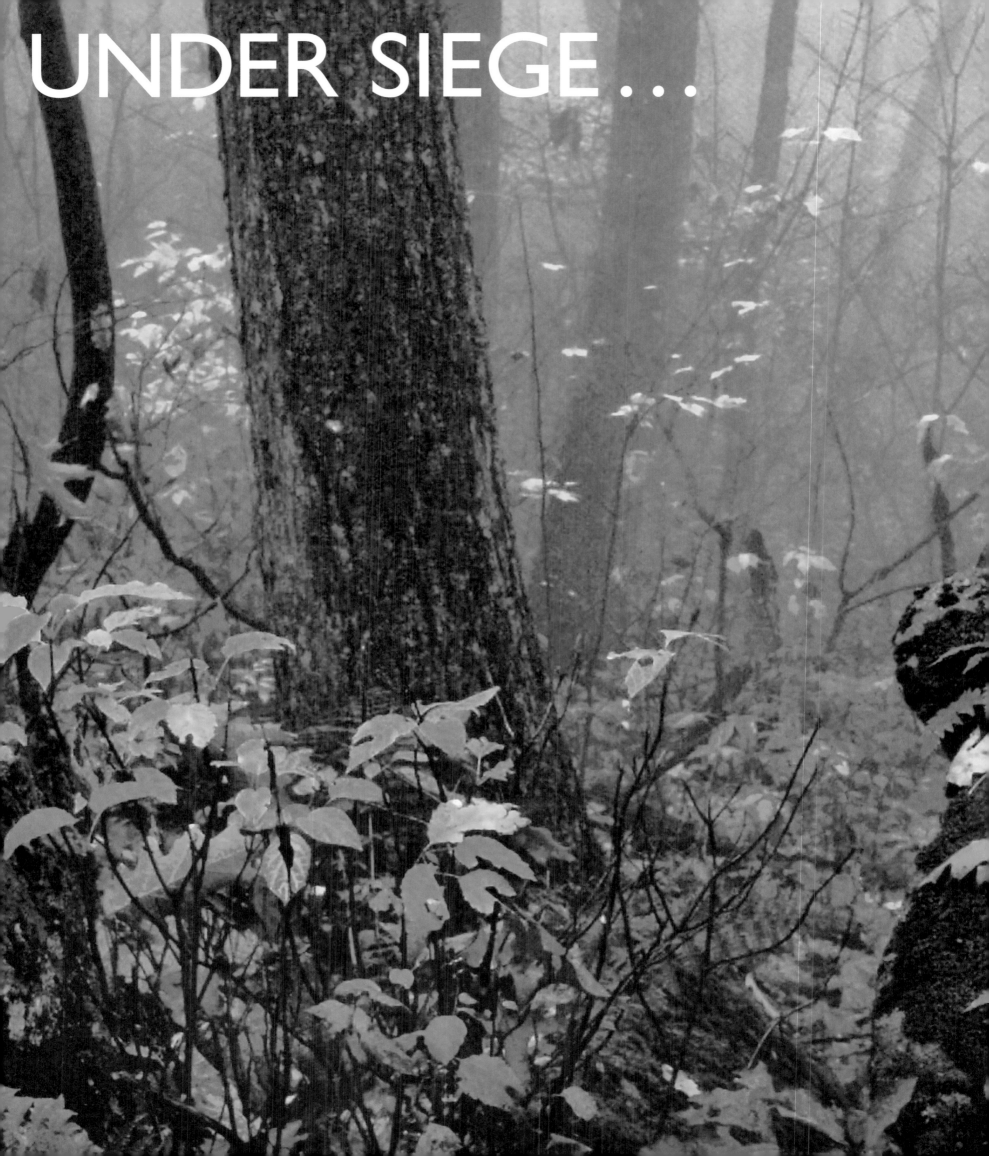
UNDER SIEGE . . .

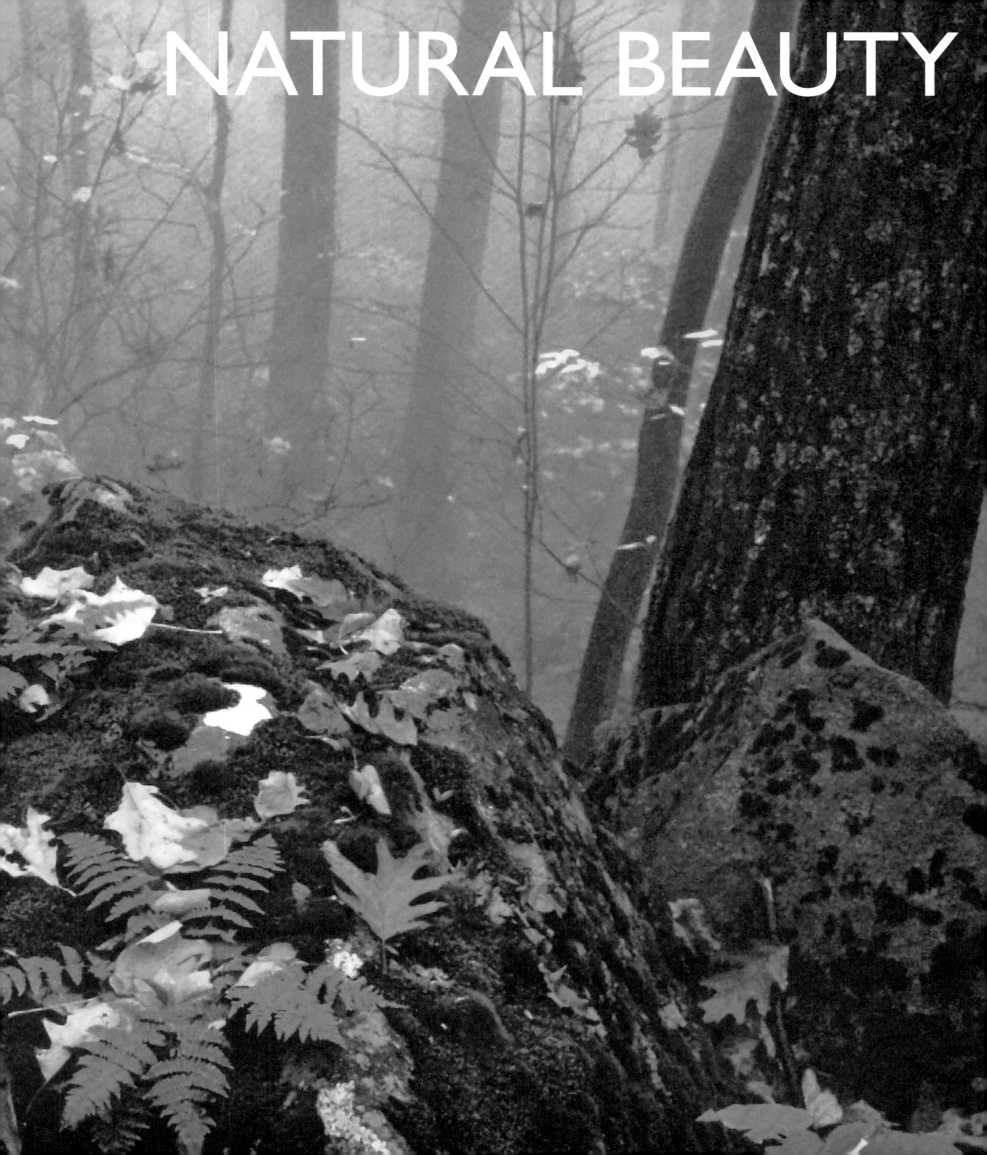

NATURAL BEAUTY

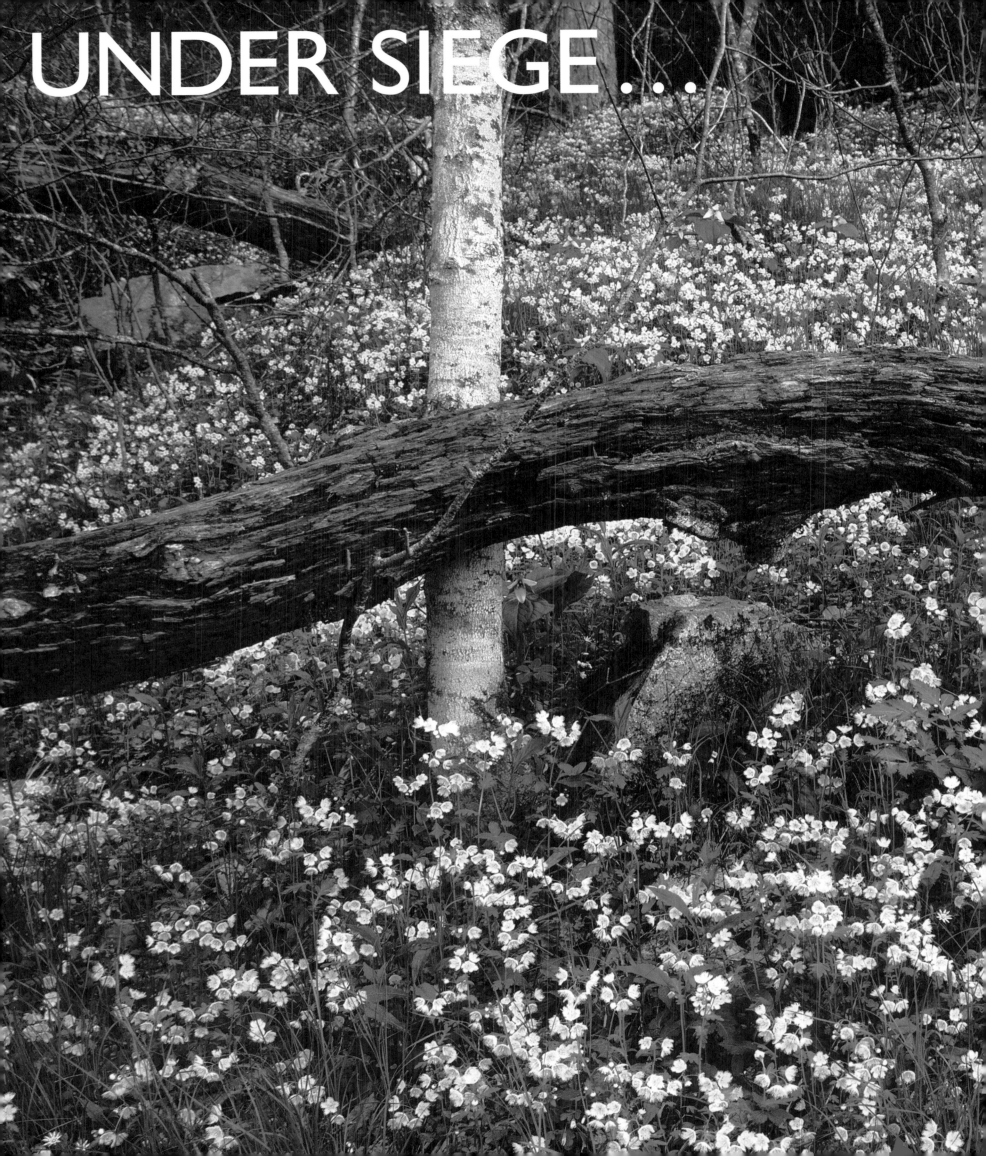

UNDER SIEGE . . .

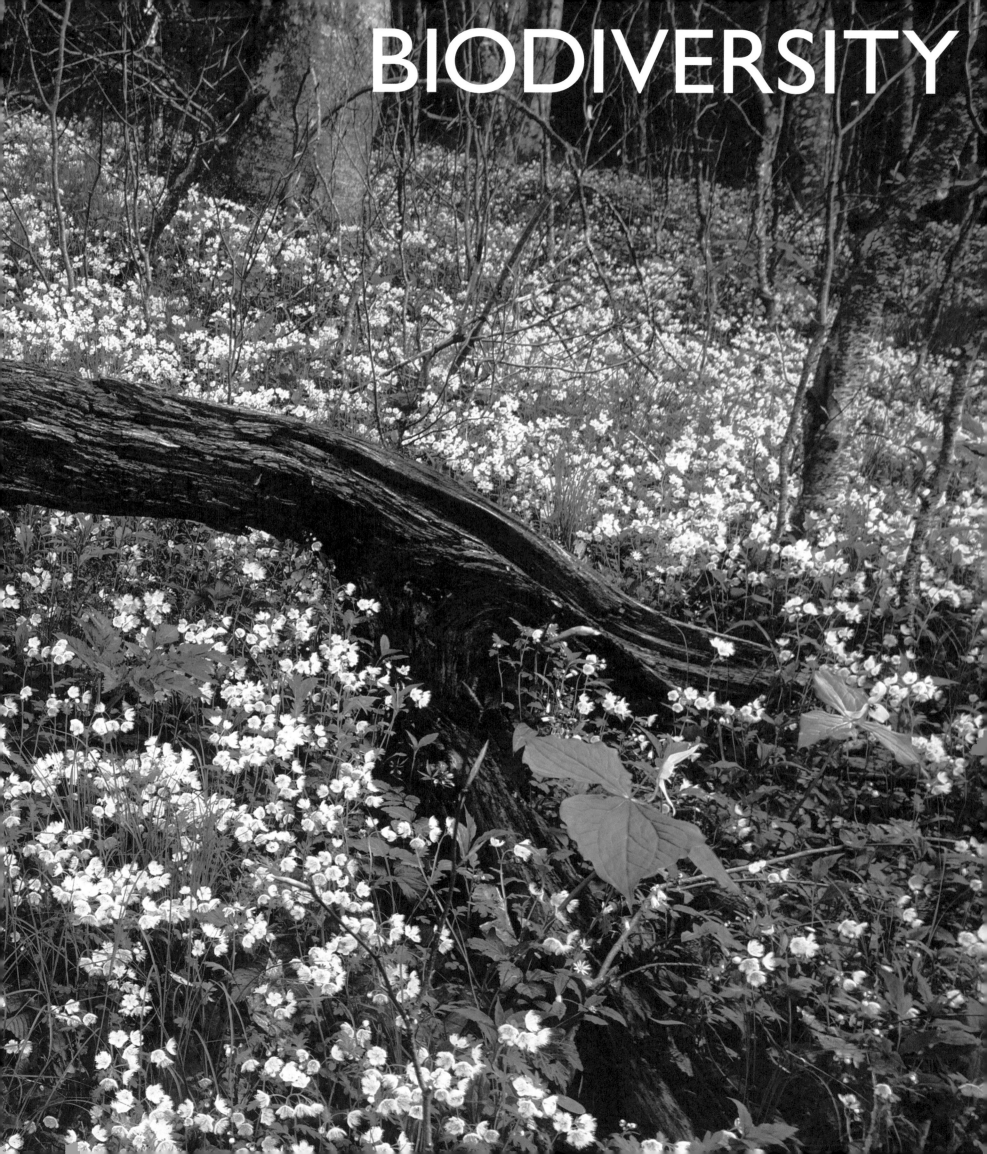

BIODIVERSITY

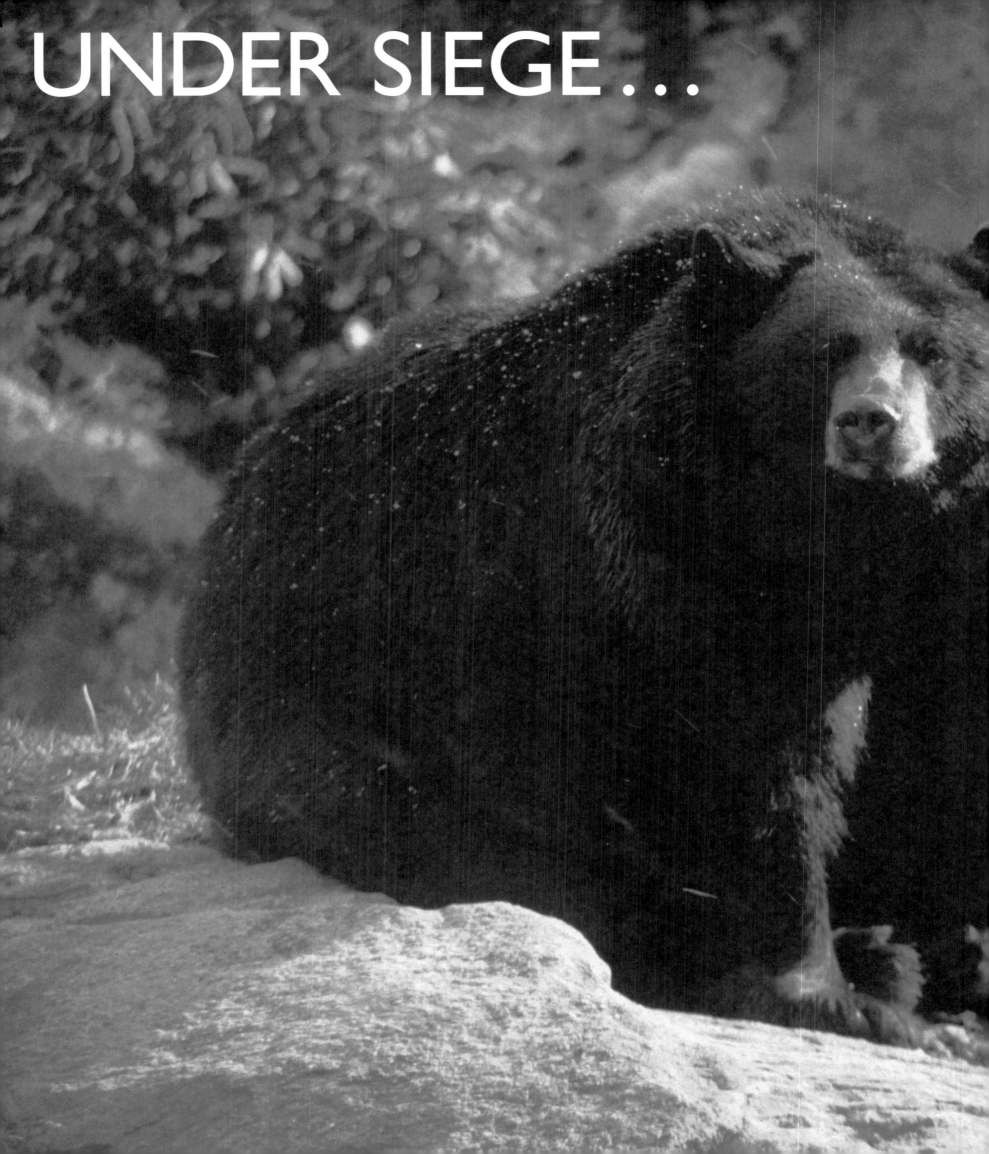

UNDER SIEGE . . .

WILDLIFE HABITAT

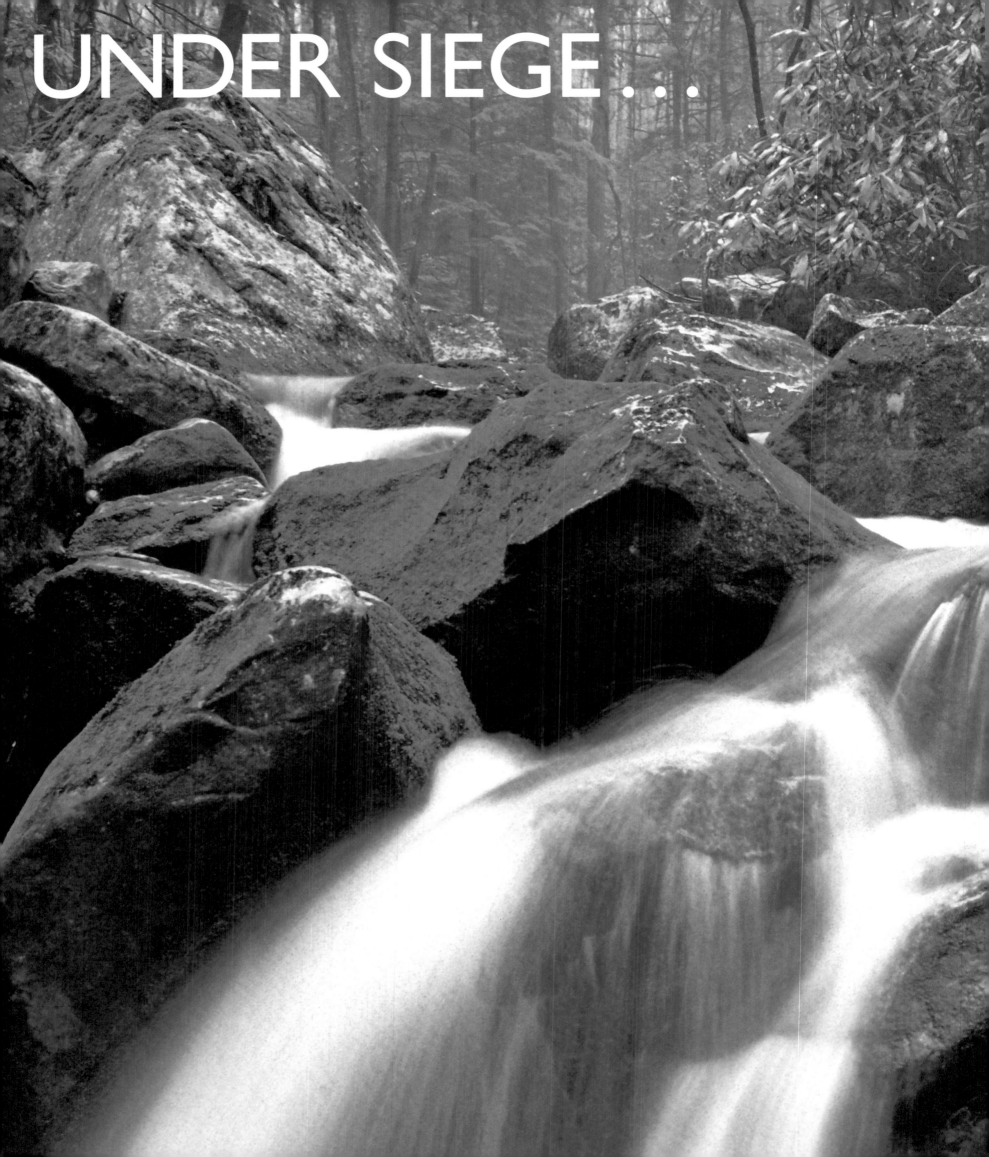

UNDER SIEGE...

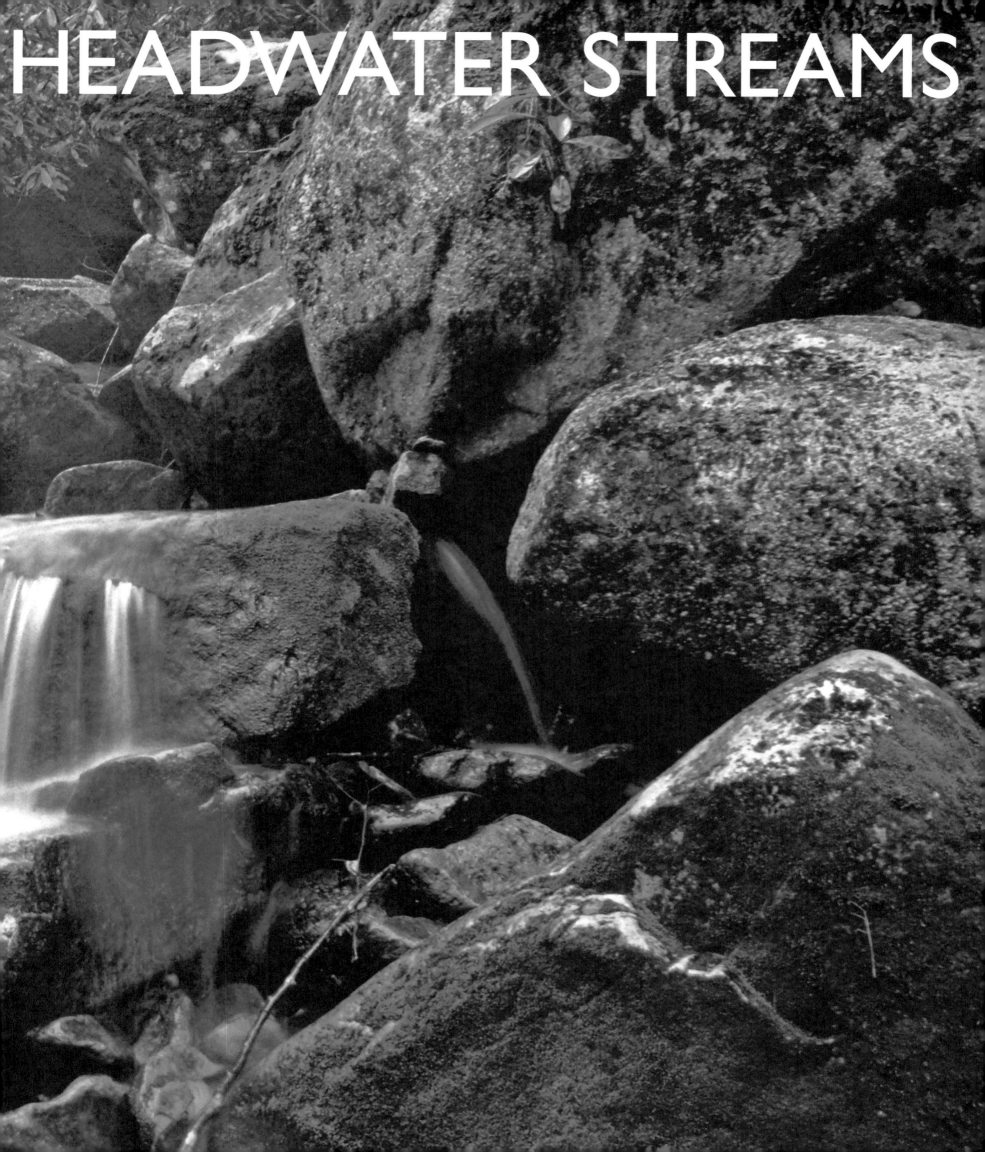

HEADWATER STREAMS

UNDER SIEGE …

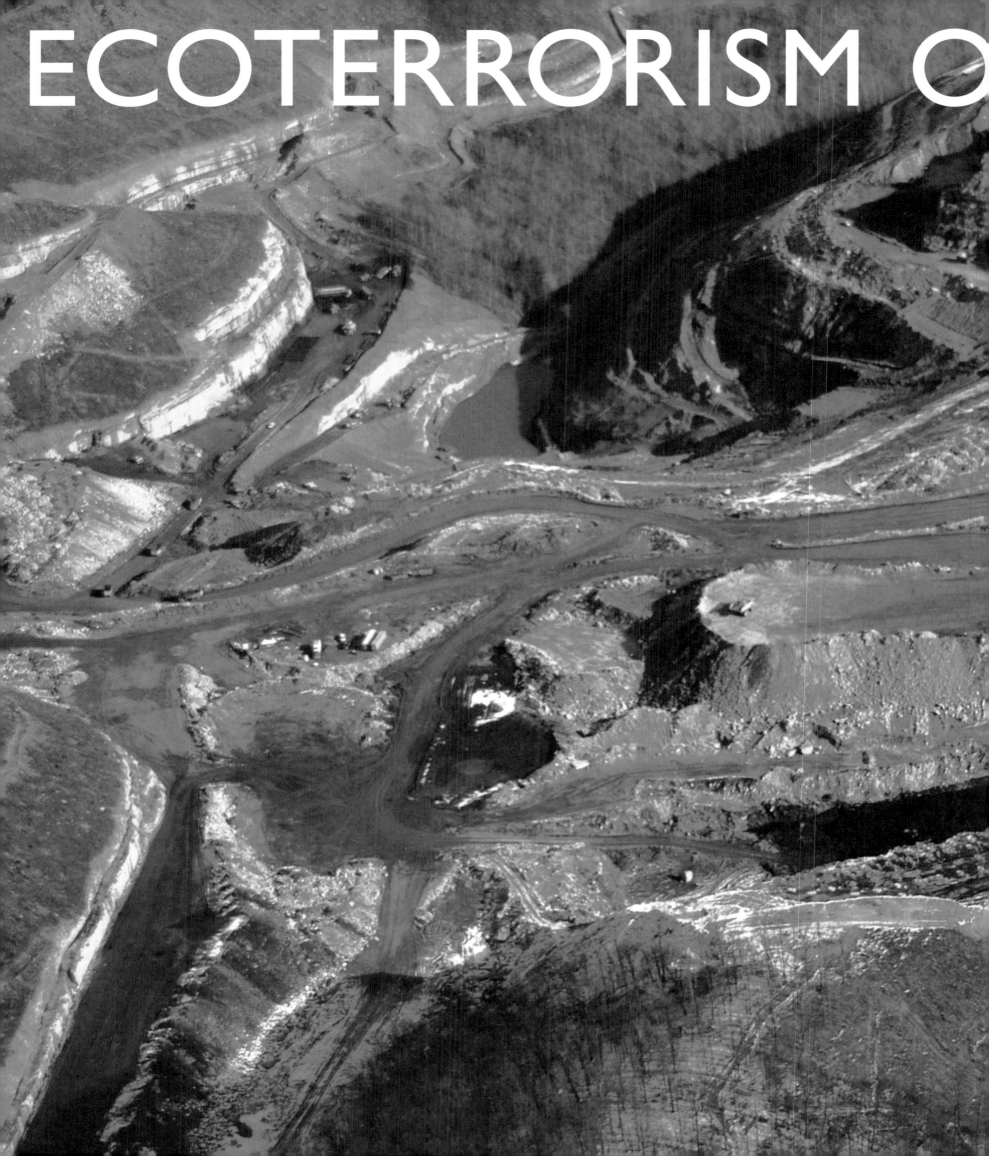

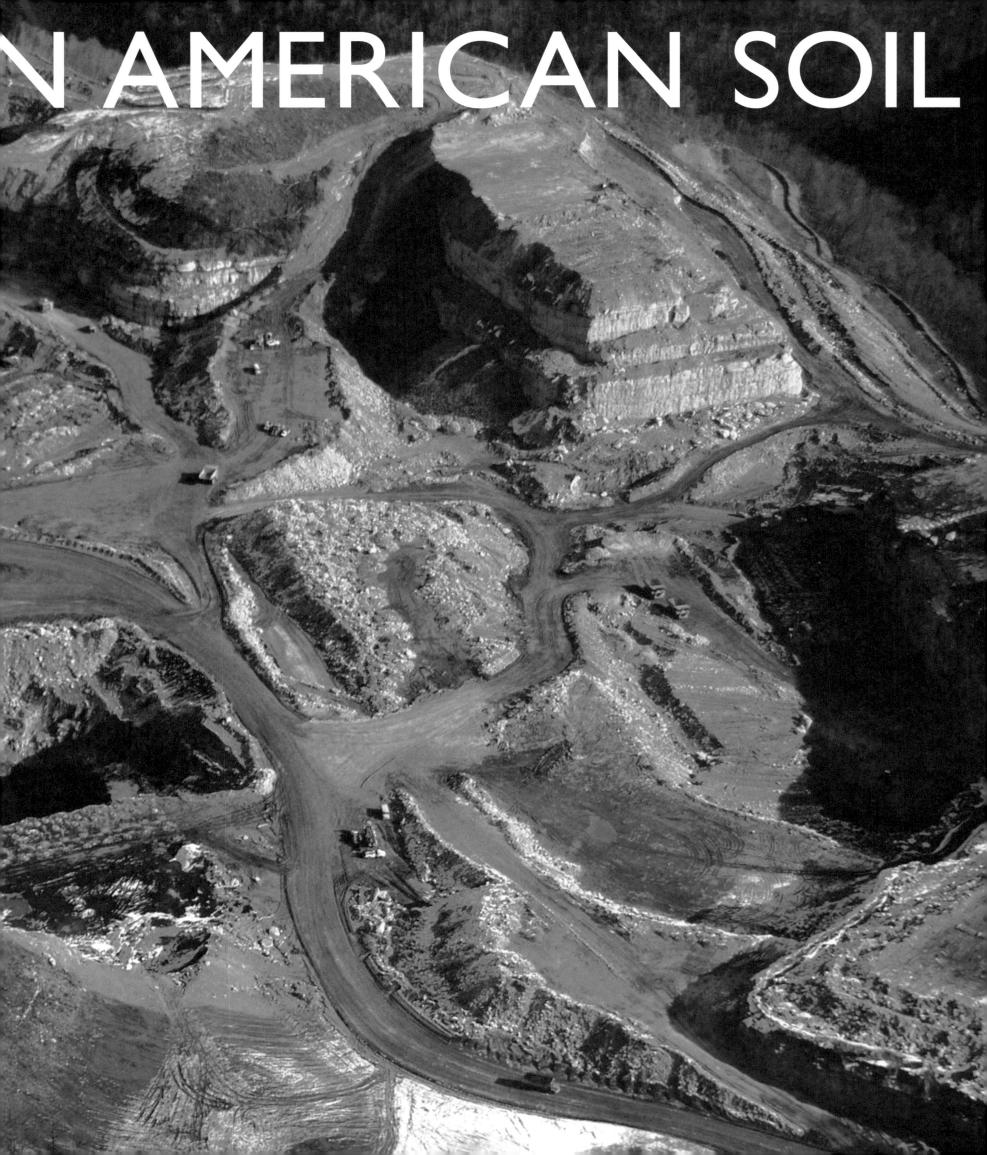

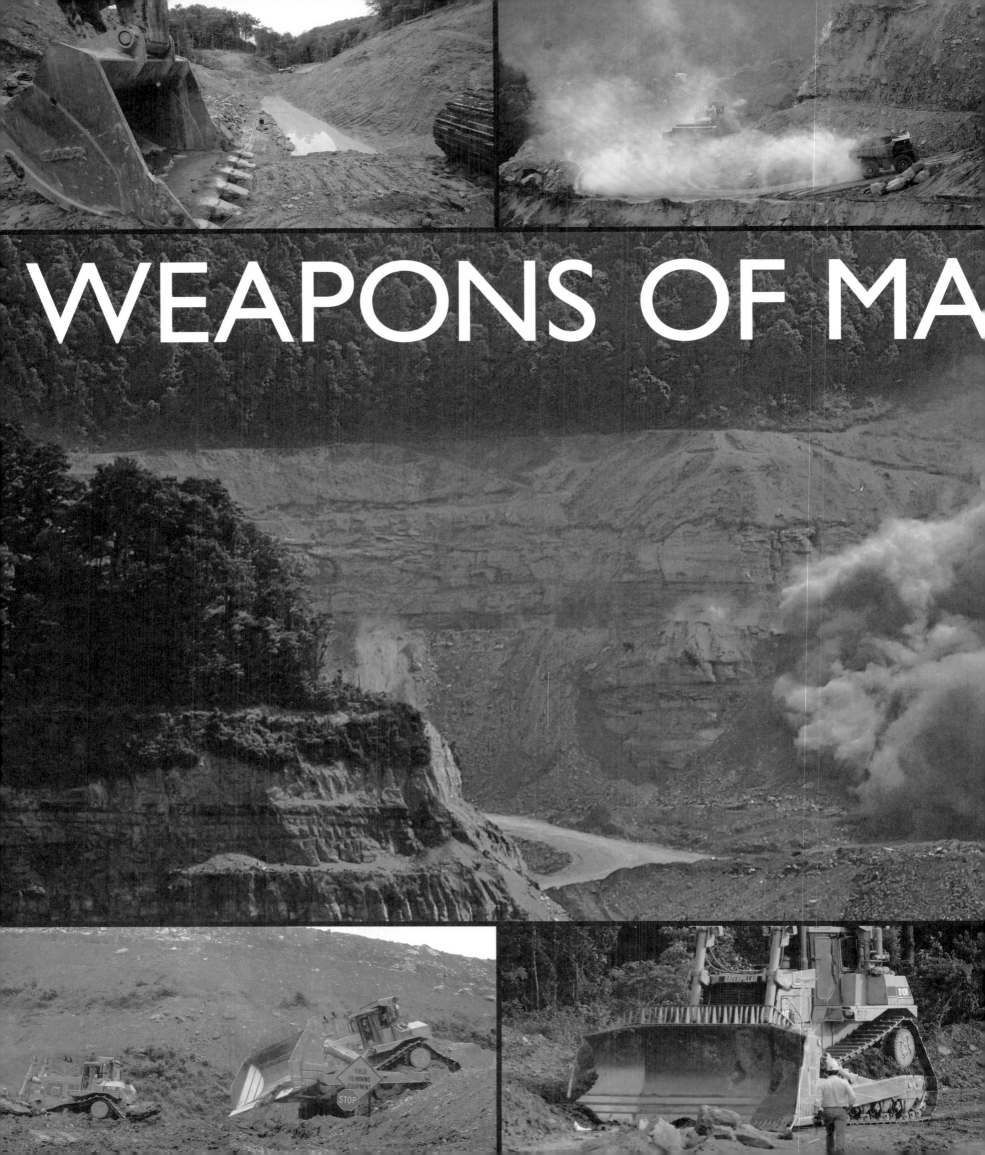

WEAPONS OF MA

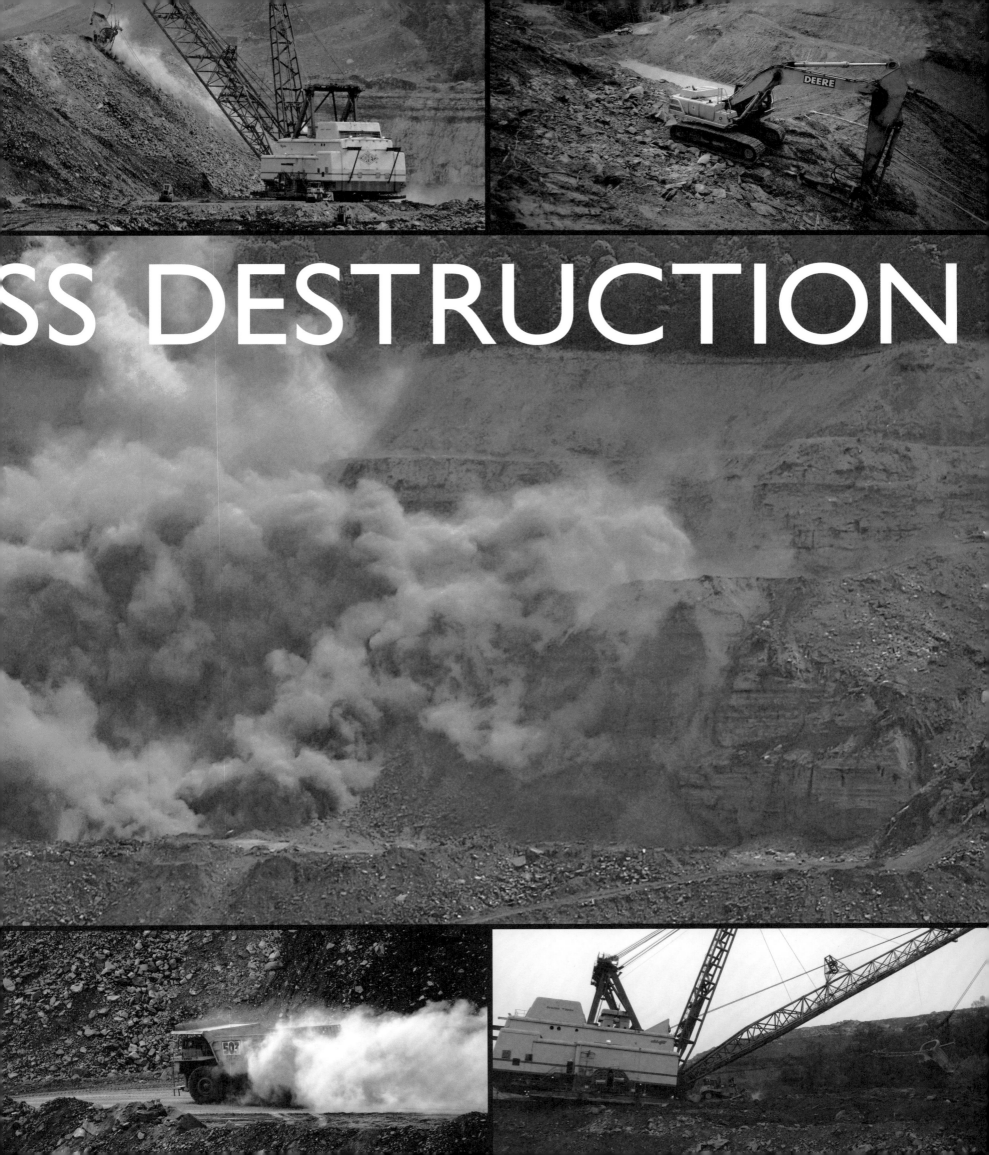

SS DESTRUCTION

DESTROYING OUR N

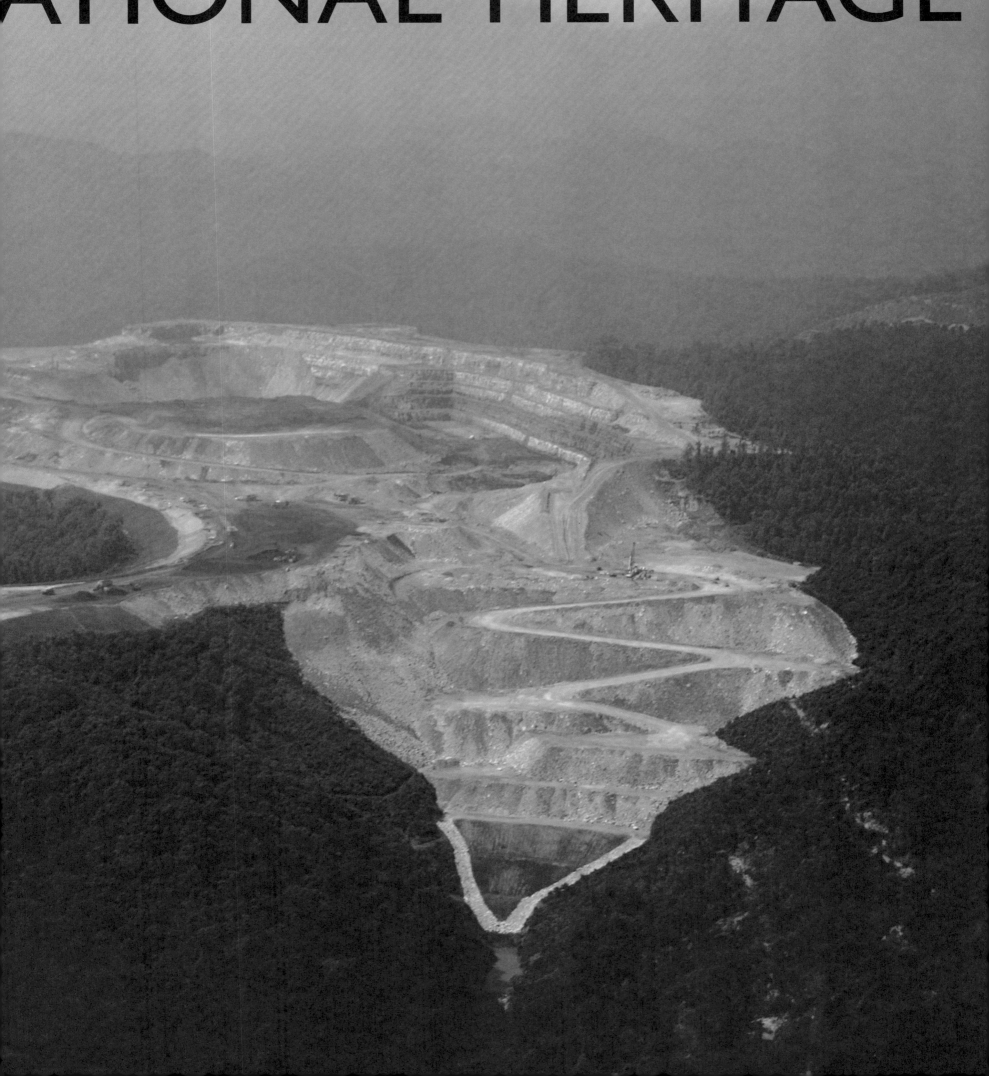

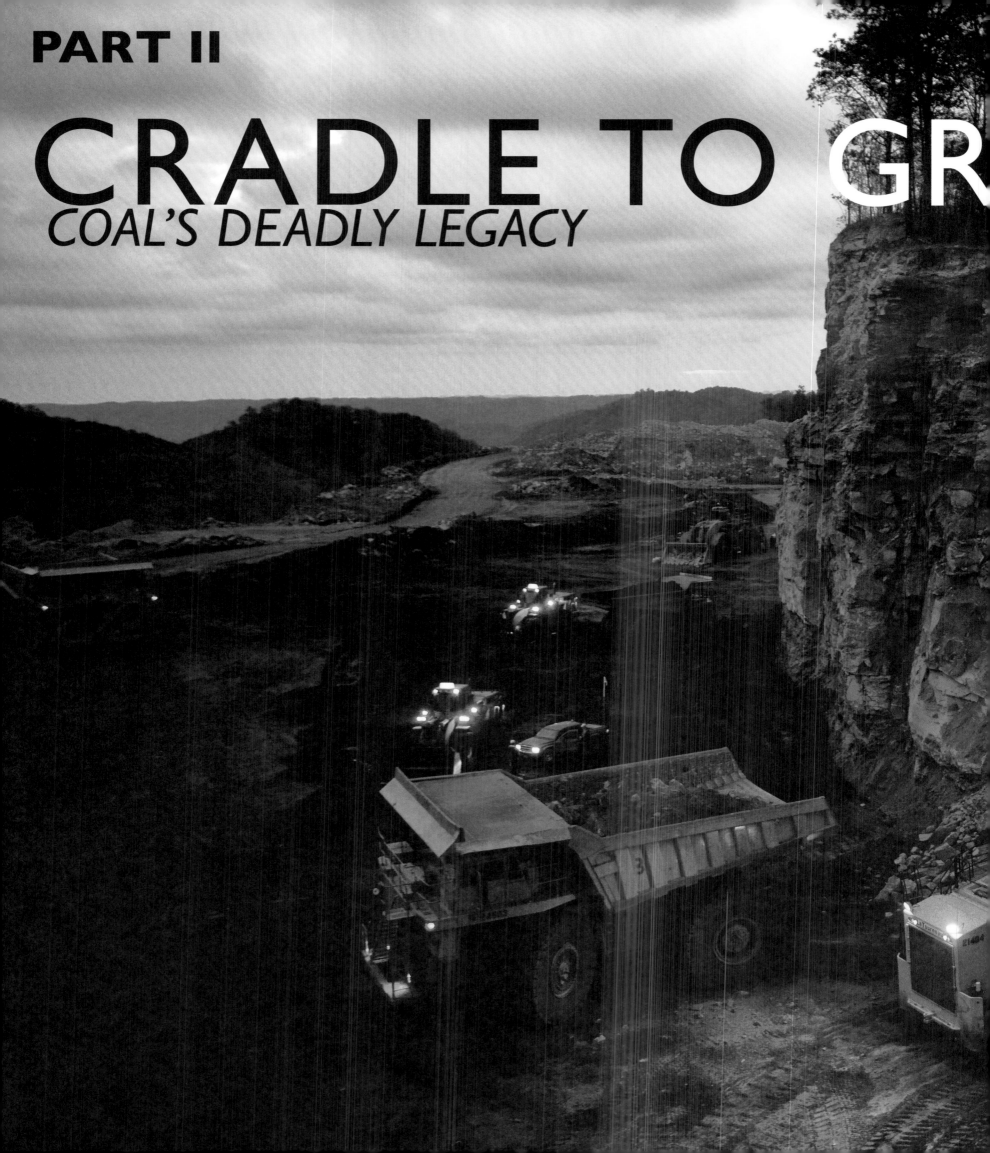

PART II
CRADLE TO GR
COAL'S DEADLY LEGACY

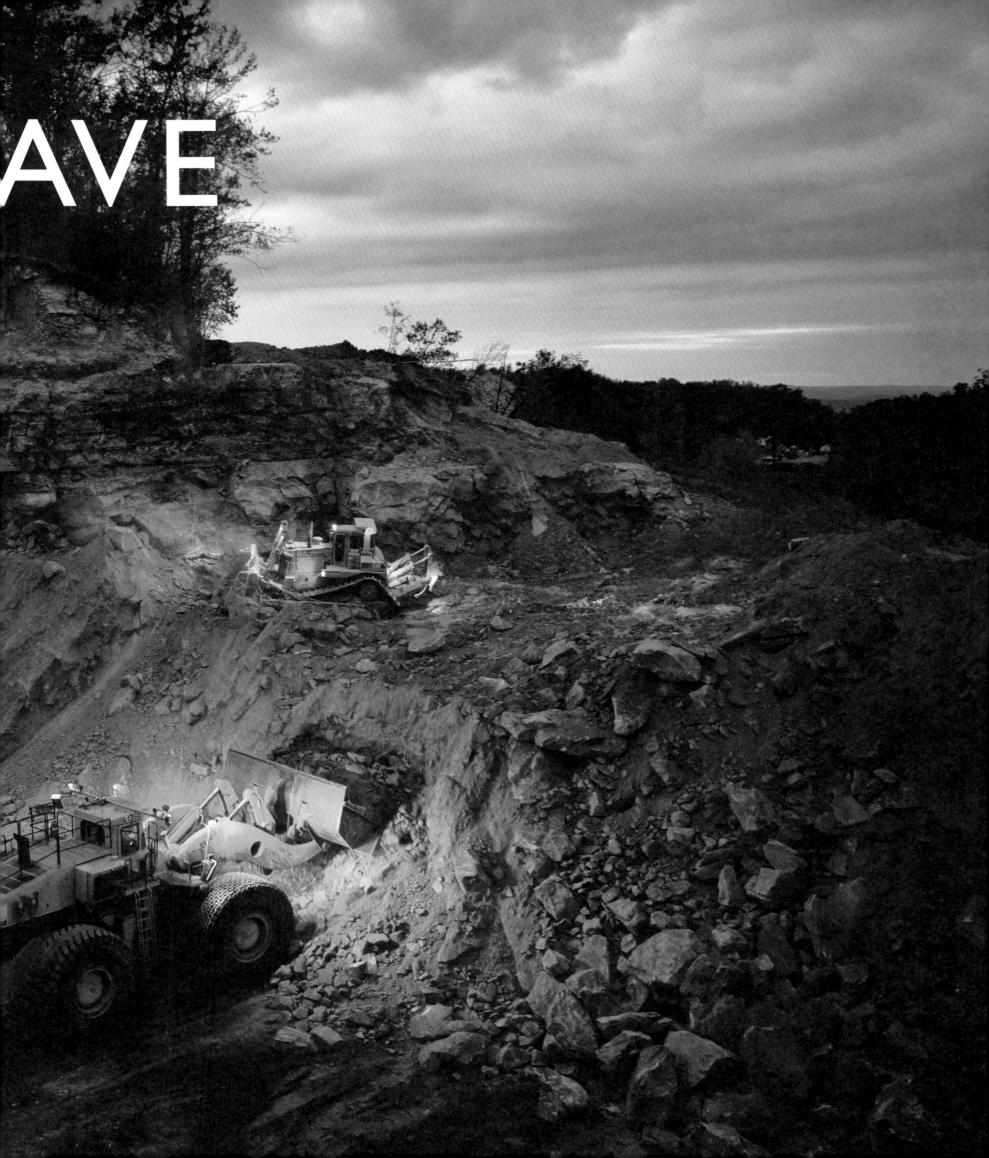

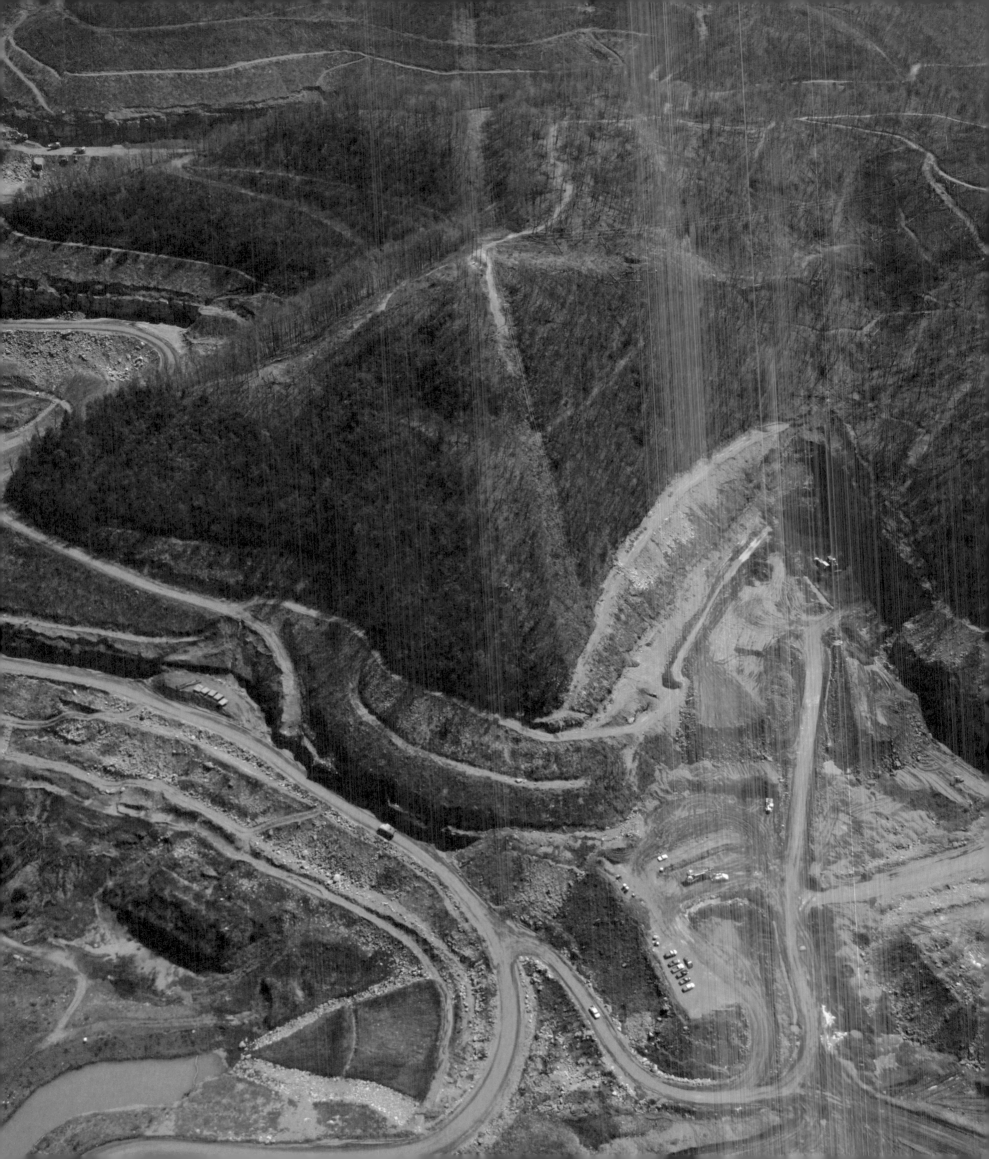

CRADLE TO GRAVE

Coal is the Enemy of the Biosphere

TOM BUTLER

Coal is a lousy way to power a society. From mining to burning to disposing the combustion waste, it's a dirty business. Unfortunately, in our reductionist age, too often people looking at the coal problem don't consider the whole problem.

Only by contemplating the entire life cycle of fossil energy—coal extraction, preparation, transportation, combustion, and waste disposal of by-products—can one fully understand the enormity of coal's toxic legacy. Even environmental writer David Roberts's pithy, oft-repeated pronouncement that "coal is the enemy of the human race" is too narrowly focused. In helping change the atmospheric chemistry and heat up the planet, coal burning is the enemy of the entire community of life, not just people.

Governments around the world have recently begun giving global overheating considerable, if still insufficient, attention. And to be sure, coal is a climate dealbreaker. If humanity keeps ripping coal from the Earth's crust and sending vast quantities of carbon dioxide into the atmosphere, there is no currently foreseeable way to stabilize and then lower atmospheric carbon to the levels that supported the climate regime our species has always known. A technological fix—carbon capture and sequestration technology—does not appear to be deployable, scalable, and economically viable anytime soon and perhaps never will be, regardless of how much funding is thrown at research.

But for discussion's sake, let's imagine this hypothetical "clean coal" technology could be made to work, and every molecule of carbon dioxide from power plant smokestacks got collected and safely tucked underground forevermore. If we're still blowing up mountains, poisoning the land, and harming human communities to get the coal, there's nothing clean about that.

Of course mountaintop-removal coal mining can and should be ended. By law or regulatory reform, by economics, or even, perchance, from societal pressure based on moral outrage, it could be stopped completely. We do not need to do it.

Mountaintop-removal mines in Appalachia are estimated to produce just 5 to 10 percent of total U.S. coal production, and generate less than 4 percent of our electricity—an amount that could be eliminated from the energy mix by small gains in energy efficiency and conservation. This discreet piece of coal's cradle-to-grave legacy is readily solvable with enough public engagement, despite the formidable political power of the coal and electric-utility industries.

But the larger problem of coal's negative impacts throughout its life cycle cannot be solved simply through application of engineering wizardry—by deploying carbon capture or other pollution-control technology, for example. It can't be solved with modest reforms to public policy—say, by improving surface-mine reclamation rules or by consistently enforcing current laws affecting coal extraction, combustion, and waste disposal. It can't be solved by tinkering around the edges of our current energy economy, which has been based on the availability of abundant, inexpensive fossil fuels and must be refashioned to fit a different future.

Granted, many kinds of incremental reform could dramatically lessen the damage coal does to natural and human communities. But ultimately, the problem of coal can only be solved with humility. With restraint. With a conscious decision to leave it in the ground, and power society using contemporary, not ancient, sunlight.

23

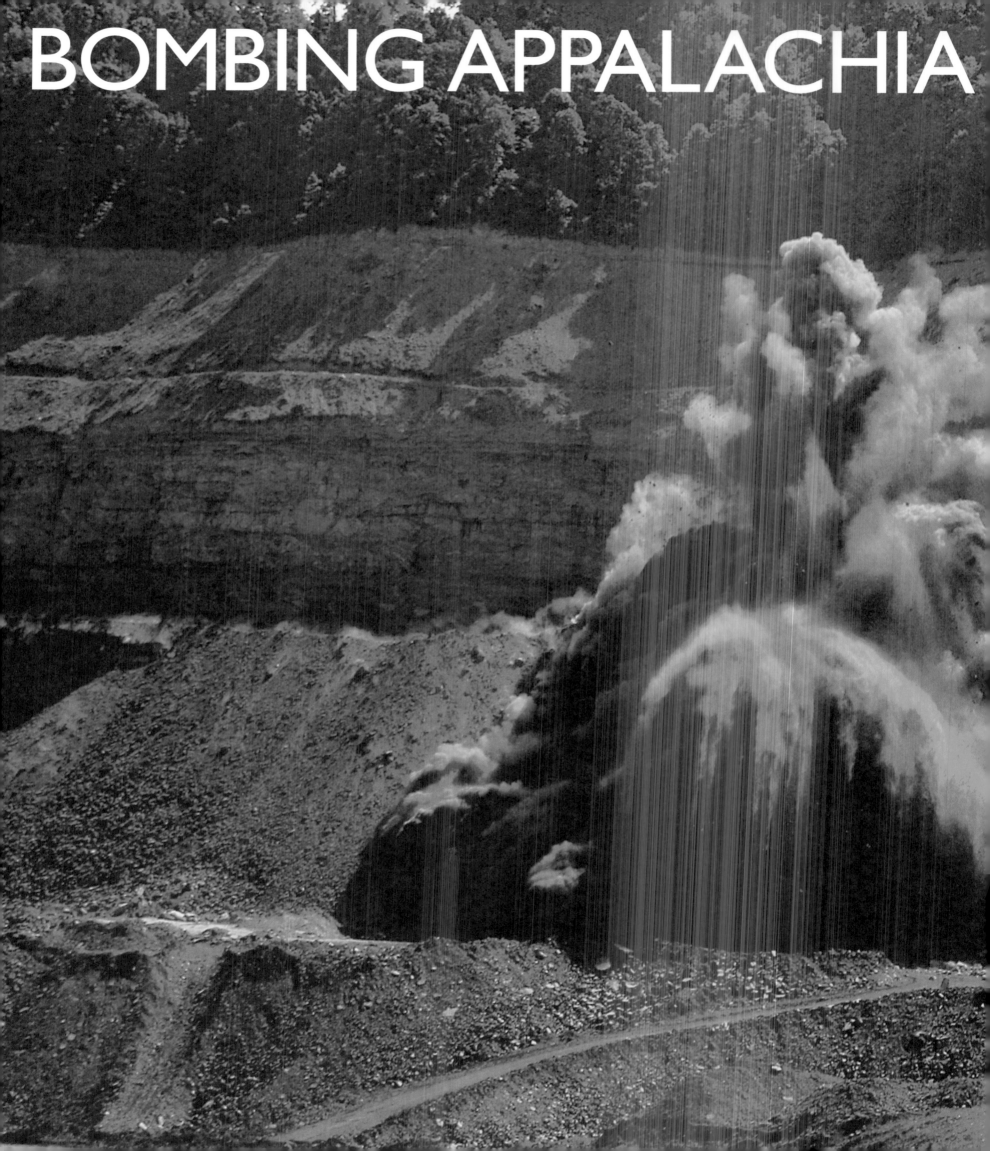

BOMBING APPALACHIA

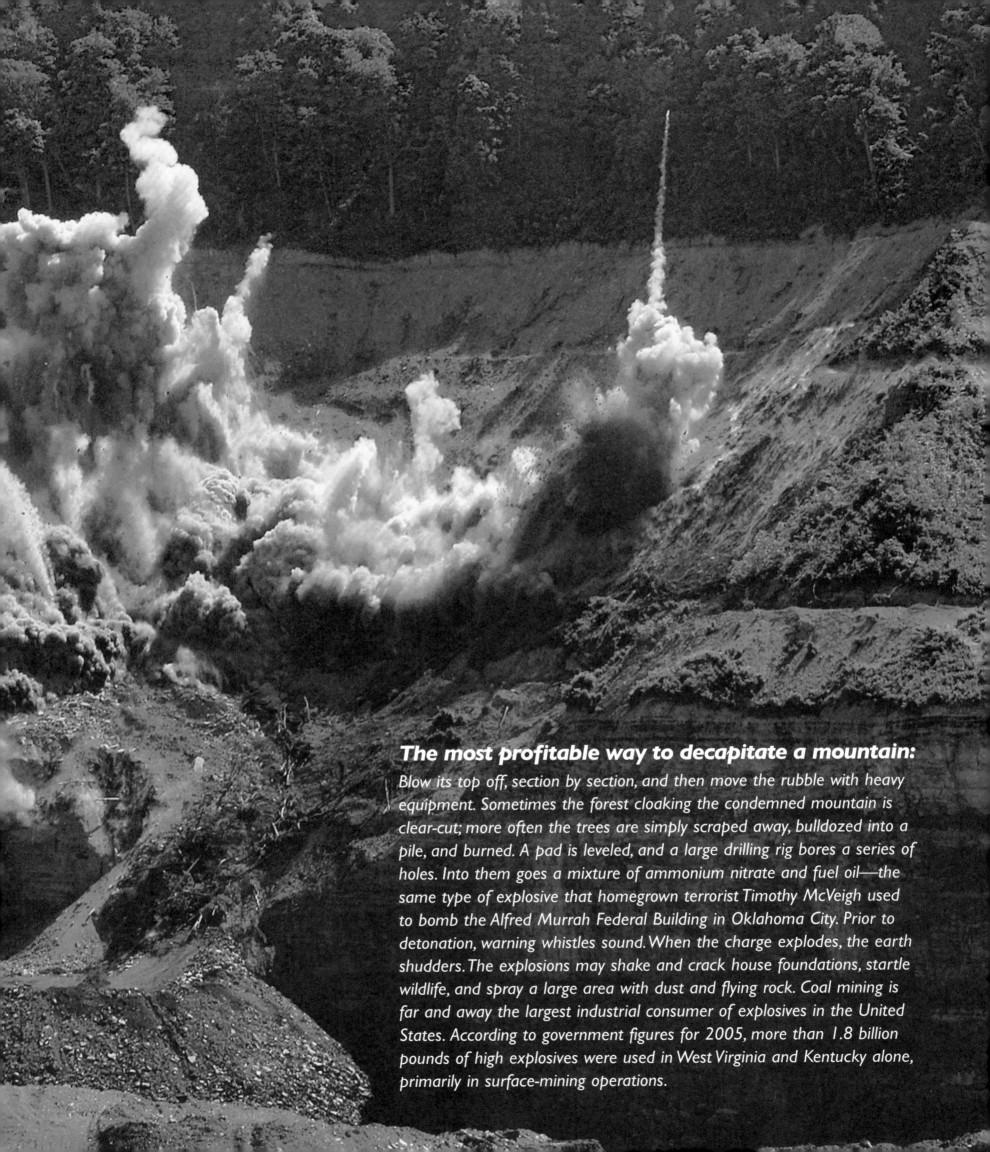

The most profitable way to decapitate a mountain:
Blow its top off, section by section, and then move the rubble with heavy equipment. Sometimes the forest cloaking the condemned mountain is clear-cut; more often the trees are simply scraped away, bulldozed into a pile, and burned. A pad is leveled, and a large drilling rig bores a series of holes. Into them goes a mixture of ammonium nitrate and fuel oil—the same type of explosive that homegrown terrorist Timothy McVeigh used to bomb the Alfred Murrah Federal Building in Oklahoma City. Prior to detonation, warning whistles sound. When the charge explodes, the earth shudders. The explosions may shake and crack house foundations, startle wildlife, and spray a large area with dust and flying rock. Coal mining is far and away the largest industrial consumer of explosives in the United States. According to government figures for 2005, more than 1.8 billion pounds of high explosives were used in West Virginia and Kentucky alone, primarily in surface-mining operations.

DISMANTLING MOUN

TAINS

The most ancient mountains in North America, plundered for profit.

The forest covering these venerable ridges and valleys is a global hotspot of biological diversity. An estimated 800,000 acres of that forest have already been destroyed—and more than 470 mountains sheared off—by surface-mining operations. Sometimes hundreds of feet of elevation are lost as a mountain's original contour is blasted away. The topsoil, foundation of the landscape's exceptional diversity of life, is wasted. Broad, plateau-like mesas remain. Federal law does not require formerly forested mine sites to be reforested during "reclamation." Even when operators meet their legal obligations to reclaim mined areas, the result is a biological wasteland compared to the native forest—generally a thin, green sheen of exotic grass growing on compacted rubble. The return of a vibrant, ecologically healthy natural community that approaches its former richness is a distant dream.

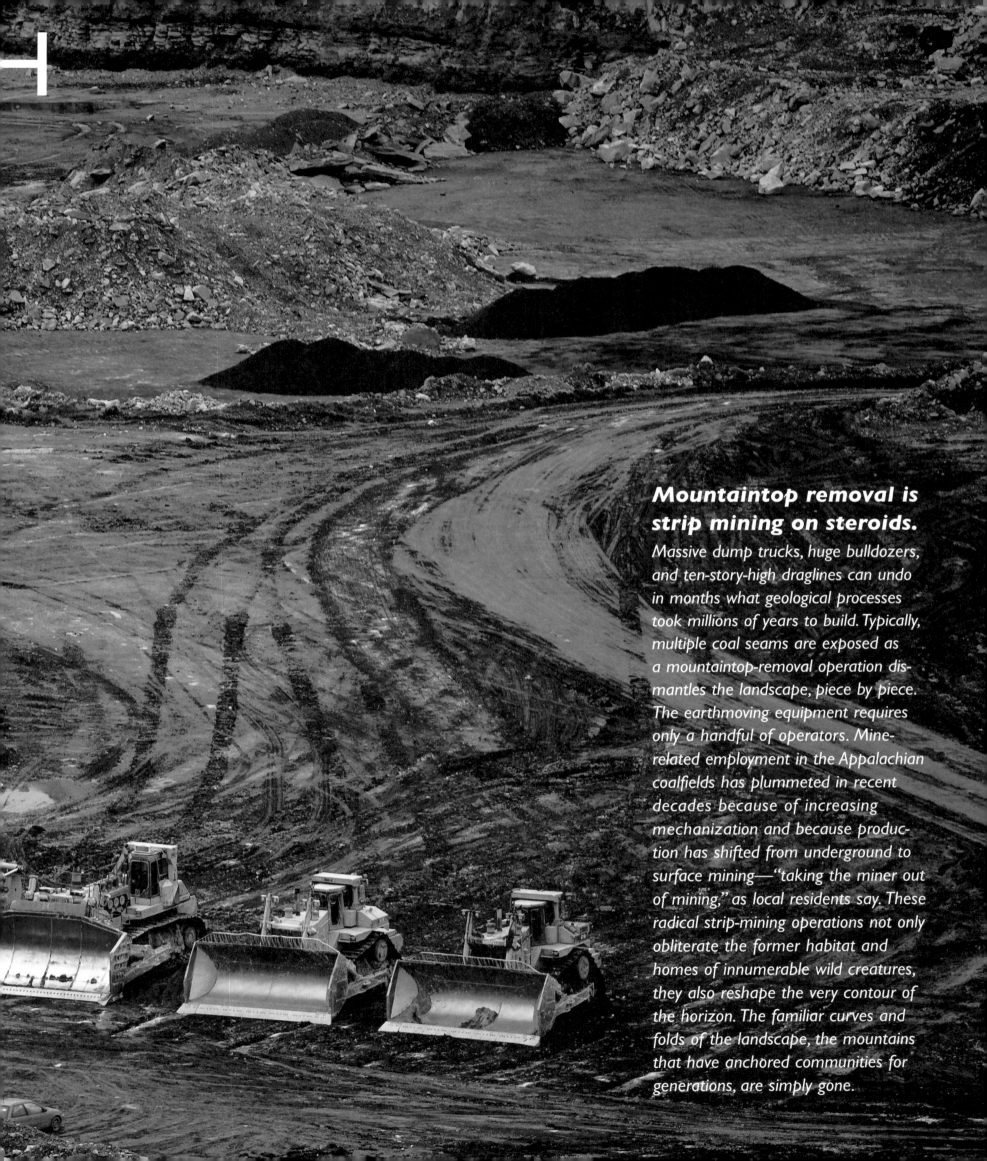

Mountaintop removal is strip mining on steroids.
Massive dump trucks, huge bulldozers, and ten-story-high draglines can undo in months what geological processes took millions of years to build. Typically, multiple coal seams are exposed as a mountaintop-removal operation dismantles the landscape, piece by piece. The earthmoving equipment requires only a handful of operators. Mine-related employment in the Appalachian coalfields has plummeted in recent decades because of increasing mechanization and because production has shifted from underground to surface mining—"taking the miner out of mining," as local residents say. These radical strip-mining operations not only obliterate the former habitat and homes of innumerable wild creatures, they also reshape the very contour of the horizon. The familiar curves and folds of the landscape, the mountains that have anchored communities for generations, are simply gone.

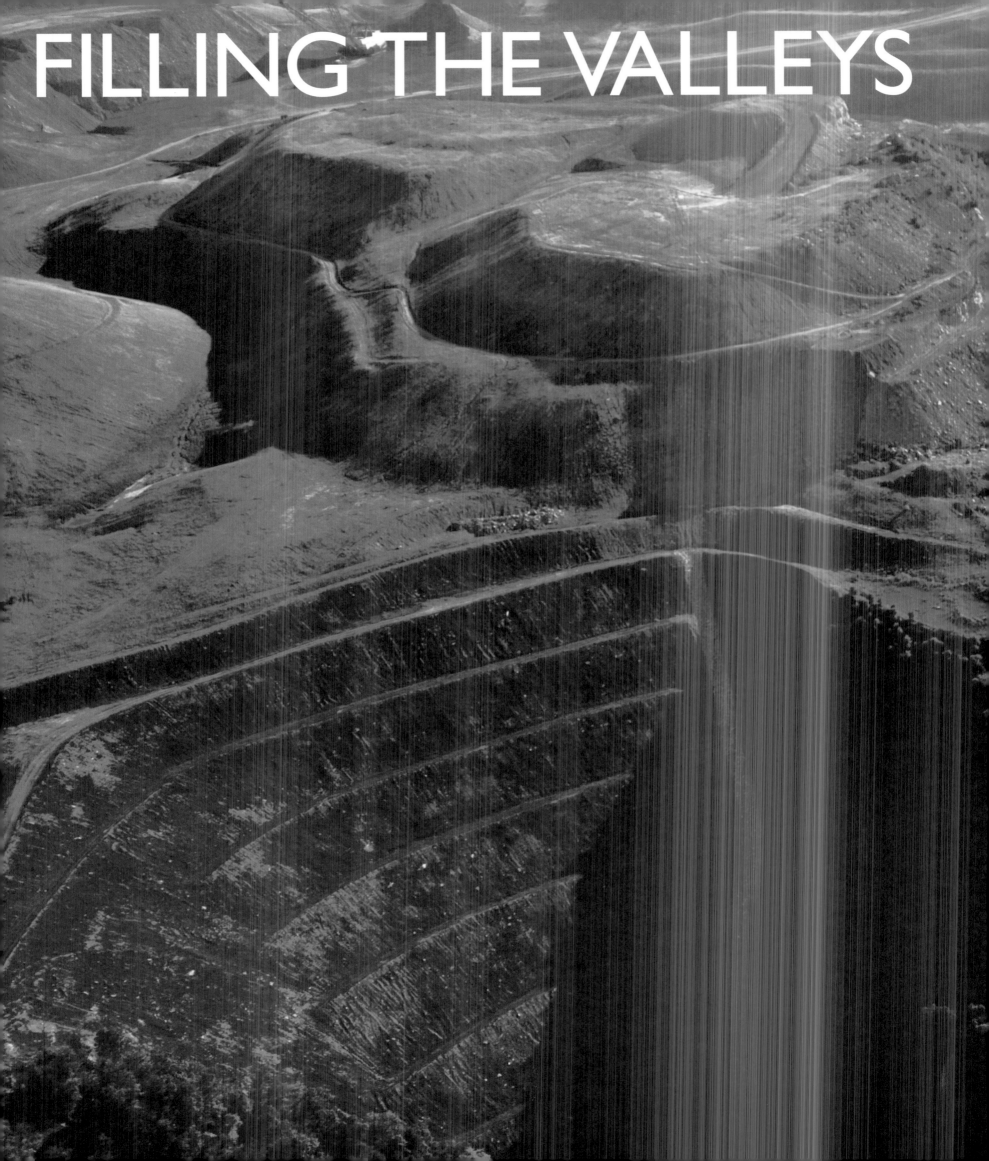

FILLING THE VALLEYS

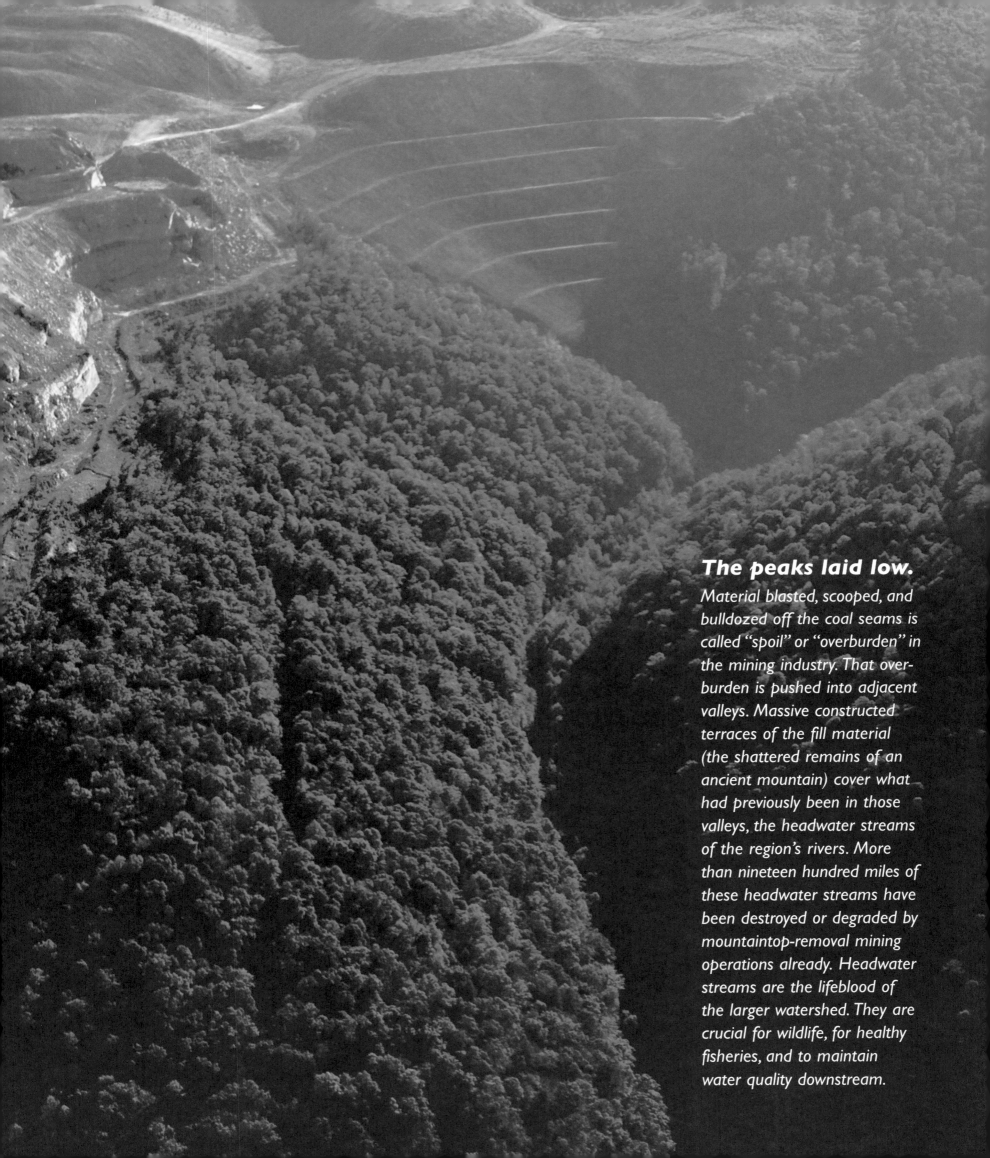

The peaks laid low.

Material blasted, scooped, and bulldozed off the coal seams is called "spoil" or "overburden" in the mining industry. That over-burden is pushed into adjacent valleys. Massive constructed terraces of the fill material (the shattered remains of an ancient mountain) cover what had previously been in those valleys, the headwater streams of the region's rivers. More than nineteen hundred miles of these headwater streams have been destroyed or degraded by mountaintop-removal mining operations already. Headwater streams are the lifeblood of the larger watershed. They are crucial for wildlife, for healthy fisheries, and to maintain water quality downstream.

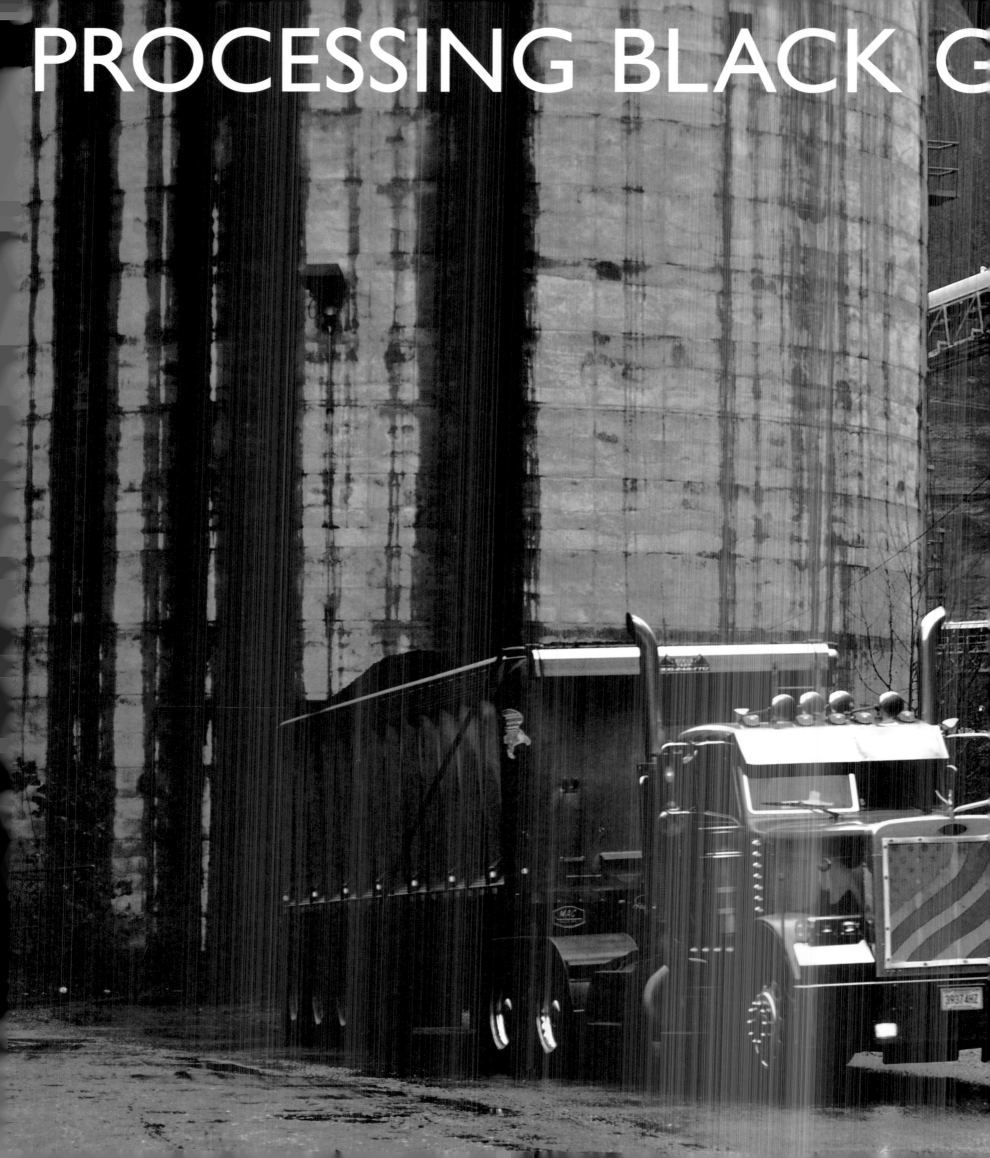

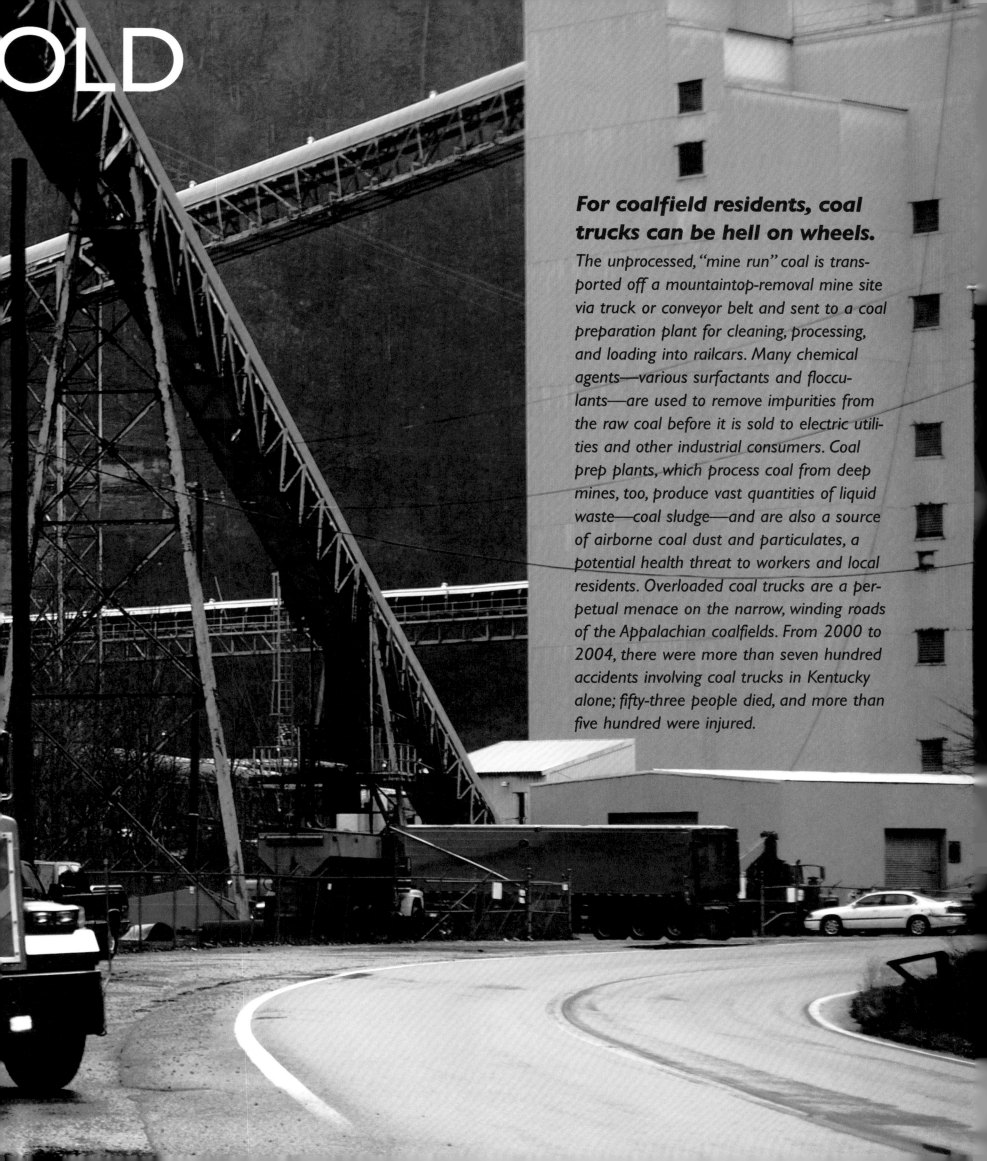

OLD

For coalfield residents, coal trucks can be hell on wheels.

The unprocessed, "mine run" coal is transported off a mountaintop-removal mine site via truck or conveyor belt and sent to a coal preparation plant for cleaning, processing, and loading into railcars. Many chemical agents—various surfactants and flocculants—are used to remove impurities from the raw coal before it is sold to electric utilities and other industrial consumers. Coal prep plants, which process coal from deep mines, too, produce vast quantities of liquid waste—coal sludge—and are also a source of airborne coal dust and particulates, a potential health threat to workers and local residents. Overloaded coal trucks are a perpetual menace on the narrow, winding roads of the Appalachian coalfields. From 2000 to 2004, there were more than seven hundred accidents involving coal trucks in Kentucky alone; fifty-three people died, and more than five hundred were injured.

STORING SLUDGE

Big coal cooks up a toxic soup. *After the coal is washed, a slurry of impurities, coal dust, and chemical agents used in the process remains. This liquid waste, called "coal sludge" or "slurry," is often injected into abandoned underground mines, a practice that can lead to groundwater contamination. In one case affecting the citizens of Pike County, Kentucky, the U.S. Environmental Protection Agency determined that coal slurry being dumped into a former deep mine by the Eastern Coal Corporation contained contaminants "which were likely to enter a public water supply…and may present an imminent and substantial endangerment to human health." In public hearings, many coalfield residents have attributed their health problems to water wells polluted after the coal mining industry "disposes" its liquid waste by injecting coal slurry underground.*

The primary disposal practice for coal slurry is to store it in vast unlined lagoons or surface impoundments created near mountaintop-removal mines. Hundreds of these slurry impoundments are scattered across the Appalachian coalfields. Individual impoundments have been permitted to store billions of gallons of waste. Occasionally the dams fail, and the result is a tragic loss of life and environmental catastrophe (see Lakes of Waste, p. 105). In 2000 a slurry impoundment operated by the Martin County Coal Company in Kentucky broke through into abandoned mineworks, out old mine portals, and into tributary streams of the Big Sandy River. More than 300 million gallons of coal slurry fouled the waterway for a hundred miles downriver. The massive spill prompted Congress to commission a National Academy of Sciences report on coal-waste impoundments.

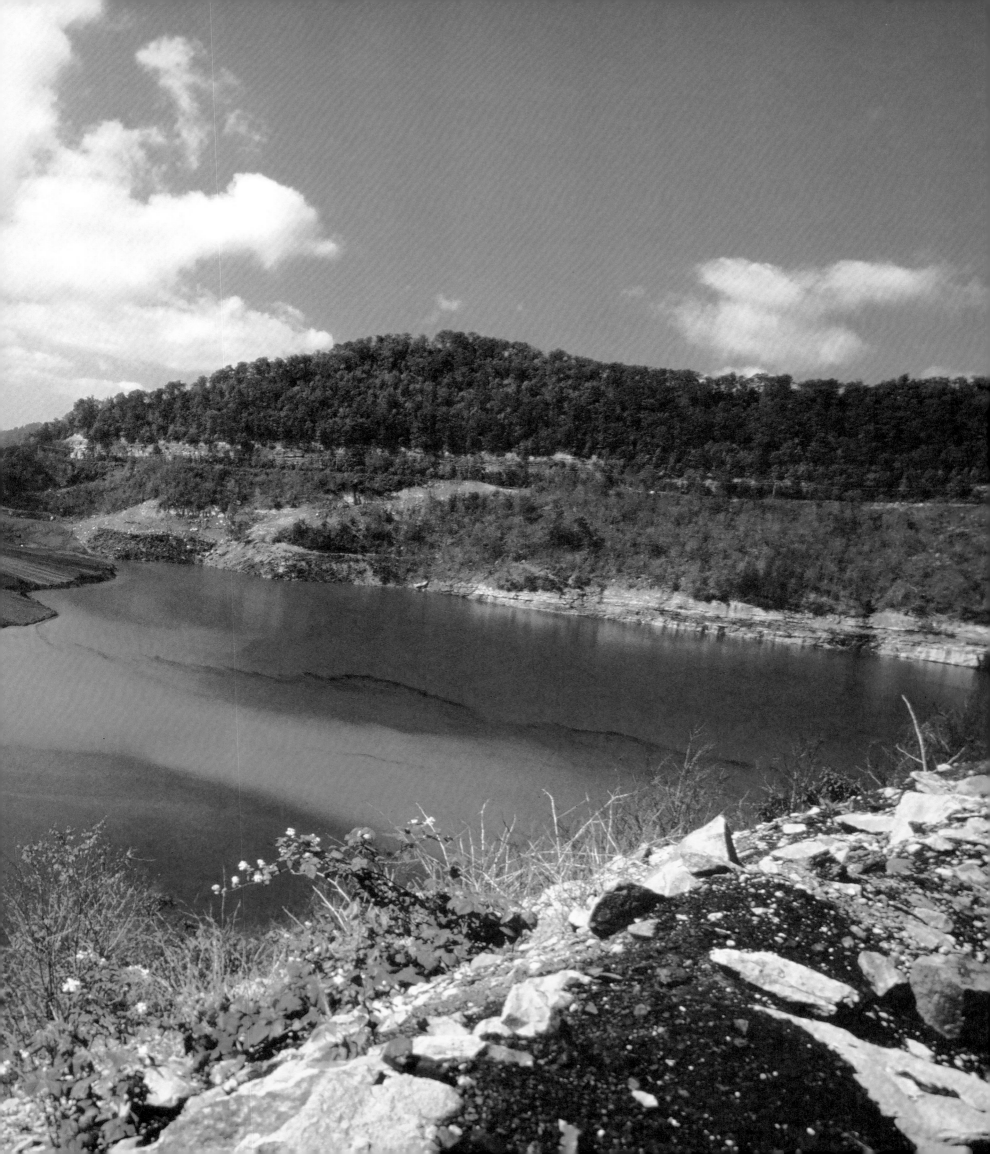

EXPORTING THE RICH

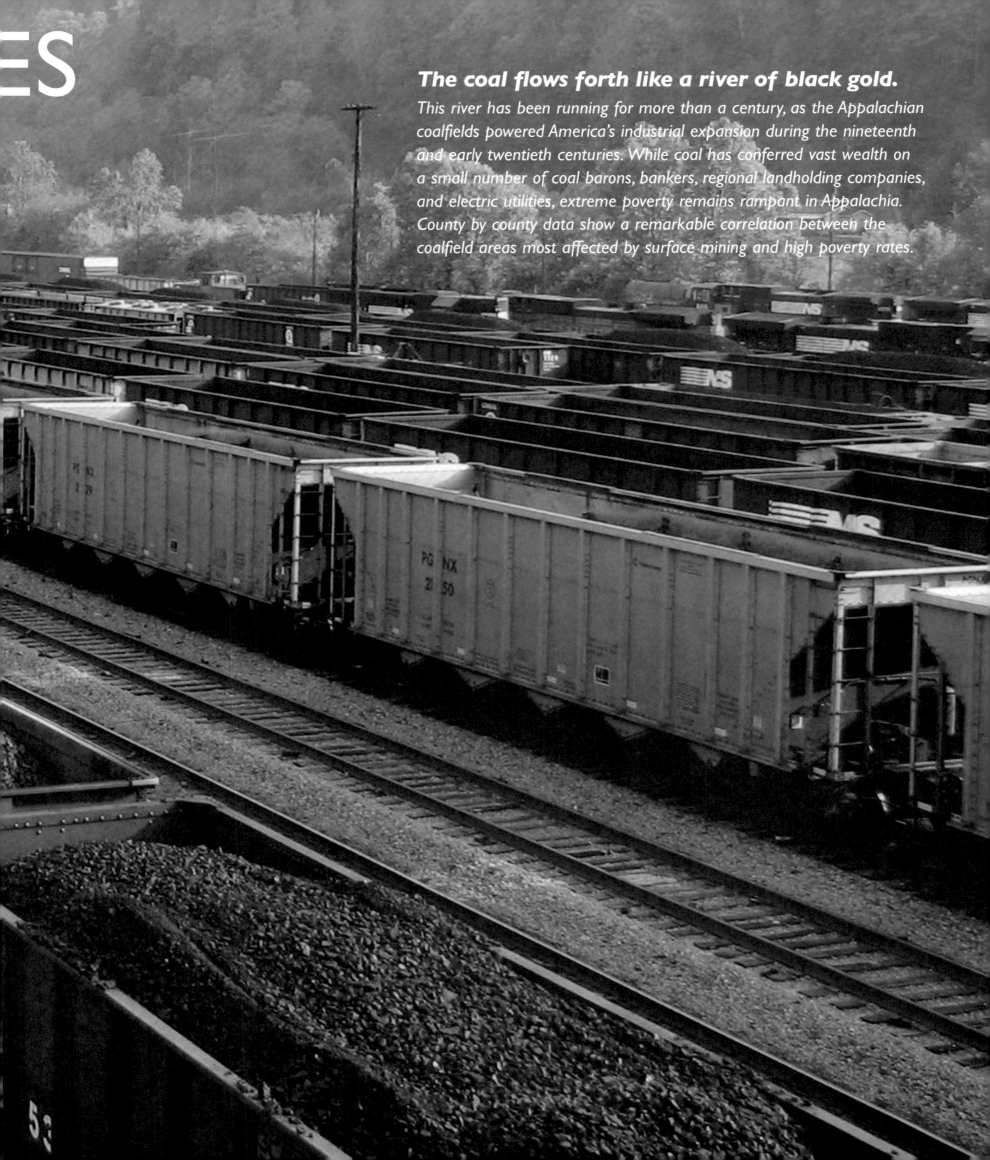

The coal flows forth like a river of black gold.

This river has been running for more than a century, as the Appalachian coalfields powered America's industrial expansion during the nineteenth and early twentieth centuries. While coal has conferred vast wealth on a small number of coal barons, bankers, regional landholding companies, and electric utilities, extreme poverty remains rampant in Appalachia. County by county data show a remarkable correlation between the coalfield areas most affected by surface mining and high poverty rates.

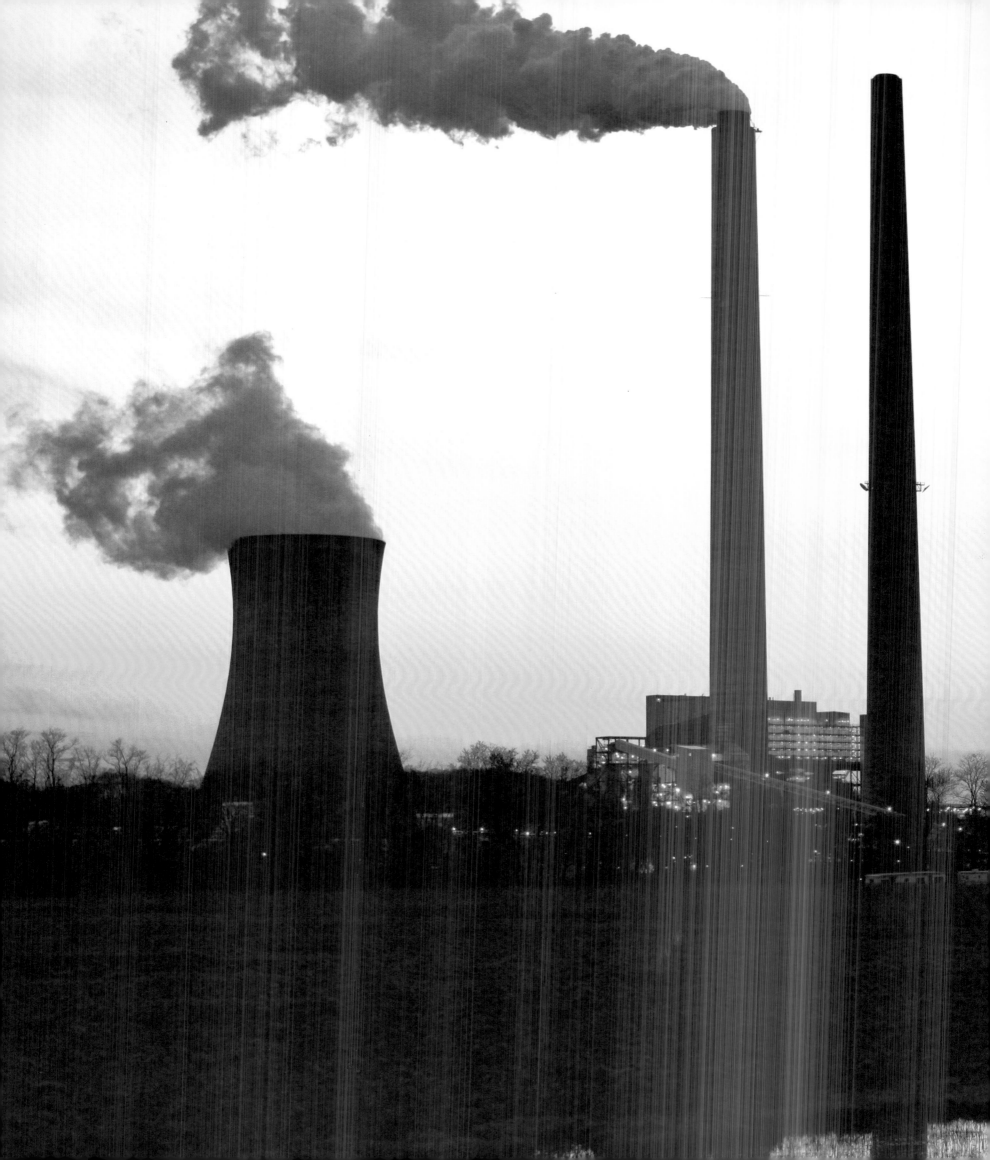

FOULING THE SKIES

A *powerful* source of pollution. *Coal-burning power plants generate roughly half the electricity produced in the United States. These plants, many of them old and without adequate pollution-control technology, are the major industrial source of air pollution, which causes needless suffering among hundreds of thousands of Americans with asthma, respiratory diseases, and heart conditions. Fine-particle pollution from power plants is estimated to cause twenty-two thousand premature, avoidable deaths among U.S. citizens every year and tens of thousands of nonfatal heart attacks.*

Coal-burning power plants are also the single largest factor in America's contribution to global warming. According to government data, they annually emit more carbon dioxide (the key greenhouse gas linked to global climate change), than the entire U.S. transportation sector.

DUMPING THE ASH

Not in my backyard. *Coal-combustion ash, the waste product left over after coal is burned in power plants or other industrial applications, actually ends up in everybody's backyard—the Earth's air and water—not just the backyards of people unfortunate enough to live next door to an ash dump. Coal-combustion waste typically contains arsenic, mercury, chromium, cadmium, and various other pollutants, but its disposal is unregulated under federal law, having been exempted by Congress in 1980 from hazardous waste rules. State rules governing coal-combustion-waste disposal are inconsistent; some states have minimal or no regulations in place. The waste can be dumped in unlined landfills and ponds, above ground in great heaps, or in active and abandoned mines. Rain and groundwater leaching through this waste has caused significant groundwater contamination at ash dumps around the country, and at least two federal Superfund sites are associated with coal-combustion waste.*

Ironically, as federal clean air legislation has prompted better capture of pollutants at the smokestack, the federally unregulated solid waste stream from power plant scrubbers and boilers has grown increasingly toxic. A risk assessment report commissioned by the federal EPA concluded that "current management of coal combustion waste in landfills and surface impoundments results in significant risk to human health and the environment."

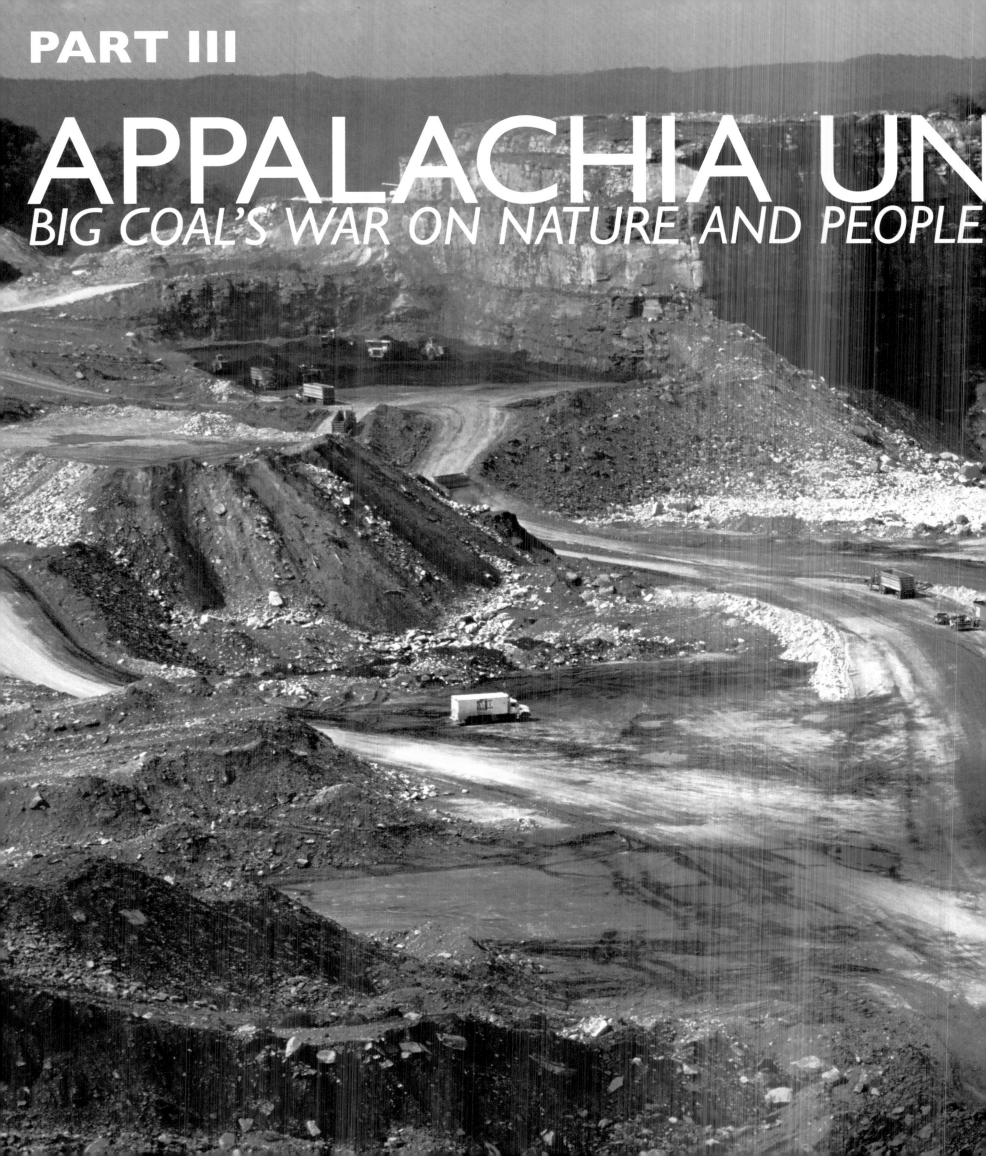

PART III

APPALACHIA UN
BIG COAL'S WAR ON NATURE AND PEOPLE

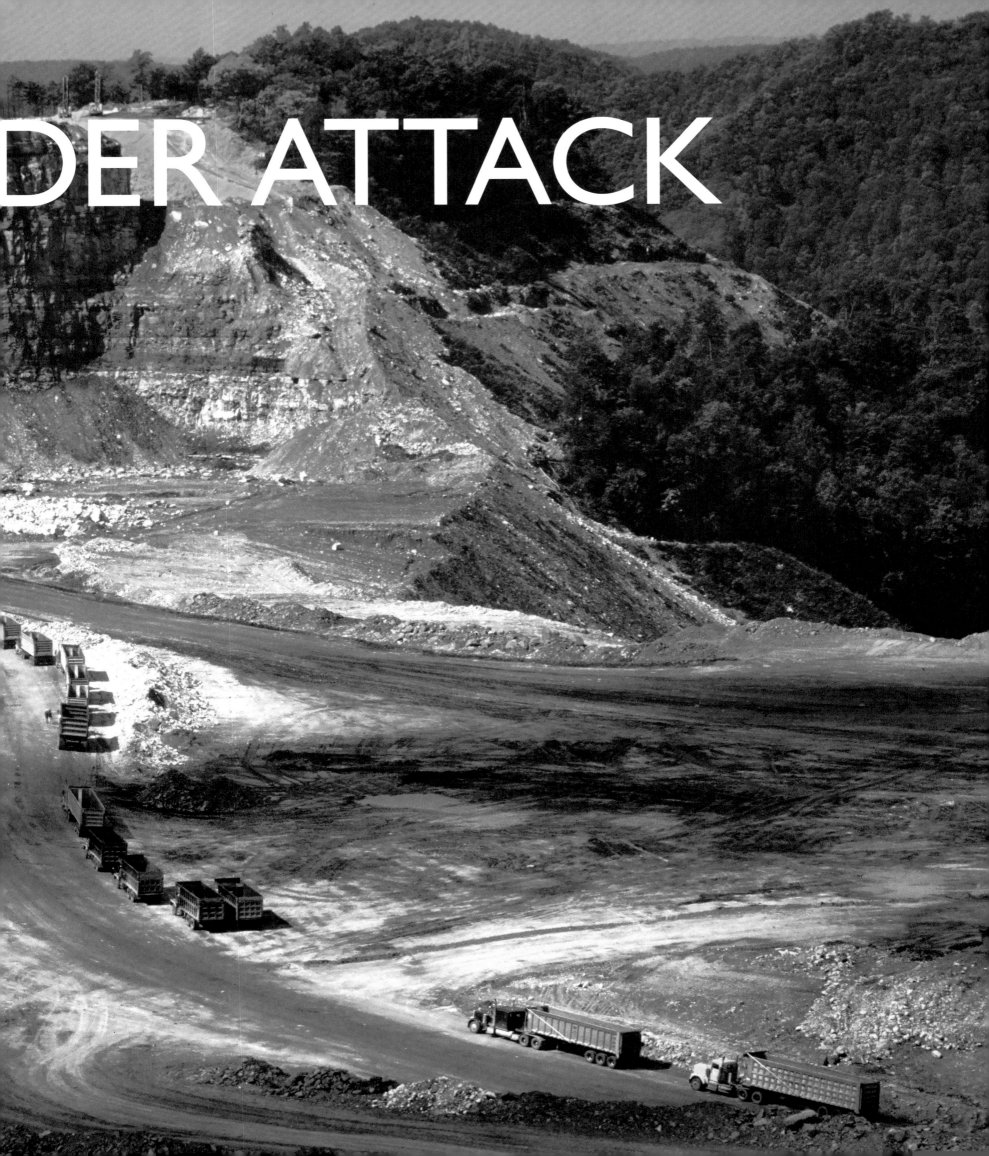

DER ATTACK

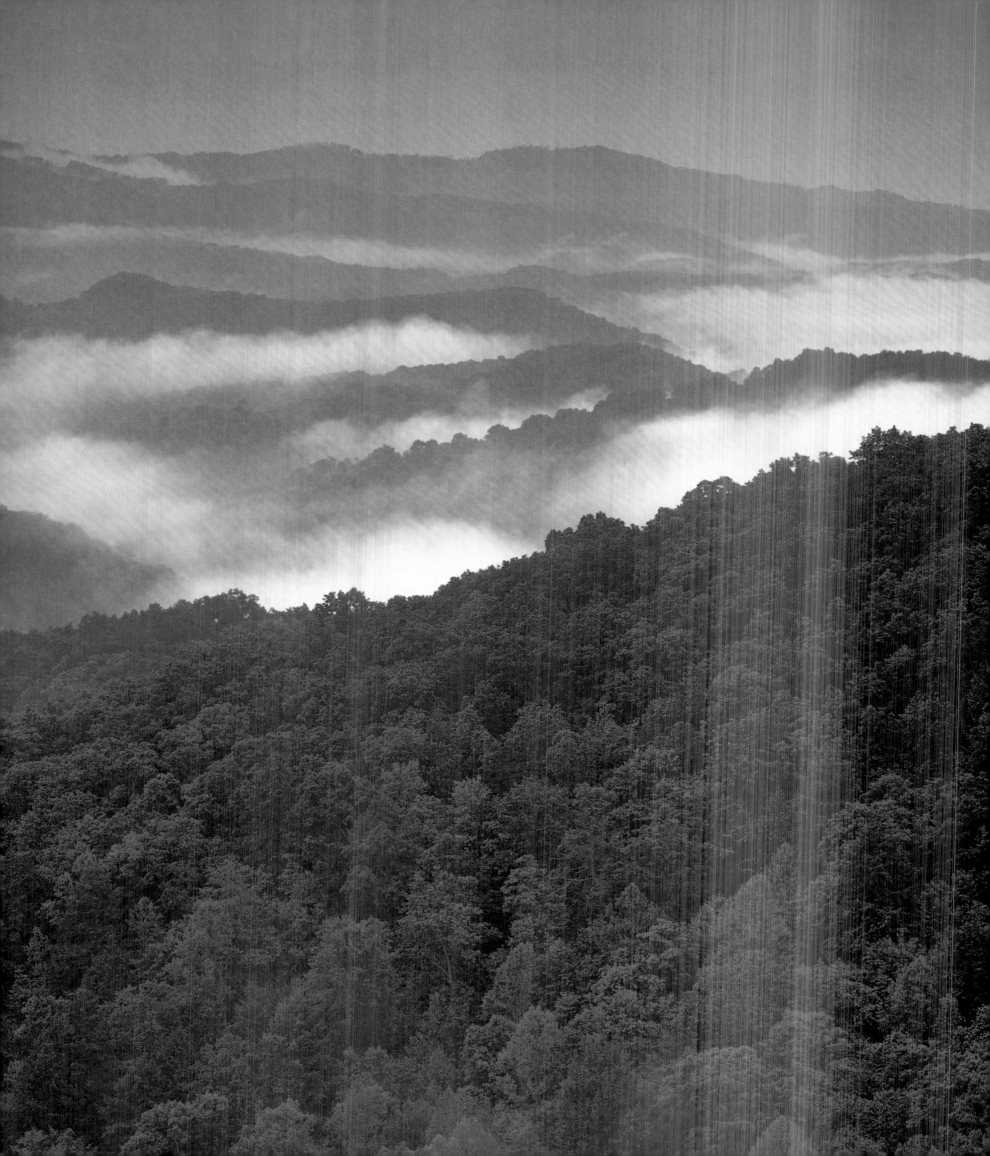

APPALACHIA IMPERILED

Fighting Back to Save the Land and People

MARY ANNE HITT

The quickest, most surefire way I know to get your heart ripped out is to take a flight in a small airplane over the coalfields of Appalachia. I have seen a wide range of people step onto the tarmac after one of those flights—reporters, celebrities, scientists, and veteran environmental activists who thought they had seen it all. Often they are speechless, sometimes with tears in their eyes. Perhaps the most pained reactions are those of local people who suddenly realize that the landscape that has enfolded their families and communities for generations is being torn away, disappearing into thin air.

And what have they seen? In our era of Hurricane Katrina and melting ice sheets, of wars and genocide, what could be so shocking? Welcome to mountaintop-removal country.

Across four Appalachian states—Kentucky, West Virginia, Virginia, and my home state of Tennessee—surface-mining operations have blown up more than 470 mountaintops, wiped them off the face of the Earth forever, to find the seams of coal that lie within. Coal companies have buried more than one thousand miles of streams by shoveling the remaining rock over the sides of the mountains and into the hollows below.

Those airplane passengers returning from an aerial view of the Appalachian coalfields have witnessed the ongoing obliteration of one of the most lush and diverse temperate forest ecosystems on the planet, renowned for its unparalleled number of freshwater aquatic species. They have seen one of the greatest assaults on clean water anywhere on Earth. They have sensed the clear and immediate danger to families that live beneath the mine sites.

They have also witnessed the theft of our national patrimony—the disfiguring of the oldest mountain range in North America, the wilderness that birthed our American democracy. During the last ice age, the Appalachian Mountains provided a refuge for northern species retreating from the glaciers, which is why the region's high-elevation ridges are still home to the type of spruce-fir forest typical of Canada, while tropical species of orchids live in the valleys. These are the Mother Mountains. They have protected North America's plants and animals for millions of years, providing a refuge from which those species could later repopulate our great continent when more hospitable times returned.

Now these ancient ridges are being blown up, in the relentless pursuit of energy. And mountains don't grow back.

THE PLACES BEING DESTROYED by radical surface mining in Appalachia are not just abstractions. These are places like the Clinch River, home to more aquatic biodiversity than almost any other river on Earth, which is slowly choking to death on mining-related sediment. Adding insult to injury, in December 2008 a massive spill of coal ash (the waste left behind when coal is burned) occurred at the confluence of the Emory and Clinch Rivers in Tennessee when a dam holding back a waste lagoon failed at a Tennessee Valley Authority (TVA) power plant. Government officials estimated that one billion gallons of coal waste were released, a hundred times the volume of the Exxon Valdez oil spill, and initial reports showed very high levels of toxic heavy metal pollution released into the watershed.

These are places like Marsh Fork Elementary School in West Virginia, where the children attend classes in a building adjacent to a processing facility that spews coal dust onto the playground, beneath an earthen dam holding back billions of gallons of toxic coal sludge, and surrounded on three sides by rapidly growing mountaintop-removal operations.

These are places like Martin County, Kentucky, where a coal-sludge impoundment failed in 2000, sending three hundred million gallons of thick, tarry coal waste into the Big Sandy River. Some government officials described the spill as probably the worst environmental disaster in the history of the Southeast—but that was before the coal-combustion-waste spill at the TVA coal plant in Tennessee.

This wholesale devastation takes an unfathomable toll on the people who live in the shadows of the mines. In one West Virginia community, Larry Gibson noticed heavy bulldozing activity from surface-mining operations right next to a family cemetery. He rushed to report the trespass to local officials, and they responded by blocking the access of family members to the graveyard. As bulldozers continued to chug along, he stood angry and helpless behind a police barricade, terrified that the bones of his ancestors were being shoveled into the rubble.

In Mingo County, West Virginia, Donetta Blankenship and her family were sick, and getting sicker. She believed the source of the problem was the brown water coming out of her tap. As described at a state legislative hearing in 2006, coal companies had injected billions of gallons of coal sludge, a thick toxic goo left behind after coal is processed, into abandoned underground mines nearby. Local residents were convinced that their water wells were being contaminated, and many suffered poor health. Donetta worked hard—organizing, testifying at government hearings, and even traveling outside of West Virginia for the first time to speak at a United Nations meeting on sustainable development—to help bring treated water to her area. But dozens of other communities across Appalachia are dealing with the same threat and do not have any municipal water supply.

Across the state border, just outside the small community of Appalachia, Virginia, one family suffered the unthinkable. In the middle of the night, toddler Jeremy Davidson was crushed in his bed and killed by a boulder that was knocked down the mountainside from a road leading to a ridgetop surface mine by a bulldozer operating without the proper permits. The A&G Coal Corporation was cited for negligence and fined fifteen thousand dollars; it appealed the fine.

In nearby eastern Kentucky, Damon Morgan, now in his eighties, has watched as surface-mining operations have scalped Huckleberry Ridge in Leslie County. He describes how nearby blasting has caused damage to two homes on his property and vows to keep fighting the two coal companies that have damaged his beloved land.

Stories like these are repeated over and over across Appalachia, the stories of people who have paid with their health, homes, and lives to line the pockets of a few coal-company owners and shareholders, most of whom live a safe distance from the coalfields of Appalachia. Coalfield residents are generally resilient, patriotic people who don't complain about hard work or sacrifice. But after decades of losing husbands and brothers to black lung disease, losing fishing holes and hunting grounds to pollution and locked security gates, mountaintop removal has proven to be the last straw. A homegrown resistance movement to radical surface mining is gaining strength among the hills and hollows of the region.

THE TRAGEDY of mountaintop-removal mining in Appalachia has been largely hidden from the American public, not only because it is happening in a part of the country that is predominantly poor, but also because it is difficult and rare to see mountaintop removal from the road. The site of one mountaintop-removal operation is stunning enough, but when viewed from the air, the real shock is the extent of the devastation, the sight of mine after mine stretching to the horizon. In a 2006 article in *Vanity Fair*, Michael Shnayerson called it "one of the greatest acts of physical destruction this country has ever wreaked upon itself."

This destruction has given rise to a powerful, growing movement comprised of citizen-led groups from across Appalachia. Coal miners and waitresses have combined forces with environmental advocates and attorneys to stop the devastation. The Alliance for Appalachia is a coalition of a dozen grassroots organizations working together to abolish mountaintop removal and build a just, sustainable future for the region.

These organizations have gone to court to demand the enforcement of laws designed to protect people and the environment from such blatant abuse. They have taken their story to the media and into the streets. They are working to close loopholes by passing new laws. Bills that would stop or slow mountaintop removal have been introduced in the Kentucky, West Virginia, North Carolina, Virginia, and Tennessee state legislatures. Thousands of people from across the United States are working together to advance a bill in the U.S. Congress called the Clean Water Protection Act, which would restore the original intent of the Clean Water Act and would prevent the dumping of mining waste into streams, dramatically curtailing mountaintop removal.

One of the most daunting challenges has been communicating the scale of the destruction to people who will never visit Appalachia or fly over the coalfields. In 2006 Appalachian grassroots organizations created the National Memorial for the Mountains, which uses Google Earth to show the locations and tell the stories of the 474 mountains (and counting) that have been lost. This interactive, online memorial is the centerpiece of iLoveMountains.org, a collaborative project by organizations from across Appalachia.

The next step was to show Americans their personal connection to mountaintop removal—because people in West Virginia and Kentucky are clearly not using all the coal stripped from their shattered mountains. A tool on iLoveMountains.org called "What's My Connection?" allows anyone in the country to enter their zip code and see the direct links from mountaintop-removal mines to electric utilities and power plants providing electricity to their homes. Using Google Earth and Google Maps, anyone can virtually fly through the ravaged coalfields of central Appalachia and see for themselves the mountains and communities that have been sacrificed on the other side of their light switch.

ULTIMATELY, this is not just an Appalachian problem. This is a national problem, caused by our appetite for coal, and it will require a national solution. We stand at an energy crossroads. There are roughly five hundred coal-burning power plants in the United States, and approximately one hundred new plants proposed to be built across the country. Air pollution from power plants has been estimated to cause some 22,000 premature deaths nationwide, in addition to 38,000 nonfatal heart attacks, and more than 550,000 asthma attacks.

These plants are also responsible for two billion tons of carbon dioxide emissions annually, making them the nation's single largest source of global warming pollution. Experts and scientists, including Al Gore and NASA's James Hansen, are calling for a moratorium on new coal plants as an essential step to preventing a climate crisis.

The coal industry and the utilities are promising a new generation of kinder, gentler "clean coal" plants that will reduce emissions. The industry also holds out the promise of someday capturing and burying carbon dioxide under the ground, rather than sending it up smokestacks to warm the planet. But industry, government, and university reports suggest that it will take a decade or two just to determine whether or not carbon-sequestration technology can be developed on a commercial scale, to say nothing of the additional decades it might take to put this massive new infrastructure in place. In those decades, the fate of the climate will likely be decided, and billions of dollars that the nation could have invested in building a truly green energy economy will instead have been frittered away on a "clean coal" boondoggle.

People from the coalfields have heard these types of assurances before—lots of them. The history of the coal industry in Appalachia is a century-long litany of broken promises and blatant disregard for the law, and the "clean coal" story sounds suspiciously like the soothing stories of the past, a perfect candidate for the next broken promise.

One of the leading industry groups promoting "clean coal" was formerly called Americans for Balanced Energy Choices. Their use of the word *balanced* is a bitter irony for those forced to watch the plunder of Appalachia, day after day. There is nothing balanced about blowing up beautiful ancient mountains, fragmenting the forest, poisoning a vast freshwater resource, destroying wildlife habitat, forever erasing part of our national heritage, and making a large swath of North America increasingly uninhabitable for local people, all in a few short decades. The industry group has changed its name, and it is now called the American Coalition for Clean Coal Electricity. Well, there is nothing clean about it, either.

TWO OF THE PLACES that we Americans go most often on vacation to recharge and renew ourselves are the mountains and the seaside. Millions of American families escape there to play, rest, reconnect with one another, and temporarily evade the demands of everyday life. I believe we return to the mountains and the ocean year after year because they give us a sense of permanence, a touchstone in a world that seems to change faster and faster all the time. We perceive the oceans and mountains as timeless and steadfast, unchanging, no matter what calamitous upheaval might befall us.

So what does it do to a nation and its psyche when we start blasting apart and hauling away the very mountains themselves? What does that say about the type of civilization we have become? What, indeed, are we are leaving behind for our children? In this case, simply nothing. Where once there were mountains, they will find air. Below the sheared-off ridges they will find a scarred and polluted landscape that is toxic to life, where storefronts are empty, the water is too polluted to drink, the fish are unsafe to eat, the hunting is poor, and mountain music no longer echoes from front porches.

We can choose a different path for Appalachia. We still have time to create a future where we honor the region's rich culture and biodiversity, where visitors revel in the stunning mountain vistas and whitewater rivers, where workers proudly continue a long tradition of contributing to America's energy security by building windmills and solar panels. Just like people everywhere else in the world, the people of Appalachia want clean water and lush forests and communities that can support their children and grandchildren. But they cannot bring about that future alone. All Americans are complicit in the plunder of Appalachia, and only by working together will we be able to save our national heritage, our purple mountains' majesty, the land and people of Appalachia.

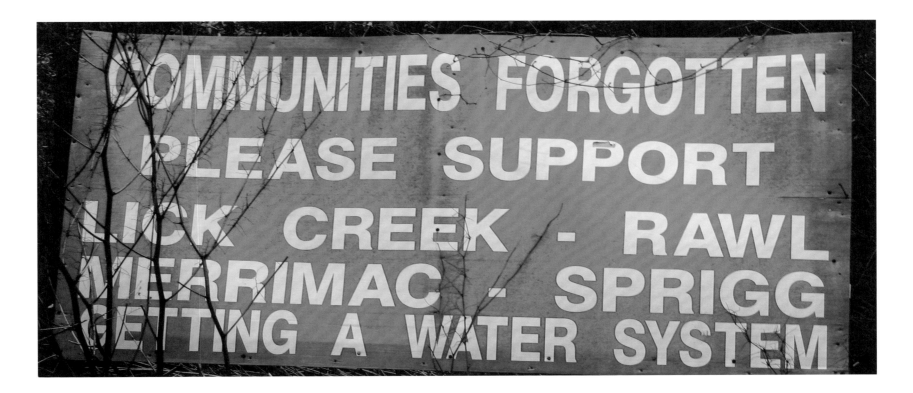

COAL
Keeps The Lights On!

MASSEY ENERGY
2005
YEAR OF INTEGRITY
S-1 P-2 M-3

COAL

Walker **CAT**

CLEANER GREENER
Power for the people and protection for the environment.

KVA

THE POWER TO MOVE PERCEPTIONS

Orwellian Language in the Land of Coal

ERIK REECE

There is no better place to understand the semiology of a strip mine than at Goose Pond, a five-acre "reclamation" area that sits in the middle of a massive mountaintop-removal project called the Starfire Mine in Breathitt County, Kentucky. One might begin, literally, at the top, with the term *overburden*. What is burdened in this case is the coal seam down below; overburden is the oak-pine forest, the topsoil, and the two hundred feet of sandstone that stand between the coal operator and the coal seam. Of course, to whom this forest is a burden depends largely on who profits from extracting the coal. When the overburden is dislodged, it becomes *spoil*. And since a 2002 Bush administration rule change freeing coal operators from the pesky provision in the Clean Water Act that prohibits "waste" from being dumped into the nation's waterways, the spoil that is pushed into the valleys below is no longer waste, but "fill." Streams are not buried; rather, valleys are filled.

Reclamation, however, is the term that finally puts us squarely in the realm of Orwellian slipknots. Speaking plainly, to reclaim something is to get it back. The 1977 Surface Mining Control and Reclamation Act (SMCRA) requires coal operators to restore the "approximate original contour" (AOC) of the land they have mined. According to the Kentucky Department of Natural Resources, "The condition of the land after the mining process must be equal to or better than the pre-mining conditions." Scanning the reclaimed portions of the Starfire Mine site, I can see hundreds of acres of rolling savanna, planted with lespedeza, a legume imported from Asia, one of the few plants that will survive in this shale. But in what sense does a savanna "approximate" a summit? In what sense is an exotic grassland monoculture "equal to or better than" the native, mixed mesophytic forest? The reality is that mountains pitched at a grade as steep as that of the Appalachians cannot be restored.

Perhaps sensing that the AOC stipulation would be a hard sell, lawmakers added this provision to SMCRA: Coal operators could obtain an "AOC variance" if they could prove the postmined land would be put to "higher or better uses." In the beginning, that meant commercial or residential development. A few housing complexes and even a prison were built on these sites. But there wasn't nearly enough developers clamoring to fill these barren flats with strip malls or apartments. And anyway, it was much cheaper to plant grass on an abandoned mine site and call it a "pasture."

That is what happened at Goose Pond, a five-acre pond surrounded by fescue and crown vetch. Rock islands dot the still water and hardscrabble locust trees cling to the cobble. Above the pond stands a small wooden observation deck, replete with two mounted viewing stations like those you find at Niagara Falls. Looking only through these binoculars, one might indeed be fooled into thinking that this is some kind of wildlife sanctuary. A couple of swans are even gliding around the pond. But back away two steps and you will see a behemoth blue crane sitting in a deep pit behind the pond, swinging back and forth like the fin of a mechanical shark. Attached to the crane is a dragline that rakes a house-sized maw across the coal seam, scooping up a hundred tons of rock at a time. Down inside the pit sits an explosives truck. Its tank reads THE POWER TO MOVE MOUNTAINS. Coal trucks rumble past on all sides of the pond. Highwalls frame the horizon. But none of that matters. A coal company has only to erect the flimsy trappings of a tourist stop and they have converted a wasteland into a "public use."

The large sign that stands next to the observation deck is covered with pictures of pink lady's slipper, large-leaf magnolia, ruffed grouse, painted trillium, spotted salamander, and a wood rat. It reads, "These are some of the other wildlife and plant species you may encounter during your visit." The word *other* adds a particular absurdity to what is already an outrageous lie. Wandering the forest below this mine, I have been lucky enough to see each of the flora and fauna pictured on this sign. But one is about as likely to find ruffed grouse or painted trillium on Wall Street as to find them up here on these hundreds of deserted acres. All the species pictured are inhabitants of a deciduous forest, the likes of which this place won't be able to sustain for another thousand years.

DIVERSITY AT RISK

The Appalachian landscape is one of the most biologically diverse in the temperate world. There are more species of trees found in some Appalachian hardwood forests than in all of northern Europe! Some 255 species of birds, 78 mammal species, 58 reptile species, and 76 amphibian species are known to inhabit the region. Of the 55 species of salamanders recorded in Appalachia, 21 are endemic, occurring nowhere else.

Geology is one key reason for this astounding diversity. Sandstone, limestone, and shale substrates provide a diversity of soil types and resulting plant variety. These soil differences combined with topographical relief (which allows for southern species to penetrate northward at the lowest elevations, while permitting northern species to survive at the highest elevations farther south) contribute to the high species diversity. Thus one may find a southern species like the tulip poplar growing in a valley bottom and a red spruce more typical of northern New England cloaking the highest peaks nearby.

Moreover, the entire region was missed by ice age glaciers, which scraped away forests farther north. This has given the region's plant and animal species a much longer period for evolution and the creation of numerous endemic species. All of this is nurtured by high annual precipitation, more or less evenly distributed throughout the year.

The regional biodiversity is not limited to the forested uplands, however. Appalachia's waterways are a treasure trove of rare species. Because the region's rivers all flow southward to the Gulf of Mexico instead of north, they remained a refuge for many aquatic species during past glacial periods. There are as many as 290 fish species in Tennessee's rivers alone—more than in all of Europe. And the diversity of crayfish, freshwater mussels, and snails is equally extraordinary.

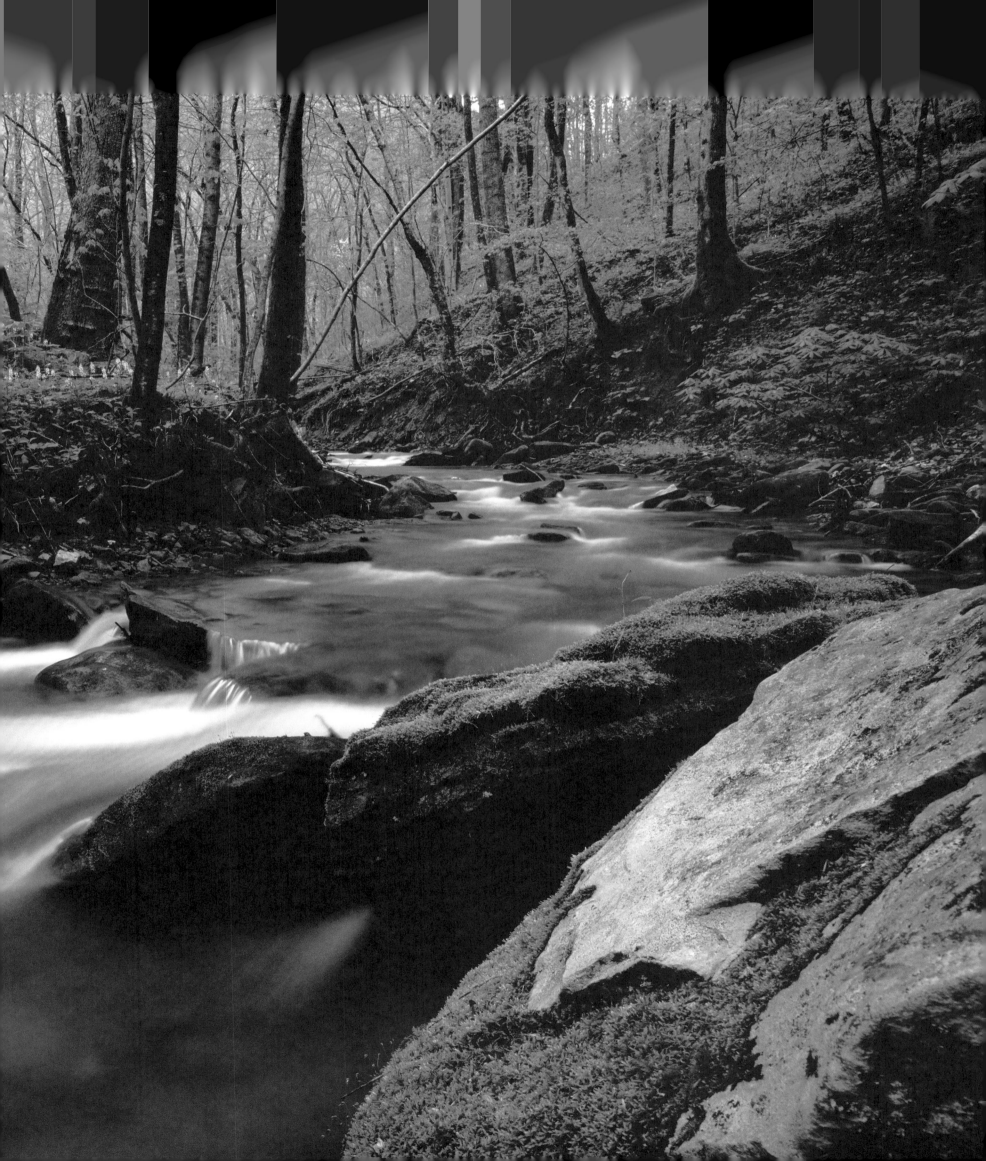

In the Appalachian region's distinctive hardwood cove forests—characterized by bowl-like topography and rich, moist soils—as many as forty species of trees may be found growing in a single stand. An extraordinary understory array of shrubs, ferns, flowers, fungi, and lichens complements the tree diversity. This globally significant natural community is threatened by mountaintop removal. Surface mining obliterates the vegetative cover. Sometimes the forest is clear-cut and the wood used, but often the trees are just bulldozed into a heap and burned. One estimate suggests that a million acres of West Virginia's forests have been destroyed by strip mining for coal between 1939 and 2005, with the most rapid deforestation occurring in the past two decades as mountaintop-removal mining increased.

One casualty of this forest loss is the cerulean warbler, a species that the U.S. Fish and Wildlife Service notes is declining at "precipitous rates," a reason the bird was a candidate for listing under the Endangered Species Act. According to a report published by the Environmental Protection Agency, "a high proportion of this species' population occurs in forested areas of southern West Virginia, where it may be threatened by loss and degradation of forested habitat from mountaintop mining/valley fills."

This deforestation compounds the ecological wounds suffered by the region's forests in earlier decades, when widespread logging left few tracts of old growth. In all of West Virginia, only two known virgin forest tracts are larger than fifty acres. Mountaintop mining, however, is even more devastating than past logging practices because topsoil is lost, and compaction of mine rubble on the surface makes reforestation difficult. (Mining companies typically plant nonnative grasses as part of their "reclamation" obligations under the law.) The extraordinary biodiversity of the native forest is lost, downslope areas are subject to greater flooding, and a huge carbon sink—the standing forest's ability to store carbon—is squandered in pursuit of coal.

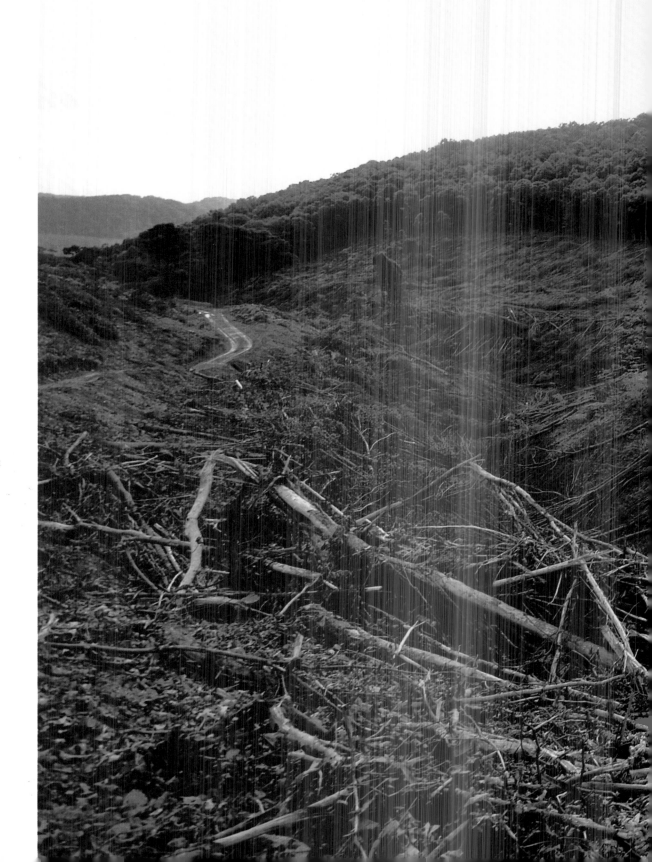

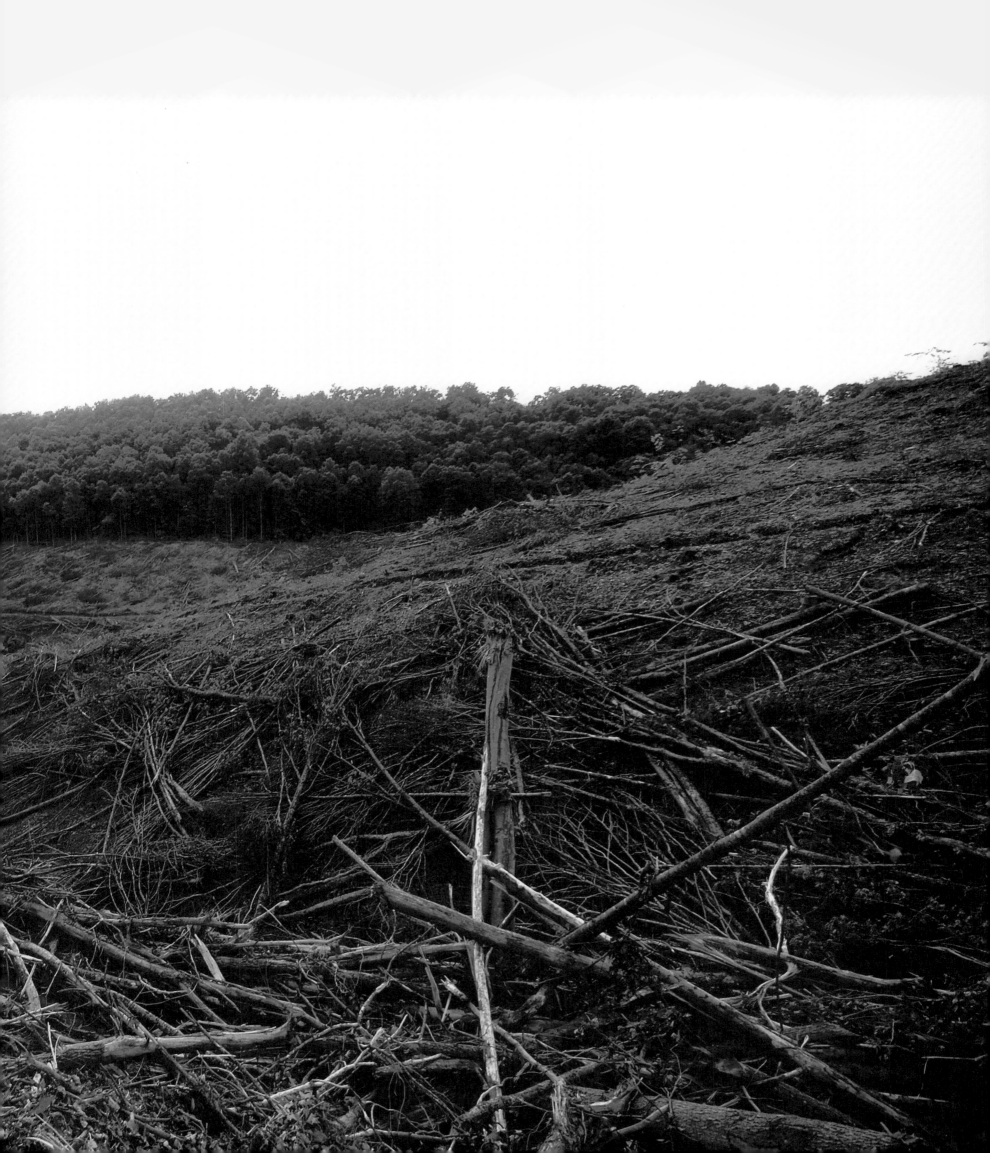

A key reason why mountaintop removal is so ecologically destructive is because surface-mine operators have been allowed to push the rubble from the mountains they are destroying into adjacent valleys. These valley fills are among the largest earthen structures on the planet. They profoundly alter the land's topography and hydrology. Government reports indicate that more than nineteen hundred miles of streams in Appalachia were severely degraded or obliterated by valley fills between 1985 and 2002. Mining permits issued subsequently condemn several hundred more miles of waterway to a similar fate. It is as if a beautiful little creek stretching from Manhattan to Salt Lake City had been buried under the rubble of blown-up mountains, and these figures likely underestimate the actual damage. A West Virginia scientist who is a leading expert on the region's headwater streams believes that the federal Office of Surface Mining analysis of stream impacts is very low because of incomplete information in the topographic maps the government used to compiles its figures.

Opponents of mountaintop-removal mining have waged a vigorous legal battle against the coal industry's practice of constructing valley fills on former streambeds, arguing that dumping mine rubble, or "spoil," into mountain streams is a violation of the Clean Water Act. When one legal challenge on this point ruled against the industry, the Bush administration assisted Big Coal with an administrative rule change that redefined mining rubble to be "fill" as opposed to "waste" under the Clean Water Act. Anti-mountaintop-removal-mining activists have responded by supporting a legislative fix clarifying that mine waste is indeed waste, and cannot be heedlessly dumped into the surface waters of the United States.

This fight, and another over stream-buffer rules governing mining operations, have become the central battleground in the war over mountaintop removal because the coal industry knows that if it cannot construct valley fills, which inevitably will cover streams in the rainy southern Appalachians, then the economic viability of mountaintop-removal-style mining is very much in question.

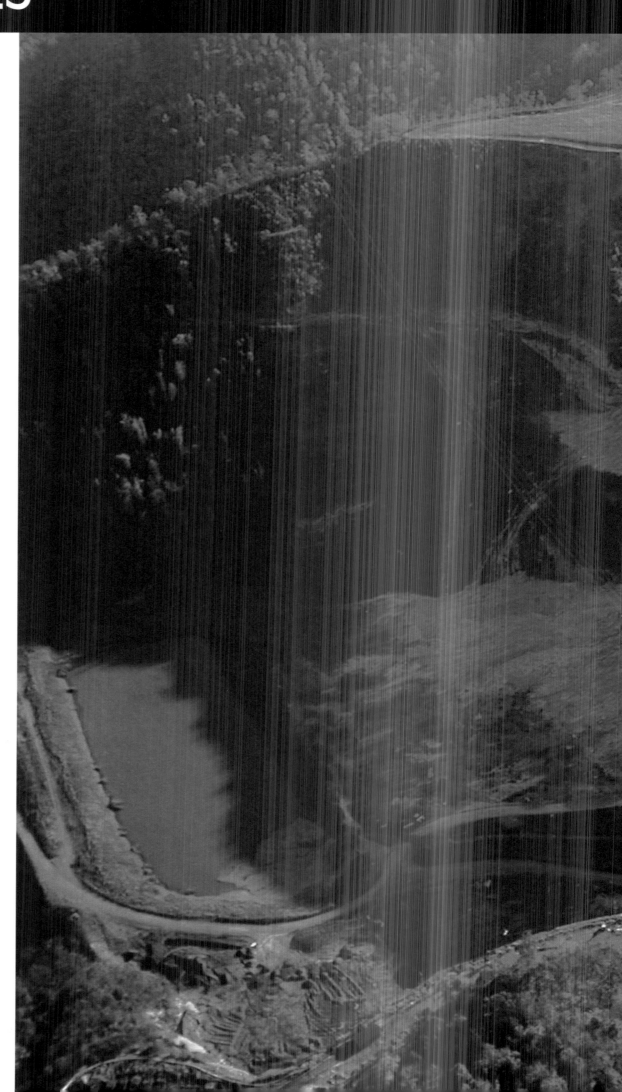

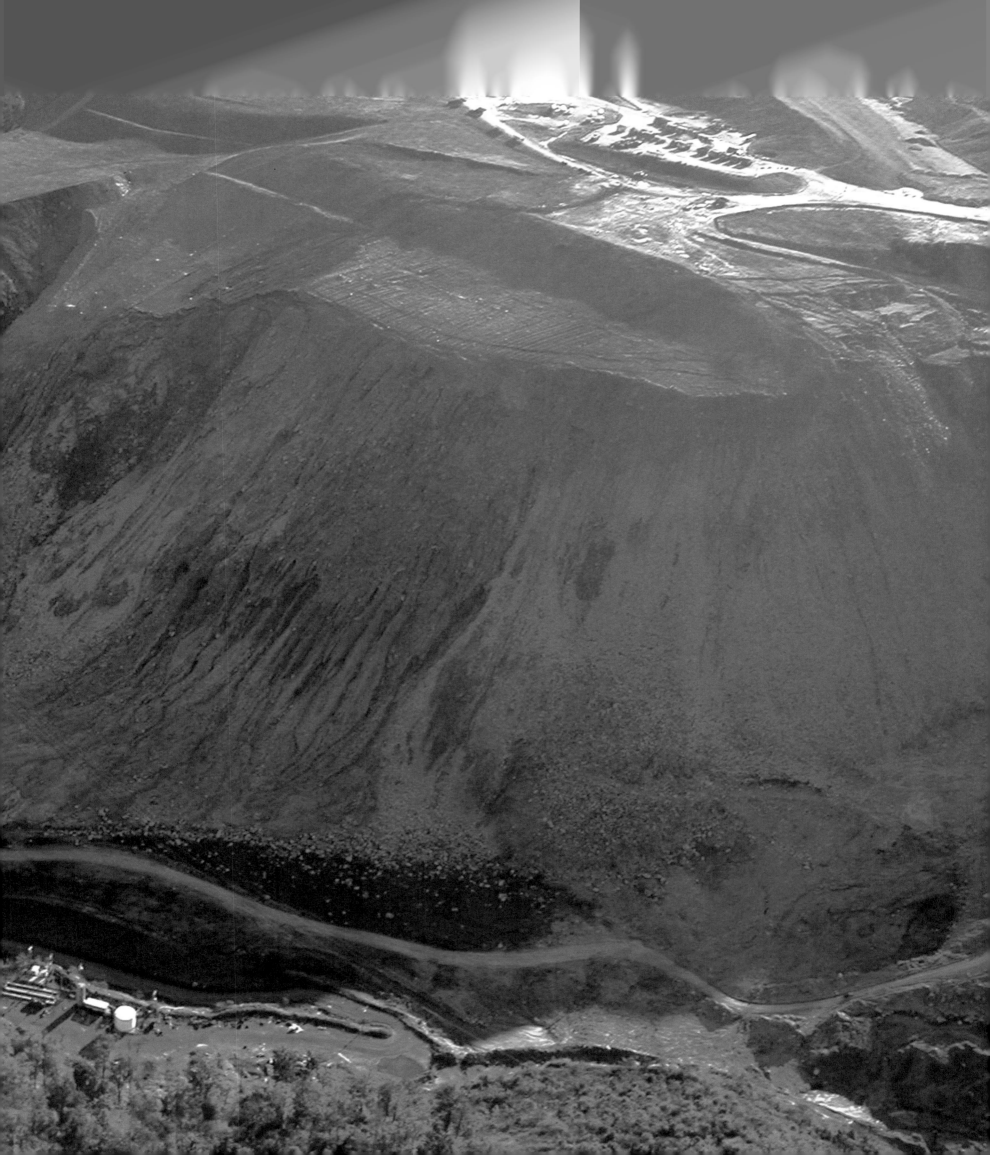

HABITAT LOST

Exploding Mountains, Missing Wildlife

MATTHEW WASSON

"Mine's selenium deforms fish, expert says." This headline from the April 29, 2008, *Charleston Gazette* was additional confirmation of what ecologists have been warning for decades: Mountaintop removal is irreparably damaging some of the most diverse forests and streams in North America. The newspaper reported how scientists had discovered fish in West Virginia's Mud River watershed that exhibited deformities ranging from S-shaped spines to larvae with both eyes on the same side of their heads. Researchers blamed the deformities on selenium, one of dozens of toxic metals that are leached into streams from mine waste dumped into valleys during mountaintop-removal operations. Dennis Lemly, the nation's foremost expert on selenium toxicity, told a federal court, "The Mud River ecosystem is on the brink of a major toxic event. If waterborne selenium concentrations are not reduced, reproductive toxicity will spiral out of control and fish populations will collapse."

Biologists have long warned that selenium concentrations downstream from valley fills can greatly exceed Environmental Protection Agency standards. But research on mountaintop removal's effects has often been suppressed and misdirected by the very agencies charged with monitoring mining impacts and enforcing regulations. As a result of a string of legal challenges to mine permits, however, the scientific story of mountaintop removal is finally being told. As EPA biologist Gregory Pond told the news media in June 2008: "While habitat degradation from mountaintop mining is what one sees on the surface, we found that chemical effects are quite pronounced and limit much of the expected biodiversity from what were once naturally rich, diverse Appalachian stream systems."

Pond coauthored a study that showed mayflies, which account for 30 to 60 percent of insects in southern West Virginia's headwater streams, had completely disappeared downstream from some valley fills. Mayflies are an important food source for fish, birds, and salamanders; they also represent a class of organisms called shredders, which convert coarse matter such as leaves and twigs into finer particles that provide the base of the downstream aquatic food web. Cutting off this energy source can compromise the integrity of an entire river system.

A study by the EPA showed that more than twelve hundred miles of streams had been buried or mined-over between 1992 and 2002 alone. The drainages affected are among the most diverse freshwater systems in the world, harboring at least 277 species of native fishes, dozens of which are native only to the region. But filling headwater streams not only affects downstream chemistry and harms fish—these streams and valleys provide habitat for hundreds of invertebrates such as crayfish, mayflies, and other aquatic insects, a large proportion of which are also endemic to Appalachia. These valleys also provide crucial habitat for salamanders; the central and southern Appalachians harbor the greatest salamander diversity in North America.

The most obvious and visible effect of mountaintop removal is the acreage of wildlife habitat lost. A satellite-based map of fifty-eight counties in central Appalachia conducted by Skytruth in 2007 showed more than eight hundred thousand acres of new large-scale surface mines between 1976 and 2005; by 2009 the area affected is certain to exceed one million acres. An analysis based on this map conducted by Appalachian Voices suggested that 135 rare, threatened, and endangered species in eastern Kentucky and 110 in West Virginia may have been impacted by mountaintop-removal operations.

Less obvious than direct habitat loss is the forest fragmentation caused by mining. Many species, including a disproportionate number of rare and endangered species, depend on large tracts of unbroken "interior" forest and do not survive or reproduce well near forest edges. A study released in 2007 estimated that the percentage loss of interior forest (blocks of forest greater than two thousand acres) from Appalachian surface mining was two to five times greater than the loss of raw forested acreage. The cerulean warbler is one well-known bird species experiencing rapid population declines in recent decades; a 2002 population study showed that this bird of mature forests is particularly vulnerable to the effects of interior forest loss and the destruction of ridges where it prefers to build nests.

From wholesale habitat loss to systemic pollution and degradation of the region's natural ecosystems, the cumulative effects of surface mining in Appalachia are described in a growing body of scientific literature. Whether policy makers will take note and act to stop mountaintop removal is a question likely to be answered in the political arena, courts of law, and the court of public opinion.

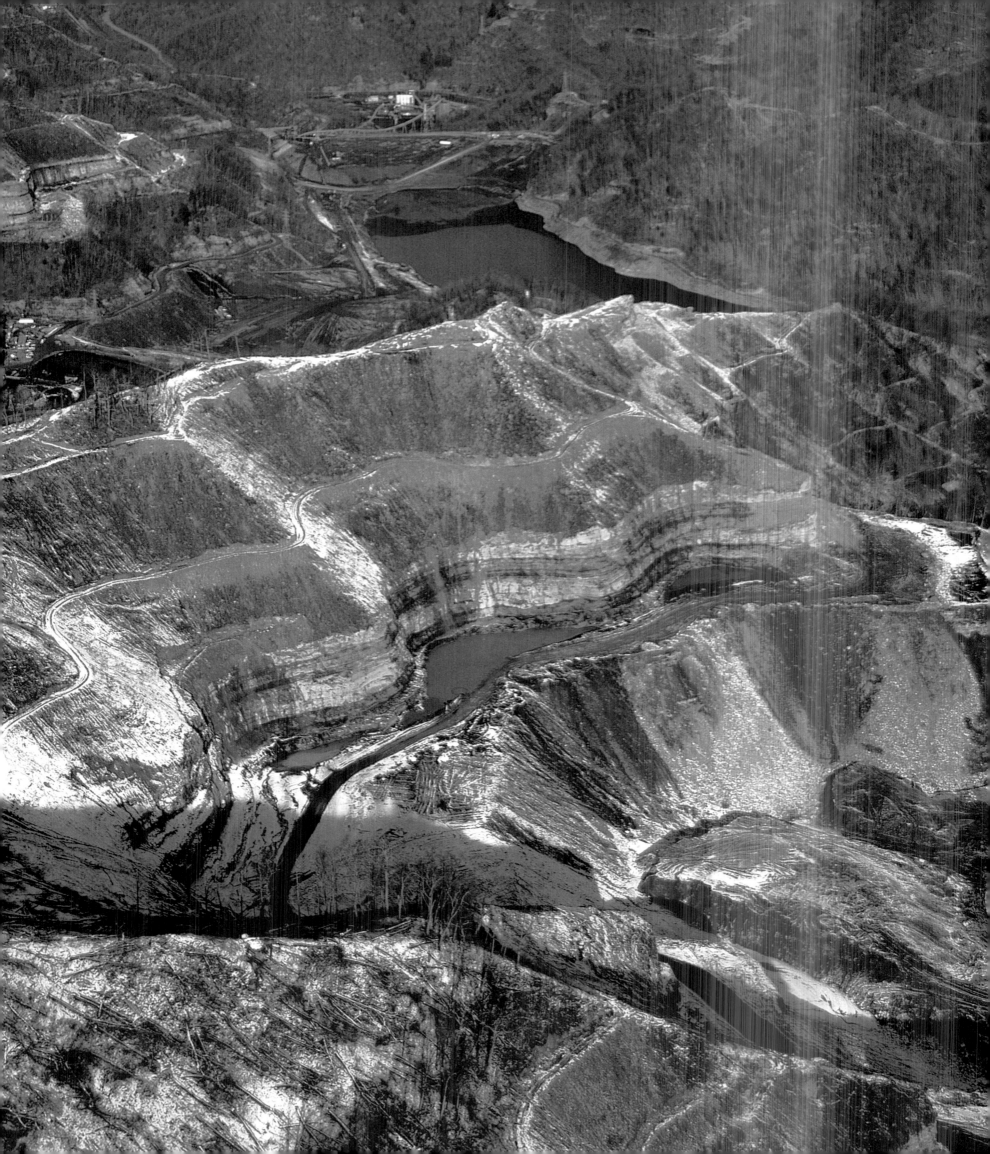

MOUNTAINTOP REMOVAL

The Destruction of Appalachia

JACK SPADARO

After spending my entire professional career working to improve health and safety for coal miners and coalfield communities, it pains me to acknowledge that the federal and state agencies responsible for regulating the mining industry have failed to stop the destruction of Appalachia.

Since the early 1970s, approximately 480,000 acres in West Virginia, 450,000 acres in Kentucky, and 100,000 acres in Virginia have been strip-mined for coal. Mountaintop-removal operations have become the predominant form of strip mining in this region. Valley fills containing millions of tons of mining debris, the former mountaintops, have been dumped with little regard to the effects upon aquatic, animal, or plant life or the human beings downstream.

More than nineteen hundred miles of streams have been severely degraded or buried—completely obliterated—by the valley fills. These mine-waste valley fills are the largest earthen structures in North America.

Since 2001 there have been at least seven periods of severe flash flooding in the region that can be linked to increased runoff from mountaintop-removal sites and other strip-mining operations. A dozen people have died during these unnatural disasters.

Sediment loading of streams, particularly in the Kentucky, Cumberland, and Big Sandy river basins in Kentucky and in the Guyandotte, Coal, and Tug river basins in West Virginia, has accelerated at an alarming rate in the past twenty-five years. This is due to increased runoff from the unstable, eroding slopes of valley fills and poorly graded mountaintop-removal areas.

The sediment load in areas downstream from mountaintop-removal operations can now be measured in the millions of tons. It is estimated that about twelve hundred miles of streams downstream from mountaintop-removal operations have been severely damaged by sedimentation and heavy metal deposition.

In October 2000 I was asked by the assistant secretary of labor for Mine Safety and Health Administration under President Clinton to participate in an investigation of the Martin County, Kentucky, coal-slurry spill, which occurred on October 11, 2000. One of the worst environmental disasters in U.S history, that toxic spill occurred when a coal-slurry impoundment broke through into an underground mine, slurry exited two mine portals, and approximately three hundred million gallons of toxic coal waste flowed into headwater streams of the Big Sandy River.

More than one hundred miles of waterway were severely polluted by the Martin County coal-slurry spill. All life forms in and along the streams and rivers were affected. Approximately 1.6 million fish were killed. More than twenty-seven thousand people had their public and private water supplies contaminated. When I objected to weakened investigation reports and less-than-appropriate enforcement actions, I was immediately attacked by administrators in the Labor Department appointed by the Bush administration. They tried to fire me, but failed because of the public uproar.

My only purpose in raising the alarm about this investigation as I did was to make certain that the mining company and the agencies responsible for enforcing mine health and safety and environmental laws be held accountable for their failure to do so.

The fact remains, however, that Massey Energy, the company responsible for the spill, which has one of the poorest environmental records in Appalachia and a spotty mine health and safety record, has avoided significant consequences for the disaster. Massey corporate executives have direct access and influence with top officials of the Mine Safety and Health Administration and other government agencies. According to Common Cause, Massey Energy contributed $100,000 to the National Republican Senatorial Committee while it was being investigated for the slurry spill. Ultimately, Massey Energy was fined just $5,600 for the Martin County coal-slurry spill.

If current mountaintop-removal mining practices are not curtailed, future slurry spills are likely, flooding and sedimentation are inevitable, and ecological destruction on a regional scale will continue. By the year 2012 more than twenty-five hundred square miles of Appalachian forests, mountains, and streams will have been utterly destroyed. At least thirty-five hundred miles of streams will have been covered up completely. One of the most precious ecosystems in the world will be completely lost—forever—and the people living immediately downstream from these massive mining operations will likely be forced to leave their homes and communities just to survive.

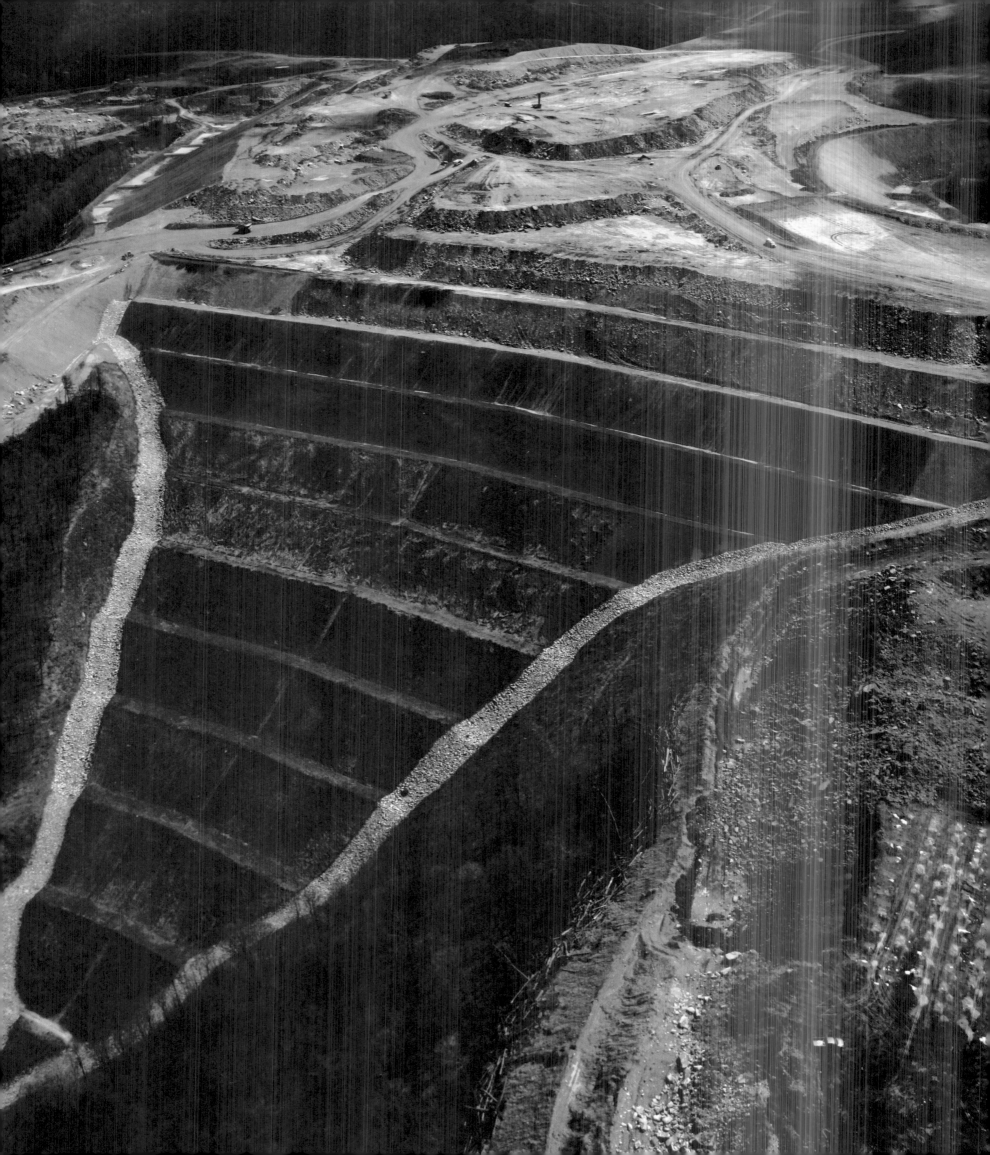

RESTORATION ECONOMY

Reclaiming the Land and Our Communities

SAMIR DOSHI

Once decapitated, a mountain can never truly be reclaimed. But ecological restoration techniques, if applied thoughtfully across Appalachia, could begin to heal the extensive damage that mountaintop mining has caused to the land and coalfield communities.

The Surface Mining Control and Reclamation Act (SMCRA), passed by Congress and signed by President Jimmy Carter in 1977, regulates both strip and mountaintop mining and established a new regulatory agency under the Department of Interior—the Office of Surface Mining. Under SMCRA, Congress gave the Office of Surface Mining overall responsibility for regulating postmining reclamation, but the primary authority for implementation was given to state governments.

Before any coal is removed, mining companies must obtain a surface-mining permit from state regulators. If they plan on placing material in U.S. waters, the company must acquire a clean water permit from the U.S. Army Corps of Engineers. The federal Environmental Protection Agency and the U.S. Fish and Wildlife Service coordinate with the corps and state regulatory agencies to issue permits. The Bush administration amended the Clean Water Act in 2002 to allow the overburden to be classified as "fill" instead of "waste," making it legal to dump blasted vegetation, soils, and rock into valley waterways.

Mining companies are obligated to post a bond and develop a plan for reclamation of the site before the mining operation commences. If all participating regulatory agencies feel the plan is satisfactory, the bond will be released by the state agency upon the completion of reclamation. (In instances where coal companies declare bankruptcy and abandon the sites prior to reclamation, the forfeited bonds may be inadequate to mitigate the mining damage, and so the costs are pushed onto taxpayers and local communities in the form of a ruined landscape.)

SMCRA also requires mining companies to return the mined land to the approximate original contour. Once a mountaintop is blasted away, returning the slope to the original is impossible, and regulators have a difficult time enforcing the mandate.

What generally passes for reclamation in the region are formerly forested mountains left as abandoned, unmanaged, and unproductive exotic scrublands. The topsoil is gone. Slopes are compacted heavily to prevent erosion, and tree establishment along with natural succession is heavily impaired. The deforestation of mined landscapes converted into grasslands and scrublands in Appalachia is estimated to represent a loss of more than two billion dollars in timber value and subsequent services related to recreation and climate regulation.

An ecologically and socially responsible agenda for reclamation would strive to return postmined sites to the same mixed oak–hickory hardwood forest ecosystem typical of the region. Toward this end, the Forestry Reclamation Approach, pioneered in demonstration projects by researchers at Virginia Tech University and other institutions, has shown promising results. The technique minimizes grading and compaction of mine spoil, utilizes topsoil, and plants tree-compatible ground covers that result in a dramatically increased tree-establishment rate. Moreover, there is evidence to suggest that these improved results can be achieved at less cost than status quo reclamation practices. Beginning immediately, the Forestry Reclamation Approach should be a key component of a regional economic transition away from extractive industries. Some might be concerned that restoring mined lands back to forest will justify further mining; it does not, but reflects a commitment to ensure the survival and sustainability of communities that have been marginalized.

Although local communities are greatly affected by mining, they have essentially no say in where mountaintop-removal-mining permits are granted or how postmining reclamation occurs. Mountaintop mining produces less than 10 percent of all coal mined in the United States, is highly mechanized, and employs few workers in an industry that is increasingly dominated by coalfields in the West. With its high economic, social, and environmental costs, mountaintop-removal mining is not a stable foundation for a sustainable Appalachian economy.

Appalachia's character as one of the most biologically diverse ecosystems in the world can be the basis of a future restorative economy. The potential jobs and income generated by ecological restoration; sustainable forestry; renewable energy in the form of wind, solar, and biofuels; and ecotourism (which already accounts for more jobs than coal in the region) will not flow from a landscape devastated by destructive mining practices that offer little future possibility for nature or for people.

FALSE RECLAMATION

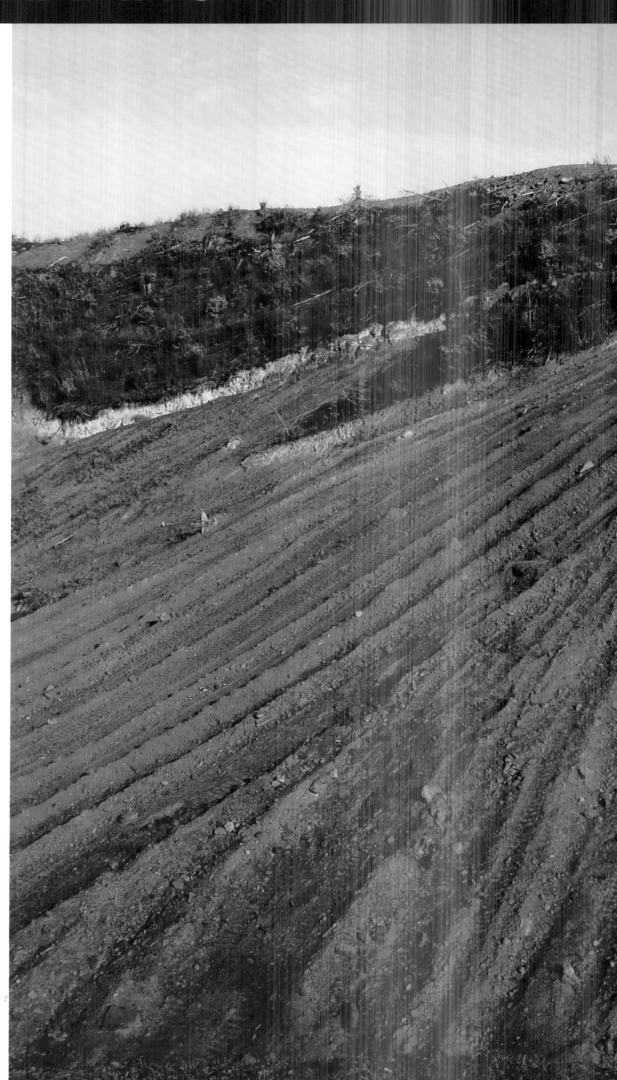

One of the myths surrounding mountain-top removal is that mined areas are "reclaimed." Despite passage of the federal Surface Mining Control and Reclamation Act, most mine sites are not restored to anything approaching their original condition. What passes for reclamation typically involves piling up rubble, smoothing off the slopes, and spreading a nonnative grass seed and fertilizer mixture over the raw land. There is usually no attempt to restore the original biologically diverse forest. Even when trees are planted, they often do not survive since the topsoil is gone, and growing conditions found on recently mined sites are harsh.

Loss of forest cover has numerous impacts. Intact forest cover lessens runoff, reducing potential flooding. Fragmented forests, interrupted by expanses of bare ground or grass, provide less of the deep forest habitat required by certain interior forest bird species, some of which are in steep decline throughout the region. One study in the scientific journal *Ecological Applications* compared a fifteen-year-old reclaimed site with an adjacent forested reference site and discovered that there were "major differences in biochemistry" between the two, mainly due to the removal of woody biomass and to loss of soil. The study also found that the "mined watershed exhibited taller, narrower storm peaks as a result of a higher soil bulk density and decreased infiltration rates." Summer stream temperatures were also higher, affecting aquatic organisms. The study concluded that this land use change (mountaintop removal) "leads to substantial, long-term changes in ecosystem capital and function."

These changes have economic consequences. It is estimated that the ecological services provided by intact forest, which include nutrient cycling, climate regulation, and watershed stability, are worth $240 an acre. In West Virginia alone, deforestation related to surface-mining operations is estimated to have cost the state $2.6 billion in lost ecological services, not including the direct value of the timber.

The Appalachia Restoration Act (S.696)

Title: A bill to amend the Federal Water Pollution Control Act to include a definition of fill material.

Latest Major Action: 3/25/2009 Referred to Senate committee. Status: Read twice and referred to the Committee on Environment and Public Works.

Sen Cardin, Benjamin L. [MD] (introduced 3/25/2009)

Sen Alexander, Lamar [TN] - 3/25/2009

Sen Durbin, Richard [IL] - 8/6/2009

Sen Feinstein, Dianne [CA] - 7/13/2009

Sen Gillibrand, Kirsten E. [NY] - 5/19/2009

Sen Klobuchar, Amy [MN] - 12/8/2009

Sen Lautenberg, Frank R. [NJ] - 12/8/2009

Sen Menendez, Robert [NJ] - 5/5/2009

Sen Sanders, Bernard [VT] - 4/29/2009

Sen Whitehouse, Sheldon [RI] - 5/12/2009

SCIENCE AND REGULATION

Mountaintop Mining Consequences

Damage to ecosystems and threats to human health and the lack of effective mitigation require new approaches to mining regulation.

M. A. Palmer,[1,2] E. S. Bernhardt,[3] W. H. Schlesinger,[4] K. N. Eshleman,[1] E. Foufoula-Georgiou,[5] M. S. Hendryx,[6] A. D. Lemly,[7] G. E. Likens,[4] O. L. Loucks,[8] M. E. Power,[9] P. S. White,[10] P. R. Wilcock[11]

There has been a global, 30-year increase in surface mining (1), which is now the dominant driver of land-use change in the central Appalachian ecoregion of the United States (2). One major form of such mining, mountaintop mining with valley fills (MTM/VF) (3), is widespread throughout eastern Kentucky, West Virginia (WV), and southwestern Virginia. Upper elevation forests are cleared and stripped of topsoil, and explosives are used to break up rocks to access buried coal (fig. S1). Excess rock (mine "spoil") is pushed into adjacent valleys, where it buries existing streams.

Despite much debate in the United States (4), surprisingly little attention has been given to the growing scientific evidence of the negative impacts of MTM/VF. Our analyses of current peer-reviewed studies and of new water-quality data from WV streams revealed serious environmental impacts that mitigation practices cannot successfully address. Published studies also show a high potential for human health impacts.

Ecological Losses, Downstream Impacts

The extensive tracts of deciduous forests destroyed by MTM/VF support some of the highest biodiversity in North America, including several endangered species. Burial of headwater streams by valley fills causes permanent loss of ecosystems that play critical roles in ecological processes such as nutrient cycling and production of organic matter for downstream food webs; these small Appalachian streams also support abundant aquatic organisms, including many endemic species (5). Many studies show that when more than 5 to 10% of a watershed's area is affected by anthropogenic activities, stream biodiversity and water quality suffer (6, 7). Multiple watersheds in WV

[1]University of Maryland Center for Environmental Science, Cambridge, MD 21613, USA. [2]University of Maryland, College Park, MD 20742, USA. [3]Duke University, Durham, NC 27708, USA. [4]Cary Institute of Ecosystem Studies, Millbrook, NY 12545, USA. [5]University of Minnesota, Minneapolis, MN 55414, USA. [6]West Virginia University, Morgantown, WV 26506, USA. [7]Wake Forest University, Winston-Salem, NC 27109, USA. [8]Miami University, Oxford, OH 45056, USA. [9]University of California at Berkeley, Berkeley, CA 94720, USA. [10]University of North Carolina at Chapel Hill, Chapel Hill, NC 27599, USA. [11]Johns Hopkins University, Baltimore, MD 21218, USA.

*Author for correspondence. E-mail: mpalmer@umd.edu

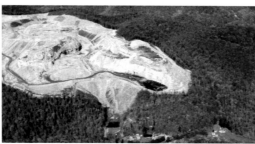

already have more than 10% of their total area disturbed by surface mining (table S1).

Hydrologic flow paths in Appalachian forests are predominantly through permeable soil layers. However, in mined sites, removal of vegetation, alterations in topography, loss of topsoil, and soil compaction from use of heavy machinery reduce infiltration capacity and promote runoff by overland flow (8). This leads to greater storm runoff and increased frequency and magnitude of downstream flooding (9, 10).

Water emerges from the base of valley fills containing a variety of solutes toxic or damaging to biota (11). Declines in stream biodiversity have been linked to the level of mining disturbance in WV watersheds (12). Below valley fills in the central Appalachians, streams are characterized by increases in pH, electrical conductivity, and total dissolved solids due to elevated concentrations of sulfate (SO_4), calcium, magnesium, and bicarbonate ions (13). The ions are released as coal-generated sulfuric acid weathers carbonate rocks. Stream water SO_4 concentrations are closely linked to the extent of mining in these watersheds (11, 14). We found that significant linear increases in the concentrations of metals, as well as decreases in multiple measures of biological health, were associated with increases in stream water SO_4 in streams below mined sites (see the chart on page 149). Recovery of biodiversity in mining waste-impacted streams has not been documented, and SO_4 pollution is known to persist long after mining ceases (14).

Conductivity, and concentrations of SO_4 and other pollutants associated with mine runoff, can directly cause environmental degradation, including disruption of water and ion balance in aquatic biota (12). Elevated SO_4 can exacerbate nutrient pollution of downstream rivers and reservoirs by increasing

nitrogen and phosphorus availability through internal eutrophication (15, 16). Elevated SO_4 can also increase microbial production of hydrogen sulfide, a toxin for many aquatic plants and organisms (17). Mn, Fe, Al, and Se can become further concentrated in stream sediments, and Se bioaccumulates in organisms (11) (figs. S1 and S2).

A survey of 78 MTM/VF streams found that 73 had Se water concentrations greater than the 2.0 µg/liter threshold for toxic bioaccumulation (18). Se levels exceed this in many WV streams (see the chart on page 149). In some freshwater food webs, Se has bioaccumulated to four times the toxic level; this can cause teratogenic deformities in larval fish (fig. S2) (19), leave fish with Se concentrations above the threshold for reproductive failure (4 ppm), and expose birds to reproductive failure when they eat fish with Se >7 ppm (19, 20). Biota may be exposed to concentrations higher than in the water since many feed on streambed algae that can bioconcentrate Se as much as 800 to 2000 times that in water concentrations (21).

Potential for Human Health Impacts

Even after mine-site reclamation (attempts to return a site to premined conditions), groundwater samples from domestic supply wells have higher levels of mine-derived chemical constituents than well water from unmined areas (22). Human health impacts may come from contact with streams or exposure to airborne toxins and dust. State advisories are in effect for excessive human consumption of Se in fish from MTM/VF affected waters. Elevated levels of airborne, hazardous dust have been documented around surface mining operations (23). Adult hospitalizations for chronic pulmonary disorders and hypertension are elevated as a function of county-level coal production, as are rates of mortality; lung cancer; and chronic heart, lung, and kidney disease (24). Health problems are for women and men, so effects are not simply a result of direct occupational exposure of predominantly male coal miners (24).

Mitigation Effects

Reclamation of MTM/VF sites historically has involved planting a few grass and herb species (20, 25). Compared with unmined

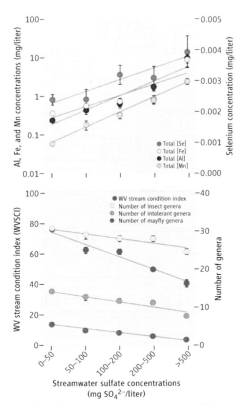

Mining effects on stream chemistry and biota.
Sulfate concentrations reflect amount of mining in watershed. (**Top**) Average concentrations of manganese, iron, aluminum, and selenium. (**Bottom**) Stream invertebrate community metrics in relation to sulfate concentrations for 1058 WV streams (methods in table S2). Regressions all statistically significant (table S3).

sites, reclaimed soils characteristically have higher bulk density, lower organic content, low water-infiltration rates, and low nutrient content (8, 25). Many reclaimed areas show little or no regrowth of woody vegetation and minimal carbon (C) storage even after 15 years (26). Decreased forest productivity may be related to the type of surface material (e.g., brown versus gray sandstone) used in the reclamation (27). In reclaimed forests, projected C sequestration after 60 years is only about 77% of that in undisturbed vegetation in the same region (28). Mined areas planted to grassland sequester much less. Since reclamation areas encompass >15% of the land surface in some regions (29) (table S1), significant potential for terrestrial C storage is lost.

Mitigation plans generally propose creation of intermittently flowing streams on mining sites and enhancement of streams off-site. Stream creation typically involves building channels with morphologies similar to unaffected streams; however, because they are on or near valley fills, the surrounding topography, vegetation, soils, hydrology, and water chemistry are fundamentally altered from the premining state. U.S. rules have considered stream creation a valid form of mitigation while acknowledging the lack of science documenting its efficacy (30). Senior officials of the U.S. Army Corps of Engineers (ACOE) have testified that they do not know of a successful stream creation project in conjunction with MTM/VF (31).

A Failure of Policy and Enforcement

The U.S. Clean Water Act and its implementing regulations state that burying streams with materials discharged from mining should be avoided. Mitigation must render nonsignificant the impacts that mining activities have on the structure and function of aquatic ecosystems. The Surface Mining Control and Reclamation Act imposes requirements to minimize impacts on the land and on natural channels, such as requiring that water discharged from mines will not degrade stream water quality below established standards.

Yet mine-related contaminants persist in streams well below valley fills, forests are destroyed, headwater streams are lost, and biodiversity is reduced; all of these demonstrate that MTM/VF causes significant environmental damage despite regulatory requirements to minimize impacts. Current mitigation strategies are meant to compensate for lost stream habitat and functions but do not; water-quality degradation caused by mining activities is neither prevented nor corrected during reclamation or mitigation.

Clearly, current attempts to regulate MTM/VF practices are inadequate. Mining permits are being issued despite the preponderance of scientific evidence that impacts are pervasive and irreversible and that mitigation cannot compensate for losses. Considering environmental impacts of MTM/VF, in combination with evidence that the health of people living in surface-mining regions of the central Appalachians is compromised by mining activities, we conclude that MTM/VF permits should not be granted unless new methods can be subjected to rigorous peer review and shown to remedy these problems. Regulators should no longer ignore rigorous science. The United States should take leadership on these issues, particularly since surface mining in many developing countries is expected to grow extensively (32).

References and Notes
1. World Coal Institute, www.worldcoal.org.
2. K. L. Saylor, *Land Cover Trends: Central Appalachians* [U.S. Department of the Interior, U.S. Geological Survey (USGS), Washington, DC, 2008]; http://landcovertrends.usgs.gov/east/eco69Report.html.
3. MTM/VF refers to surface mining operations that remove coal seams running through a mountain, ridge, or hill; it may also refer more broadly to large-scale surface mining, including area or contour mining in steep terrain that disposes of excess rock in heads of hollows or valleys with streams.
4. Debates are conspicuous because of recent high-profile federal court cases [e.g., (33)], widely publicized exchanges between the U.S. Environmental Protection Agency (EPA) and the ACOE over permitting decisions, advocacy by non-governmental organizations, and protests by miners.
5. J. L. Meyer et al., *J. Am. Water Resour. Assoc.* **43**, 86 (2007).
6. J. D. Allan, *Annu. Rev. Ecol. Evol. Syst.* **35**, 257 (2004).
7. This 5 to 10% issue is based on studies done on many nonmining types of land-use change. Thus far, EPA has not done mining-specific studies on this "threshold" issue (percentage of watershed mined versus impacts on streams) despite many calls for such data.
8. T. L. Negley, K. N. Eshleman, *Hydrol. Process.* **20**, 3467 (2006).
9. B. C. McCormick, K. N. Eshleman, J. L. Griffith, P. A. Townsend, *Water Resour. Res.* **45**, W08401 (2009).
10. J. R. Ferrari, T. R. Lookingbill, B. McCormick, P. A. Townsend, K. N. Eshleman, *Water Resour. Res.* **45**, W04407 (2009).
11. K. S. Paybins et al., *USGS Circular* 1204 (2000); http://pubs.water.usgs.gov/circ1204/.
12. G. J. Pond, M. E. Passmore, F. A. Borsuk, L. Reynolds, C. J. Rose, *J. N. Am. Benthol. Soc.* **27**, 717 (2008).
13. K. J. Hartman et al., *Hydrobiologia* **532**, 91 (2005).
14. J. I. Sams, K. M. Beer, *USGS Water Res. Report* 99-4208 (2000); http://pa.water.usgs.gov/reports/wrir_99-4208.pdf.
15. N. F. Caraco, J. J. Cole, G. E. Likens, *Nature* **341**, 316 (1989).
16. S. B. Joye, J. T. Hollibaugh, *Science* **270**, 623 (1995).
17. M. E. van der Welle, J. G. Roelofs, L. P. Lamers, *Sci. Total Environ.* **406**, 426 (2008).
18. EPA, *Stream Chemistry Report*, part 2 (EPA Region 3, Philadelphia, PA, 2002); http://www.epa.gov/region3/mtntop/pdf/appendices/d/stream-chemistry/MTMVFChemistryPart2.pdf.
19. A. D. Lemly, *Selenium Assessment in Aquatic Ecosystems: A Guide for Hazard Evaluation and Water Quality Criteria* (Springer, New York, 2002).
20. EPA, *Mountaintop Mining/VF Final Programmatic Environmental Impact Statement* (EPA Region 3, Philadelphia, PA, 2005); http://www.epa.gov/region3/mtntop/index.htm.
21. J. M. Conley, D. H. Funk, D. B. Buchwalter, *Environ. Sci. Technol.* **43**, 7952 (2009).
22. S. McAuley, M. D. Kozar, *USGS Report* 5059 (2006); http://pubs.usgs.gov/sir/2006/5059/pdf/sir2006-5059.pdf.
23. M. K. Ghose, S. R. Majee, *Environ. Monit. Assess.* **130**, 17 (2007).
24. M. Hendryx, M. M. Ahern, *Public Health Rep.* **124**, 541 (2009).
25. Mining industry and government organizations recently signed a statement of intent to promote reforestation approaches that improve reclamation [see, e.g., (34)]; however, adoption of recommendations is voluntary. Reforestation of a mined site to premined conditions has not been demonstrated.
26. J. A. Simmons et al., *Ecol. Appl.* **18**, 104 (2008).
27. P. Emerson, J. Skousen, P. Ziemkiewicz, *J. Environ. Qual.* **38**, 1821 (2009).
28. B. Y. Amichev, A. J. Burger, J. A. Rodrigue, *For. Ecol. Manage.* **256**, 1949 (2008).
29. P. A. Townsend et al., *Remote Sens. Environ.* **113**, 62 (2009).
30. EPA and ACOE, *Fed. Regist.* **73**, 10 (2008).
31. U.S. District Court, Civil Action No. 3:05-0784, transcript, vol. 3, pp. 34–45; http://palmerlab.umd.edu/MTM/US_District_Court_Civil_Action_Official_transcript_Volume_III.pdf.
32. A. P. Chikkatur, A. D. Sagar, T. L. Sankar, *Energy* **34**, 942 (2009).
33. U.S. Court of Appeals for the 4th District, *Ohio Valley Environmental Coalition* et al. vs. *U.S. ACOE* et al., case 07-1255.
34. Appalachian Regional Reforestation Initiative, www.arri.osmre.gov/FRApproach.shtm.
35. This is contribution no. 4368 of the University of Maryland Center for Environmental Science.

Supporting Online Material
www.sciencemag.org/cgi/content/full/327/5962/148/DC1

10.1126/science.1180543

Congress of the United States
Washington, DC 20510

June 11, 2009

Dear Colleague:

We invite you to join us in cosponsoring S. 696, The Appalachian Restoration Act. This legislation would ban the practice of mountaintop removal coal mining operations and their associated valley fills. Mountaintop removal is an environmentally destructive method of coal mining in which the summits of mountains are removed to expose the coal seams beneath. The process results in the dumping of millions of tons of waste rock, dirt and vegetation into nearby streams and river valleys. More than 1 million acres of Appalachia have already been affected by this process. An estimated 1,200 miles of headwater streams have been buried under tons of mining wastes. More than 500 mountains have been impacted. Homes have been ruined and drinking water supplies contaminated.

Our bill, S. 696, the Appalachia Restoration Act, would make clear that coal mining wastes cannot be dumped into our streams, smothering them and sending plumes of toxic run-off into surface and groundwater systems. The Cardin-Alexander legislation would achieve this by amending the Clean Water Act, specifically preventing the so-called "excess spoil" of coal mining wastes from entering our streams and rivers. This simple legislation, consistent with the Clean Water Act's original purpose, would stop the wholesale destruction of some of America's most beautiful and ecologically significant regions.

Mountaintop removal mining produces less than five percent of the coal mined in the United States. This bill would not ban other methods of coal mining. Instead, it is narrowly tailored to stop a practice that has earned the condemnation of communities across Appalachia as well as citizens across the rest of the country. To add your name to the list of cosponsors, please have your staff contact Josh Klein (josh_klein@cardin.senate.gov) of Senator Cardin's staff or Curtis Swager (curtis_swager@alexander.senate.gov) of Senator Alexander's staff.

Sincerely,

Benjamin L. Cardin
United States Senator

Lamar Alexander
United States Senator

1

Appalachia Restoration Act

111th CONGRESS
1St SESSION
S. 696

To amend the Federal Water Pollution Control Act to clarify that fill material
cannot be comprised of waste.

A BILL

To amend the Federal Water Pollution Control Act to clarify
that fill material cannot be comprised of waste.

Be it enacted by the Senate and House of Representatives of the United States of America in Congress assembled,

SECTION 1. SHORT TITLE.

This Act may be cited as the `Appalachia Restoration Act.'

SEC. 2. FILL MATERIAL.

Section 502 of the Federal Water Pollution Control Act (33 U.S.C. 1362) is amended by adding at the end the following:

'(26) FILL MATERIAL
 (A) IN GENERAL – The term 'fill material' means any pollutant that --
 '(i) replaces a portion of the waters of the United States with dry land; or
 '(ii) modifies the bottom elevation of a body of water for any purpose.

 (B) EXCLUSIONS – The term 'fill material' does not include--
 '(i) the disposal of excess spoil material (as described in section 515(b)(22) of the Surface Mining Control and Reclamation Act (30 U.S.C. 1265(b)(22))) in waters of the United States; or

 `(ii) trash or garbage.'.

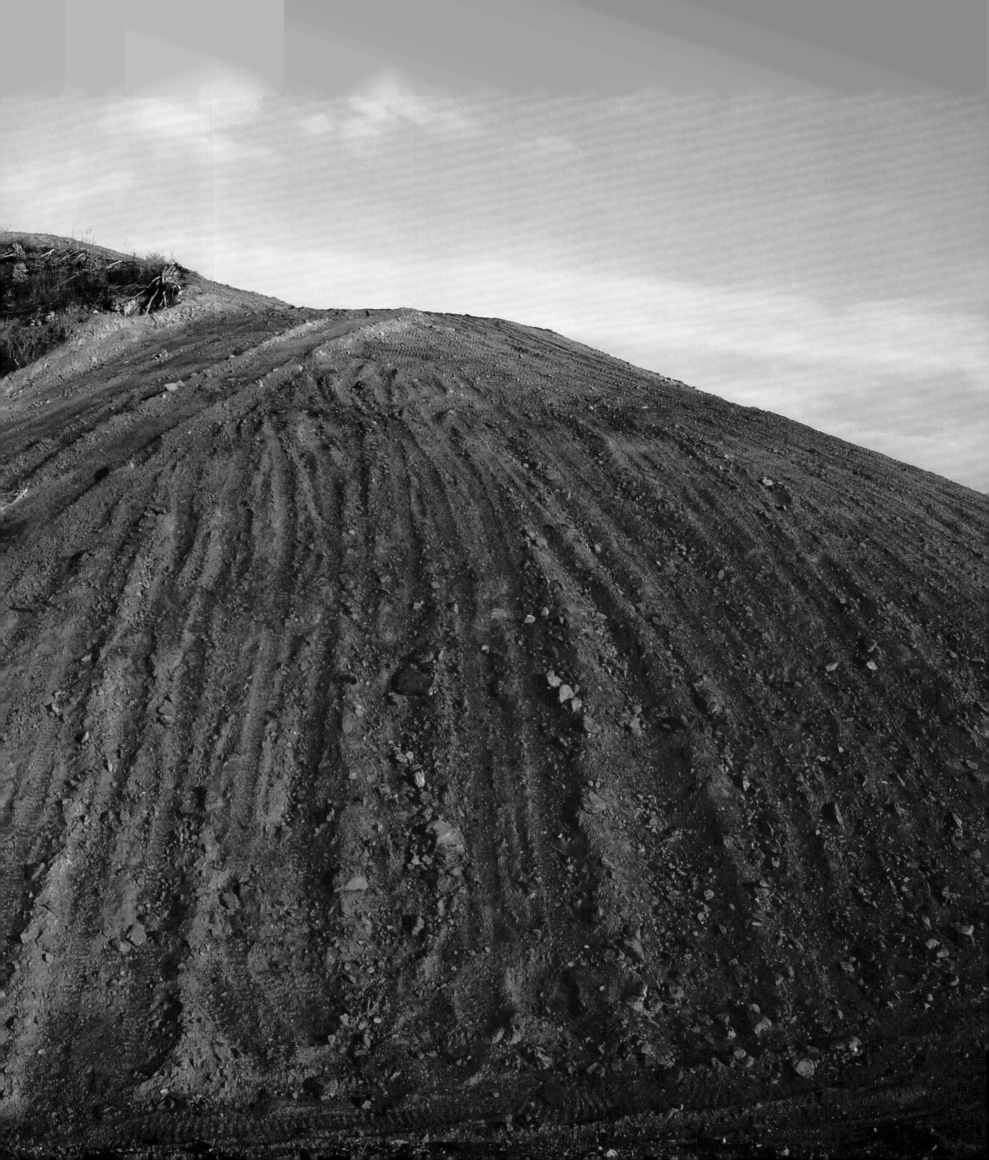

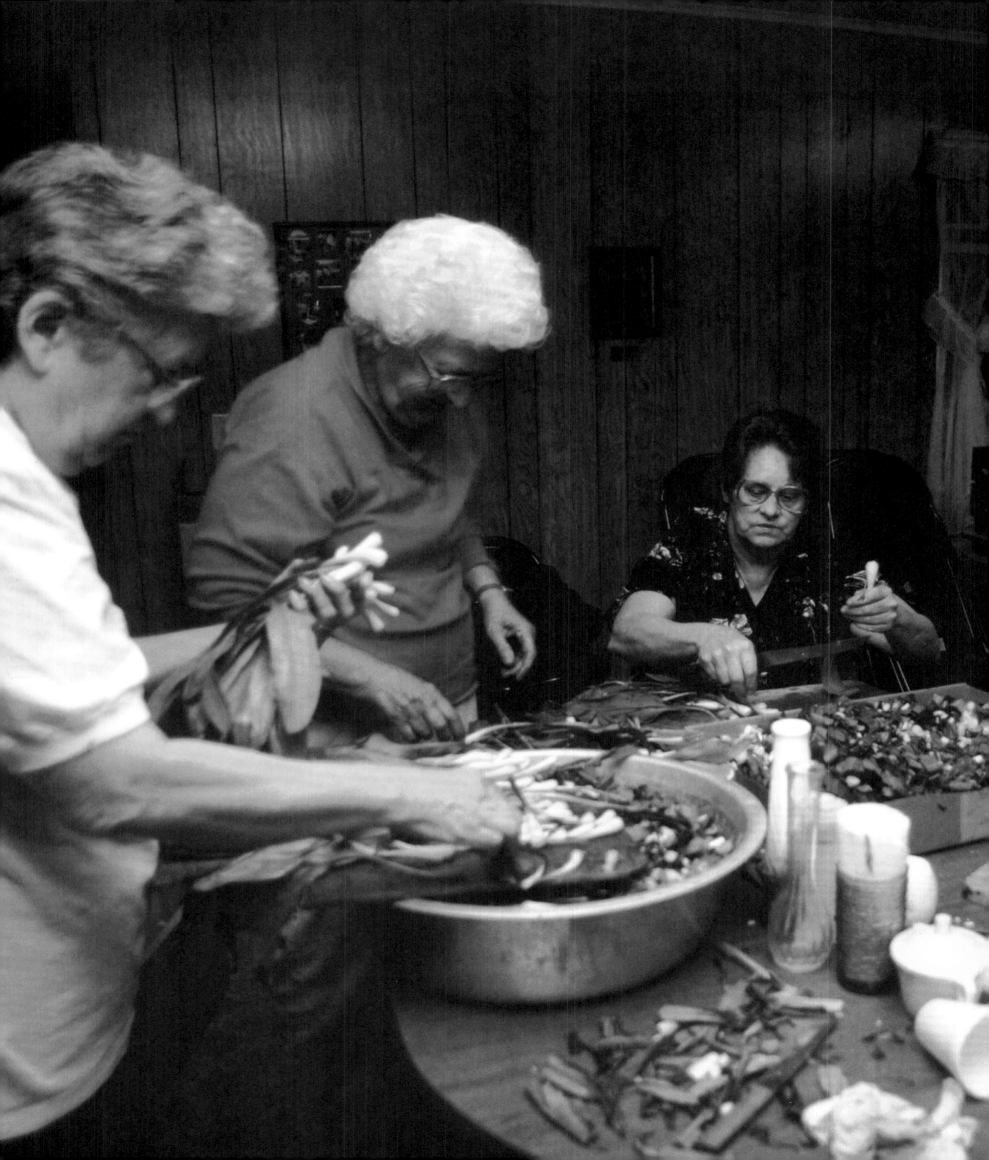

THE SEASONAL ROUND

Mountain Life and the Commons of Biocultural Diversity

MARY HUFFORD

The central Appalachian Mountains harbor the world's oldest and biologically richest temperate zone hardwood forest. Spreading across the crumpled terrain of the Allegheny and Cumberland Plateaus, from northern Alabama to southeastern Ohio and southwestern Pennsylvania, the system that pioneering ecologist E. Lucy Braun called "mixed mesophytic" (medium moisture-loving) evolved over the course of a hundred million years. Whereas most forest types are dominated by two or three canopy species, the mixed mesophytic system features nearly eighty woody species in its canopy and understory, including beech, tulip tree, basswood, American chestnut, sweet buckeye, birch, black cherry, white ash, butternut, black walnut, red mulberry, paw-paw, persimmon, four kinds of magnolia, and a variety of species of oaks, maples, hickories. Never glaciated during the ice ages, the coves and hollows of central Appalachia sheltered this biodiversity from the freezing temperatures that extirpated species elsewhere. E. Lucy Braun theorized that the seed stock kept alive in the coves eventually replenished the forests of eastern North America. Ecologists today reason that the coves could again protect biodiversity in a time of global warming. A widespread nickname for this system is the "Mother Forest."

The soils of this region were so productive that Native Americans regarded much of southern West Virginia as commons, and traditionally warring bands suspended hostilities during seasons of hunting, gardening, and gathering nuts, fruits, and medicinal herbs. Communities living in the region today continue to prize the gifts of forest diversity, not only as economic and subsistence resources, but as templates for patterning life. The formula "plant corn when the oak leaves are as big as a squirrel's ear" illustrates in a small way the integration of community life with the life of the forest. The environment itself stores memories, issuing the prompts to which generations of community forestry have responded.

The mixed mesophytic seasonal round is the linchpin of the community forest. Synchronizing gardening, hunting, gathering, and the marketplace, the round begins each year in mid March with a trip to the ramp patch. Ramps, wild cousins of garlic and the first of the wild foods, are featured at spring feasts and community fundraisers [see accompanying photo]. Forest bounty is always in season: hunting turkey, greens, and morel mushrooms in spring; fishing in creeks and berry picking in summer; digging ginseng, gathering walnuts, hazelnuts, chinquapins, butternuts, paw-paws, and persimmons, hunting squirrel and deer from August until December; tapping sugar trees and preparing to drink sassafrass tea in the late winter when the need for spring tonic grows acute. Participation in this annual round integrates disjunct parts of the landscape: Knowing where the old apple orchards are is vital to hunting for morels; knowing which species of bait emerge and when along particular creeks informs the practice of fishing in major tributaries; following fruits as they ripen later at higher elevations extends the berry season; following the cycle of ripening nuts is formula for success in squirrel hunting. Resting on the knowledge of elements of a system in relation to one another, the community forest fosters ideas about healthy forests that are less and less well-known: that healthy forests need multiple-aged stands, including den trees, bee trees, and nut trees; or that depleting resources too rapidly is a form of "robbing the land."

The mixed mesophytic community forest exemplifies what anthropologist Gregory Bateson called "the thinking system," that is, the organism plus its environment. You cannot take apart the thinking system without destroying it. Violent technologies used to extract timber and fossil fuel destroy thinking systems all over the world, producing social and cultural dislocation and economic hardship. In the central Appalachian region, mountaintop-removal mining is destroying not only mountains and their communities but community forest systems that could be conserved to support local economies and societies while sustaining a carbon sink that could help to heal the planet.

Who wouldn't recoil from the sight of water blackened by coal-mining pollution? (In this case, a member of the West Virginia Public Energy Authority reacts to a household water sample presented by a Mingo County resident at a public hearing.) Unfortunately, for too many citizens in the Appalachian coalfields, the look and smell of contaminated water is as familiar as turning on the tap—and getting their voices actually heard by policy makers has been an uphill struggle.

In the rugged, mountainous areas of the region, the vast majority of rural residents depend on wells for household water. Generally, only larger communities have municipal water systems. Many people across Appalachia believe their wells or springs have been contaminated by coal slurry injected into former deep mines that leaches into groundwater (as alleged at the aforementioned public hearing), or from other coal-extraction and processing activities. A local area's hydrology can be radically altered when mountains are destroyed and former valleys filled.

Even when the likely source of pollution affecting a household's water supply is obvious, coal companies usually deny responsibility, and few people have the resources to hire hydrologists or other specialists to prove the link between mining operations and their polluted water. Many coalfield residents feel betrayed by the coal companies that have polluted their homeplace's most precious resource—clean water—and equally betrayed by government regulators who have turned a blind eye to the problem. Many citizens have been forced to purchase bottled water for household use, a huge burden on families that are already struggling to make a living in an economically depressed region.

Where mountaintop-removal mines operate, coal dust is pervasive. Pneumoconiosis, or black lung disease, contracted from breathing coal dust, has been a health hazard to miners for centuries. More than fifty-five thousand miners died from black lung disease between 1968 and 1990.

Though surface mining reduces the risk of black lung disease for miners, the continual presence of coal dust in the air from blasting, machinery use, coal washing, and loading coal trucks and railcars exposes many more local residents to excessive air pollution from coal dust. The grime sifts into homes to cover everything from furniture to people's lungs. The sulfur in coal dust also causes rapid deterioration in stone monuments and buildings.

The residents of Sylvester, West Virginia, have suffered from coal-dust pollution from Massey Energy's Elk Run Coal preparation facility for more than a decade. The West Virginia Division of Mining and Reclamation noted dozens of violations for excessive coal dust emissions there during 2000–2001. Local residents brought a nuisance suit against Massey for dust pollution and diminished real estate values, winning a jury verdict against the company's Elk Run subsidiary in 2003. Citizen pressure also forced a settlement between the coal company and the West Virginia Department of Environmental Protection, whereby Elk Run agreed to place a nylon dome over its massive coal storage yard just outside the Sylvester town limits. That structure has reduced but not eliminated the plume of airborne coal dust affecting the community. Local activists have continued to fight the company over expansion of its Elk Run facility and its ongoing pollution.

Mountaintop-removal mining is profitable because it takes few workers (minimizing labor costs), because demand for coal is strong, and because its high environmental and social costs are not internalized by the industry. For instance, the price of human health impacts is passed on to society, and the extraordinary damage to natural systems is unaccounted for. More frequent and more severe flooding events are one of these external costs of mountaintop removal, one that has dramatic negative consequences for both natural and human communities.

Mountaintop removal begins with deforestation—removing the vegetative cover and topsoil, which collectively soak up and hold moisture when it rains. Eliminate this natural sponge, and precipitation runs off faster and with more erosive force. Various government reports have noted that stream flow from areas affected by surface mining and valley fills is increased. Since 2001 several severe flash-flooding events downstream from mountaintop-removal or other surface-mining sites have affected communities in the West Virginia and eastern Kentucky coalfields. Most often the result has been property damage, but fatalities have also occurred. People living below mountaintop-removal mines begin to live in constant fear during rainy weather; it is not uncommon for mothers to put their children to bed fully clothed in case they need to flee in the night from a wall of water roaring down the hollow.

The coal industry's standard line on floods is that they are "acts of God." Coalfield residents who know that radical surface mining's alteration of the landscape is contributing to the flooding respond, "It isn't God who's blowing up the mountains."

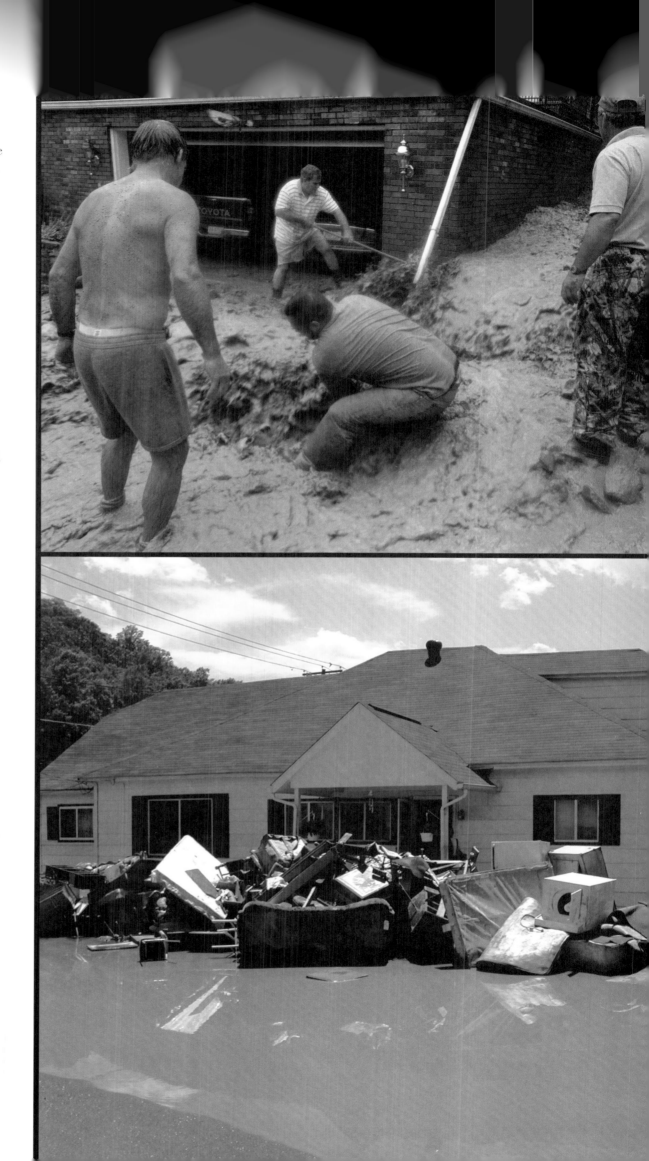

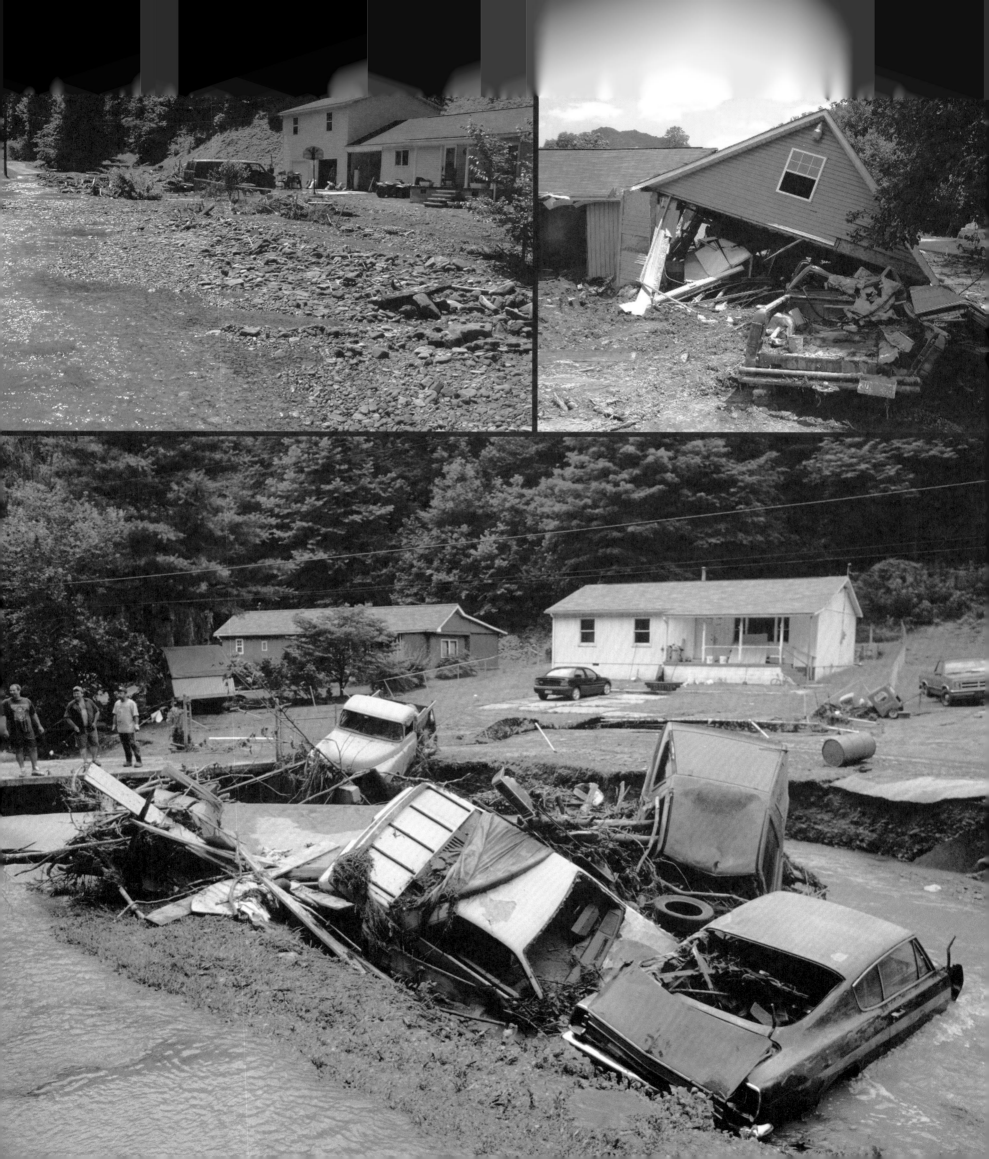

One of the little-known consequences of radically destructive surface coal mining is rural depopulation. Appalachia has long been one of the poorest regions of the country; earlier waves of outmigration saw mountaineers from Kentucky and West Virginia settle in Detroit and other cities of America's industrial heartland when those places offered more opportunity. Few Appalachian residents want to leave their ancestral homelands, where family ties run deep and a connection to the land remains strong, but are compelled to move by employment and health concerns.

A key factor behind population decline in some coalfield communities is loss of mining jobs, which declined nationally by 90 percent between 1923 and 2000, even as total coal production more than doubled. Increased mechanization and a shift toward surface mining eliminated more than six hundred thousand mining jobs, many of them union. People whose families have lived in these mountains for generations are now being driven from the region by economic hardship and unhealthy living conditions. When mountainsides are deforested, and floodwaters race down the valleys to destroy homes, people leave the area. When the blasting noise from exploding mountains seems never-ending, people leave the area. When coal dust pollutes the air families must breathe, people leave the area. When wells are polluted by coal slurry injected into abandoned mines, people leave the area.

In Mingo County, West Virginia, for example, the population peaked at roughly forty-seven thousand in 1950; by 2006 it was down to twenty-seven thousand and falling. Unfortunately, for some who wish to move to a new community, relocating is impossible. The disruptions associated with mountaintop-removal mining can cause real estate values to plummet; people can't sell their homes and can't buy new homes someplace else. For these folks, living with mountaintop removal is a living hell.

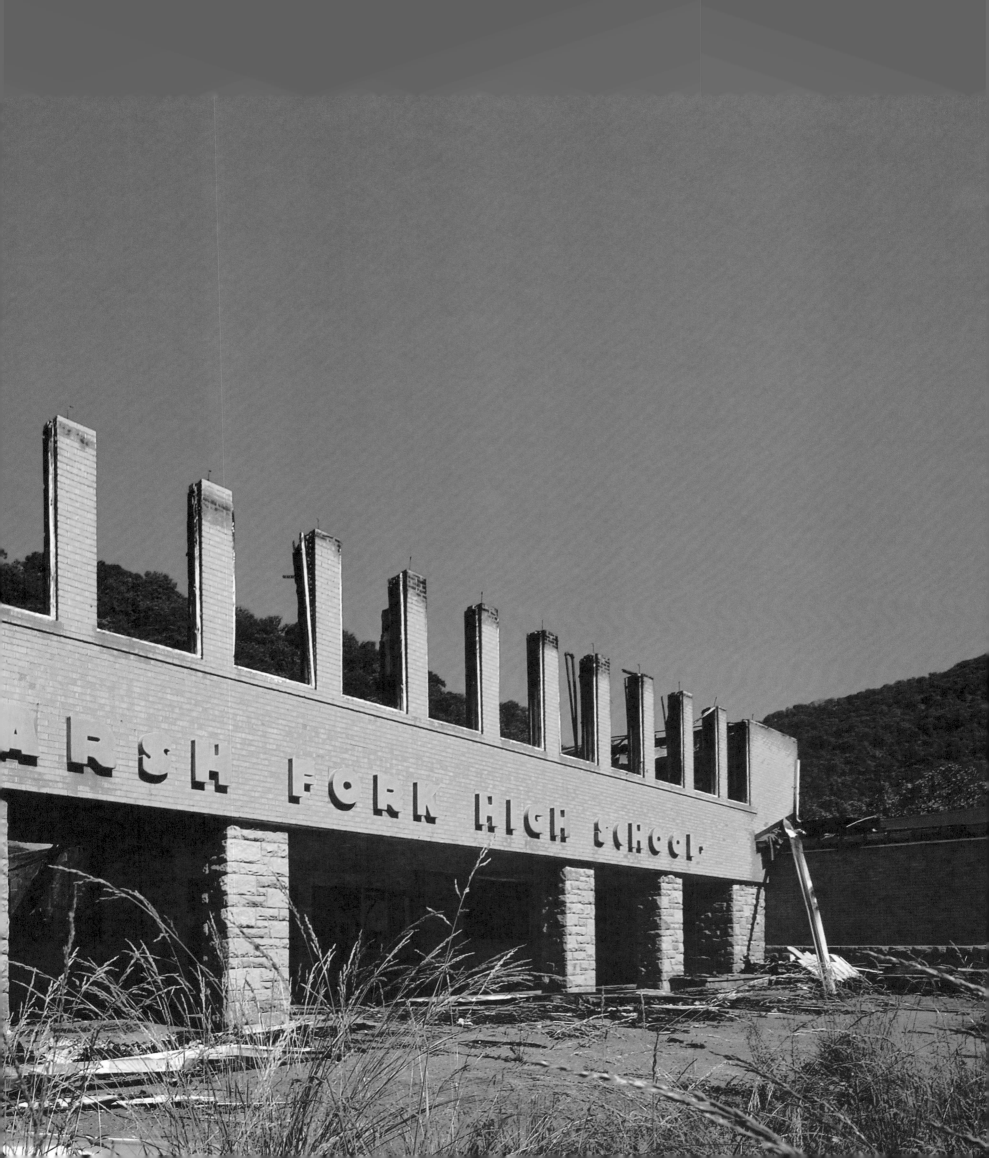

This Deed of Conveyance, made and entered into this _2d_ day of _May_ 190_8_

by and between _Henry Nickels Mahala Nickel his wife_

of Magoffin County Ky

part _ies_ of the first part, hereinafter called "Grantor," and _John C.C. Mayo_

of Johnson Co Ky.

part _y_ of the second part, hereinafter called "Grantee."

WITNESSETH: That said part _ies_ of the first part, in consideration of the sum of _____ One Dollars

and other good and valuable considerations

cash in hand paid, receipt whereof is hereby acknowledged, ha_ve_ bargained, sold, granted and conveyed, and by these presents do hereby bargain, sell, grant and convey unto the said part _y_ of the second part, the following property, rights and privileges, in, of, to, on, under, concerning and appurtenant to the hereinafter described tract of land, which said property, rights and privileges are as follows, to-wit:

All the coal, minerals and mineral products, all the oils and gases, all salt minerals, and salt water, fire and potters' clay, all iron and iron ore, all stone, and such of the standing timber as may be, or by the Grantee, _his_ heirs or representatives, its successors, or assigns, be deemed necessary for mining purposes, and including timber necessary for railroads or branch lines thereof, that may hereafter be constructed upon said land, and the exclusive rights-of-way for any and all railroads and ways, and pipe lines that may hereafter be located on said property by the Grantee, _his_ heirs or representatives, its successors or assigns, or by any person or corporation under authority of said Grantee, _his_ heirs or representatives, or its successors, or assigns, in, of, under concerning or appurtenant to the hereinafter described tract of land, together with all the right to enter upon said lands, use and operate the same and surface thereof, and make use of, and for this purpose, divert water courses thereon, in any and every manner that may be deemed necessary or convenient for mining, and therefrom removing, or otherwise utilizing the products of said minerals, and for the transportation therefrom of said articles, and the right to use of such, as well for the removal of the products taken out of any other land, owned or hereafter acquired by the Grantee, _his_ heirs or representatives, its successors or assigns, and the right to erect upon the said land, maintain, use and at pleasure remove therefrom all such buildings and structures as may be necessary or convenient to the exercise and enjoyment of the property, rights and privileges hereby bargained, sold, granted or conveyed; and in the use of said land, and surface thereof, by the Grantee, _his_ heirs or representatives, its successors, or assigns, Grantee and _his_ heirs, representatives, successors and assigns, shall be free from, and is, and are, hereby released from liability or claim of damage to the said Grantor _his_ representatives, heirs and assigns. Free access to, upon and over the said land is hereby conferred upon the Grantee, _his_ heirs and representatives, its successors, and assigns, for purpose of surveying and prospecting the aforesaid land, property rights, privileges and interests; and there is reserved to the Grantor all the timber upon the said land, except that necessary for mining, and the purposes hereinbefore mentioned, and the free use of land for agricultural purposes, so far as such use is consistent with the property, rights and privileges hereby bargained, sold, granted or conveyed, and the right to mine and use coal for Grantor's own personal household and domestic purposes.

The following is a description of the land referred to: Situated in the County of _Magoffin_ State of _Kentucky_ on the waters of _Big Lick byas Lk of the right fork_ of Middle creek of the Big Sandy river and bounded as follows Beginning at a stake on east bank of right fork of Big Lk branch on line of Wilson Risner thence up the hill with said line of said Risner N26-31 W215 ft to a stoke N48 W183 ft to a stoke N 39-30 W2 4 ft to a stoke N40 W324 ft to a stoke N32-45 W466 ft to a stoke S48 30 W79 ft to a stoke S20-45 W266 ft to a stoke S9-15 W221 ft to a stoke S13-15 W458 ft to a stoke in the road S8 45 W238 ft to a stoke S7-30 W104 ft to a stoke S48 E292 ft to a stoke on top of hill a corner to Geo. Marshall leaving Wilson Risner with a line of Geo. Marshall N88 E 295 ft to a black jack S48-31 E335 ft to a stoke S39-45 W272 ft to a stoke S53 W318 ft to a stoke in branch up hill S5-45 N328 ft to a stoke S38-30 E230 ft to a stoke S31 W299 ft to a stoke S 5-30 W240 ft to a stoke S26-30 E293 ft to a stoke S80-45 E 312 ft to a bunch of chestnut sprouts a corner to Walls Cole leaving Geo Marshall with the line of Walls Cole N56-E 285 ft to a stoke N35-30 E243 ft to a stoke N3-45 E48 ft to aux on a rock N7-30 W95 ft to a stoke N64 W288 ft to a chestnut a corner to Fairis Cole leaving Walls Cole with a line of Fairis Cole N6 E 203 ft to a stoke down hill N 39-30 W259 ft to a stoke N32-45 W193 ft to a stoke N22-30 W153 ft to a stoke N 37-30 W293 ft to a stoke N65-30 W 136 ft to a stoke N60-30 W261 ft to a stoke S 62-15 W80 ft to the beginning — Containing 72.89 Acres

This deed is executed in compliance of an agreement executed for rights by first party to the Midland Coal and Iron Co recorded in book 1, p 57 titled "Agreement for rights" an assigned by said Company to the said second party.

AGENTS OF DESTRUCTION

Broad-Form Deeds and the Birth of Big Coal

HARRY M. CAUDILL

In the summer of 1885 gentlemen arrived in the county-seat towns for the purpose of buying tracts of minerals, leaving the surface of the land in the ownership of the mountaineers who resided on it. The Eastern and Northern capitalists selected for this mission were men of great guile and charm. They were courteous, pleasant, and wonderful storytellers. Their goal was to buy the minerals on a grand scale as cheaply as possible and on terms so favorable to the purchasers as to grant them every desirable exploitive privilege, while simultaneously leaving the mountaineer an illusion of ownership and the continuing responsibility for practically all the taxes which might thereafter be levied against the land...

When the highland couple sat down at the kitchen table to sign the deed their guest had brought to them they were at an astounding disadvantage. On one side of the rude table sat an astute trader, more often than not the graduate of a fine college and a man experienced in the larger business world. He was thoroughly aware of the implications of the transaction and of the immense wealth which he was in the process of acquiring. Across the table on a puncheon bench sat a man and a woman out of a different age. Still remarkably close to the frontier of a century before, neither of them possessed more than the rudiments of an education...Unable to read the instrument or able to read it only with much uncertainty, the sellers relied upon the agent for an explanation of its contents—contents which were to prove deadly to the welfare of generations of the mountaineer's descendants.

Sometimes the instrument was what lawyers in later years called "the short-form deed," merely passing title to the minerals underlying the land "together with all the usual and ordinary mining rights and privileges thereunto appertaining." But the great majority of these deeds were the "broad-form" and, in addition to the minerals, conveyed a great number of specific contractual privileges and immunities.

The broad-form deeds passed to the coal companies title to all coal, oil, and gas and all "mineral and metallic substances and all combinations of the same." They authorized the grantees to excavate for the minerals, to build roads and structures on the land, and to use the surface for any purpose "convenient and necessary" to the company and its successors in title. Their wordy covenants passed to the coal men the right to utilize as mining props the timber growing on the land, to divert and pollute the water, and to cover the surface with toxic mining refuse. The landowner's estate was made perpetually "subservient" to the superior or "dominant" rights of the owner of the minerals. And, for good measure, a final clause absolved the mining company from all liability to the landowner for such damages as might be caused "directly or indirectly" by mining operations on his land.

Beneath the feet of the highlander lay quantities of minerals, the magnitude of which would have dumbfounded him. In practically every ridge a vein of coal was to be found near the top of the hill, sometimes with as little as forty feet of overburden on it...The agents assured [the mountaineer] that the coal would not be mined for many years and then only under circumstances harmless to him and to his children. So the deeds were signed and duly recorded in the clerks' offices of the county courts, and then the coal buyers, or most of them, departed...

Under ordinary mining methods prevailing throughout the region during the years after 1913, the operating coal companies were able to recover from one thousand to fifteen hundred tons of coal per acre foot. This means that a seam of coal five feet thick produced a minimum of five thousand tons per acre! Where more than one seam was mined, a single acre sometimes yielded fifteen or twenty thousand tons!...For this vast mineral wealth the mountaineer in most instances received a single half-dollar.

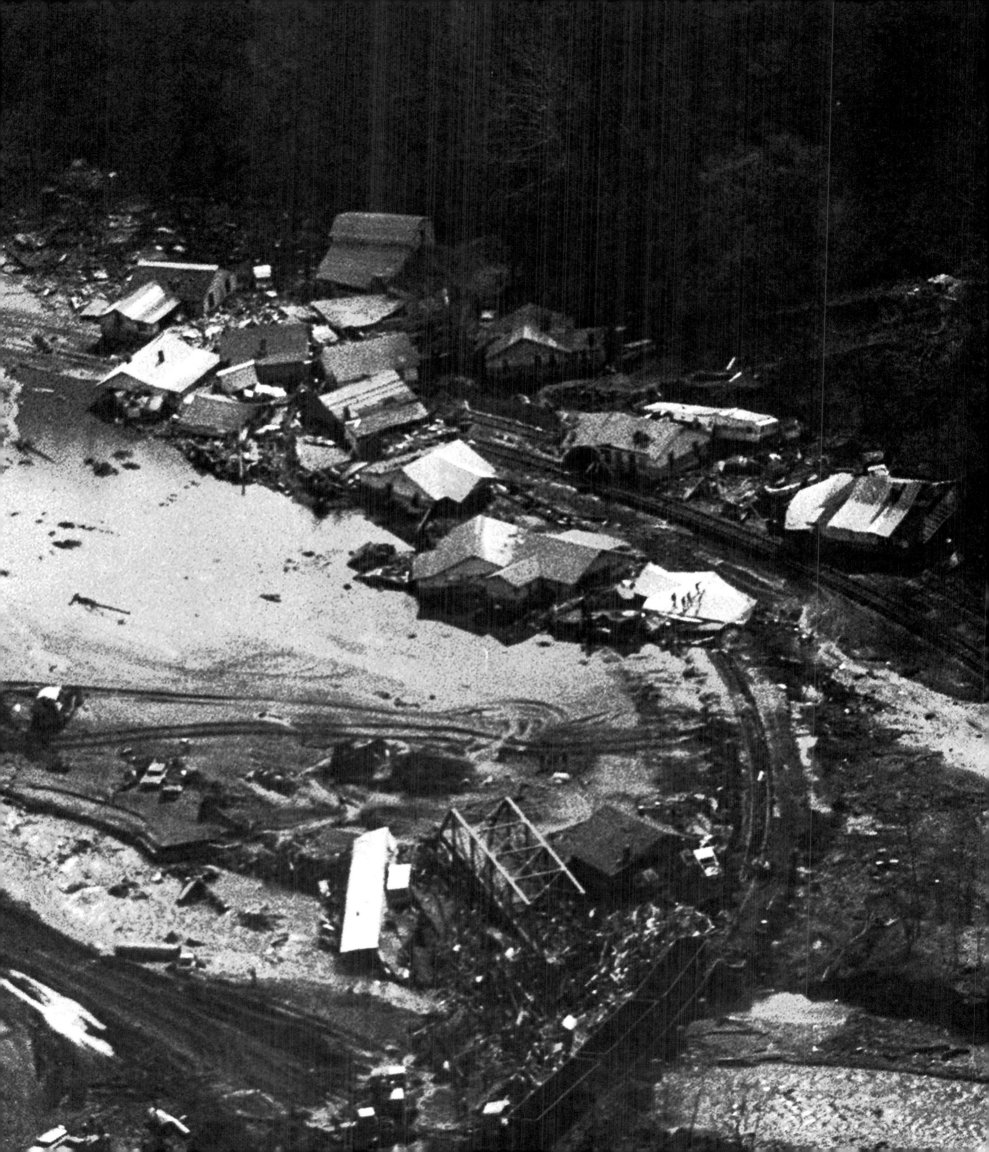

BUFFALO CREEK, WEST VIRGINIA

Disaster on February 26, 1972

KAI ERIKSON

At one minute before 8:00 AM, the coal-waste dam simply collapsed… The entire lake of black water, all 132 million gallons of it, roared through the breach in a manner of seconds. It was already more than water, full of coal dust and other solids, and as it broke through the dam and landed on the banks of the refuse below, it scraped up thousands of tons of other materials, the whole being fused into a liquid substance that one engineer simply called a "mud wave" and one witness described as "rolling lava." The wave set off a series of explosions as it drove a channel through the smoldering trough of slag, raising mushroom-shaped clouds high into the air and throwing great spatters of mud three hundred feet up to the haul road where a few men were returning from the mines. The rock and debris dislodged by those explosions were absorbed into the mass, too. By now, there were something like a million tons of solid waste caught up in the flow.

All of this took only a minute or two, and then the wave shot out of Middle Fork and landed on the town of Saunders. It was not really a flood, not a straight thrust of water, but a churning maelstrom of liquid and mud and debris…

The wave demolished Saunders entirely. It did not crush the village into mounds of rubble, but carried away everything with it—houses, cars, trailers, a church whose white spire had pointed to the slag pile for years—and scraped the ground as cleanly as if a thousand bulldozers had been at work. At this point, the wall of mud and water was fifteen or twenty feet high when measured from the flood plain and thirty or forty feet high when measured from the creek bed…

The view from Braeholm, about two-thirds of the way down the hollow:

I could see Amherst Camp up there at the crossing right above me. It looked like the whole town just raised up and started moving down the hollow, just like it was sitting. I seen the first house hit the bridge, then the second, then the third and fourth. And then a mobile home hit those houses where they had done jammed up against the bridge, and I guess the pressure and the impact was rolling under and that mobile home just vanished underneath. I never did see no more of it. There were three women in it. They were standing in a big picture window and their mouths were moving. I gathered they were hollering…

The front edge of the flood knifed out of Middle Fork around 8:00 AM and passed through the town of Man, where Buffalo Creek finally empties into the Guyandotte River, at 10:00. An hour later, the last of the water was gone. During its seventeen-mile plunge down the hollow, the flood had moved slowly, almost deliberately, but its awesome forces were twisting and seething inside its advance wave so that it pulverized everything caught in its path.

During those hours, most of the homes on Buffalo Creek had been touched in one way or another and a large number of them had been wholly destroyed. Four thousand of the area's five thousand inhabitants were homeless…The wreckage of hundreds of homes and other buildings was strewn all over the landscape, much of it splintered into unrecognizable mounds of debris, and the entire valley was coated with a layer of thick sludge. Trees that still stood despite the force of the flood had been stripped of their foliage and the very contours of the land had been reshaped. Miles of railroad track had been torn loose from the roadbed and were now twisted around trees or bent into coils like barbed wire. And scattered somewhere in all this litter were 125 bodies, hanging from tree limbs, pinned in wreckage, buried under piles of silt, or washed up limp on the banks of the creek. It took a long time to recover the bodies…7 have not been found at all, and 3—young children of identical size—lie in anonymous graves because they were too badly battered to tell apart. The story is that they were headless.

The Marsh Fork Elementary School in Sundial, West Virginia, sits below a mountaintop-removal mine site and immediately adjacent to a prep plant where raw coal is washed and processed before being loaded into railcars. The students and teachers at the school are subject to airborne dust from the processing facility, which begins just seventy-five yards from the school. A massive coal-slurry impoundment sits four hundred yards uphill from the school. It's designed to hold 2.8 billion gallons of liquid coal waste. In the event of a dam break, the school and other nearby residents would have only a few minutes to evacuate—a practical impossibility in the narrow Coal River valley.

In 2004 local resident Ed Wiley became concerned about the health problems that his granddaughter and other children schooled at Marsh Fork were experiencing. A skilled heavy equipment operator and former coal-industry worker, Wiley had helped build the towering earthen dam that holds the slurry impoundment above the school. In a heroic effort that has gained national attention, Wiley began a campaign to gain funding for a new, relocated school for the children of his community. He walked 450 miles from his home to Washington DC to meet with West Virginia Senator Robert Byrd. He and other coalfield activists have vigorously lobbied West Virginia's governor and education officials and even launched private fund-raising efforts to construct a new school.

Despite their tireless campaigning, as of 2009, the kids at Marsh Fork Elementary still sit in the shadow of a mountain being systematically scalped, beneath an ever-filling lake of coal-slurry waste, and next to a processing facility that potentially threatens their health and future.

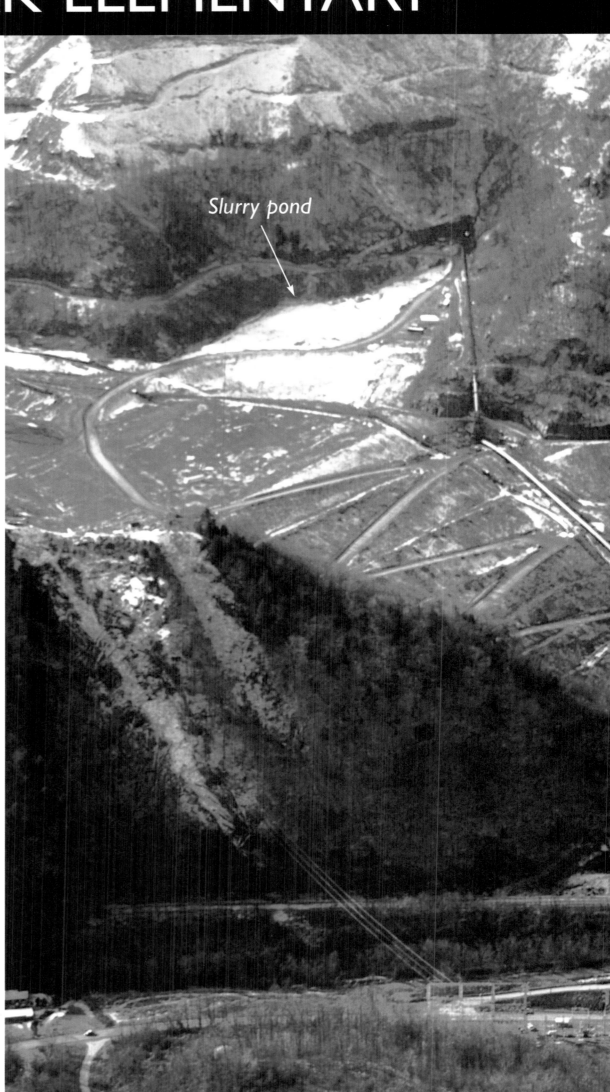

Slurry pond

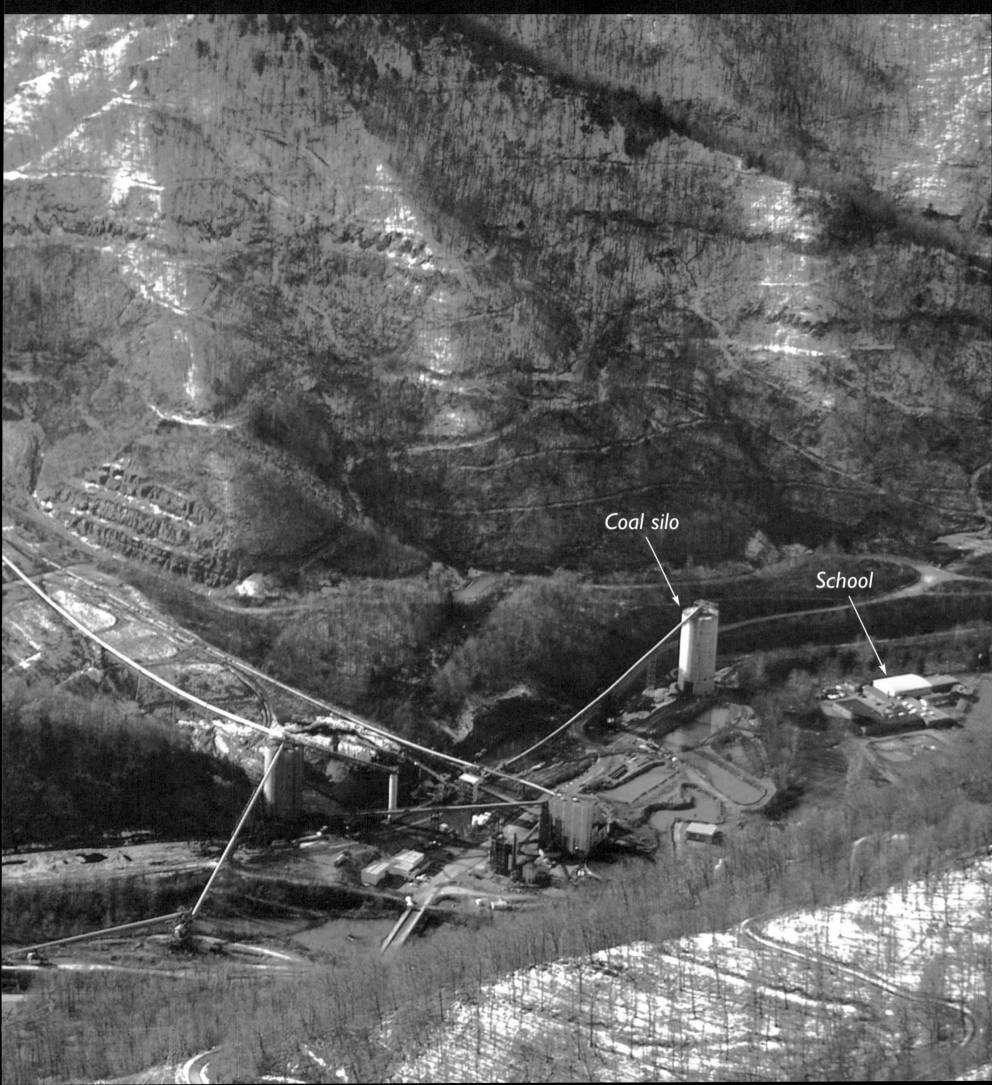

Coal silo

School

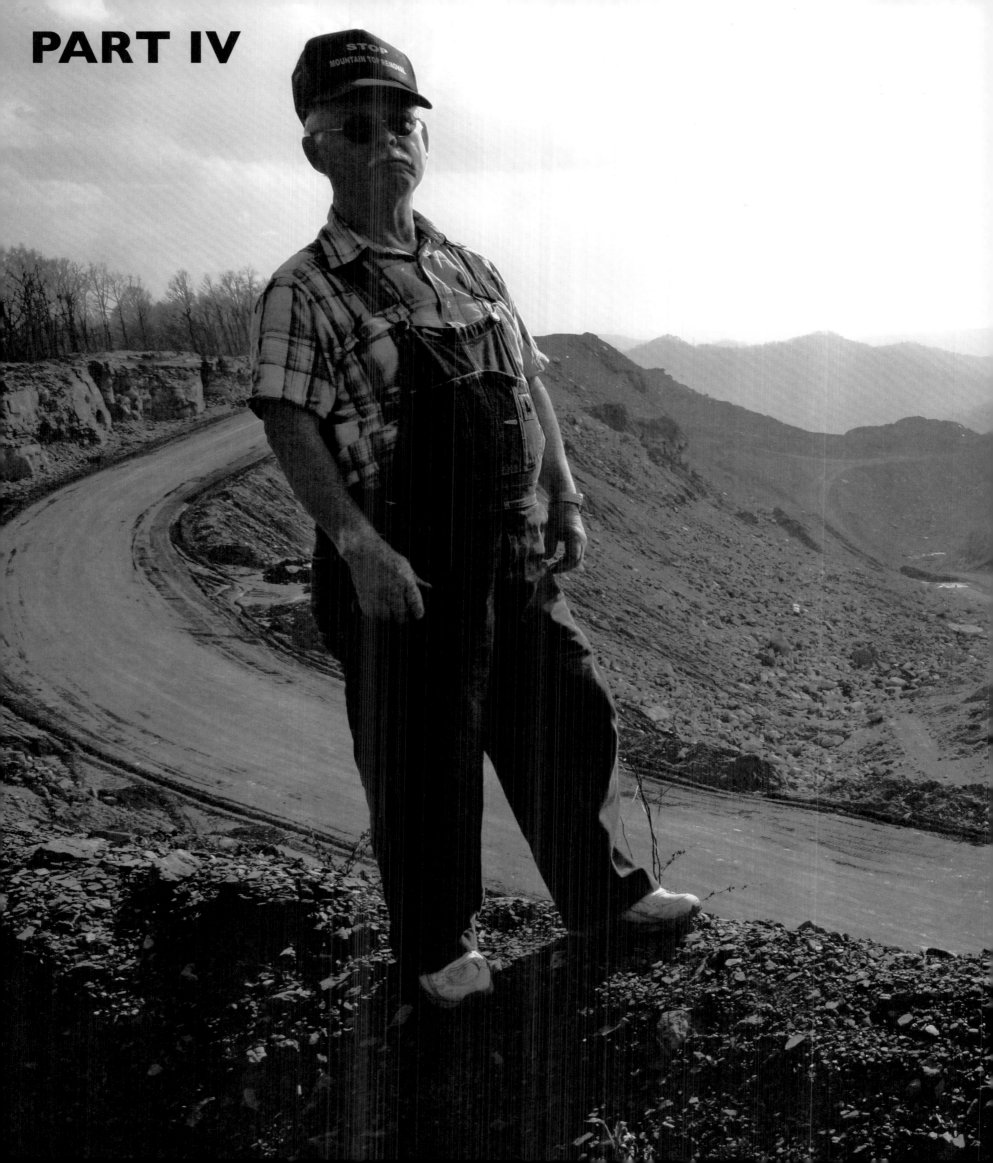

PART IV

TESTIMONIES
COALFIELD RESIDENTS SPEAK OUT

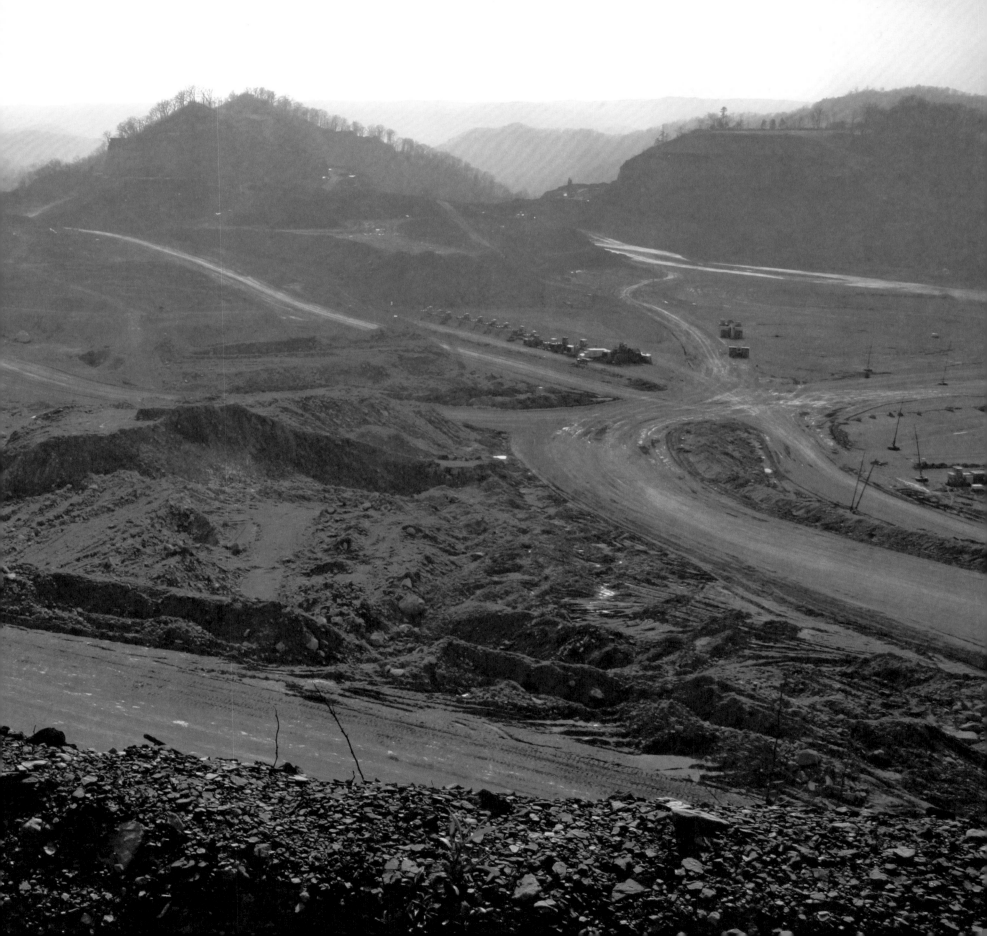

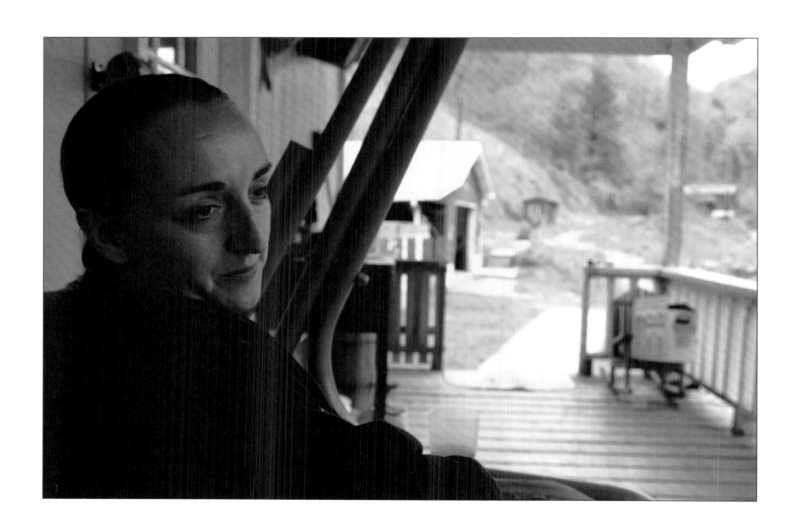

MY LIFE IS ON THE LINE

MARIA GUNNOE

Bob White, West Virginia

Since mountaintop removal moved into my backyard in 2000, I've lost two access bridges, the use of my water, and five acres of land. I've been flooded seven times.

The mountain behind me is crumbling in on my home. Everyone downstream from where that mountaintop-removal site is gets flooded, and their wells are contaminated. My well is contaminated. Can't drink my water.

In response to all the floods, and to the coal company's claims that this was an "act of God," I began organizing other people here in the neighborhood. I got to looking around, and it seemed that the people around me were being affected or were in line to be affected by this same mountaintop-removal site. I've also educated myself on mountaintop removal in the Appalachian region. And I've been working consistently for the past years on the issue and what it's doing to our communities.

People around here are swigging down contaminated water all day long, every day. Many folks around the area have pancreatic cancer or some kind of liver disease, or kidney stones, gallstones, digestive tract problems. The blasting causes all kinds of dust, which we have to breathe. Why do they expect us to just take this?

Through my organizing, I've met quite a bit of opposition. I've had my children get harassed. I've been accused of all kinds of stuff. I've had sand put in my gas tank. Teachers in the schools make comments to my kids. I've had my tires cut, my dog shot. People spit on my truck all the time—big, gross tobacco-juice spit.

When all this first come up, I really felt it was in our best interest to leave, but the property's been devalued so bad that you can't get nothing out of it to move forward with your life. And you can't hardly walk off and leave everything you've got.

The people in these communities, they feel the blasting, they see the overloaded coal trucks on the road, but they don't see what it looks like from the sky. That scares you. When it rains here, we all get flooded. After five acres of my land and my life washed down the stream, the coal company engineer came into my front yard and said that this was "an act of God"!

That was the same claim they made after they killed 125 people in the Buffalo Creek flood. I lost family in the Buffalo Creek flood. My father was a rescuer in the Buffalo Creek flood. So that incident was very close to our family.

My father and my grandfather before me took very good care of this land. We had fruit trees and an abundance of food-producing plants. Now our soil's contaminated. A garden that we'd tended for all the thirty-seven years that I've been here is now covered with coal slurry. You can't grow food in that. My yard was completely washed out. My fruit trees are gone. My nut trees are gone.

I'm setting there on my porch, which is my favorite place in the whole world, and as it stands right now, with the new mining permits, they're going to blast off the mountain I look at when I look off my front porch. And I get to set and watch that happen, and I'm not supposed to react. Just set there and take it. They're going to blast away my horizon, and I'm expected to say, "It's okay. It's for the good of all."

Am I willing to sacrifice myself and my kids and my family and my health and my home? No—my life is on the line. My kids' lives are on the line. You don't give up and walk away when they contaminate our water, our air, and our environment. There's no choice but to fight the coal companies that are blasting away God's mountains.

I see this happening throughout the communities in southern West Virginia, and also in Tennessee and Kentucky. And it's wrong. I mean it's flat-out wrong to do people like this.

Interviewed by Carol Warren

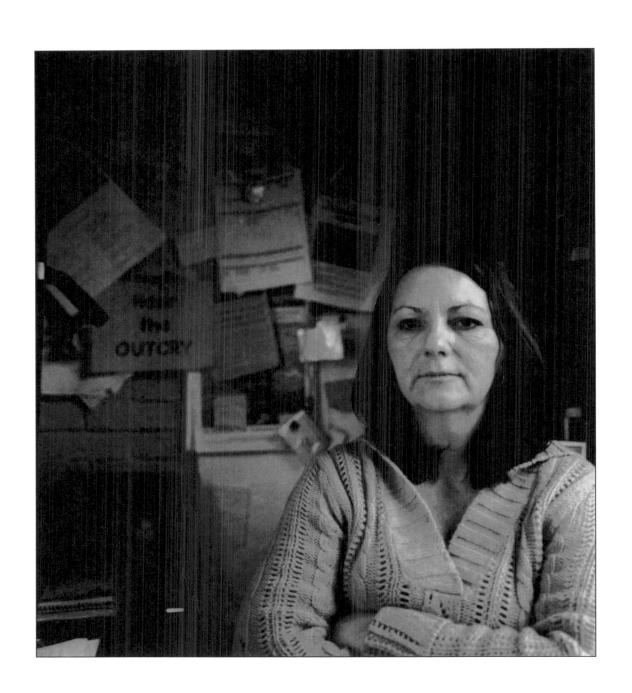

WE CAN'T LIVE WITHOUT WATER

TERI BLANTON

Berea, Kentucky

I left Dayhoit, Kentucky, to get married, and then came back with two kids. And I came back to my community where my family lived, as a single mother, thinking I was bringing my kids back to my community. I bought about three acres of land on the hill. And I worked for the circuit court clerk's office in Harlan—I was planning on building myself a solar-powered house. Then I found out I was living in the middle of a federal Superfund site. My water was polluted. And they had burned toxic waste there for years and years.

It wasn't discovered until 1989. I moved back in 1982. So I was there for about seven years with my children. My children would get sick all the time, and they would break out into rashes all over their bodies. It was a constant thing of never changing soaps, never changing detergents, never bringing anything new in the house. And you take them to the doctor and, you know, "It's a measles-type rash." "It's an allergic reaction." But to what? I remember one summer, because my daughter had a hard time breathing, I ripped all the carpets out of the house. Just anything and everything to make them not be sick. I felt like I was a scientist for a few years, because I could tell you about all these chemicals and exactly how many people out of how many thousand would die if they inhaled them or ingested them—simply trying to understand what had happened in my community.

The water didn't look any way other than normal. It didn't have a smell or anything, other than the coating on the inside of my toilet where the water would sit—an orange, furry coating. But I always had to replace my faucets. They'd disintegrate and I'd think, "Man, they don't make these things very good anymore." I watched my friend—she was suffering from cancer, and her mother was dying. And she'd had two different wells dug. They were doing massive blasting around her, and she's having to carry water into her house, being as sick as she was. I've watched the creek I would play in as a child be destroyed before my very eyes.

We can't live without water. In Kentucky we live in a forest with forty to fifty inches of rainfall a year, and can't get a clean drink of water. That's a sad story. And to think we've allowed one industry—one industry—to take it away from us. You cannot continue to destroy the most diverse hardwood forests in the world, leaving deserts on top of these mountain ranges, and expect to have water for the southeastern part of the United States. You can live without coal. You can live without oil. You can live without gas. But you cannot live without water.

It frightens the hell out of me because I just see it accelerating. When they say coal is a clean and cheap source of energy, it's like, "Okay, tell the people who live every day with coal in their lives that coal is cheap or coal is clean." I think they would say, "Come live a while in my house and you'll see how clean it is." Mountaintop removal is just one large symptom of the entire problem. The problem is that this is an outlaw industry that has operated above the law for the past one hundred years.

McKinley Sumner. He's in his seventies and lives at the head of his hollow. He's lived there all his life; his parents lived there before him. He had his land surveyed—it cost him a lot of money to do it, but he knew the mining was encroaching on him and he wanted to preserve his land. And you know you're walking through these forests to get to the top of his mountain, and you get to the top, and it's just gone. Gone. I mean, gone. Two-hundred foot drop-off, down to nothing. You're walking through the forest and then suddenly you come to the end of the world.

They had actually taken several feet of McKinley's land. I asked one of the people I was with if she would go over and stand where his land ended. And she said to me, "Well, I can't fly."

Interviewed by Rebecca Howell

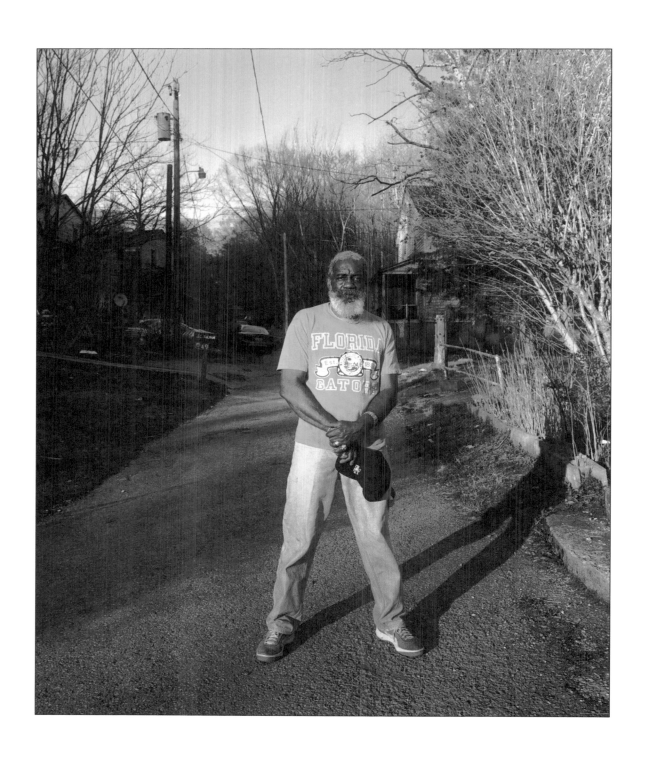

FLOODING US OUT

LUCIOUS THOMPSON

McRoberts, Kentucky

The Tampa Energy Company (TECO) operates a mountaintop-removal site just above Lucious Thompson's home.

Now, these hills have been stripped before, but they never have done like TECO done. Flooding us out. And dusting us out. Blasting us out. There never was nothing like that. Anything they can do to get you out of the hollow, that's what they want, so they can get the coal.

They say if they can move a hundred feet of rock, a foot of coal will pay for that rock that they moved. So, if you move a hundred foot of rock, and you hit a seam of coal five or six foot high, you making good money. Good money. And, you got a dozer operator, maybe three rock truck operators, and a drill man, and two powder men, and you ain't paying them nothing to work for you. Underground, you got two men on the miner, two men on the bolt machine, you got a curtain man, you got a repair man, and . . . well, you got about ten men on a section. Underground. The men are making good money, you making a hundred and something dollars a day.

They out here, they might be making six, eight dollars an hour working for TECO. They ain't union, they got no insurance, you got to buy your own. We had insurance underground, cause we were union. We were UMWA (United Mine Workers of America). Underground. They done us real good. They looked after us. We looked after each other. Every Monday morning we had a safety meeting and prayer for that week. We prayed together, the whole group. It was too beautiful under there. I loved it.

TECO, when they moved in here, they bought a trailer park from a boy in Jenkins. And they brought all their men in here—there's very few locals working for TECO. Very few. They said there wasn't no equipment operators up in here qualified to do nothing. They just do

what they want to do, and people let them get by with it. Some people get paid for the damage and some of them don't. Ain't nothing you can do with these people. If you get a lawyer, you can't win. You got one lawyer, they got forty-eleven of them. You know, they buy your lawyer under the table. Now, they offer you two or three hundred thousand dollars not to fight them, wouldn't you take it?

We had this addition put on the house and never did worry about it leaking. When they started all that heavy blasting, it shook the addition loose. They never did pay us for it. And they shoot forty, fifty, one hundred holes, and that's a good blast when they go off. It rock the nation. It knock all the dishes out the cabinet, pictures off the wall. I'm telling you. Right up here. See that clear spot right over there? It's that close. Just that close.

The second time they flooded this holler, it had rained for about two weeks, seemed like every day. They had about five or six dams built up there and they had coal piled up in it. And they was going to clean that pond, that pit of coal up, and what they had was loose dirt piled up to hold that water in there. When they sunk that backhoe bucket in that loose dirt all that water pressure just rushed it all out, it come all down through here. You talk about something awful. Car tires. Trees. Logs. Car hoods. Everything. 'Cause it used to be a garbage dump up there. Everything come down and you talk about something stinking. Good God almighty.

Up on that second step, that lady's house over there, that's how high that water come down through here. If it had been the kids out here, they'd of been washed off. It happened that quick. And I told them: 'I don't give a damn. Take me to jail, say I'm threatening, whatever. But if one of my babies had been out here and got hurt or got killed, I'd have killed every one of you. 'Cause you all know you're wrong.'

Interviewed by Rebecca Howell

THEY DO WHAT THEY WANT

PAM MAGGARD

Sassafras, Kentucky

This makes my seventh year in my house. Kids used to ride bikes. The guy at the end of our street, his son used to skateboard in front of our house all the time. Now, children play out on the street on Sundays, since that's the only day the coal trucks don't run.

You would not believe it. Halloween. Kids dodging coal trucks, actually, the trucks dodging kids, going down the center of the lane. Now, you know the drivers could have made concessions. They knew when the kids would be out trick-or-treating. They could have been home by then. They could have done without a load. I wanted a picture. I want people to see this. Nobody knows that kids have to trick-or-treat and dodge coal trucks in eastern Kentucky. The drivers could have taken the access road. They could have gotten up extra early. They're only supposed to run seven in the morning to five-thirty, six at night. But, honest to God, I've been outside in the summer and had a truck go past me at eleven-thirty at night. They run when they want. They do what they want. We can't even get the speed limit lowered.

You see the ads on television: *TECO Pride*. Hal Rogers is the only politician I've written who I haven't heard from. And in my letter to him I said, I don't think we can be advertising PRIDE [Personal Responsibility In a Desirable Environment, launched in 1997 by Congressman Hal Rogers] in Kentucky when tourists come through and see roads torn up, dirt, and dust. See that they're mining behind our water supply. Carr Creek Lake is our water supply, and I just can't believe they're mining that close to it. So much of this seems so illogical. You just shouldn't have to fight for this stuff. We thought we had an EPA. We thought we had people looking out for us. But I don't think they do.

The longer you stay here, the more invested you become, and the more they're stripping. Speaking as a person in education, recently in the news they've been putting out all these reports that the counties richest in coal are the poorest counties in the state. We should have every piece of technology in the world at this school. Our school should not do without anything. We didn't even have enough money to pay a music teacher this year. That's not progress. I had a music teacher when I went to school forty years ago. These kids shouldn't have to do without anything. They're hauling all that coal out of here, and the kids are suffering these consequences, and they can't play on their roads; they have no sidewalks. Our schools should be state-of-the-art, and we don't have a music teacher.

Near the end of the year, I gave extra points, in free time, to work on posters and draw what it's like to live around coal. And I had a lot of posters, excellent art; my kids are excellent artists. One had coal flying off and hitting a truck. I had another one with the big potholes in the ground. They would say things like "Please slow down." I got more than enough information to know that their lives aren't all hunky-dory.

I think the world needs to know what mountaintop removal is doing to our communities. They're just taking so much away, not just our mountains. It totally affects your whole life. I can get out and clean my house and spray it down. My elderly neighbors can't. The lady at the end of the street can't sit outside anymore. Mrs. Polly watches her little birds through her window. And I know that doesn't sound like much, but when you've worked your whole life for it, that's a lot. Owning a home is the American dream. If that's what she enjoys, if that's the way Mrs. Polly wants to spend her retirement, she should have the right to do it in comfort and peace.

Interviewed by Rebecca Howell

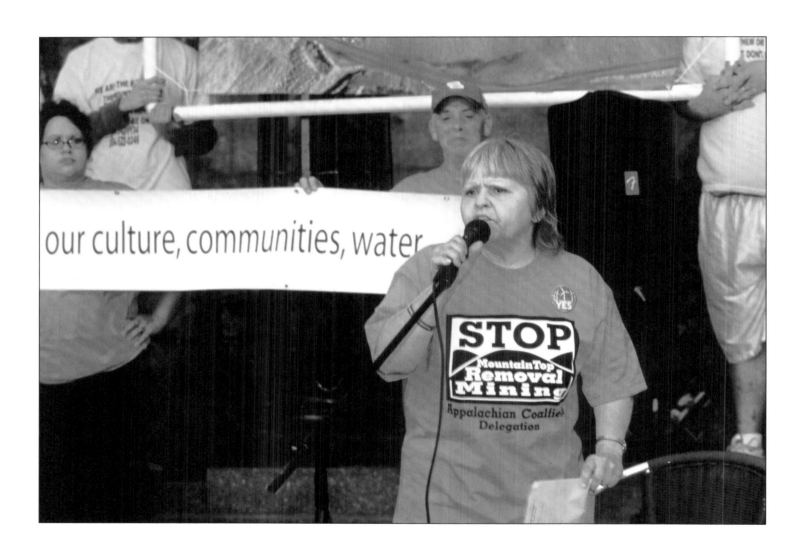

WE WON'T SHUT UP

JUDY BONDS

Rock Creek, West Virginia

The coal operators, from the moment they stepped foot in West Virginia, were determined to rape and run, determined to beat us down as a people, determined to use us as their servants in any way they see fit. Why not speak up? You have nothing left to lose. I mean, they poison us, they blast your house, they threaten you—what else do you have left to lose? What else can they do except kill you, and you're going to die anyway, and my theory is, I'm going to go out swinging. My family has never been one that would back away from something as important as this.

My mother was never one to shut up about an injustice. My mother always spoke up. My family comes from Scots-Irish heritage—scrappy people—and we don't shut up. Going back centuries, we fought for our existence. My ancestors fought bears and mountain lions to live here. And I'm going to let a coal company destroy that? Why would I do that?

It's not simply about my mountains or my hollow or my stream, it's about our existence as human beings. It's about not allowing an industry to poison your neighbors, to poison your friends. The day that I stood and watched black water—coal sludge—go down my creek, I knew Whitesville's drinking water intake pipe was three miles downstream. My relatives, and people I loved, were going to be affected. I knew a coal company was poisoning the people below me. How do I not react to that? If I had stood there and not said anything, I would've been just the same as the people doing the poisoning.

My family lived in Marfork Hollow for six generations, and in the Coal River Valley for ten generations. My grandson is the tenth generation. No one lives up in the hollow now; the coal company put up a gate. I was the last one to leave.

We [activists from Coal River Mountain Watch] don't work alone. We don't travel alone. My daughter got me a stun gun for Christmas this year. And it's not the companies that I worry about—it's the local people

that they're scaring into thinking that we're trying to take their jobs. Well, no one needs a job that poisons their neighbor. Those are unacceptable jobs. But still, the workers believe the coal companies. That physical threat is there, absolutely it's there. I've been told that my picture and Larry Gibson's picture are up on the wall in some coal company offices. You feel shunned, but the intimidation can be physical and it has been physical.

If you don't know where you came from, you don't know who you are. And that sense of place, that strong sense of living in the hollow, and your connection to that ground, your connection to that river, your connection to where your parents and grandparents lived—that's very fierce in us. And that job in the mine is maybe the only thing that allows you to stay in your homeplace, even while it's destroying that place. People think it's the only option. It's a very tricky, complicated thing.

I think the sense of pride among miners comes from the fact that you do have to be tough. There's no other way around it. You have to be tough to be a coal miner. But we were mountaineers long before we were coal miners, there was a love and connection to this land long before they went in there and set blasts and dug coal.

My daddy was a mountaineer before he was a coal miner. God made mountaineers. Man—and greed—made coal miners. I'm sorry, that's the truth. My daddy mined coal to make money. I prize my sense of being a mountaineer, my sense of place more than I prize the money that coal mining brought, and if I knew then what I know now, I would rather my father have lived off the land. I would rather not have had any materialistic things, because my father suffered mightily from black lung. It broke his body. It broke him. He died six months after he retired. And coal does that to people. It breaks a man's back. It breaks his spirit. You see what it does to people—that they're willing to allow their children to be poisoned so that they can make a living. Coal does bad things to you.

Interviewed by Tom Butler

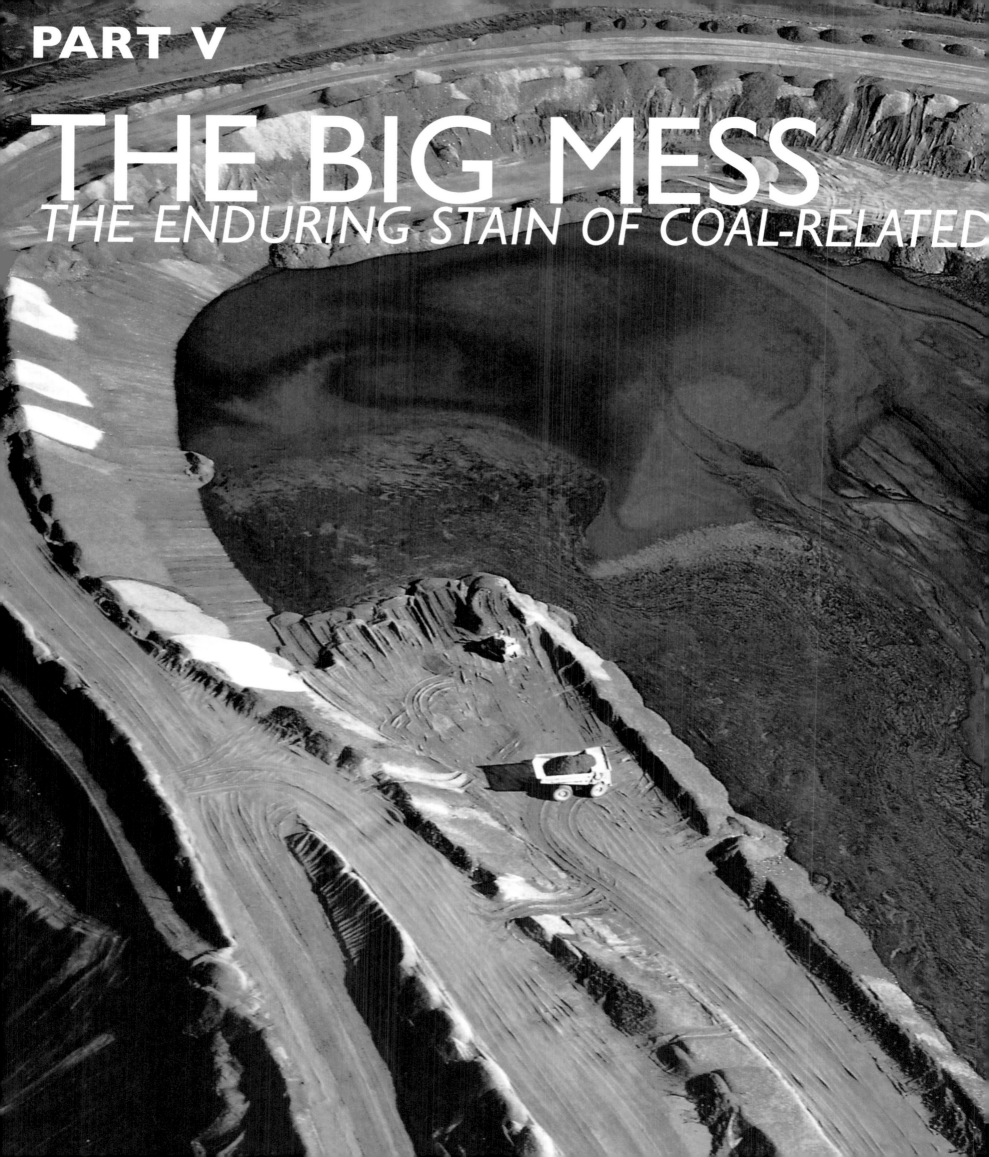

PART V

THE BIG MESS
THE ENDURING STAIN OF COAL-RELATED

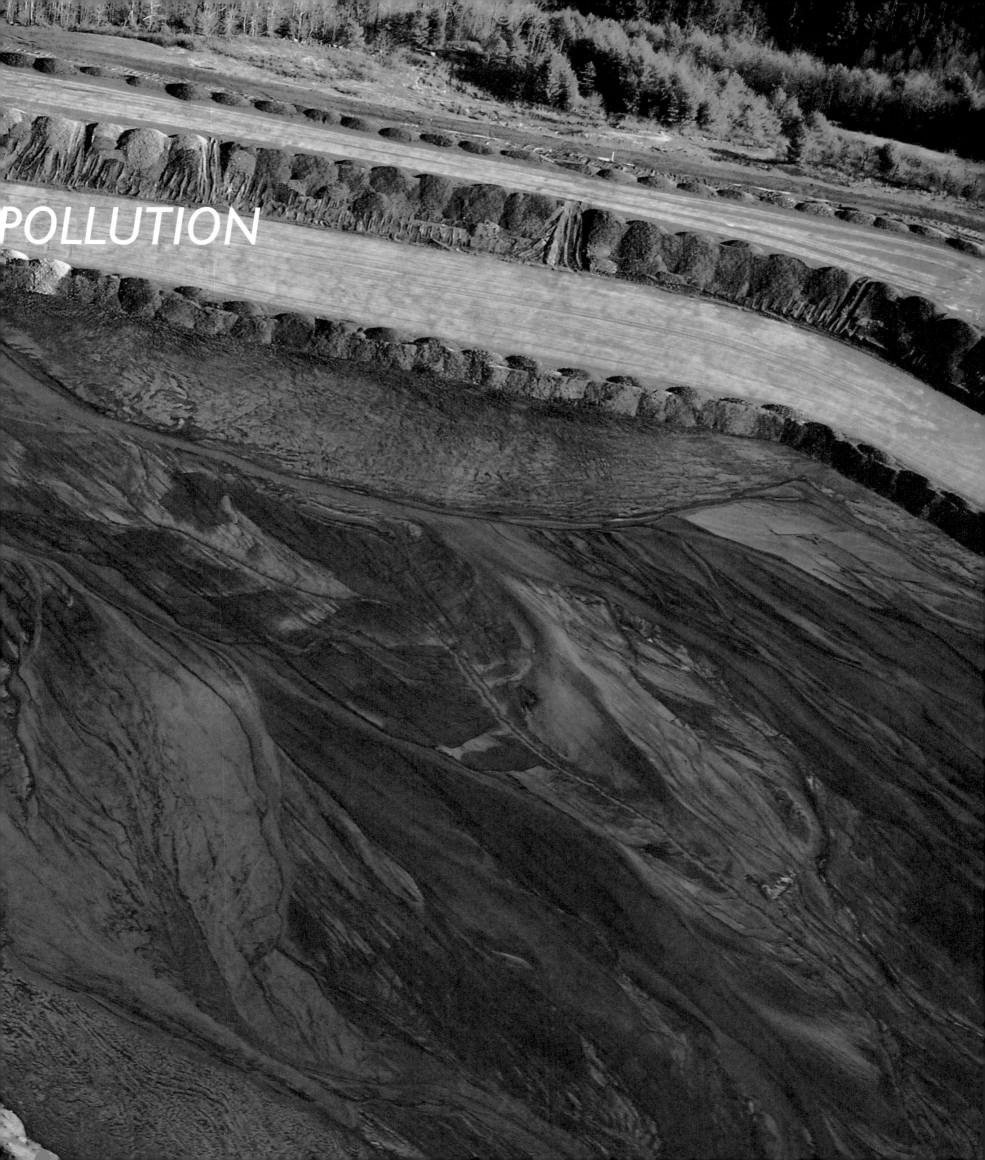
POLLUTION

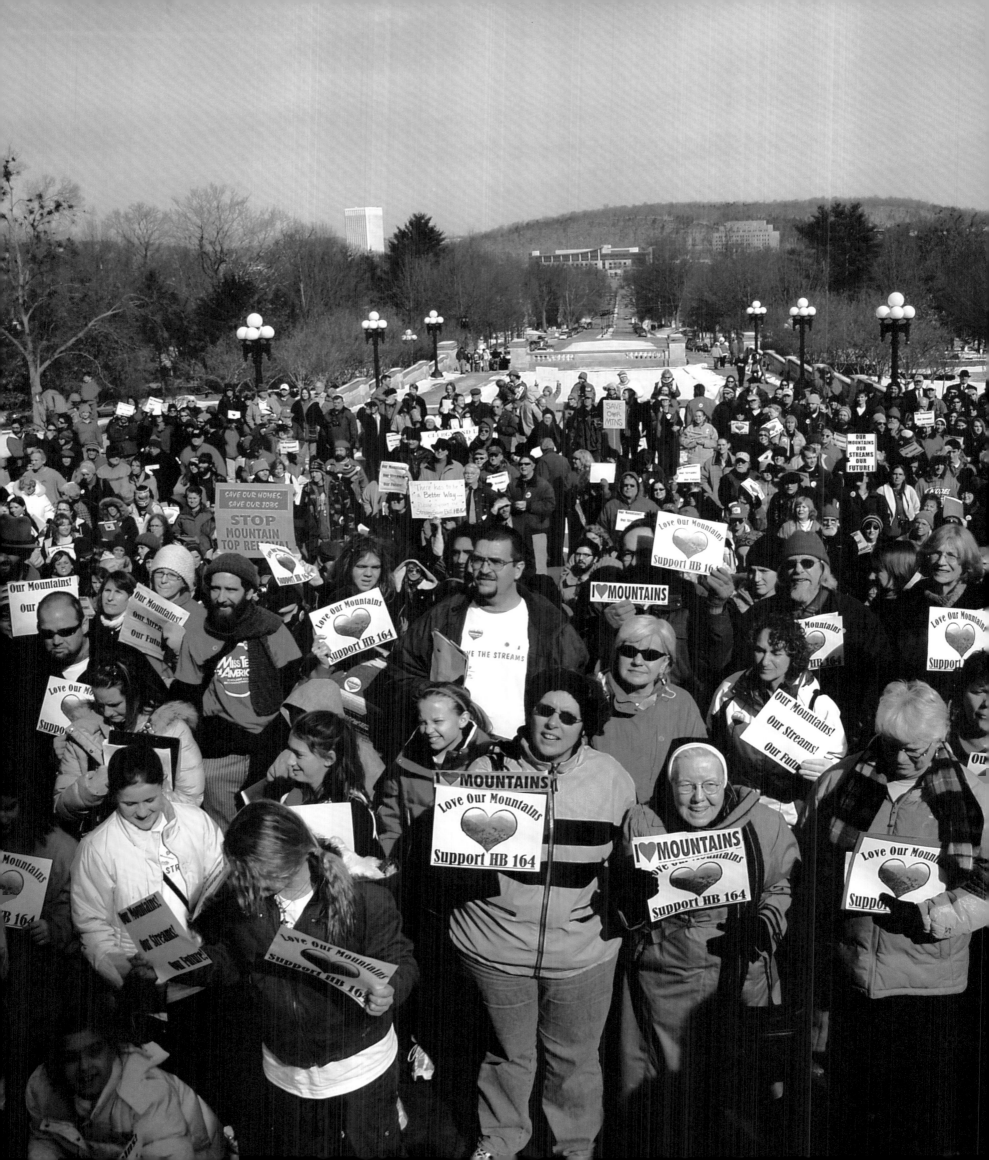

FIGHTING FOR AMERICA

Mountaintop Removal and the Subversion of Democracy

ROBERT F. KENNEDY JR.

King Coal sells its product to the American public as cheap and clean—but the propaganda phrase "clean coal" is a dirty lie. While coal-generated power may appear cheap on your electric bill, its true costs to our nation make it the most catastrophically expensive method ever devised for boiling a pot of water. Coal's hidden costs begin with its extraction.

If the American people could witness the destruction I have seen in the coalfields of Kentucky and West Virginia there would be a revolution in this country. Mountaintop-removal mining is devastating southern Appalachia, tearing up mountains, burying streams, flattening forests, and extinguishing the region's rich culture.

In 1968, my father, then fighting strip mining in Appalachia, told me that the coal companies were not just destroying the environment, they were permanently impoverishing local communities. "There is no way to generate an economy from the moonscapes they leave behind," he said. "They're doing it so that they can break the unions." He was right. Back then, there were tens of thousands of miners in West Virginia; unionized workers taking coal out of underground mines were the economic life-blood of coalfield communities. Today there are less than 6,000 union miners left in the state. The coal moguls are mining more coal than in 1968 but with far fewer workers due to mechanization and increasing emphasis on surface mines. Then as now, the profits go to the Wall Street bankers and out-of-state corporate interests who would liquidate West Virginia's natural heritage for cash.

Detonating explosives equivalent to a Hiroshima bomb weekly, the coal barons are blasting the tops off the mountains to access sub-surface coal seams. Giant machines—draglines and dozers—then scrape the rubble and debris into the adjacent valleys, filling the hollows, and leveling the landscapes. They've already buried 1,200 miles of streams, decapitated nearly 500 mountains, and flattened hundreds of thousands of acres of Appalachia's irreplaceable forests. They will soon have destroyed a landscape the size of Delaware. It's all illegal. You cannot dump rock, debris, and rubble into a waterway without a Clean Water Act permit. So environmental lawyer Joe Lovett sued the industry and prevailed before a conservative federal judge in West Virginia, the late Charles Hayden. Hayden agreed that the entire racket was unlawful and enjoined all mountaintop mining.

After that judicial decision, Peabody Coal and Massey Energy, two of the nation's biggest coal companies, met with Bush administration officials who obligingly overturned thirty years of statutory interpretation by changing the meaning of one word of the Clean Water Act. Their new definition of the word "fill" effectively overruled Judge Hayden's decision, making it legal to dump rock, rubble, construction debris, and other solid waste into any American waterway without a Clean Water Act permit. All they need today is a rubberstamp permit from the Army Corps of Engineers.

Devastated mountains, ruined communities, and political corruption are the legacies of coal mining in Appalachia—but there are many other costs of coal. Carbon dioxide pollution from coal plants is the primary cause of climate change, which threatens to destroy human civilization and cause the death of hundreds of millions of people. Acid rain from coal plants has sterilized one-fifth of the lakes in the Adirondacks and degraded Appalachian forests from Georgia to Quebec. Mercury from coal plants has helped poison 100 percent of the waterways in nineteen states and contaminate fish in all fifty states. According to the EPA, one in six American women now has toxic levels of mercury in their bodies that threaten their children with a grim inventory of disease including mental retardation. Some 640,000 American children born each year have been exposed to dangerous mercury levels in their mothers' wombs. Ozone and particulates from coal plants kill tens of thousands Americans each year from respiratory failure and cause a million asthma attacks and a million lost workdays.

The government's response is to ignore these crimes. Captured regulatory agencies shield the coal barons from enforcement of environmental and public health laws while toadying politicians in thrall to their Big Coal paymasters pass laws to insulate this filthy industry from private litigation. Adding insult to injury, the federal and state governments provide billions of dollars in annual subsidies and pollution waivers to coal moguls already rolling in cash. Those subsidies allow the coal companies to multiply their crimes against our generation and our children.

When Henry David Thoreau went to prison for protesting the Mexican-American War, his friend Ralph Waldo Emerson called to him through the prison window, "What are you doing in there, David?" Thoreau's answer: "What are you doing out there, Ralph?" Today each of us needs to recall Thoreau's question and ask what we are doing to stop this criminal holocaust.

AIR POLLUTION

Coal-based energy production causes air pollution during mining, transport, and combustion. During surface mining, large amounts of coal and rock dust are spewed into the air when mountaintops are blown apart. Additional coal-dust particles are broadcast into the atmosphere during transport, whether by truck, train, or barge. Carbonaceous particles in the air can cause children to develop asthma and adults to have difficulty breathing and in severe cases can lead to black lung disease. The sulfur contained in coal dust can accelerate weathering of limestone and marble used in buildings and cemetery headstones.

Coal-fired power plants emit 59 percent of total U.S. sulfur dioxide pollution and 18 percent of total nitrogen oxides every year. They are also the largest source of mercury pollution and responsible for 50 percent of all particle pollution, which is linked with various respiratory ailments and other chronic health problems in people.

Acid rain is caused when sulfur and nitrogen oxides from coal-fired plants mix with water in the atmosphere. This unnaturally acidic precipitation leaches critical nutrients from the soil, harming plant growth. Acid precipitation has been measured as low as 2.12 pH (neutral is 7.0) on Mount Mitchell in western North Carolina. Acid rainfall is notoriously famous for killing brook trout in some of the lakes found in the Adirondack Mountains in New York.

Coal burning is the largest single source of greenhouse gases worldwide—and roughly 40 percent of U.S. emissions of greenhouse gases come from coal-fired energy production. Pollutants released by coal burning also include uranium, thorium, and other heavy metals. Ironically, coal burning is one of the largest sources of background radiation exposure—with more radiation permitted to occur downwind from coal-fired plants than many nuclear facilities.

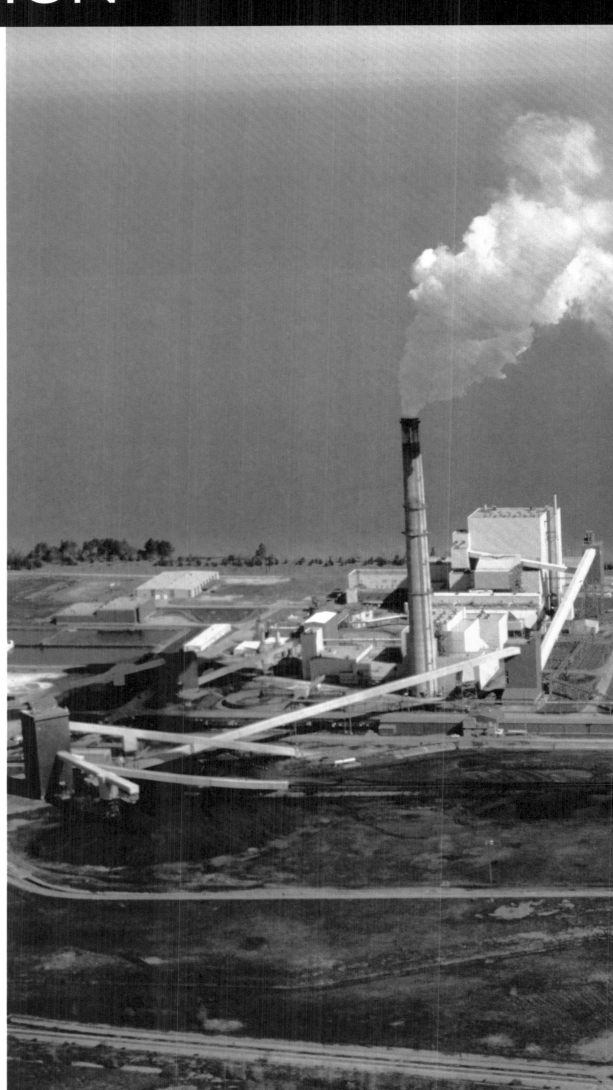

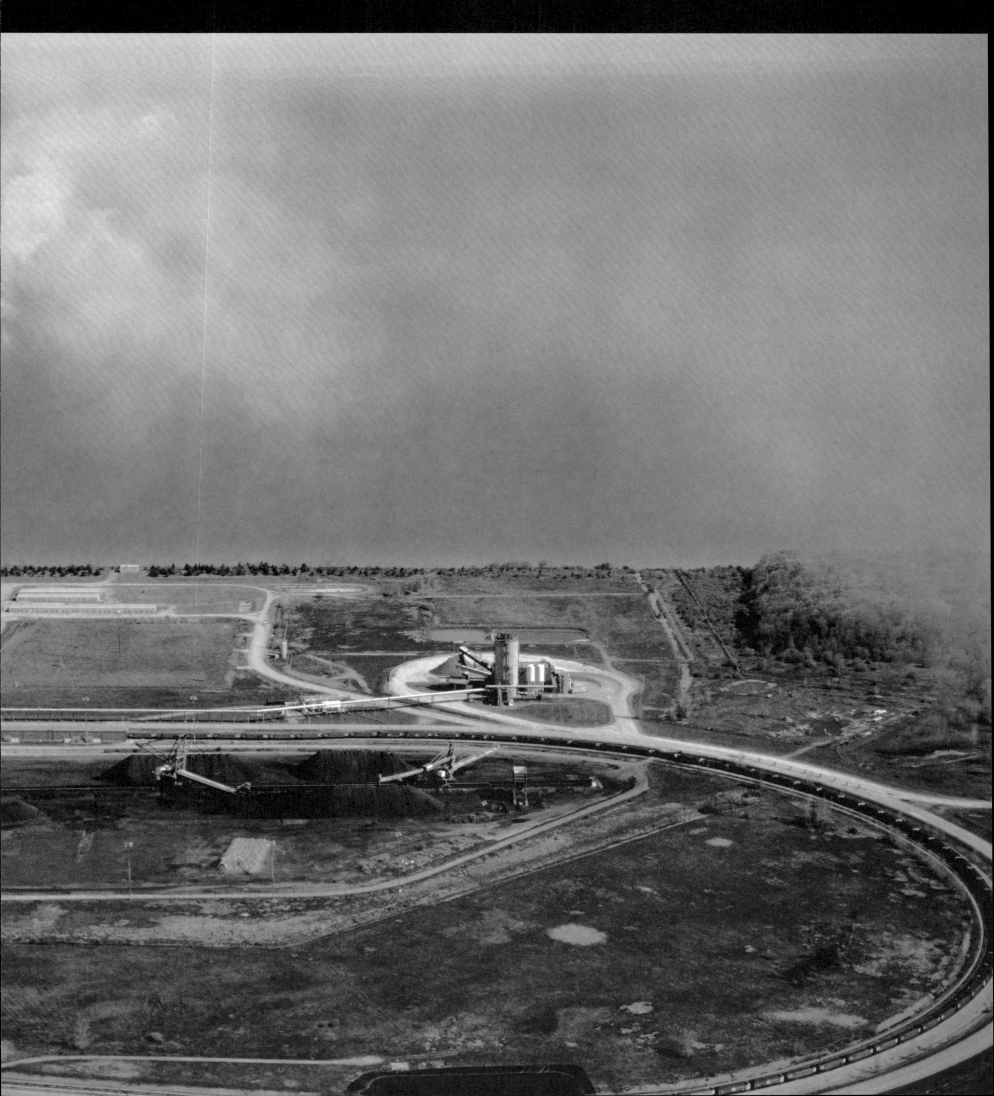

Coal-burning power plants are the single largest source of toxic mercury pollution emitted into the atmosphere in the United States. Electricity generation is responsible for roughly 40 percent of total human-caused mercury emissions, with coal the overwhelmingly dominant source, but oil- and natural gas–fired plants emit mercury at lesser levels. Mercury can also leach into streams from mine runoff.

Mercury, sometimes called quicksilver, can be inhaled and absorbed through the skin and mucous membranes. Mercury causes both chronic and acute poisoning. Chronic exposure may cause tremors, impaired cognitive skills, and sleep disturbance. At higher levels of exposure, psychotic symptoms occur; these include hallucinations, memory loss, depression, suicidal tendencies, and insomnia.

Mercury can also affect fetal development. In unborn children, it is a source of brain damage, mental retardation, and blindness. In many parts of the United States today, mercury pollution is known to bioaccumulate in fish, particularly certain species, making it dangerous to regularly consume fish taken from local streams and lakes. The federal Environmental Protection Agency tracks fish advisories issued by state and tribal governments around the country and has offered general recommendations on fish consumption. While the dangers of mercury injestion from wild-caught fish are highest for pregnant women and children, eating fish high in mercury has also been found to put middle-aged men at risk for heart disease.

Across Appalachia, there are numerous lakes, streams, and rivers covered by fish consumption advisories issued by state agencies because of known high levels of mercury, PCBs, and other pollutants affecting fish populations.

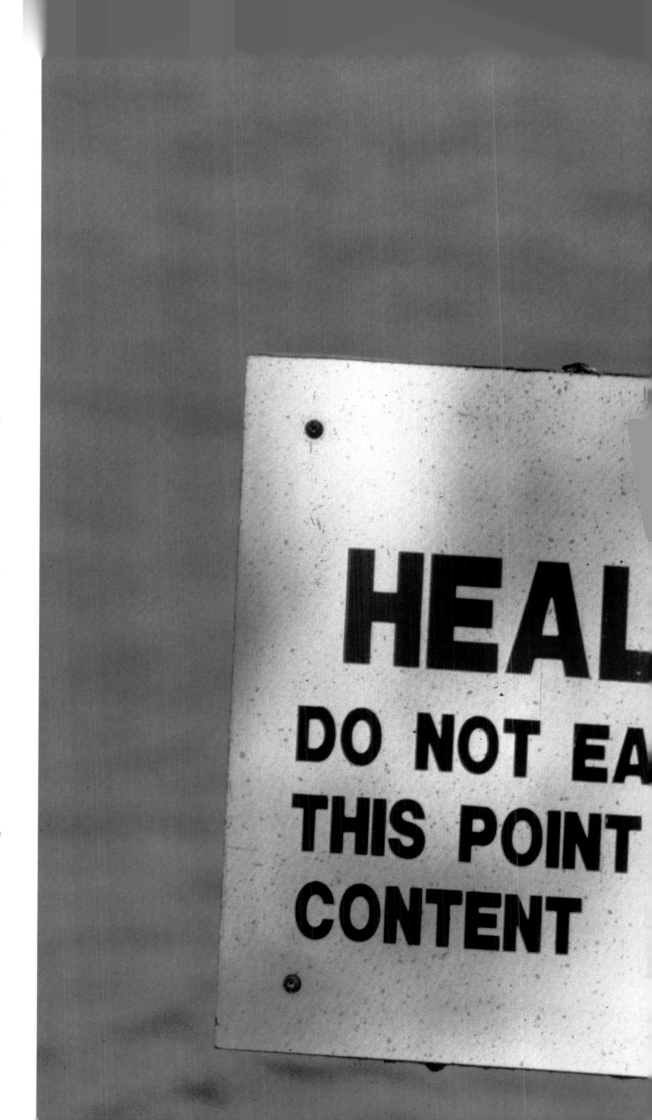

WARNING
TH HAZARD

T BASS CAUGHT BEYOND
DUE TO HIGH MERCURY

WATER POLLUTION

Coal mining in all its forms is a major source of water pollution in Appalachia. This pollution affects all living things, from human residents to the smallest aquatic insects in the region's headwater streams. Massey Energy, which operates dozens of underground and surface mines across Appalachia, agreed in 2008 to pay a twenty-million-dollar civil penalty for more than forty-five hundred violations of its Clean Water Act permits. It was the largest such penalty ever assessed by the U.S. Environmental Protection Agency for Clean Water Act permit violations. The government complaint noted unlawful releases over a multiyear period, with Massey operations discharging excess amounts of metals, sediment, acid mine drainage, and coal slurry, affecting hundreds of streams and rivers in West Virginia and Kentucky.

Water quality violations pose a real threat to people because of the high dependency of Appalachian citizens on surface and well water. One government study of the Kanawha–New River Basin found that 61 percent of human residents relied upon surface water for their domestic use, and another 31 percent relied upon domestic wells. The report concluded: "Stream sites downstream from mines more commonly exceeded drinking-water guidelines for sulfate, iron, manganese, and aluminum concentrations than streams in unmined basins." The study also found that iron and manganese concentrations exceeded EPA drinking-water guidelines in at least 70 percent of wells near "reclaimed" surface coal mines.

Mining-related water pollution greatly affects aquatic ecosystems. According to an EPA study, "comparison of unmined sites and filled sites in Kentucky and in the New River drainage indicate that mountaintop-removal/valley-fill coal mining has had an effect on the number and composition of the fish communities in these streams." In another study published by the EPA, researchers found "that benthic macroinvertebrate communities at all the test sites (mined) were severely impaired."

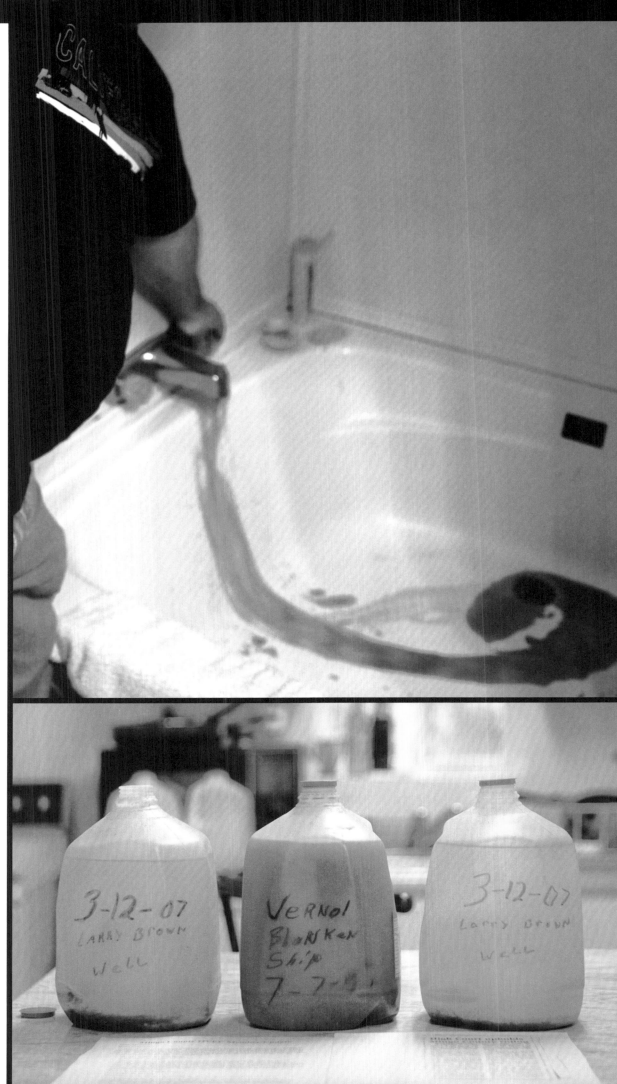

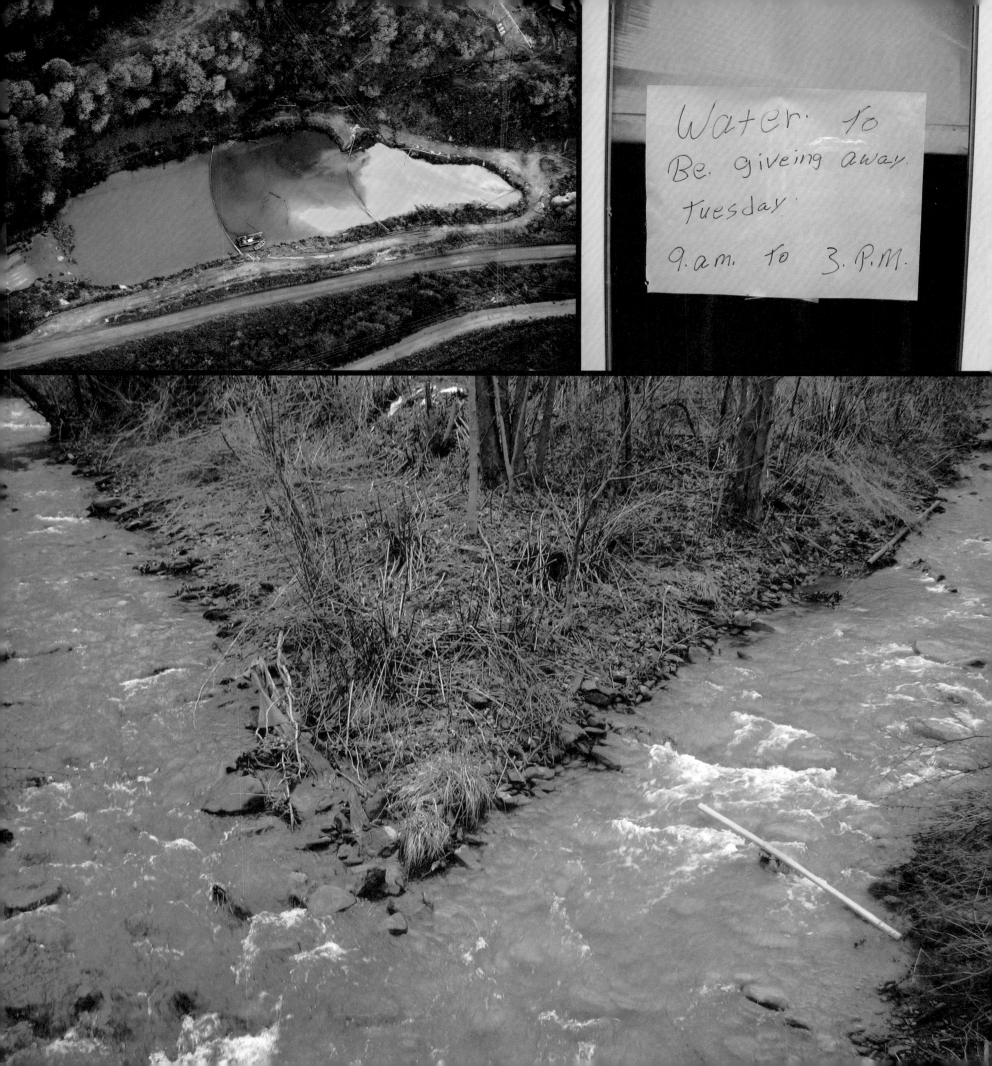

ACID MINE DRAINAGE

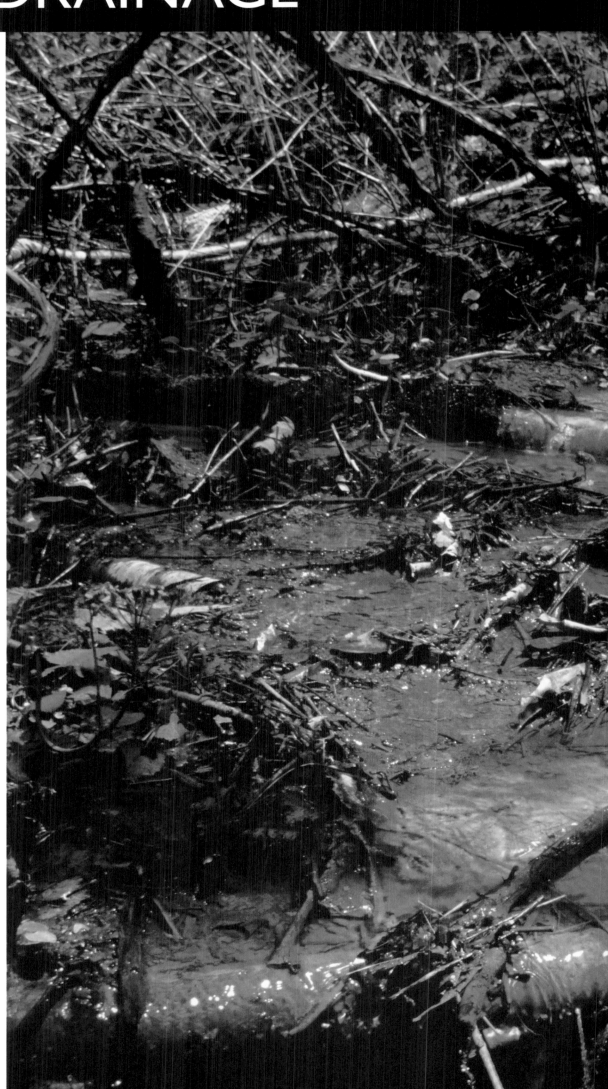

One major environmental impact of coal mining is acid rock drainage, also known as acid mine drainage. Acid drainage occurs when rock high in metal sulfides such as iron sulfide (pyrite, or "fool's gold") is exposed to air and water, creating sulfuric acid. The iron precipitates out of solution, coloring the bottom of contaminated waters red, yellow, or orange. The U.S. Geological Survey notes, "The acidity of coal-mine drainage is caused primarily by the oxidation of the mineral pyrite (FeS_2), which is found in coal, coal overburden, and mine-waste piles."

As the pH of drainage water decreases and becomes more acidic, it increases the leaching of additional minerals. Iron-oxidizing bacteria, microorganisms that naturally live in acidic waters, can exacerbate the process, leading to pH that is one thousand times more acidic than would occur in their absence. Lower pH waters also leach out more toxic heavy metals such as lead and copper, further contaminating the resulting acid-mine drainage.

Exposing mine walls to air and water increases acid runoff, but the broken rock surfaces in talus piles—mining-waste piles and dumps—have the greatest rock surface area for acidification to occur, hence the worse drainage problems are usually associated with these sources. Surface coal mining can cause acid drainage, but much of the problem is attributable to underground mining operations going back decades.

The bituminous coalfields of Pennsylvania, West Virginia, eastern Kentucky, western Maryland, southwestern Virginia, and southeastern Ohio are the most susceptible to acid mine drainage and account for 95 percent of the reported occurrence in the eastern United States. More than eight thousand miles of streams in the eastern United States are estimated to have been negatively affected by coal mining–related acid drainage.

Acid mine drainage disrupts aquatic ecosystems, killing many organisms including fish, mussels, and aquatic insects. It also contaminates drinking water and causes accelerated corrosion of metal pipes like those used in wastewater treatment facilities.

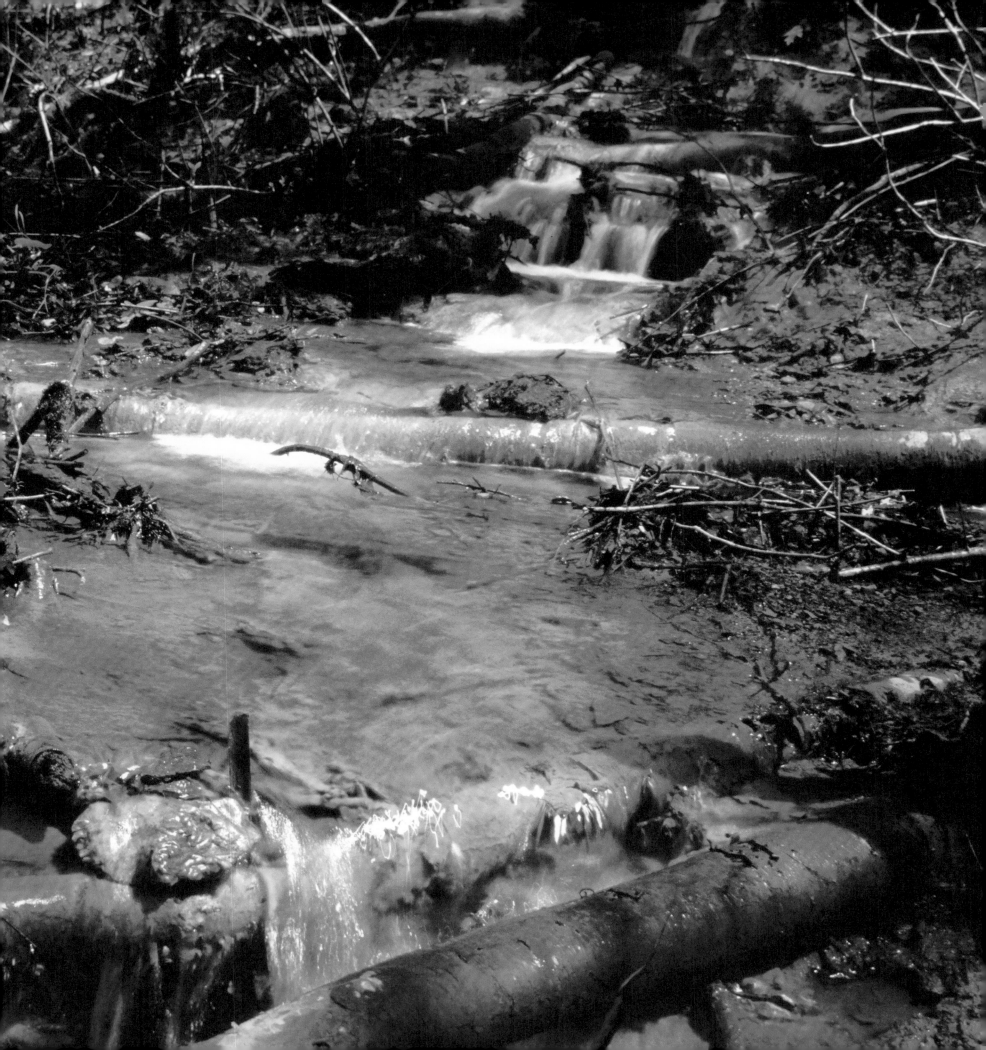

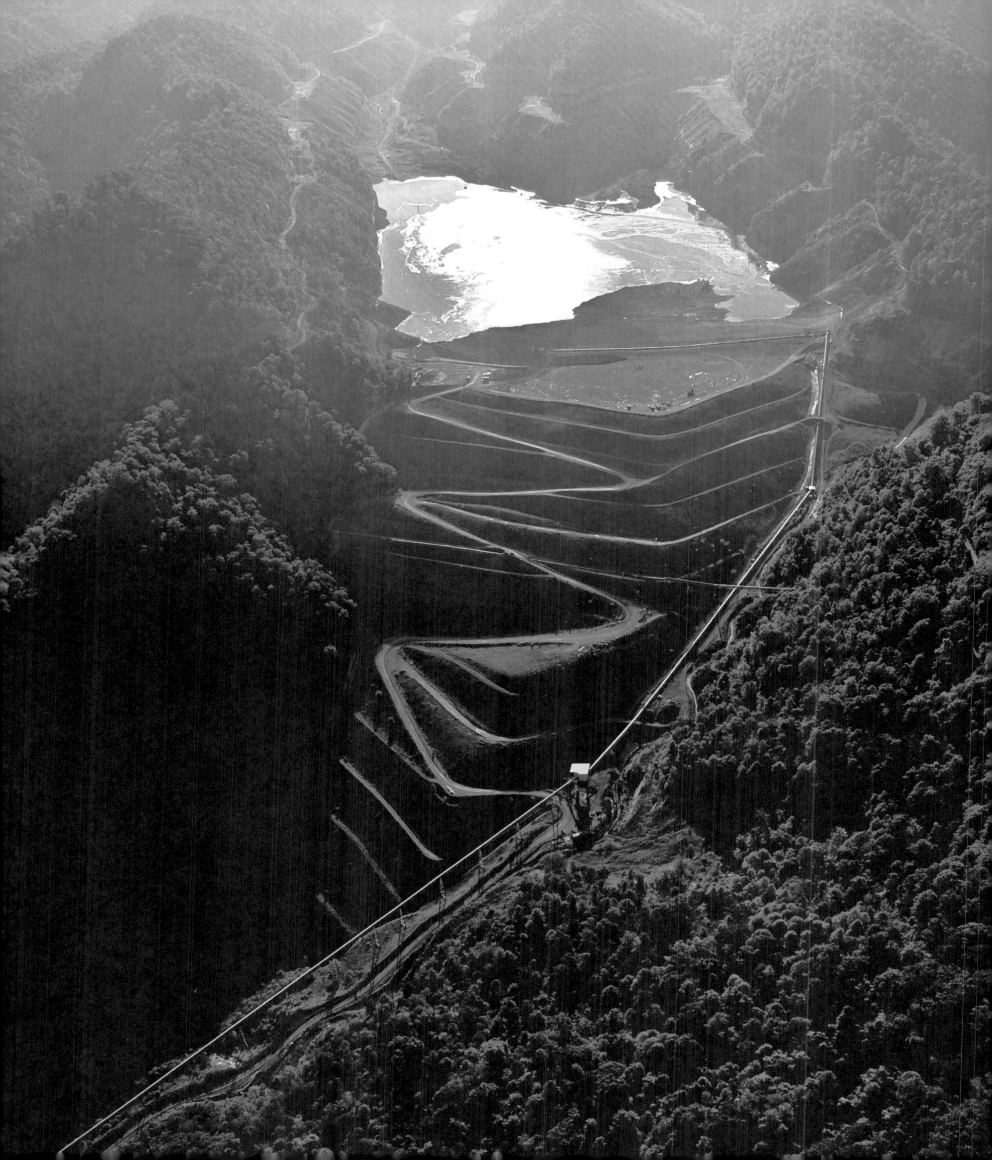

LAKES OF WASTE

Coal-Slurry Impoundments

VIVIAN STOCKMAN

In 1972 a coal-waste dam failed at Buffalo Creek, West Virginia, killing 125 people and leaving thousands homeless. Largely as a result of this tragedy, in 1975 the Mine Safety and Health Administration (MSHA) drafted regulations governing the construction, design, and maintenance of coal-waste dams. The Buffalo Creek disaster was also a contributing factor prompting passage of the Surface Mining Control and Reclamation Act of 1977.

Before being transported to market, coal is processed to separate it from the surrounding soil and rock—the more impurities a company can remove from coal, the higher its market value and the lower its transportation costs. The washing process generates huge volumes of coarse refuse and liquid waste. The cheapest way for coal companies to deal with this waste is by constructing dams from the coarse refuse to impound the liquid waste. Coal companies usually build these dams in stream valleys, called "hollows" in Appalachia, close to their coal-processing plants. (The mining process itself generates millions of tons of solid waste—excess rock and coal. Some of the solid coal waste is left on site as part of the backfill area, and, in mountaintop removal, the excess rock and spoil from the mining are also dumped into stream valley hollows. These "valley fills" bury additional miles of streams.)

The dams and impounded slurry or sludge are often euphemistically referred to as "ponds," but "toxic lake" is a more accurate name, as coal-sludge impounds typically store vast quantities of liquid coal waste. Marfork Coal's Brushy Fork slurry impoundment, currently permitted for 645 acres, sits above the community of Whitesville, West Virginia. The dam is permitted to hold eight billion gallons of slurry and, when complete, will be the largest slurry impoundment in state history. The waste-rock dam will stand 920 feet from toe to crest, 50 feet higher than the famous New River Gorge Bridge at Fayetteville, West Virginia. Yet the Brushy Fork impoundment is not listed on the U.S. Army Corps of Engineers "National Inventory of Dams."

Coal companies say the sludge contains mostly water, rocks, and mud. But sludge also contains toxic chemicals used to process coal. It contains metals that are present in coal, such as arsenic, mercury, chromium, cadmium, boron, selenium, nickel, iron, and manganese.

Alternative methods of coal preparation that do not create large volumes of liquid waste are available, but have not been widely adopted.

Coal companies use flocculants, which help solids drop out of suspension, and surfactants, or soaps, to wash coal of impurities. Material safety data sheets for flocculants say that overexposure can cause central nervous system depression, corneal injury, and pulmonary damage to workers and the public who become exposed to the chemicals. The precise chemical composition of coal slurry is largely unknown and likely variable. In November of 2006, the West Virginia Department of Environmental Protection told a state legislative subcommittee that approximately one hundred chemicals can be used to prep coal, but they are all approved chemicals, so not to worry.

In October of 2000 at Martin County Coal Company's mountaintop-removal coal-mining operation near Inez, Kentucky, a crack developed between the bottom of the 2.2-billion-gallon impoundment and the underlying underground mine. Before workers could get control of the situation, roughly 300 million gallons of lavalike black sludge gushed into the mine. The sludge exploded out of two mine portals and into Coldwater and Wolf creeks, wiping out all aquatic life. Eventually the sludge spill traveled some one hundred miles, into the Tug Fork and Big Sandy rivers bordering Kentucky and West Virginia. Communities along the waterways were forced to temporarily shut down their drinking water intakes. The Environmental Protection Agency called the sludge spill the worst-ever environmental disaster in the Southeast.

According to the Coal Impoundment Project's Location and Information System, there are 115 slurry impoundments in Kentucky and more than 130 in West Virginia. The federal Mine Health and Safety Administration suggests that more than 150 impoundments are at some risk for breaking through into former deep mines. While such accidents and outright failures of slurry dams are rare, when they have occurred, the consequences have been horrific. In coalfield communities across the region, people live in fear of the next blackwater release from a coal prep plant and the day-to-day pollution these lakes of waste cause. People worry about the next catastrophic failure that could bring a tidal wave of slurry down their hollow.

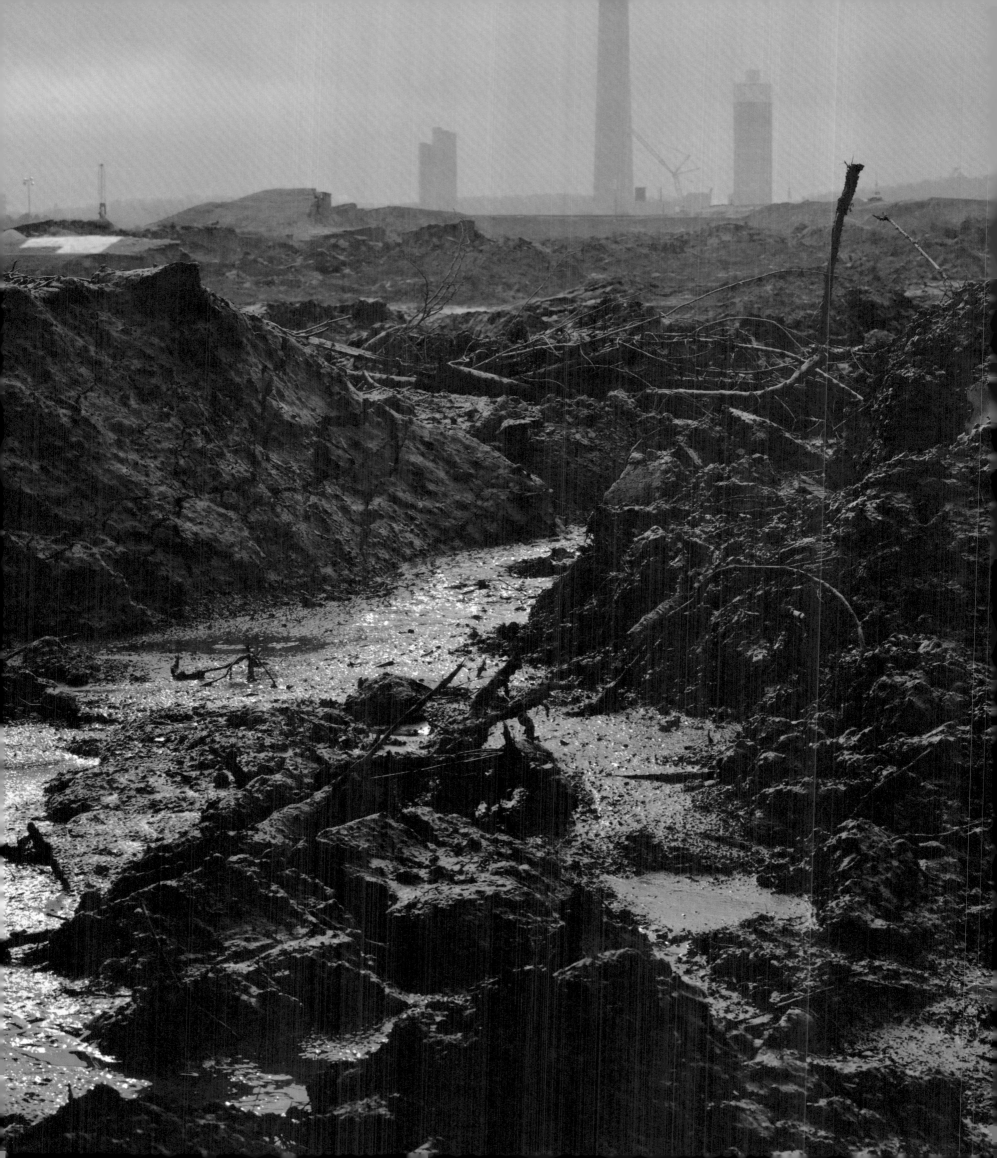

COAL'S CATCH-22

Toxic Combustion Waste a Growing Menace

LISA GOLLIN EVANS

When a massive spill of coal-combustion waste from a power plant in Kingston, Tennessee, made national news in December 2008, millions of Americans saw images of devastation [see acompanying photo]. It's unfortunate that it took an environmental catastrophe of such magnitude to focus public attention on the toxic tail end of coal burning.

Global climate change and the human health effects of mercury exposure have prompted growing concern about carbon dioxide emissions and air pollution from coal-burning power plants. But these aren't the only pollutants we need to worry about—burning coal also releases many others. And, ironically, deploying better pollution control technology at the smokestack means an increasingly dangerous solid waste stream. In the absence of tough new federal regulations for managing that waste, cleaning up coal's air pollutants could make highly toxic pollution of land and water worse. Much worse.

American power plants consume a billion tons of coal every year, producing mountains of coal combustion waste. Because burning concentrates coal's impurities, power plants generate not just electricity but also a witches' brew of carcinogens, neurotoxins, and poisons—arsenic, lead, mercury, chromium, thallium, selenium, cadmium, boron. These toxins pollute water and foul the land and air in communities near thousands of landfills, old mines, waste ponds, and myriad holes in the ground where coal ash is dumped.

Coal combustion produces solid waste in the form of fly ash (the ash captured by pollution control devices), bottom ash, scrubber sludge, and boiler slag. The more pollutants a coal-fired power plant captures to prevent air pollution, the more toxic and voluminous the solid waste. Clean Air Act regulations that require reductions in mercury emissions, for example, can increase mercury in coal ash up to seventy-five-fold. Similarly, requirements that reduce sulfur and nitrogen air emissions will boost scrubber sludge production by tens of millions of tons over the next twenty years.

Even without these increases, coal combustion produces an immense industrial waste stream, second only to mining waste. U.S. power plants generate about 131 million tons of solid coal-combustion waste each year—enough to fill the boxcars of a train stretching ten thousand miles, from New York City to Melbourne, Australia. By weight, the amount of chemicals in coal-combustion waste surpasses that created by pulp and paper mills, petroleum refiners, and textile mills *combined*.

Amazingly, despite the enormous volume and toxicity of all this waste, the federal Environmental Protection Agency does not regulate it. Consequently, there are no national disposal standards. Because disposal in lined landfills is costly, utilities dump waste unsafely in unlined mines, landfills, gravel pits, and waste ponds. And they do this in nearly every state in the country.

Damage from mismanagement is abundantly evident. Consider water: When coal-combustion waste comes in contact with water, hazardous chemicals leach into streams, lakes, and underground drinking water. EPA scientists estimate that certain current waste-disposal practices present a cancer risk nine hundred times higher than the EPA's regulatory goal. The EPA has also concluded that some constituents of coal-combustion waste—primarily selenium, lead, and boron—pose significant threats to aquatic ecosystems. These threats are not theoretical. Coal-combustion waste contamination has wiped out entire populations of fish in the southeastern U.S., and coal ash has poisoned drinking water in more than two dozen states.

Dumping coal ash in large, open pits poses additional serious threats to health and the environment whenever the wind blows. Large amounts of dust blow from the disposal areas, fouling the air. Coal ash's small particle size, high pH, and toxic metals contribute to asthma and lung disease. And when the dust settles, soil contamination exposes people—especially children—directly to toxic metals such as lead, arsenic, and mercury.

These harms to human health and the environment can easily be prevented. The first solution is secure and monitored engineered landfills, controlled by enforceable federal regulations. The second is safe reuse of ash in the manufacture of various products, such as concrete, that keep the toxins out of water and air. Yet because the EPA refuses to propose such rules, our health and the natural world continue to be damaged by exposure to toxic ash.

Absent a horrific incident like the Kingston spill, coal-combustion waste may be out of the news and out of sight, but it is not out of our air, our water, and our bodies. We ignore its dangers at our peril.

The Kingston Fossil Plant, a coal-burning power plant operated by the Tennessee Valley Authority near the confluence of the Emory and Clinch rivers, has been storing its coal-combustion waste on site next to the plant for decades. On December 22, 2008, in what has been characterized as the largest environmental disaster of its kind in U.S. history, one of the coal-waste lagoons breached a dike, unleashing a massive wave of toxic sludge—more than a billion gallons—onto nearby homes, farmland, and into the Emory River. The flood of coal waste covered roughly three hundred acres of land, buried some houses up to their roofs, destroyed several homes and damaged dozens, and put so much toxic sludge into the river that it partially dammed the flow. The spill was estimated to have been more than one hundred times the size of the Exxon Valdez disaster in Alaska. U.S. Senator Bob Corker (R-TN), touring the site, was quoted as saying "this is a devastated area now."

Coal-combustion waste, which primarily consists of fly ash and boiler slag from power plants, contains various heavy metals known to be harmful to humans and wildlife. According to government documents, the Kingston plant deposited more than 2.2 million pounds of toxic heavy metals into its waste dumps annually. Like most ash ponds, this one was adjacent to a river and had no special liners or other protective mechanisms to prevent leaching into groundwater or accidental bank failure. Independent testing after the spill conducted at the Environmental Toxicology and Chemistry laboratories at Appalachian State University found significantly elevated levels of arsenic, copper, barium, cadmium, chromium, lead, mercury, nickel, and thallium in samples of slurry and river water. Testing by the Environmental Protection Agency reported arsenic levels in water samples at 149 times the level EPA considers safe for drinking water.

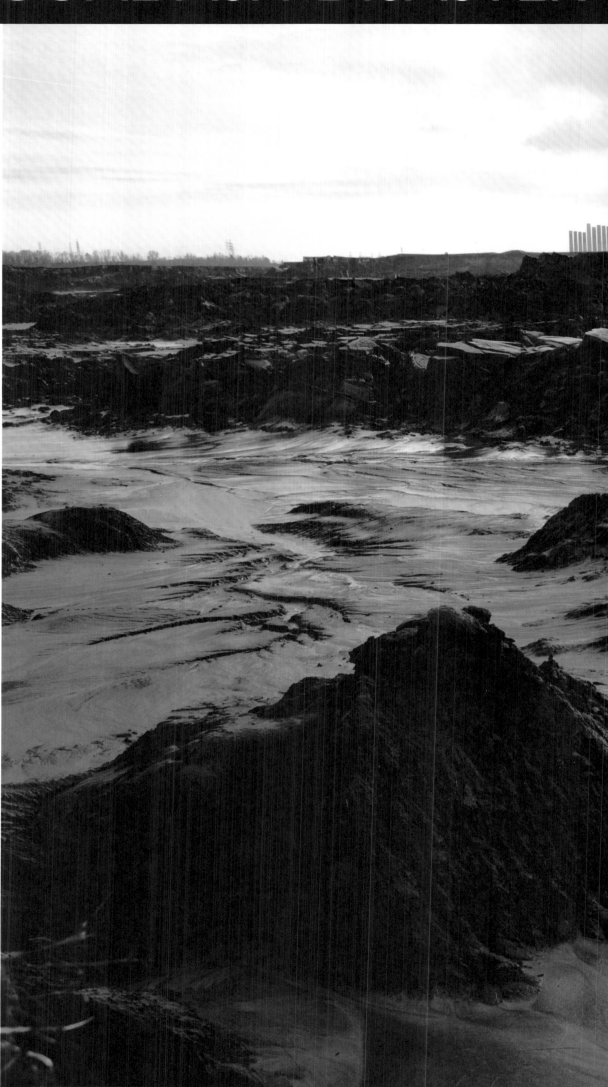

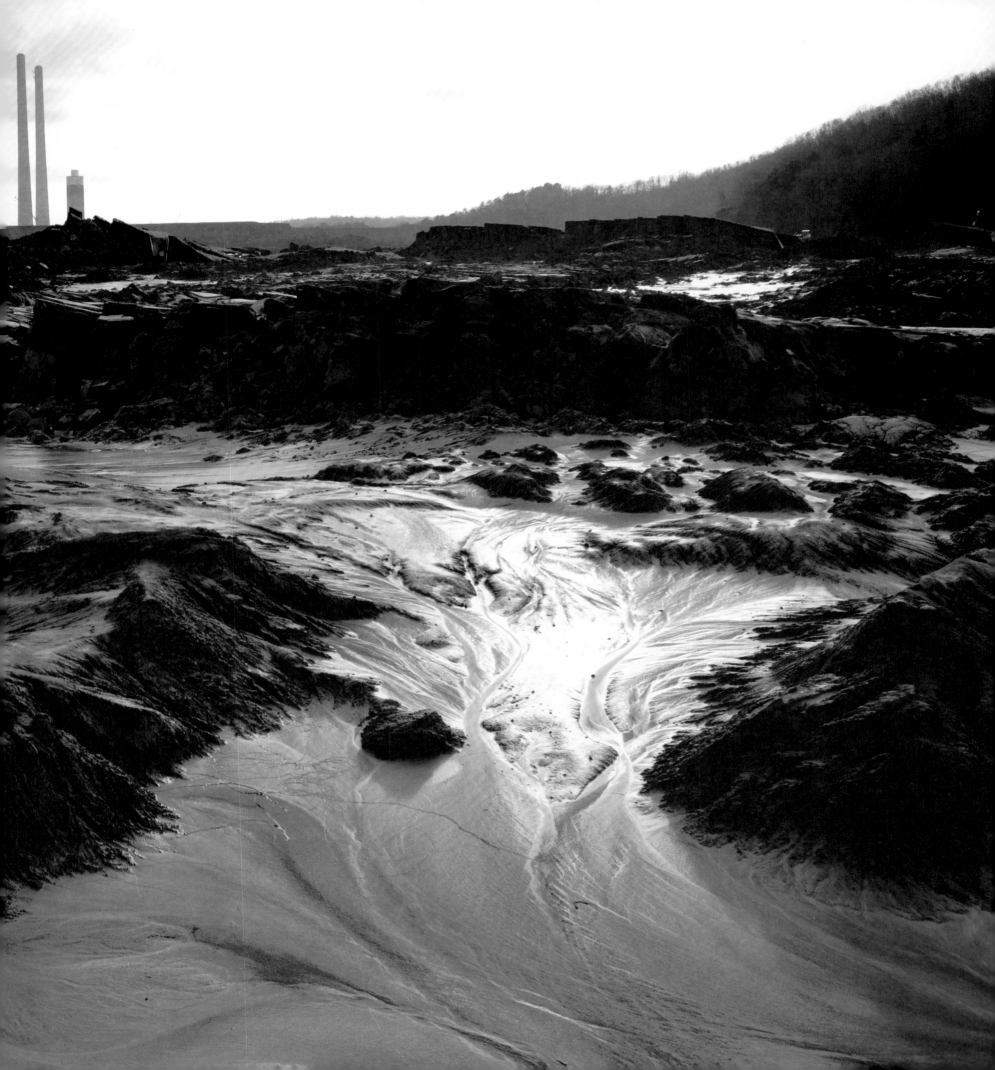

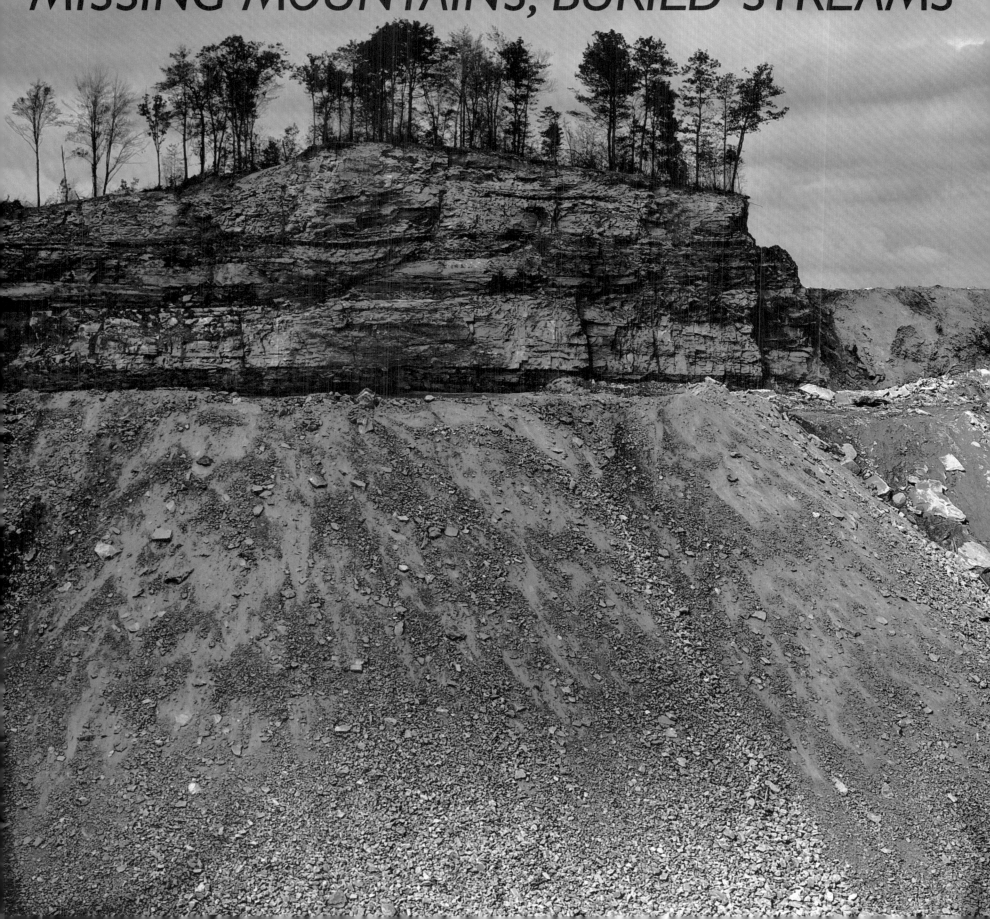

PART VI

DISFIGURING A
MISSING MOUNTAINS, BURIED STREAMS

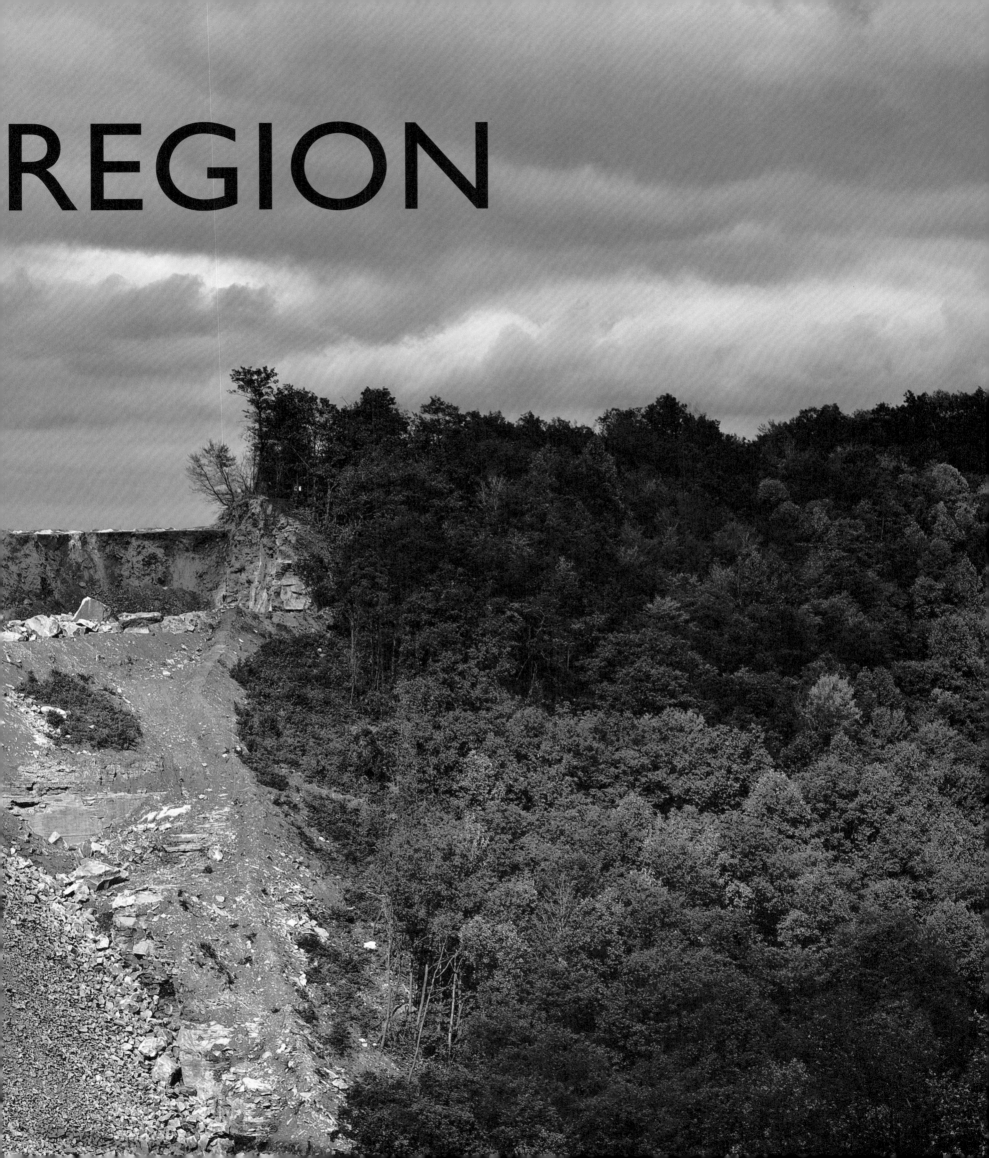

REGION

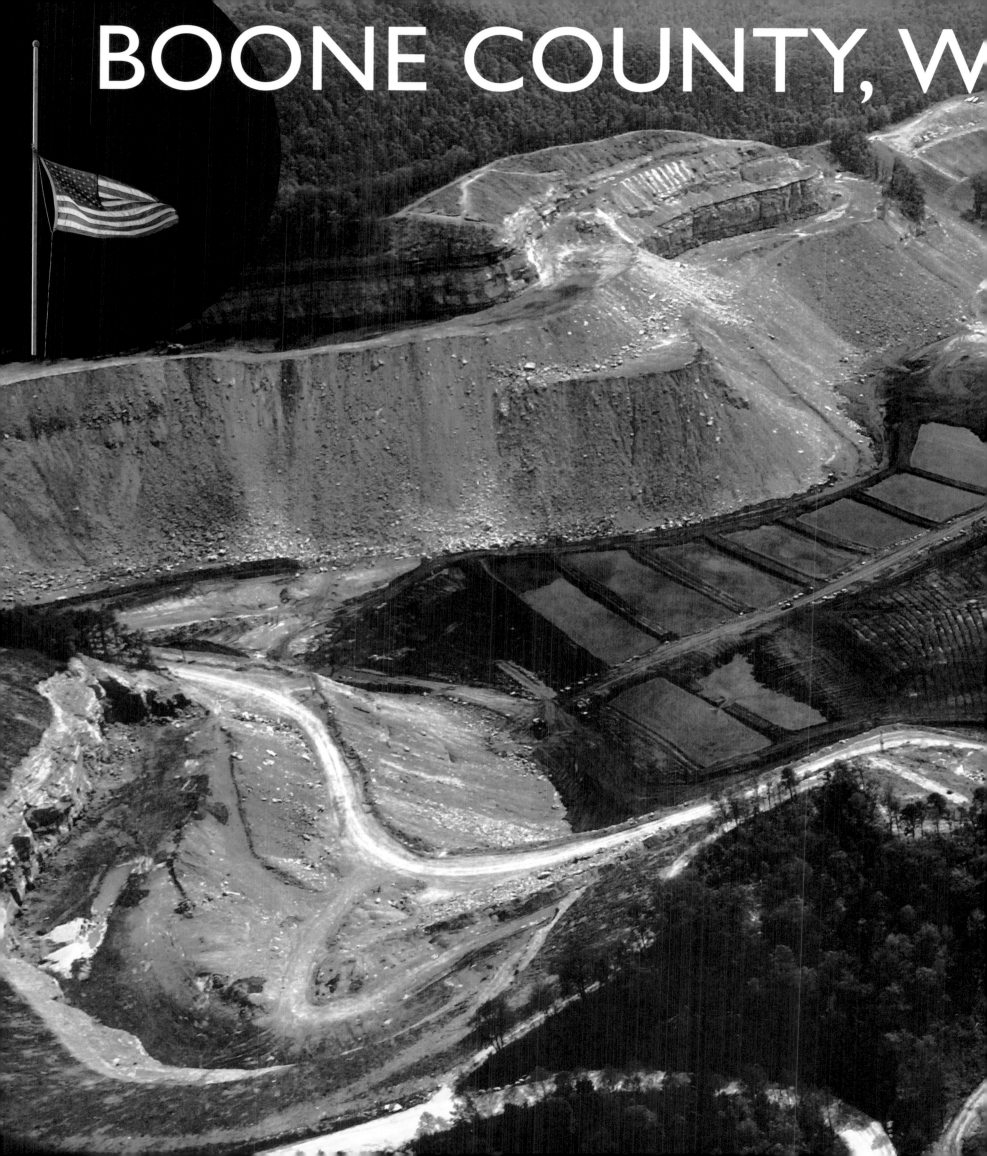

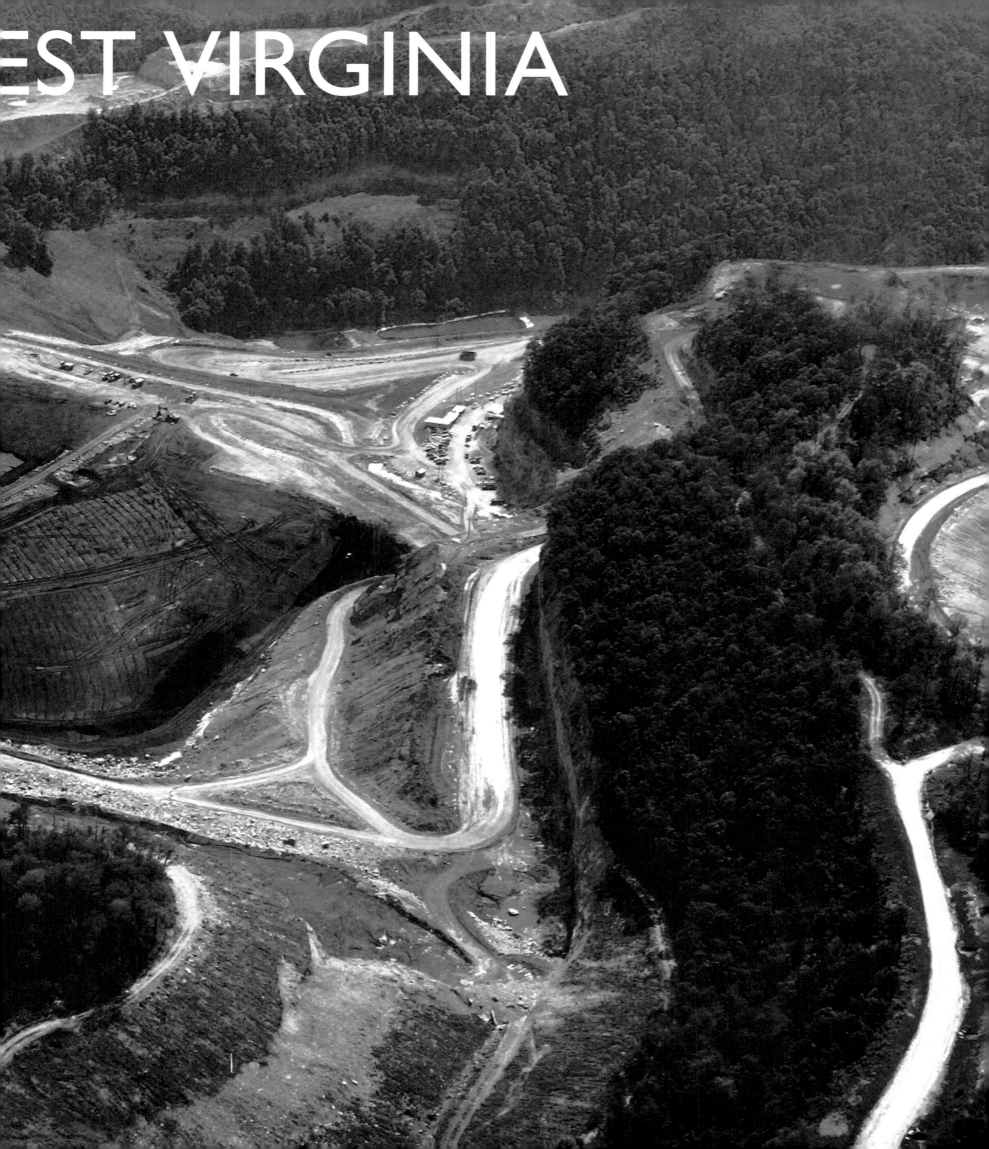

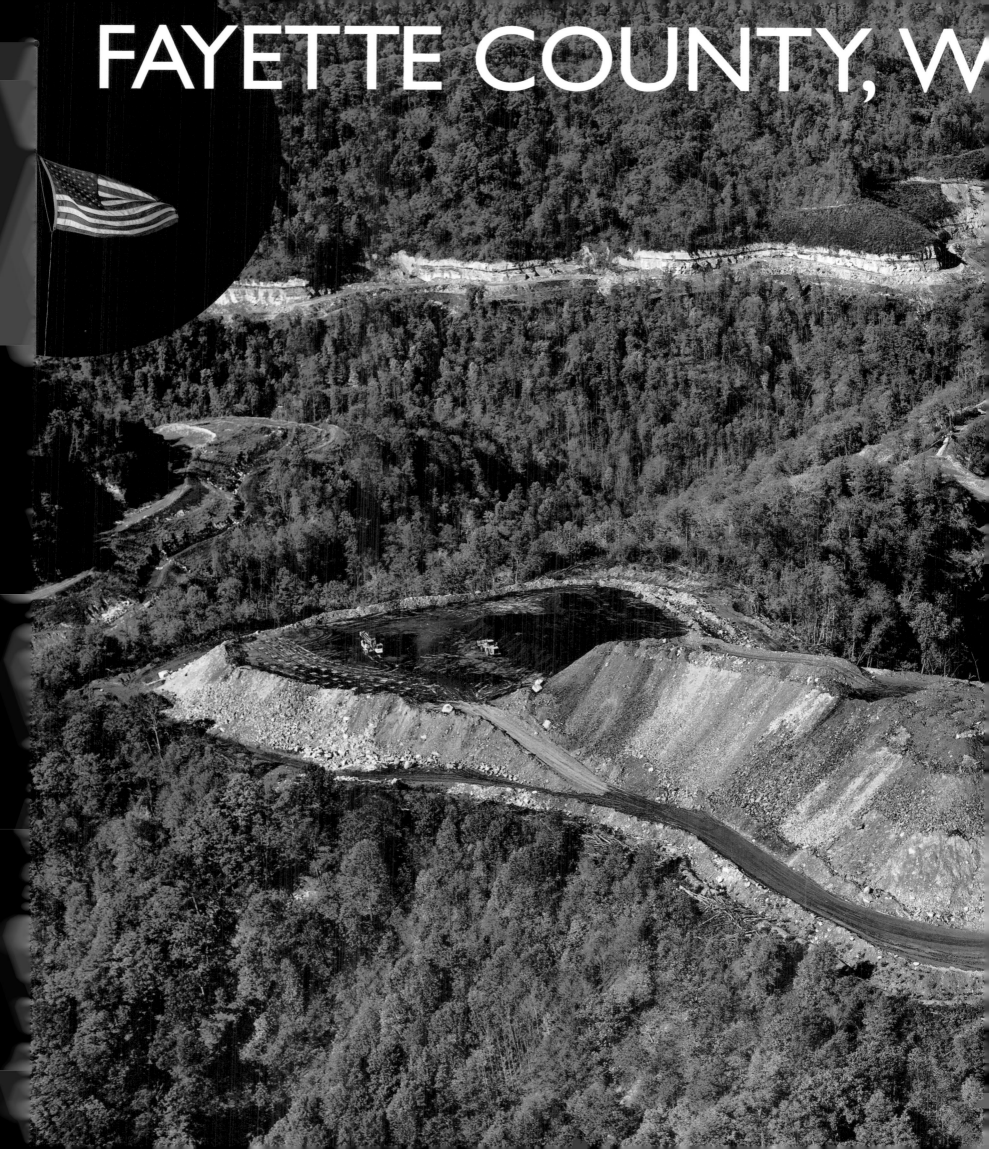

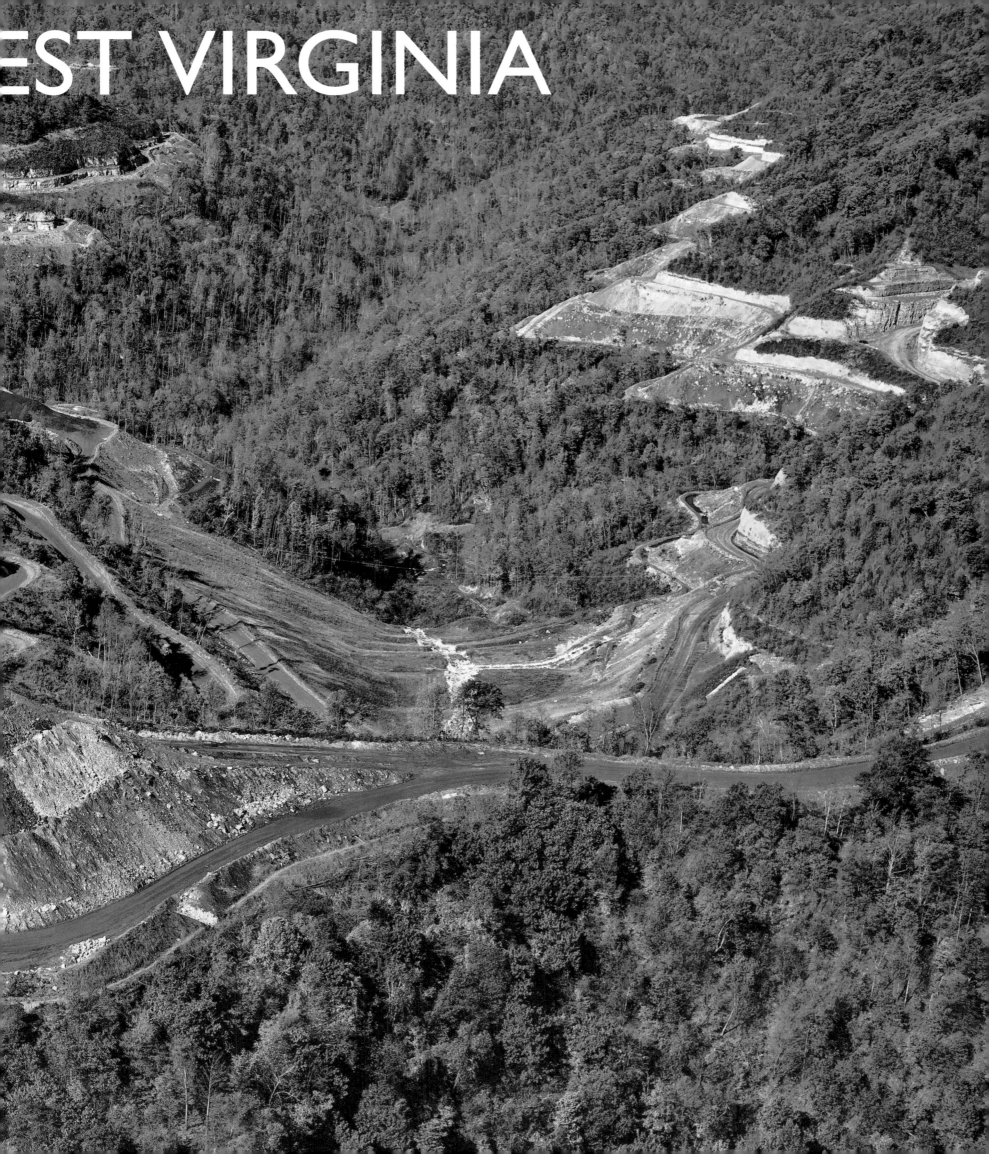

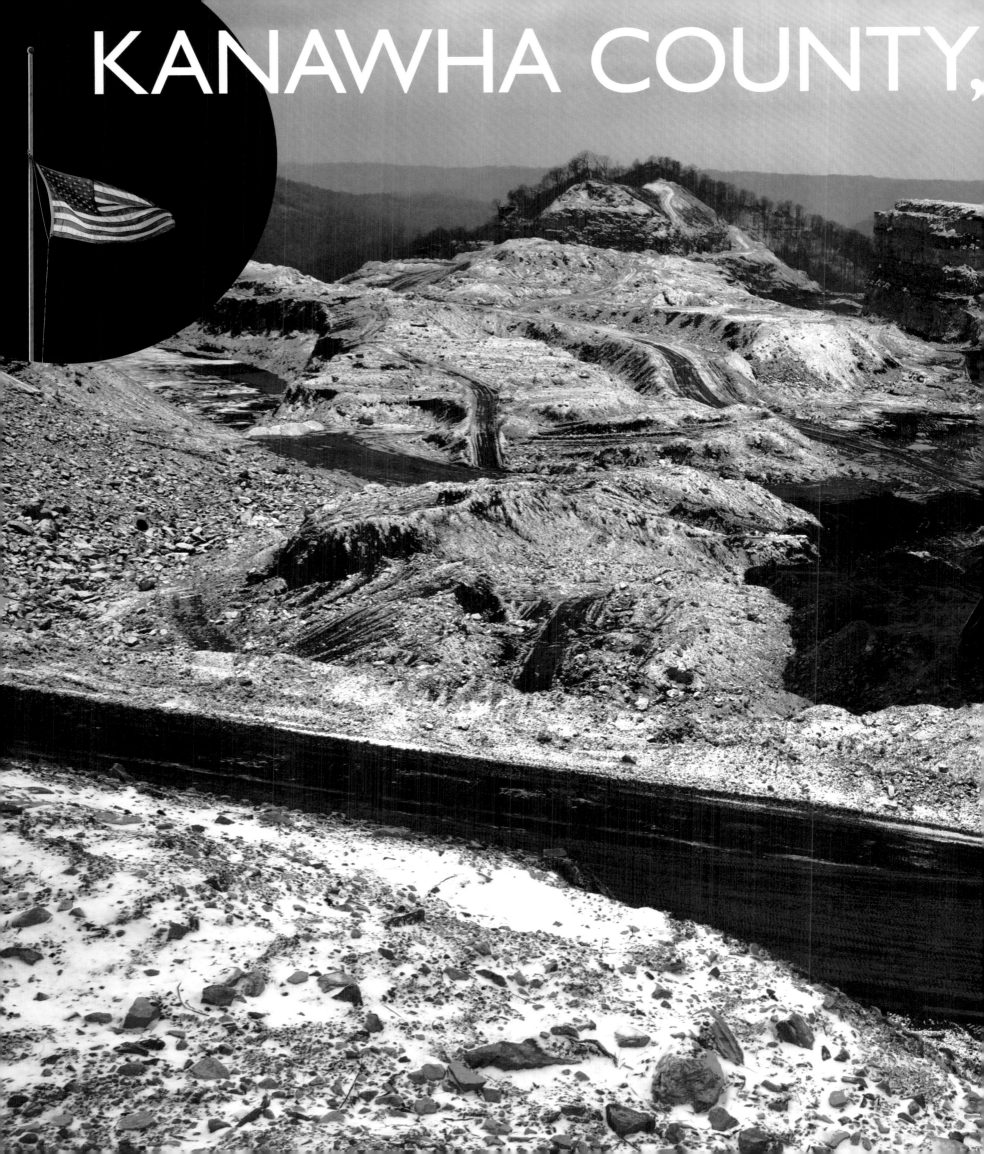

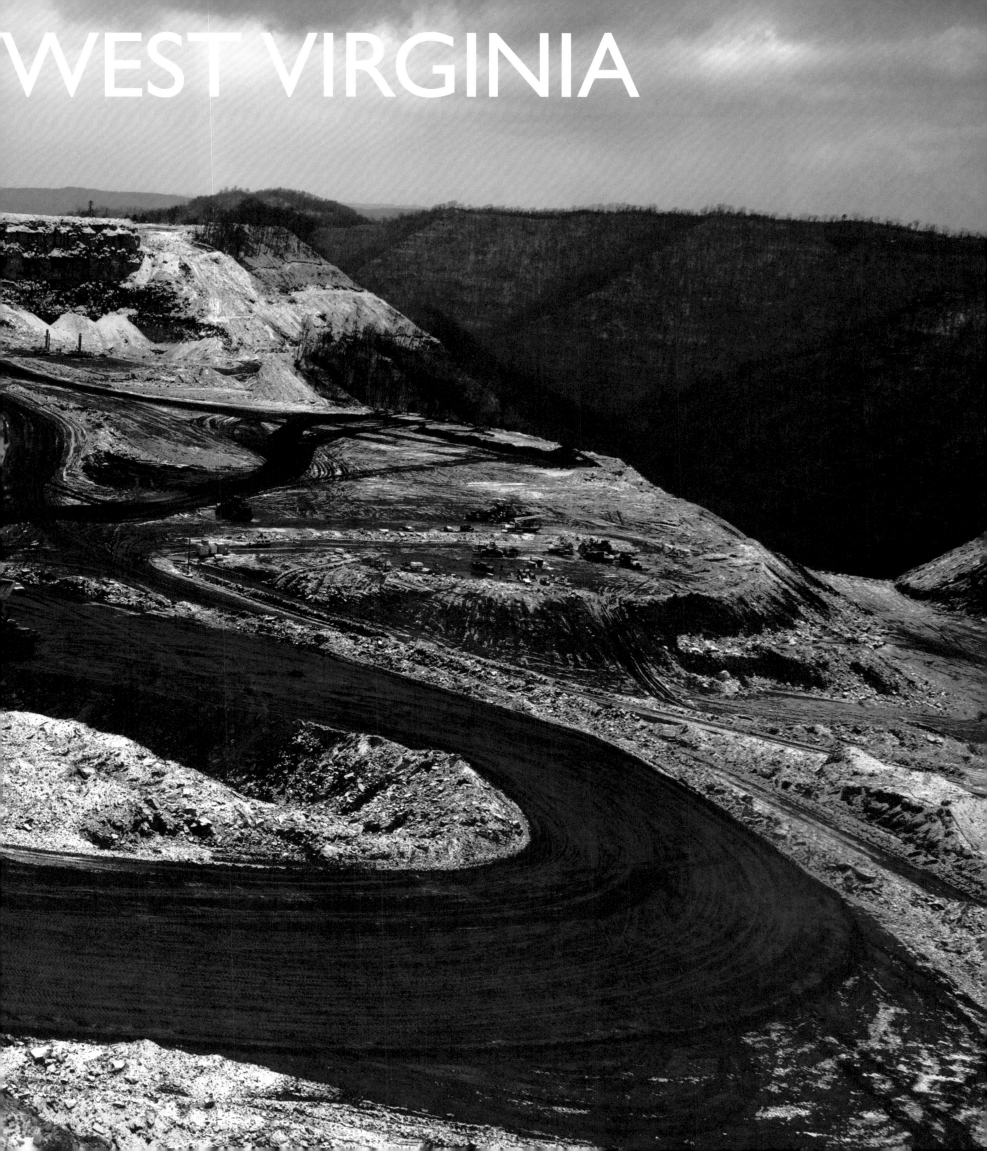

WEST VIRGINIA

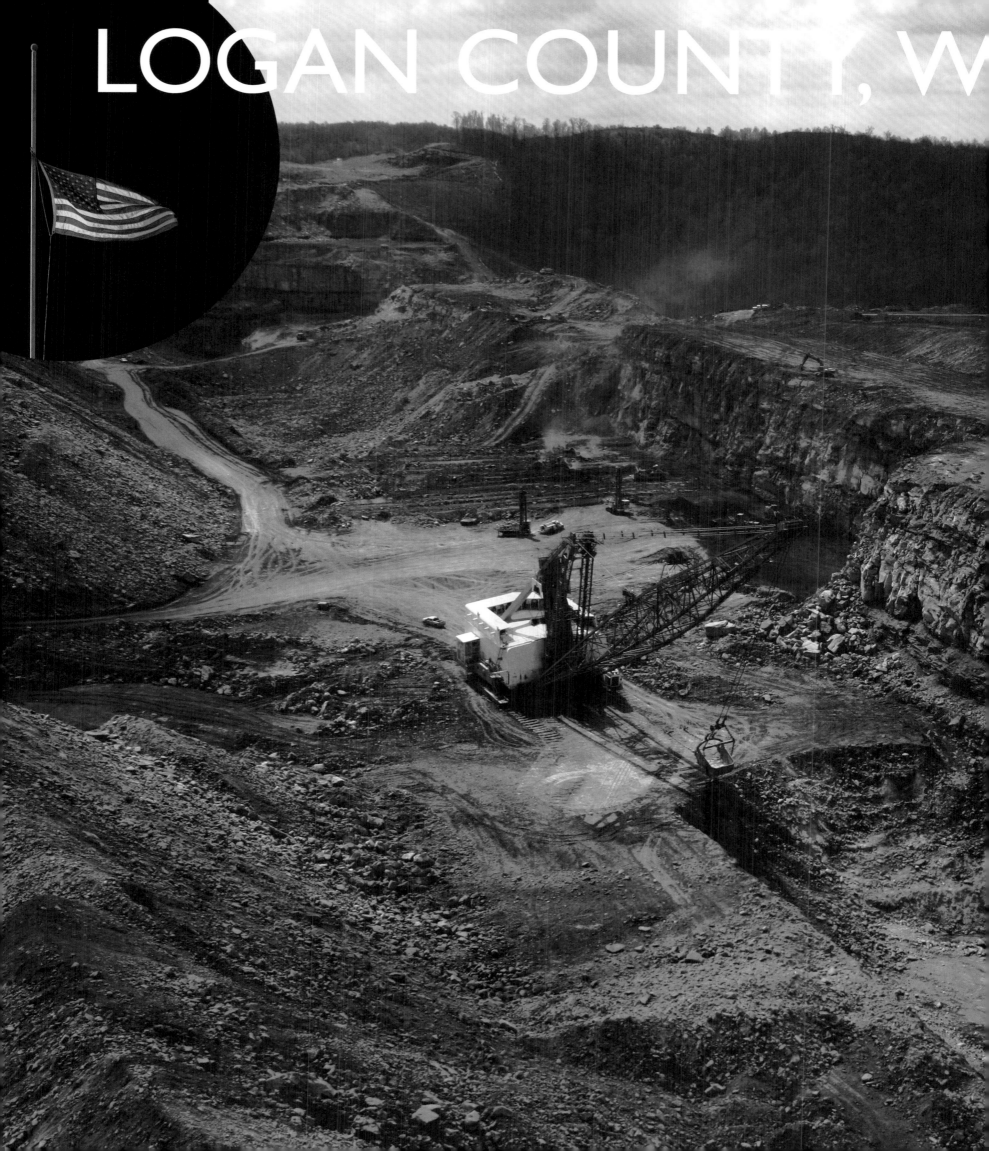

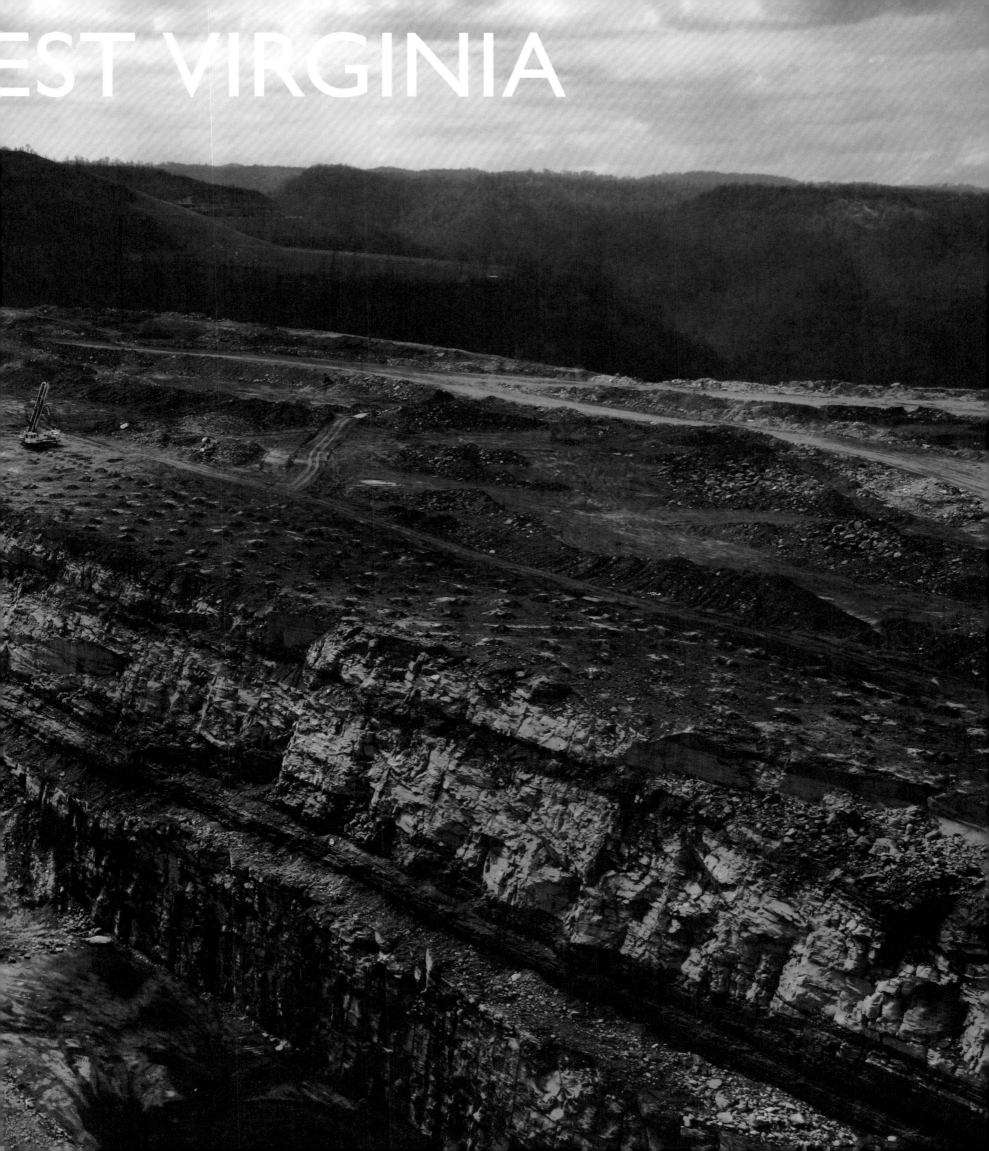

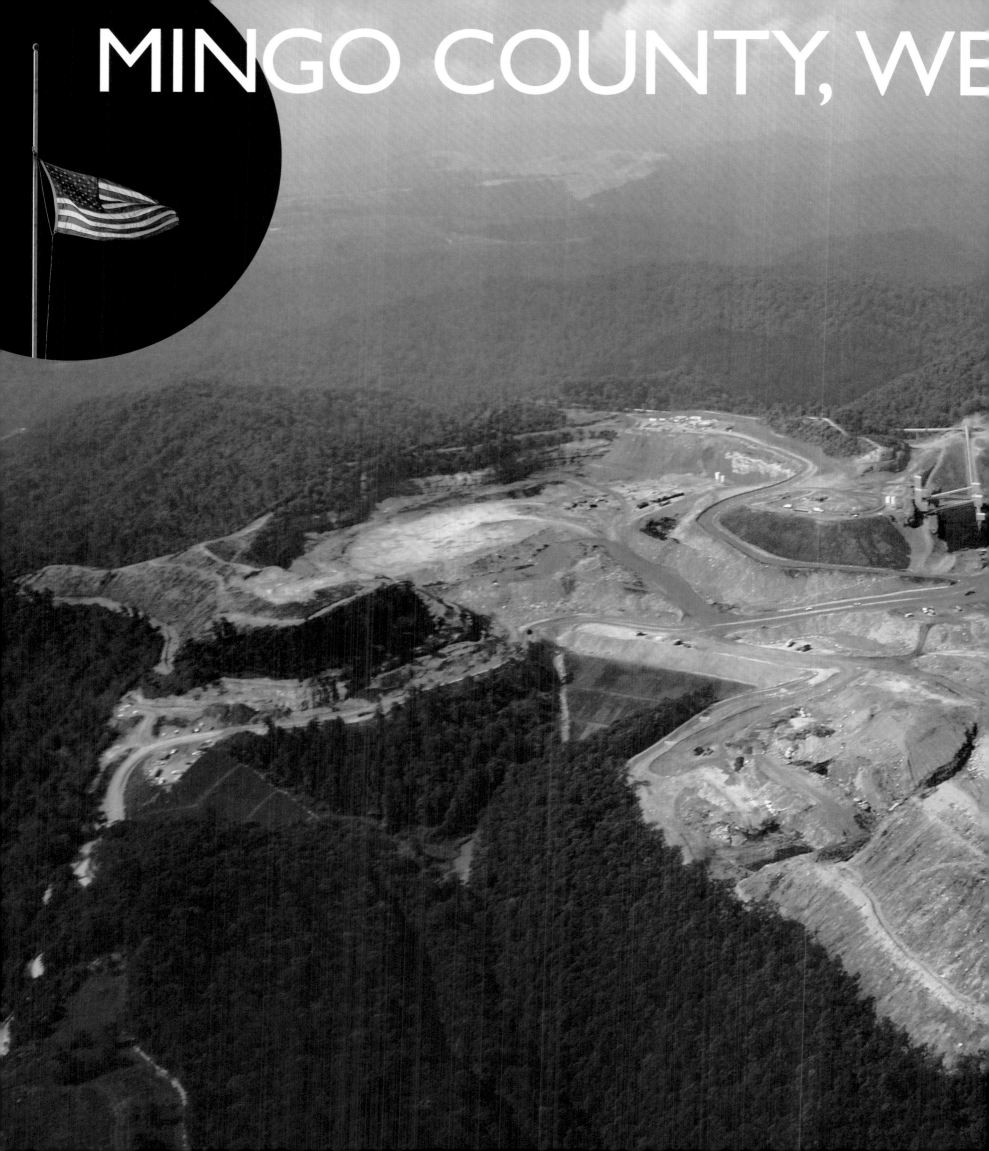

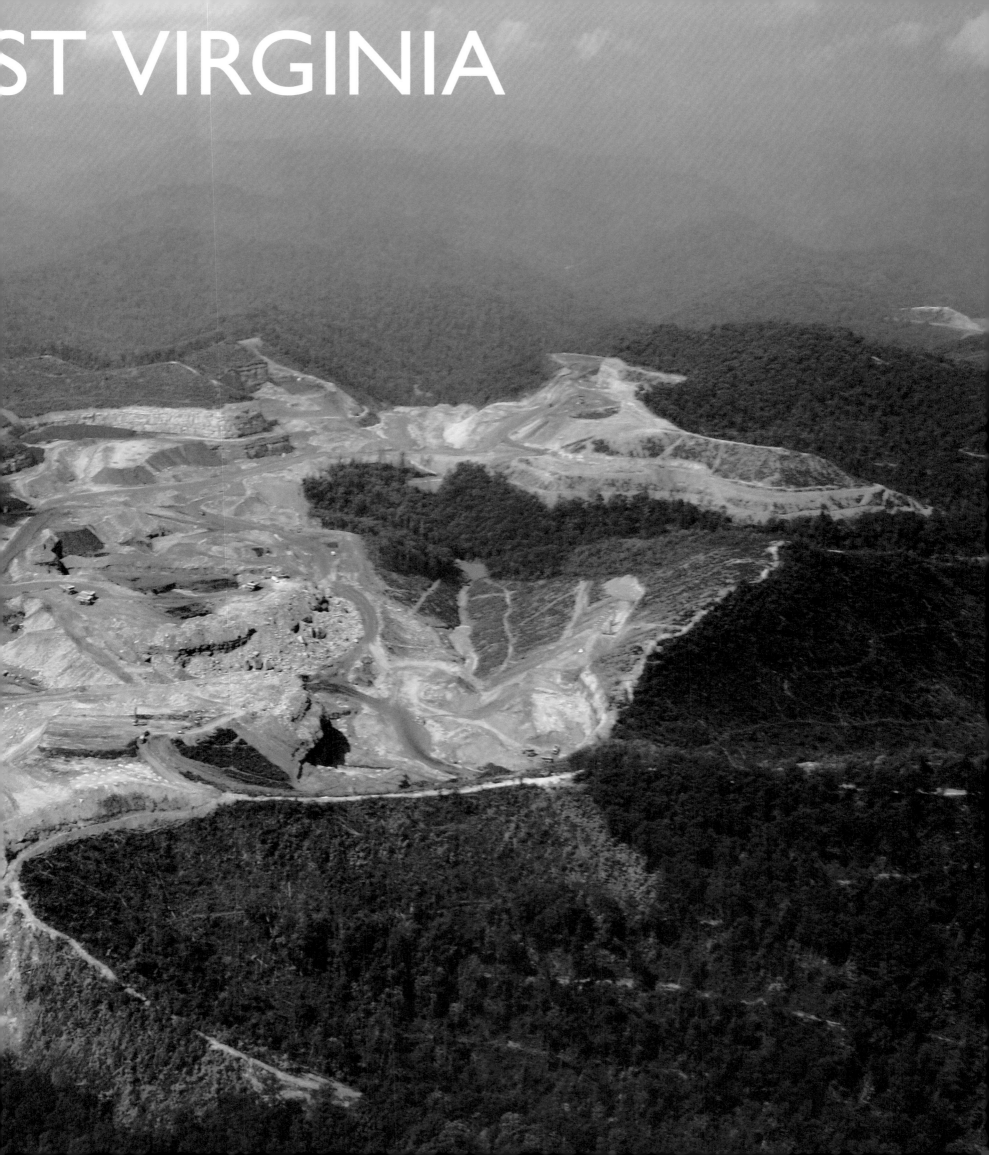
ST VIRGINIA

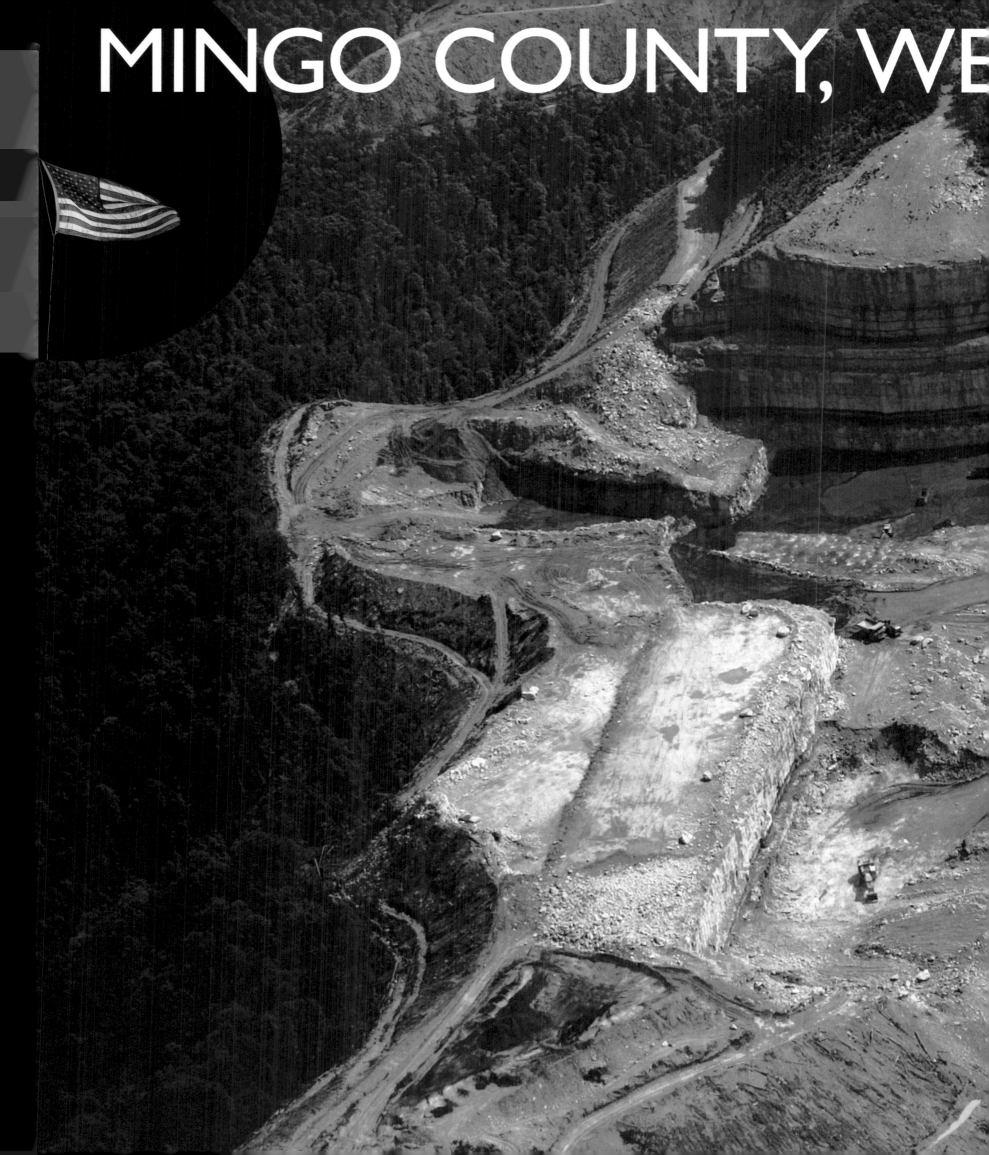

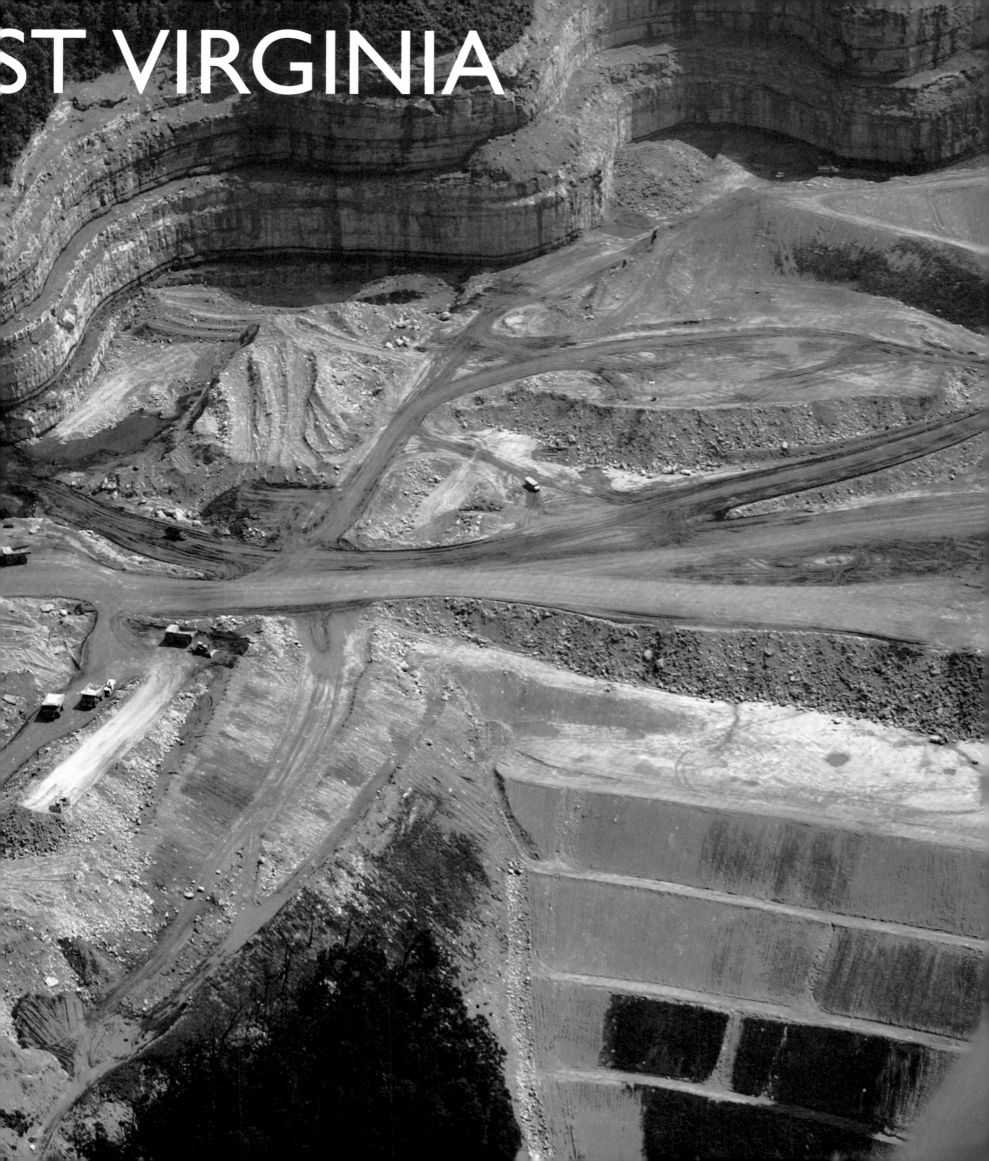

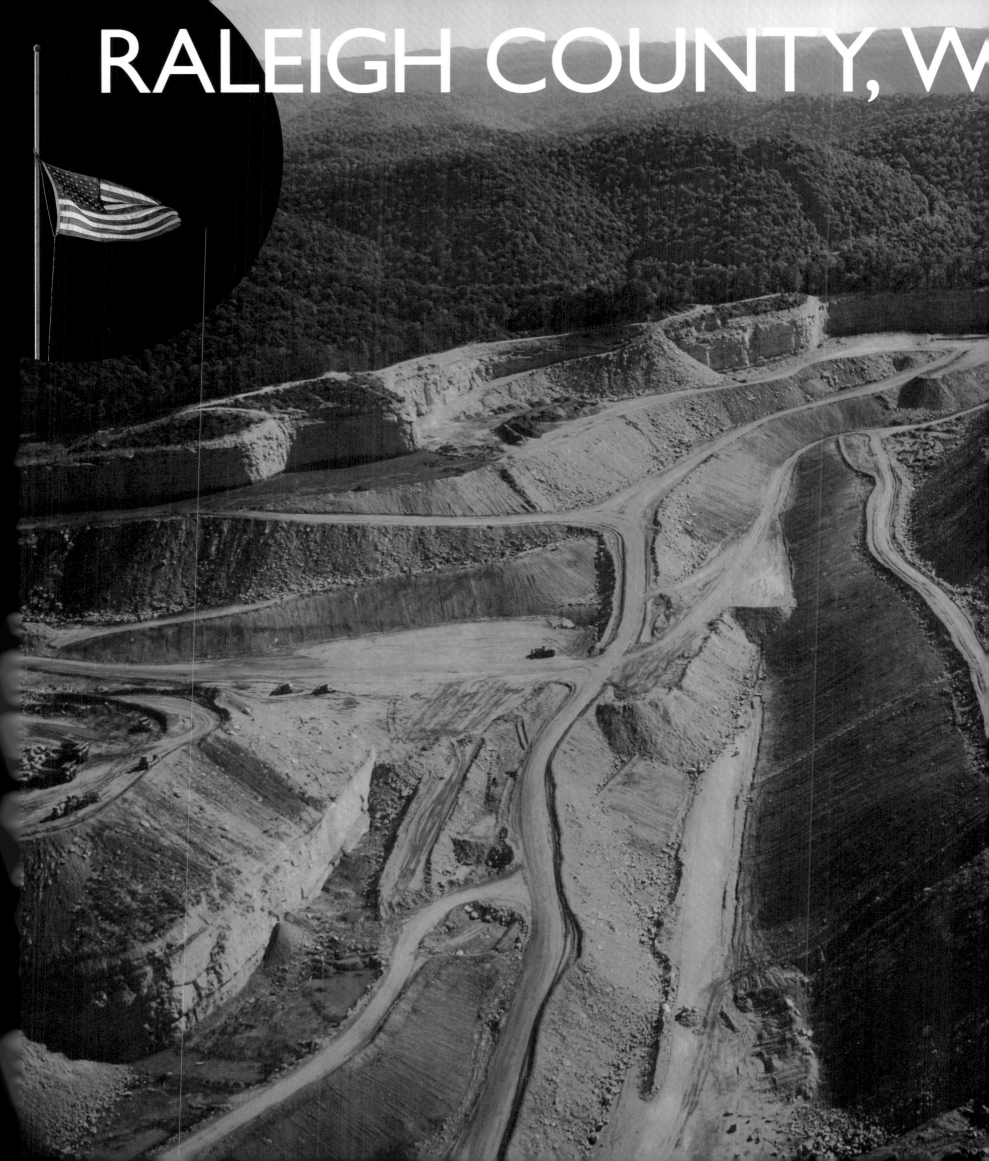

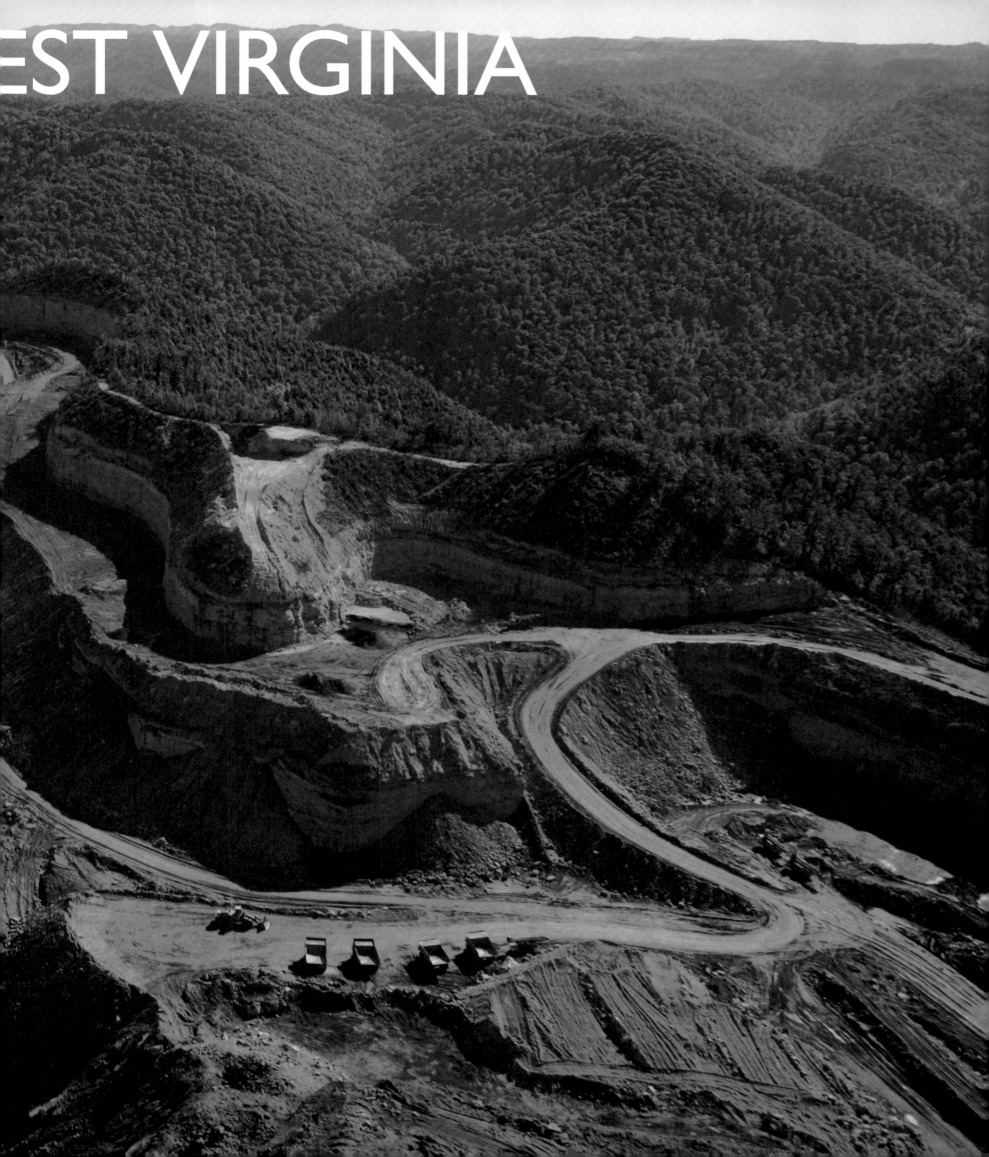

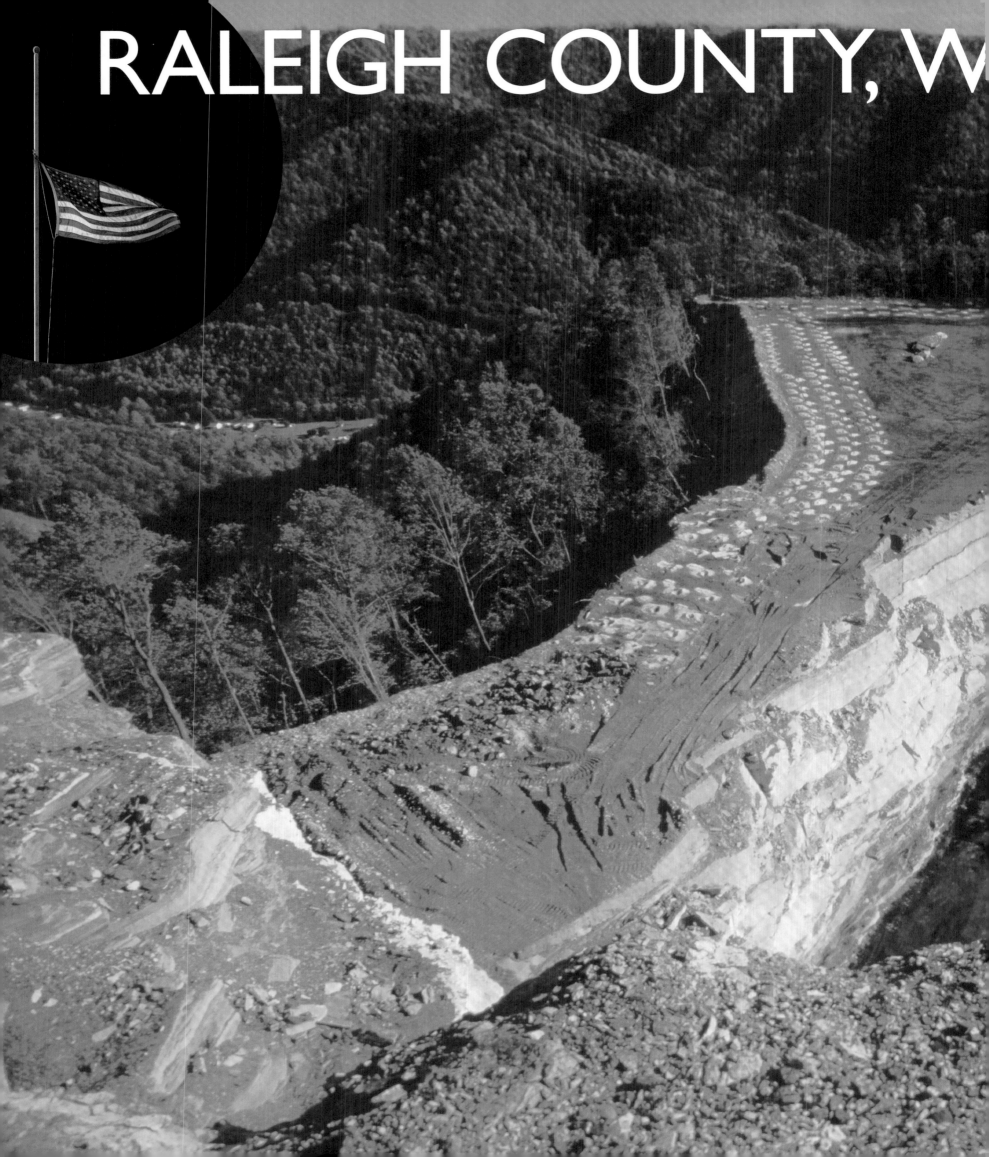

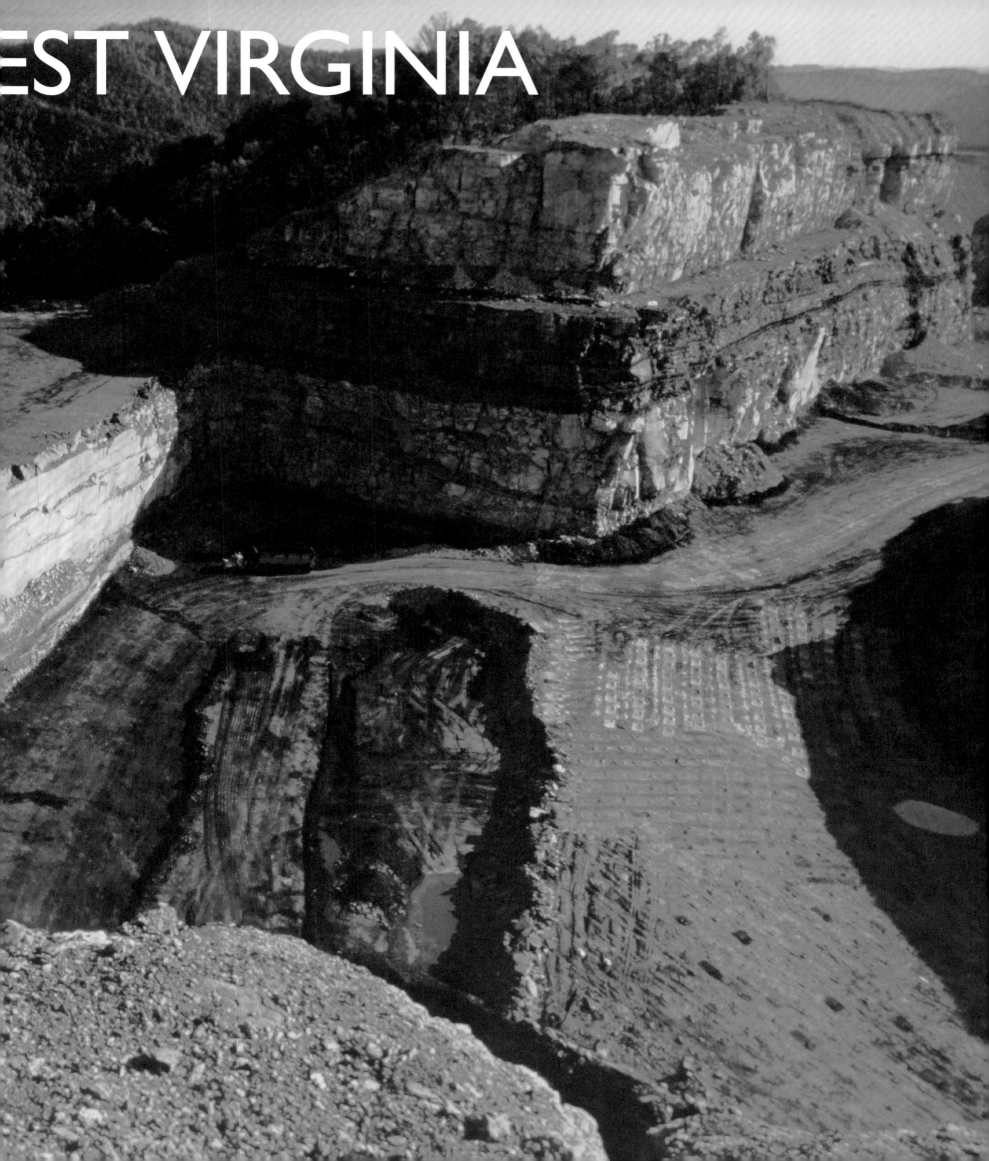

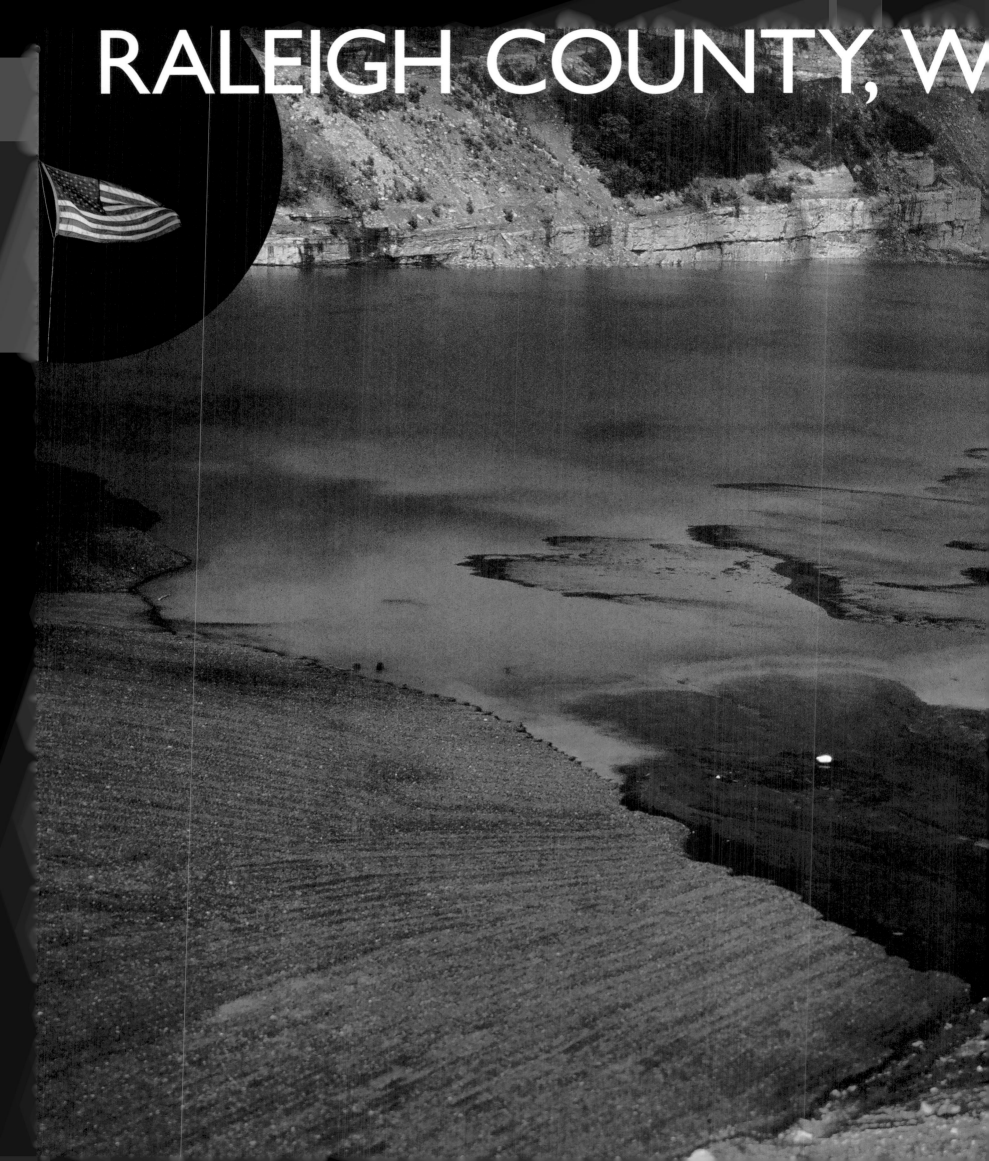

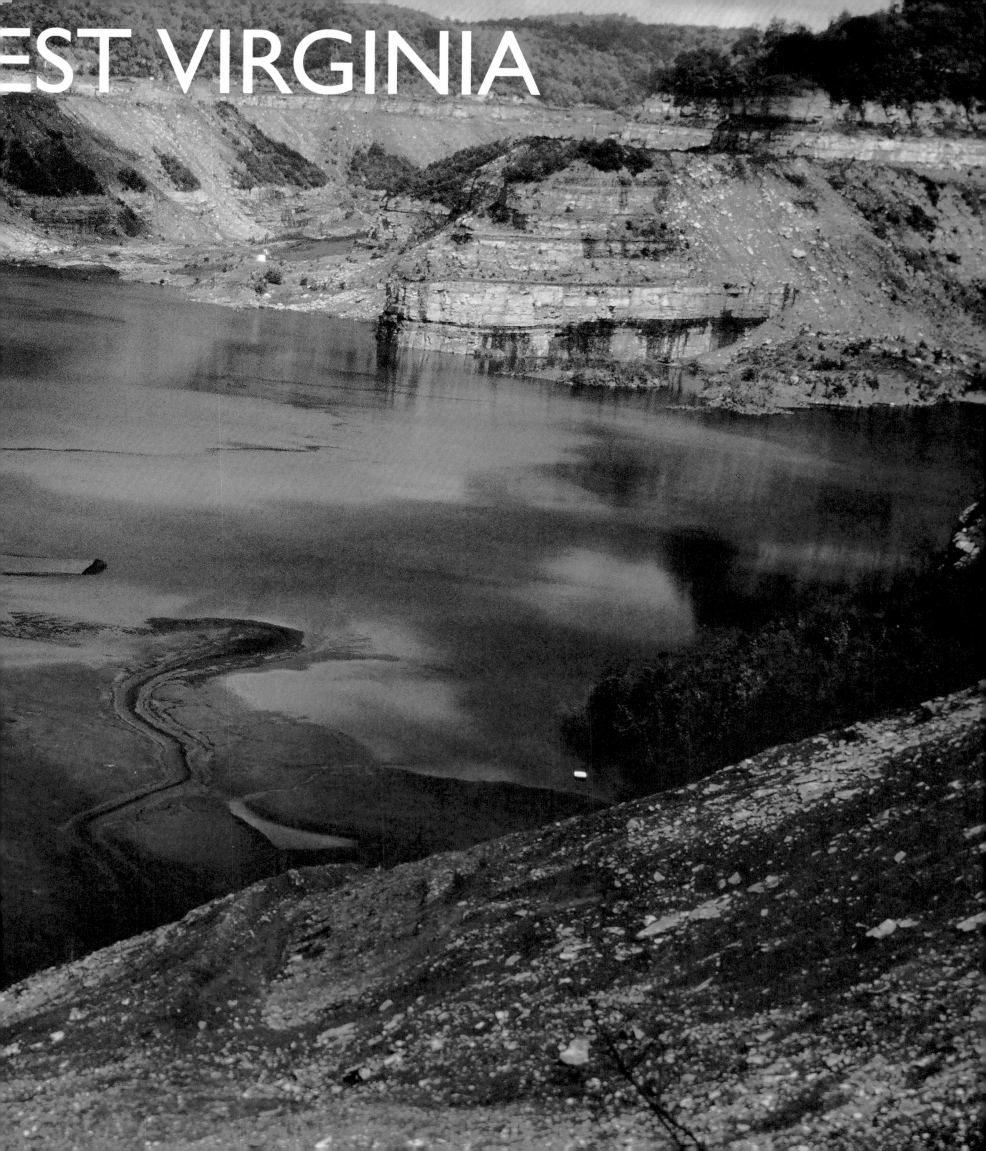

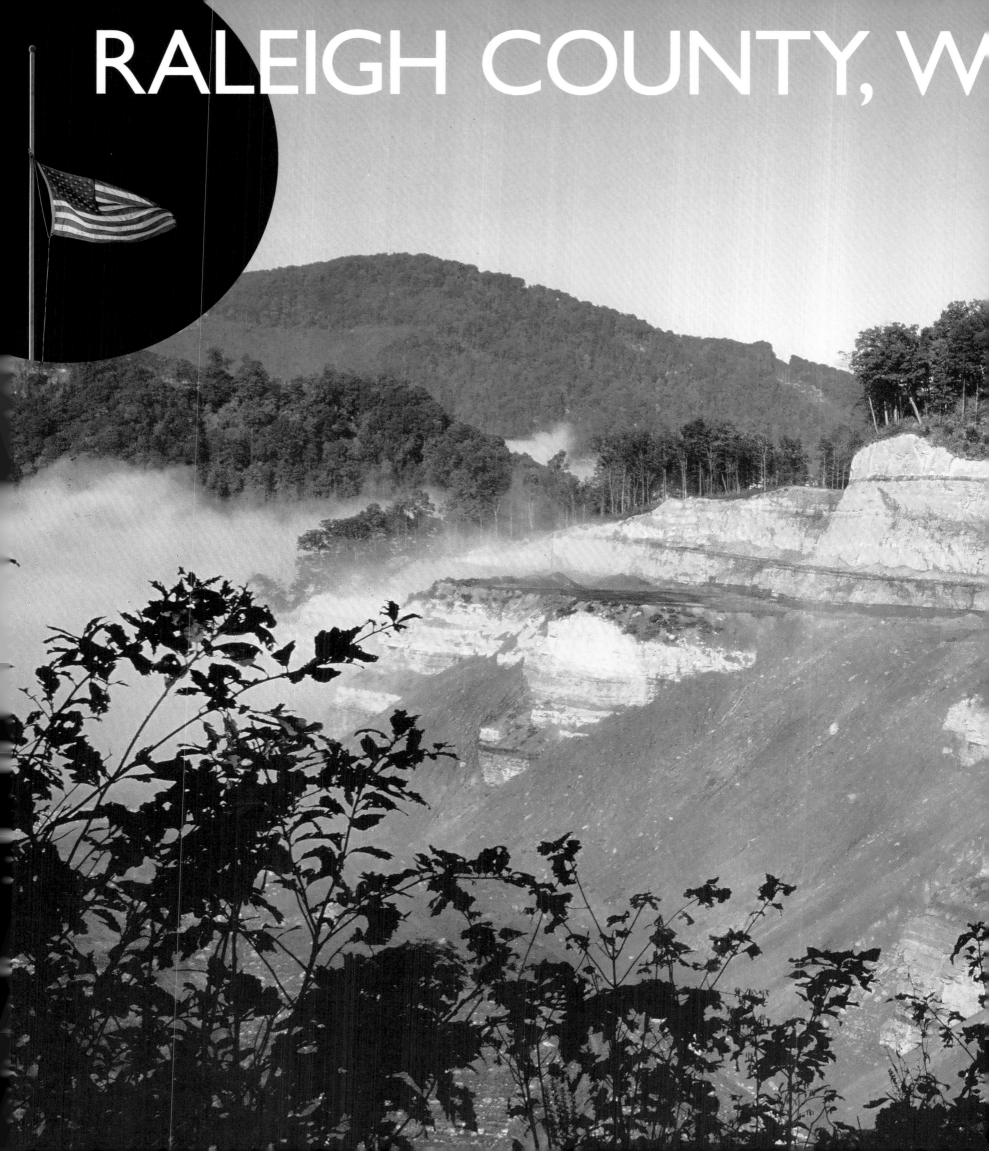

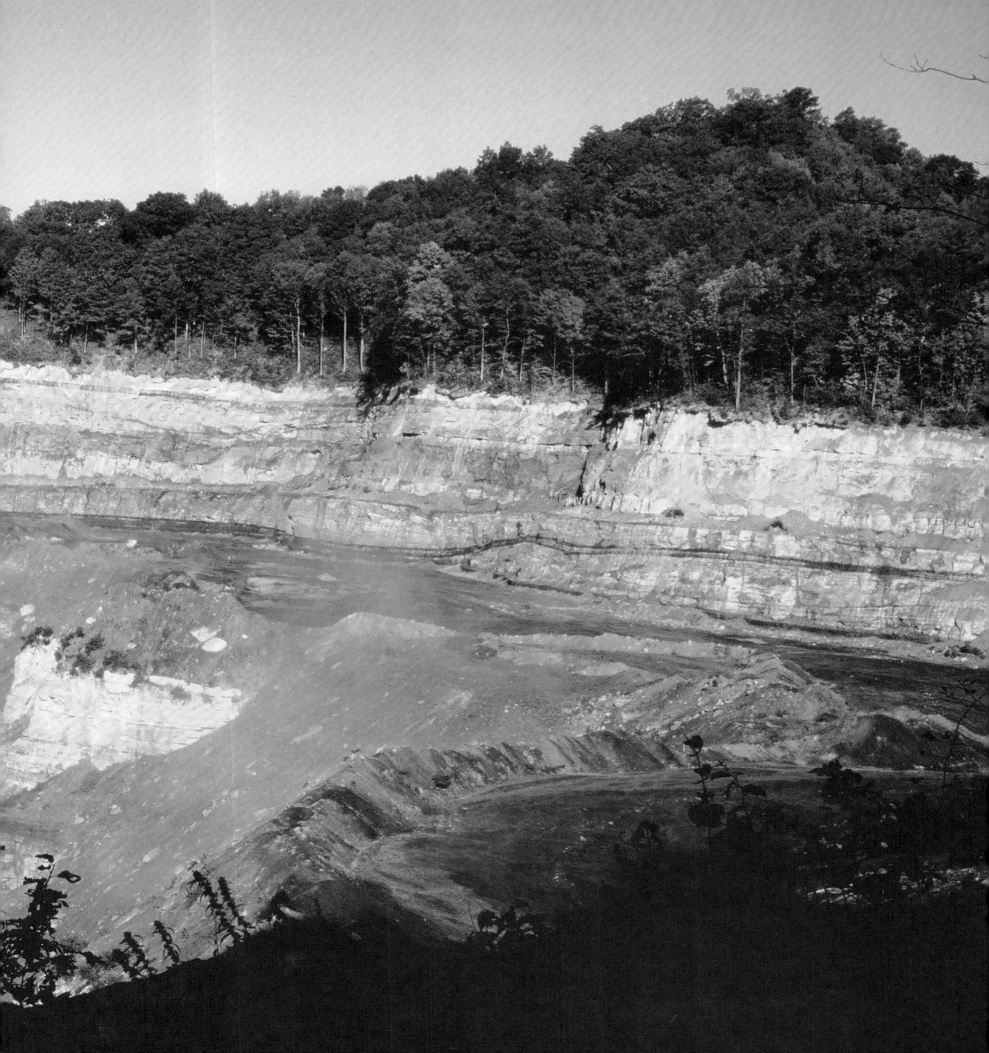

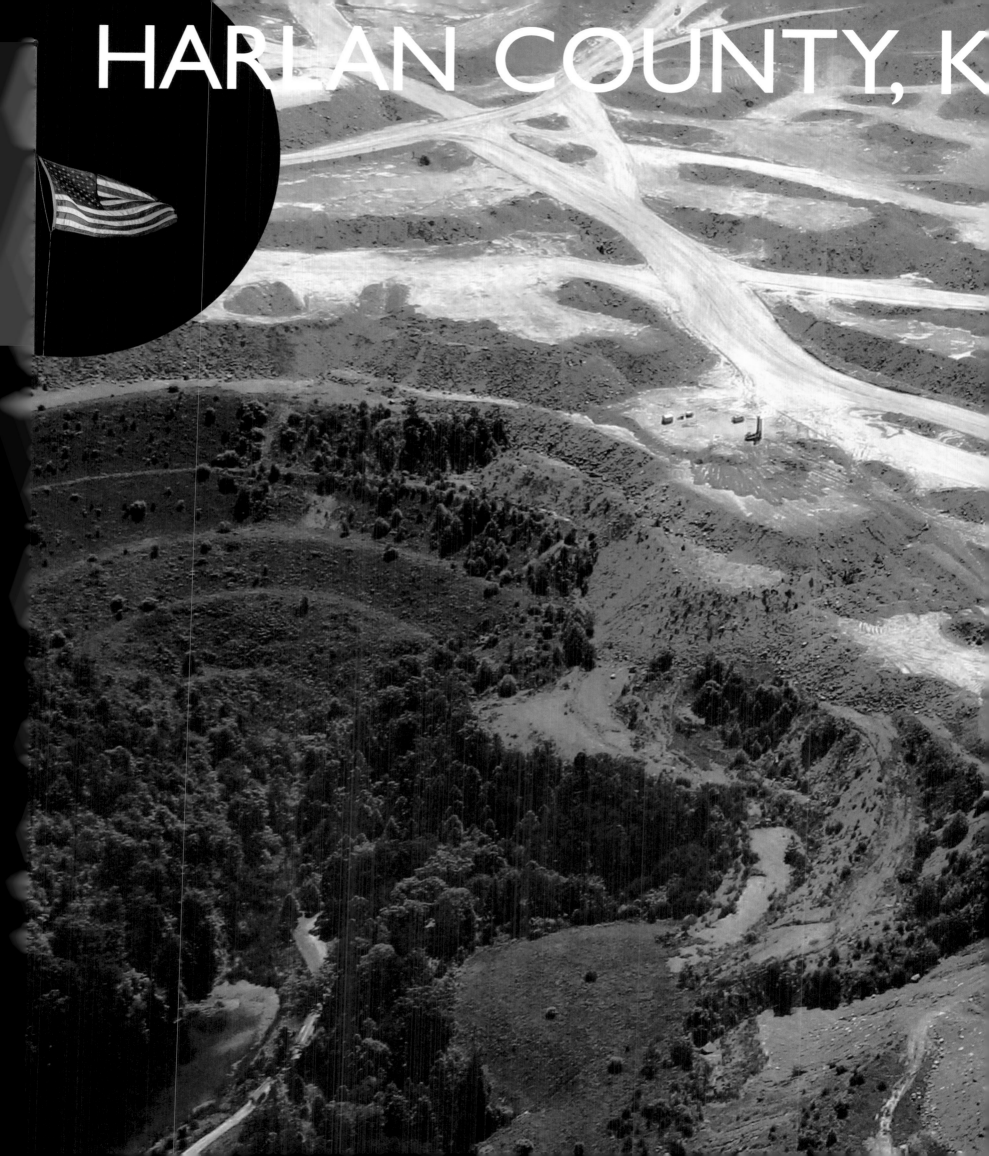

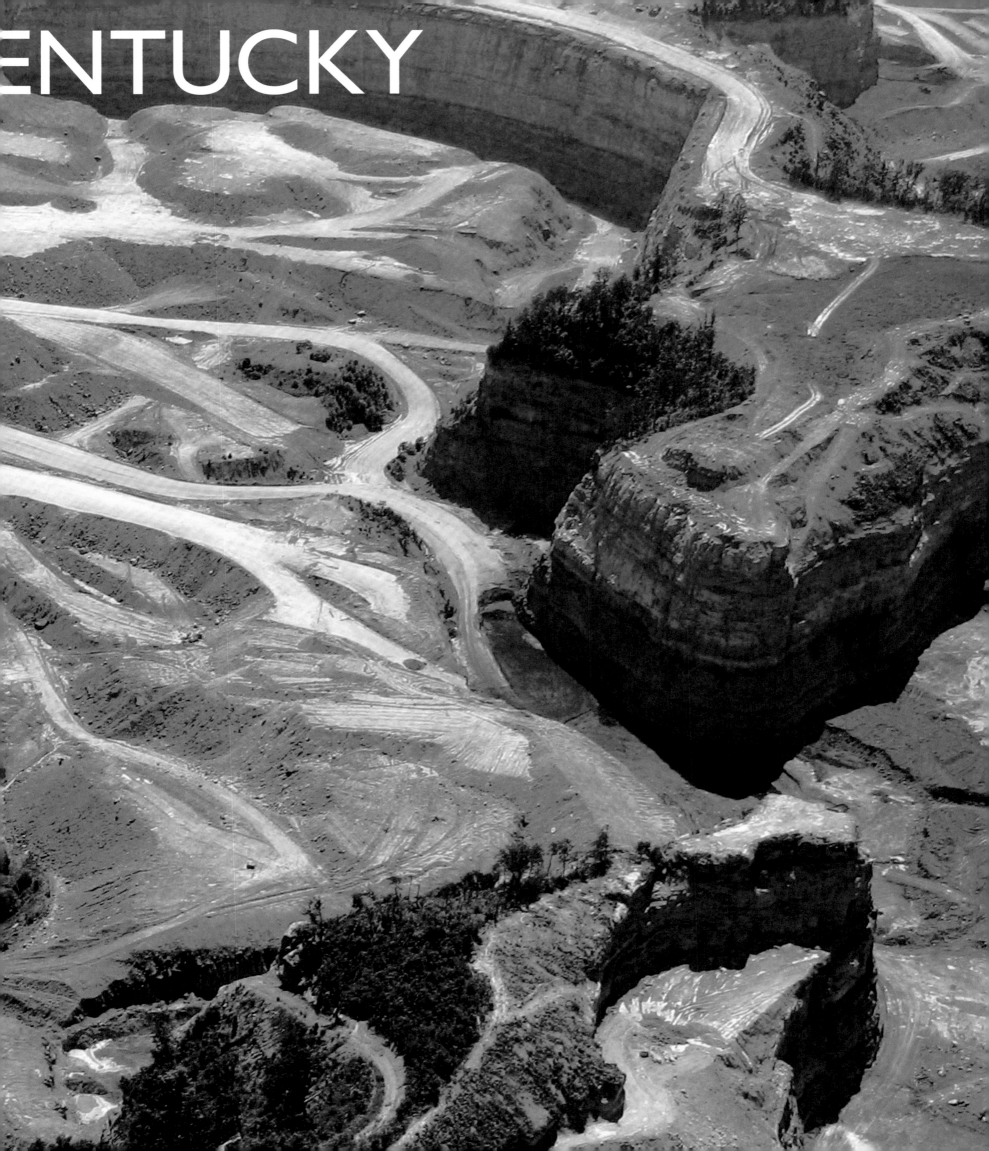

PERRY COUNTY, KEN

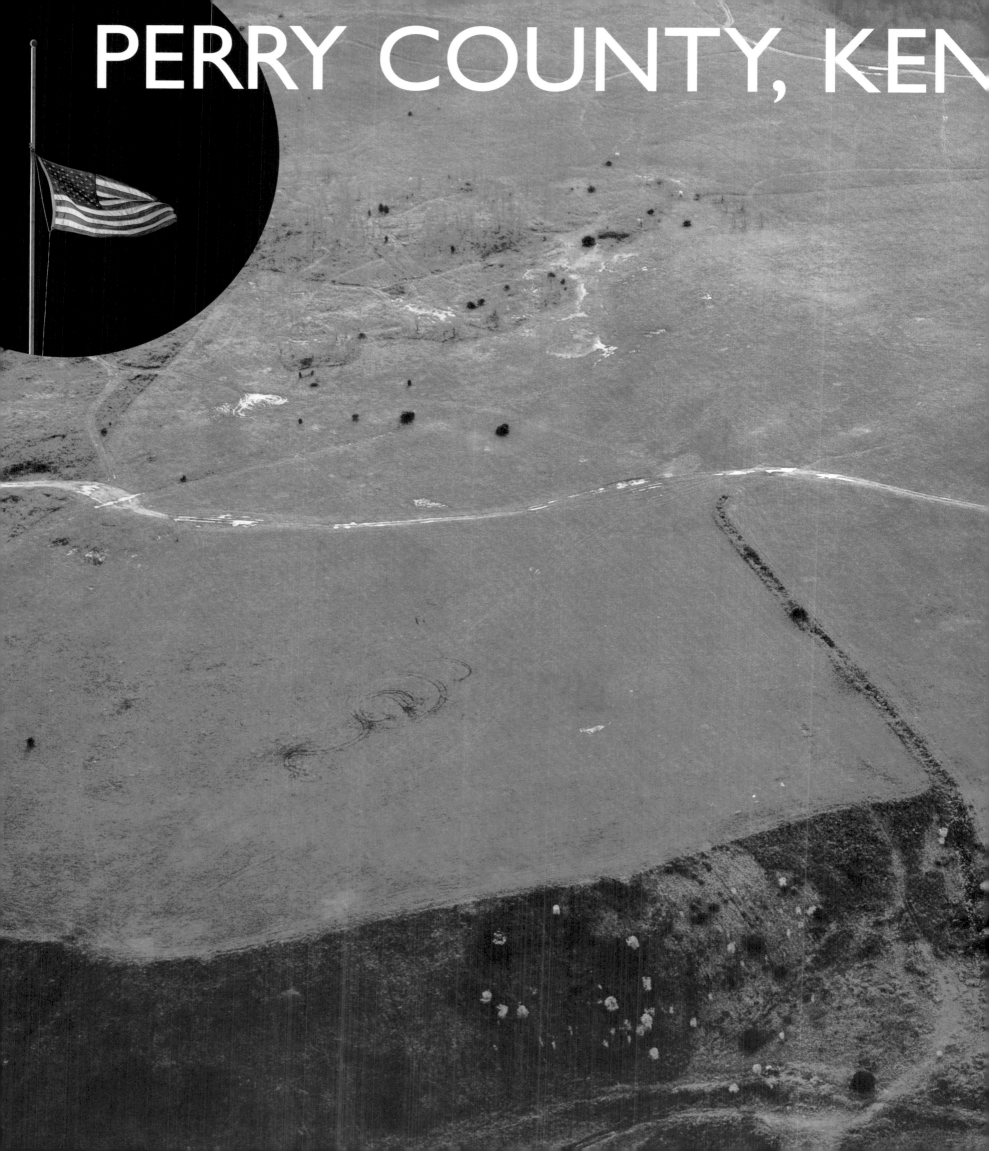

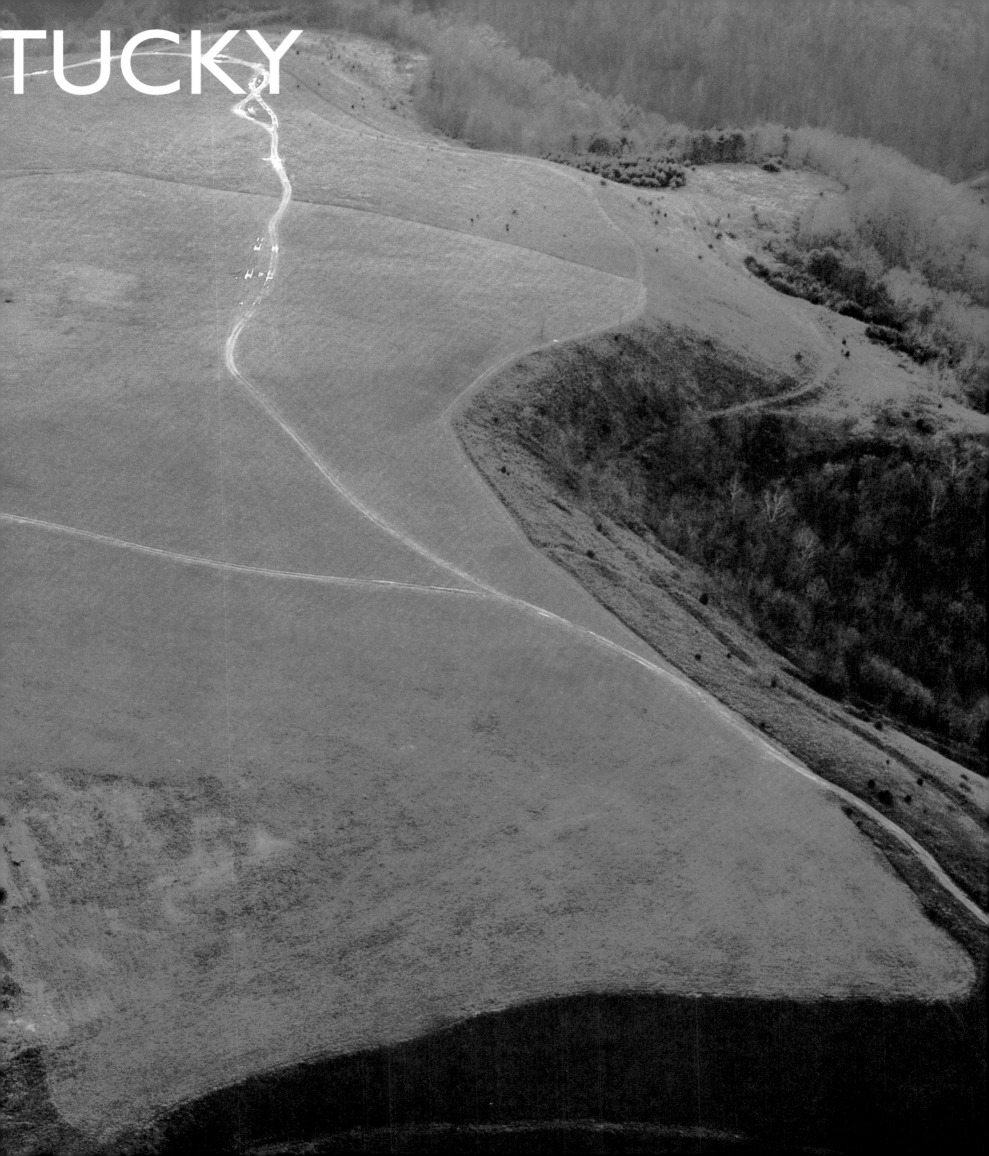

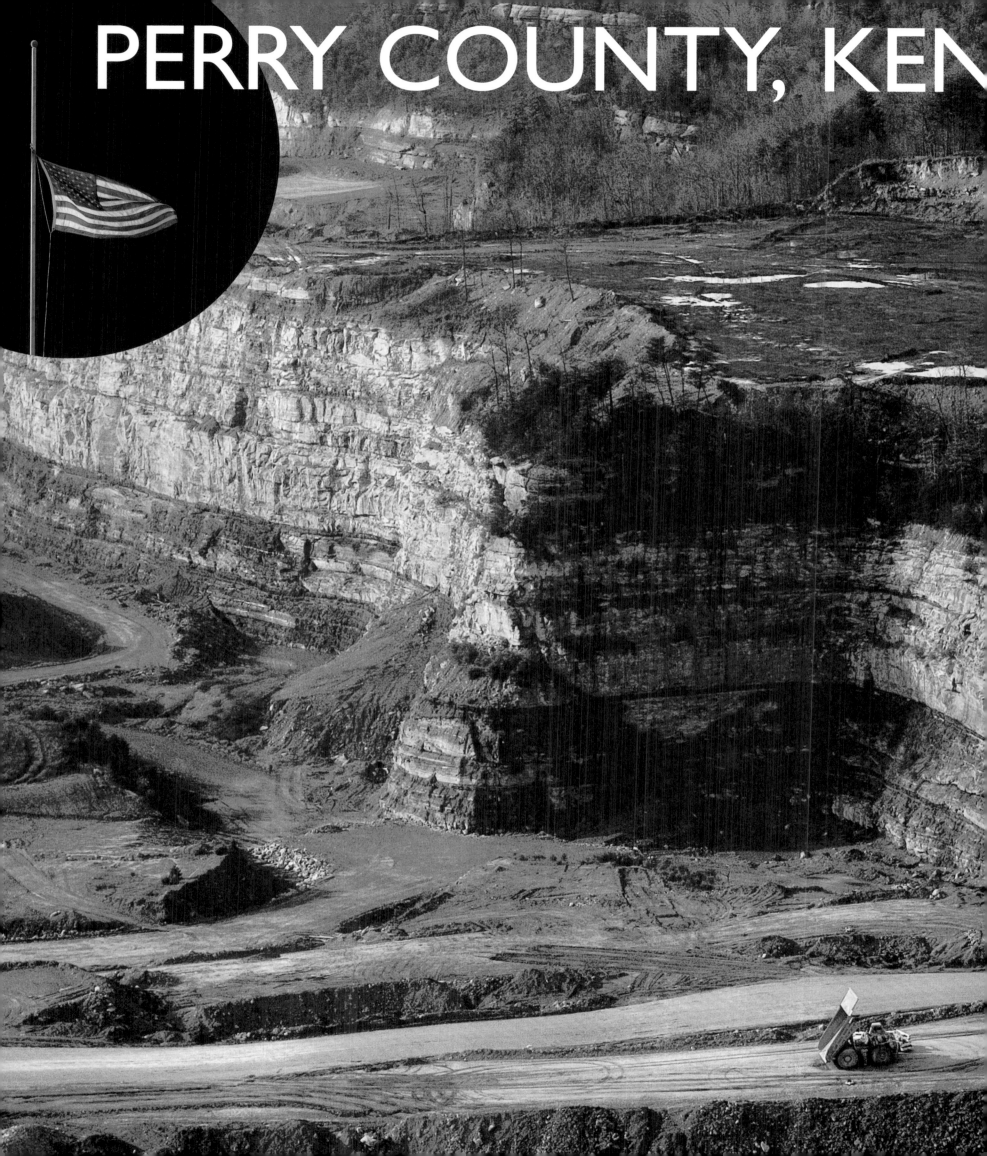

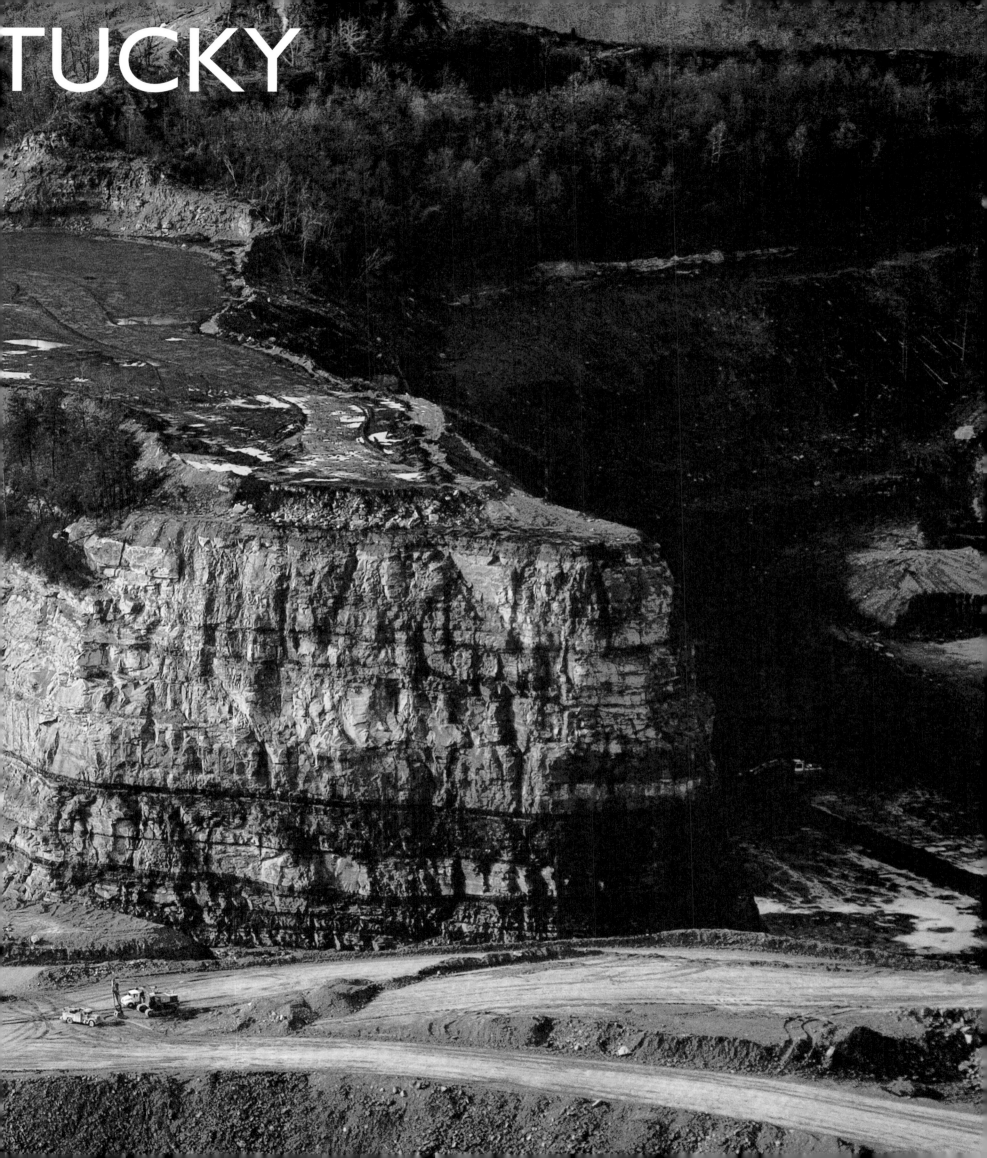

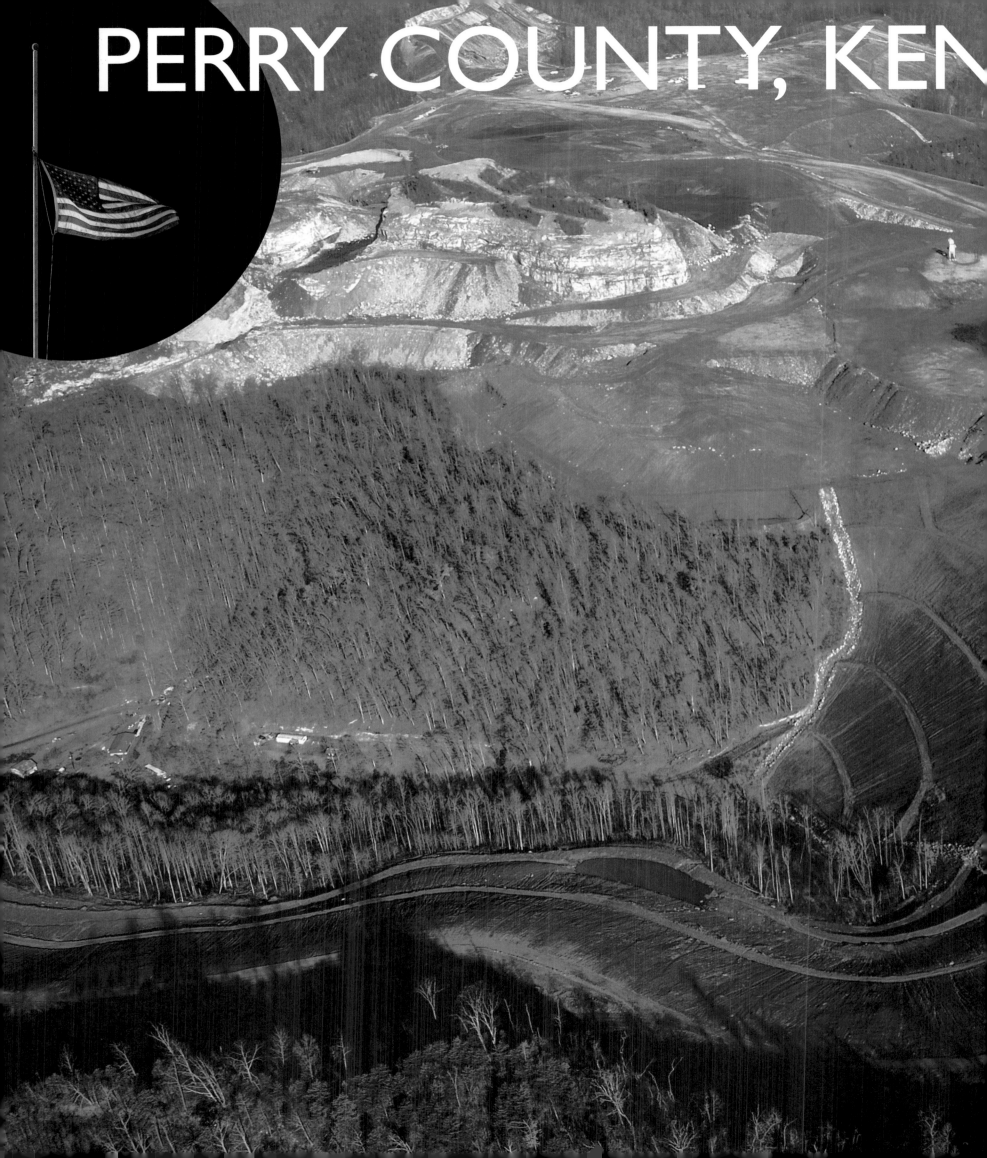

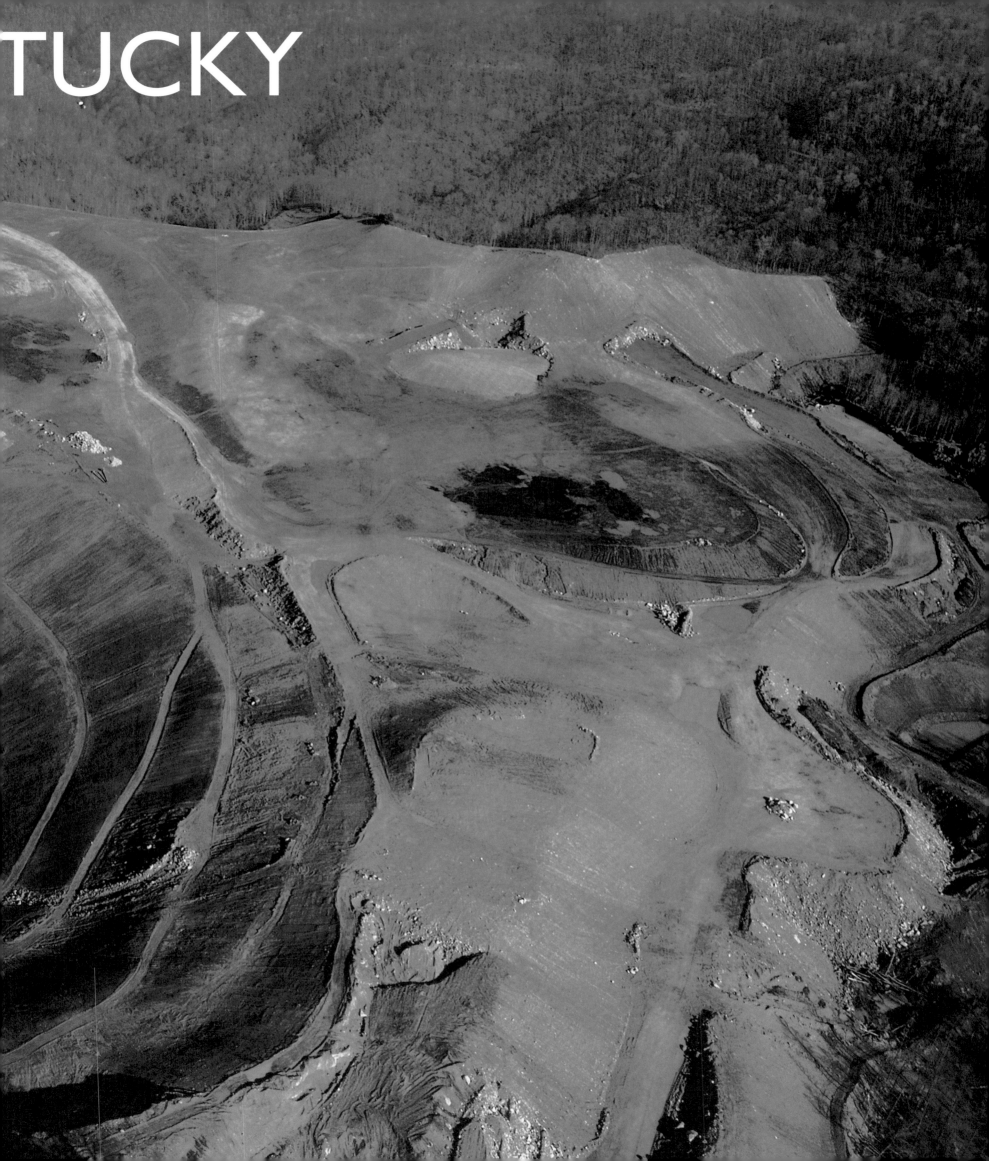

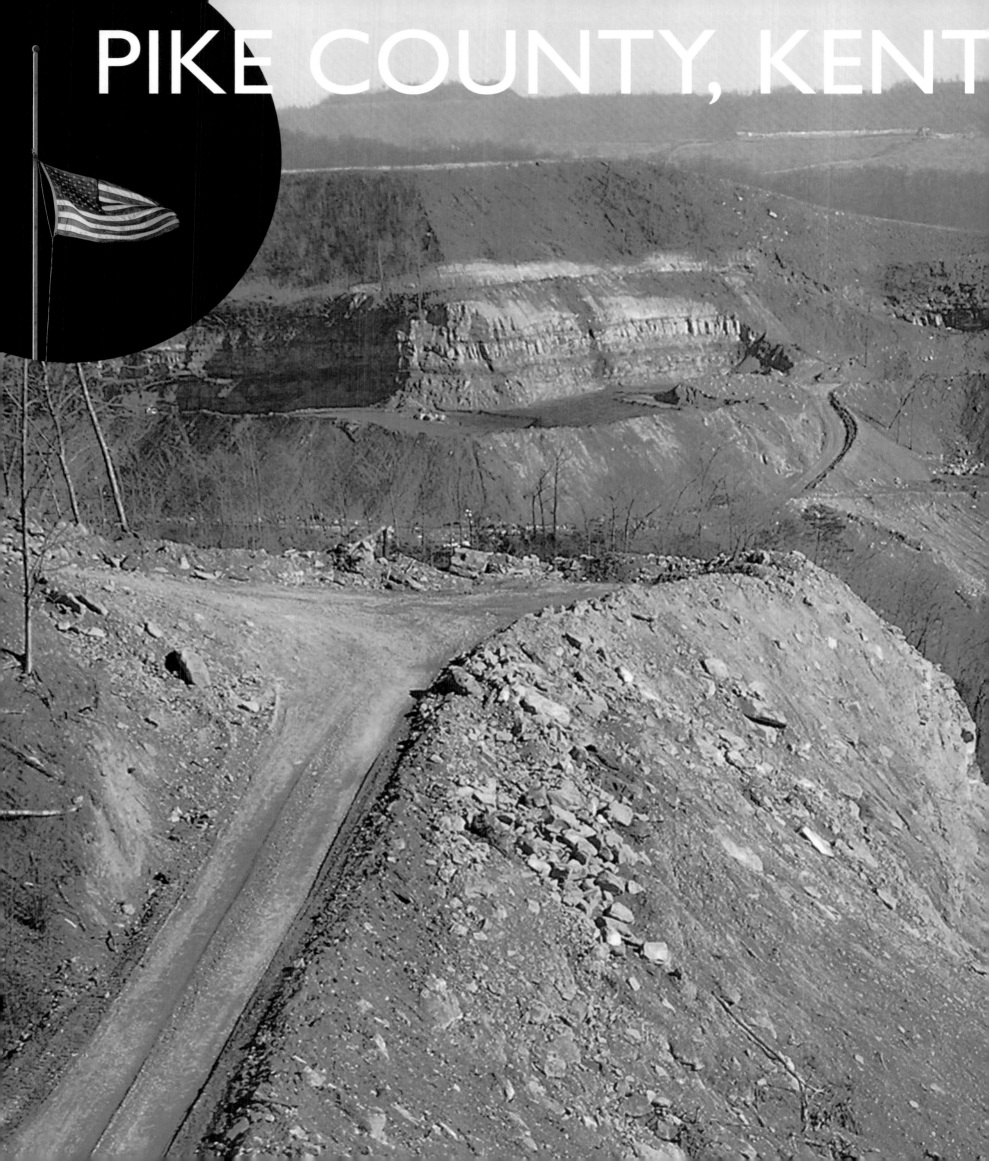

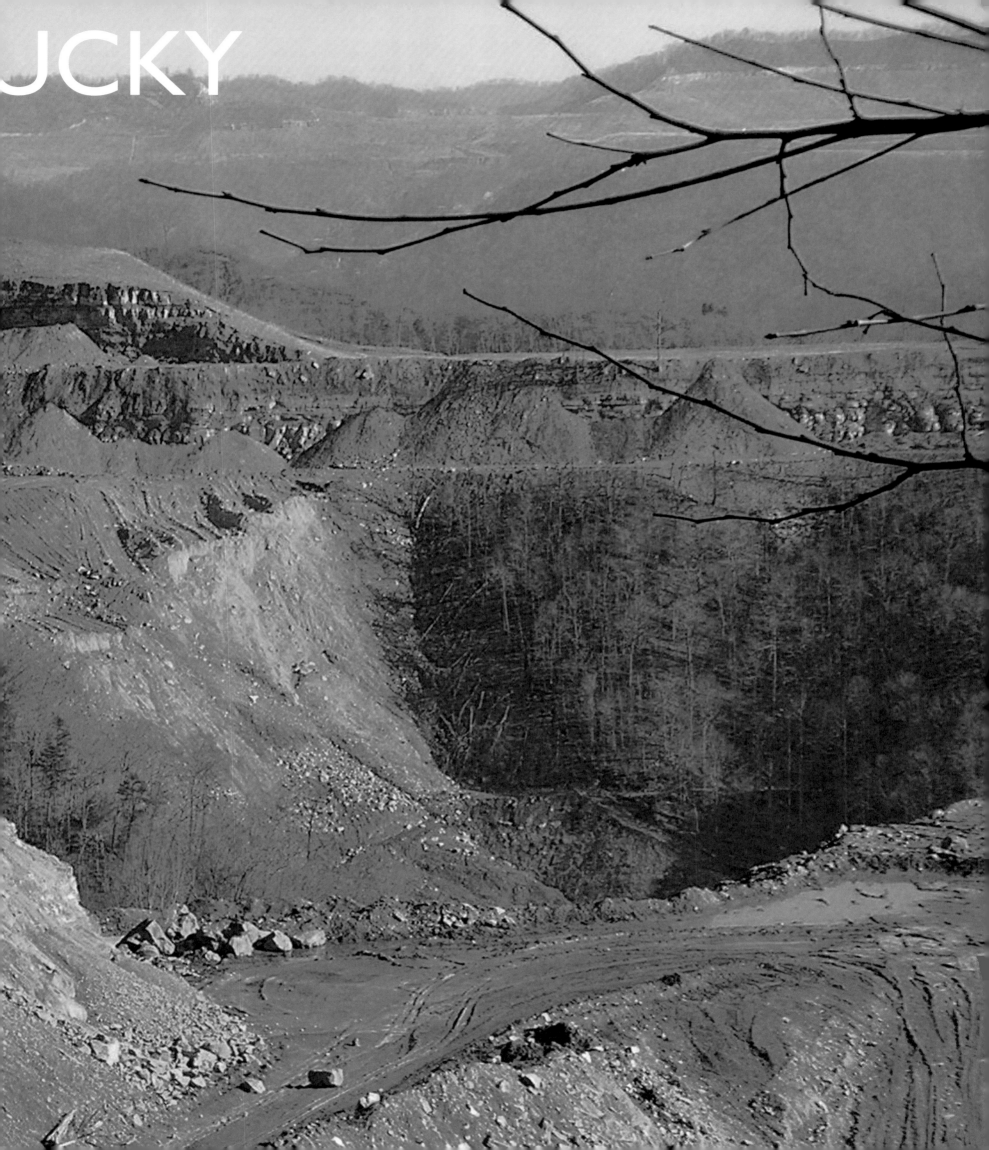

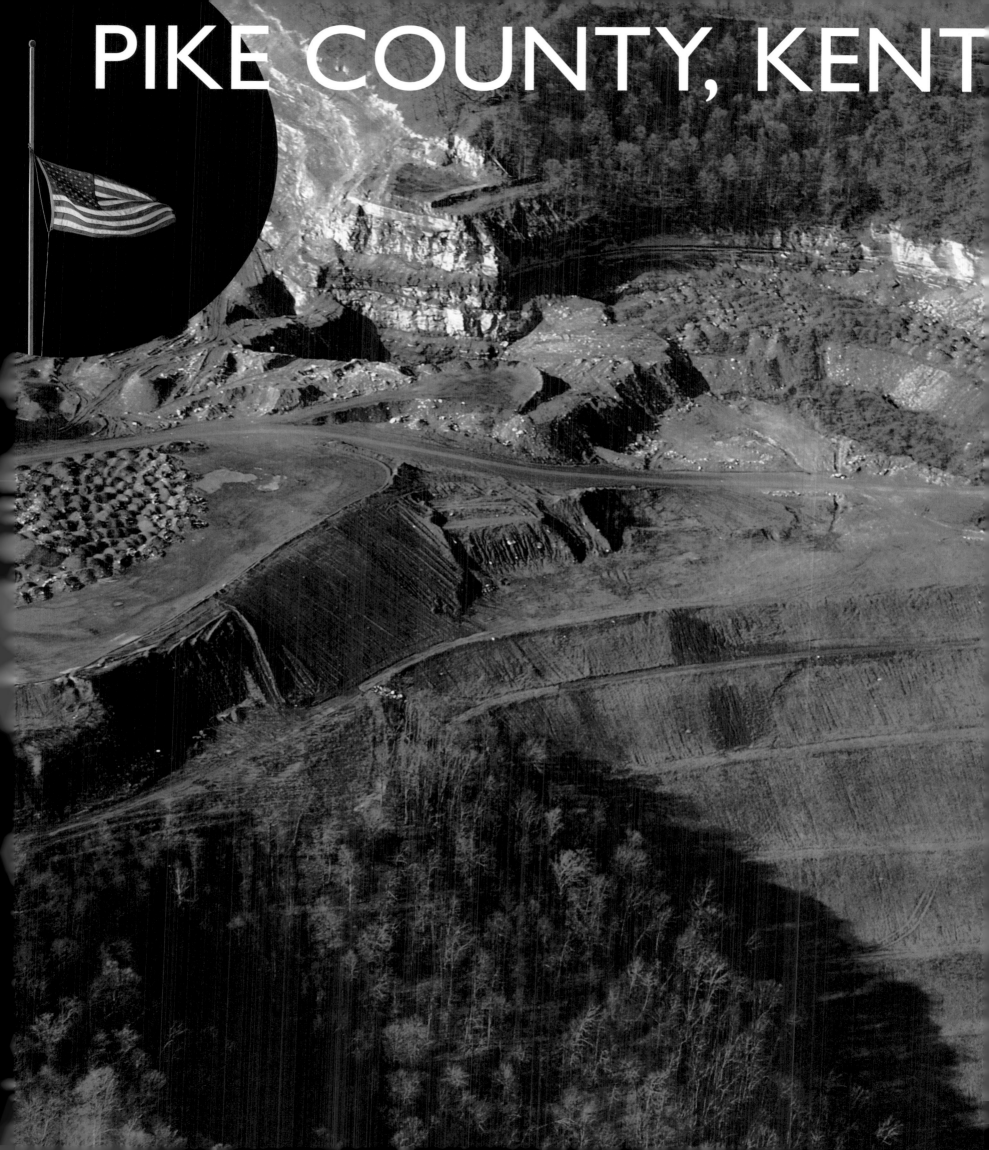

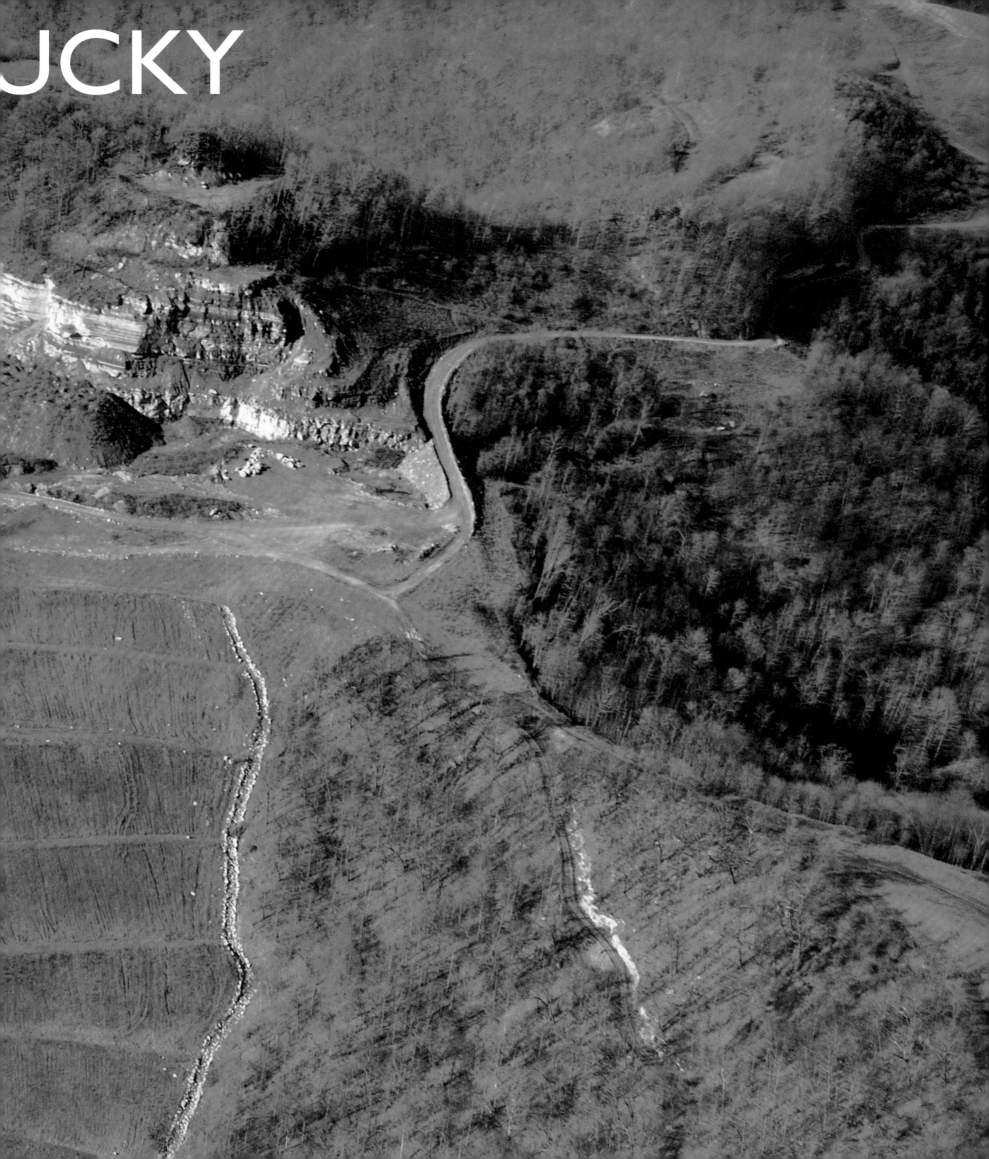

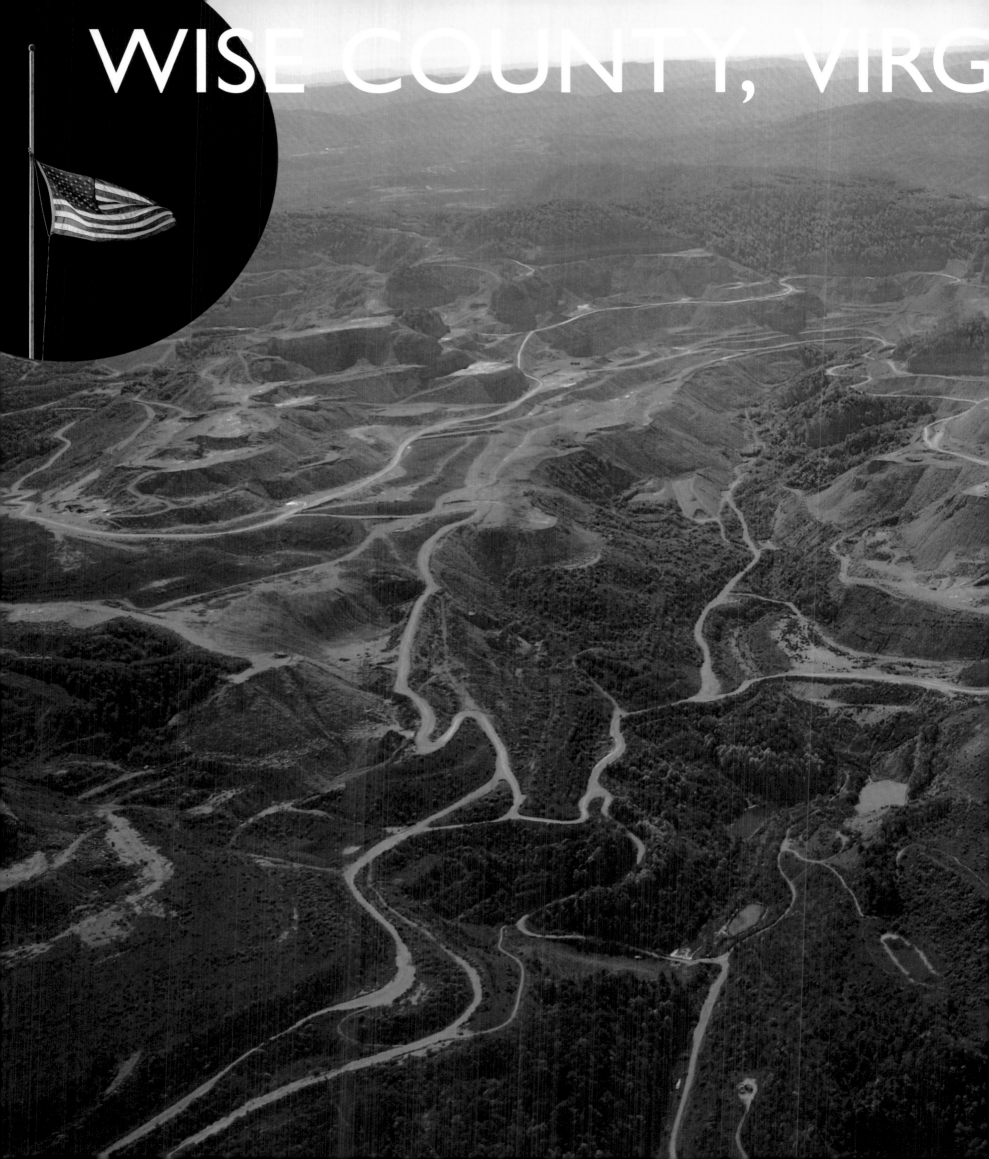

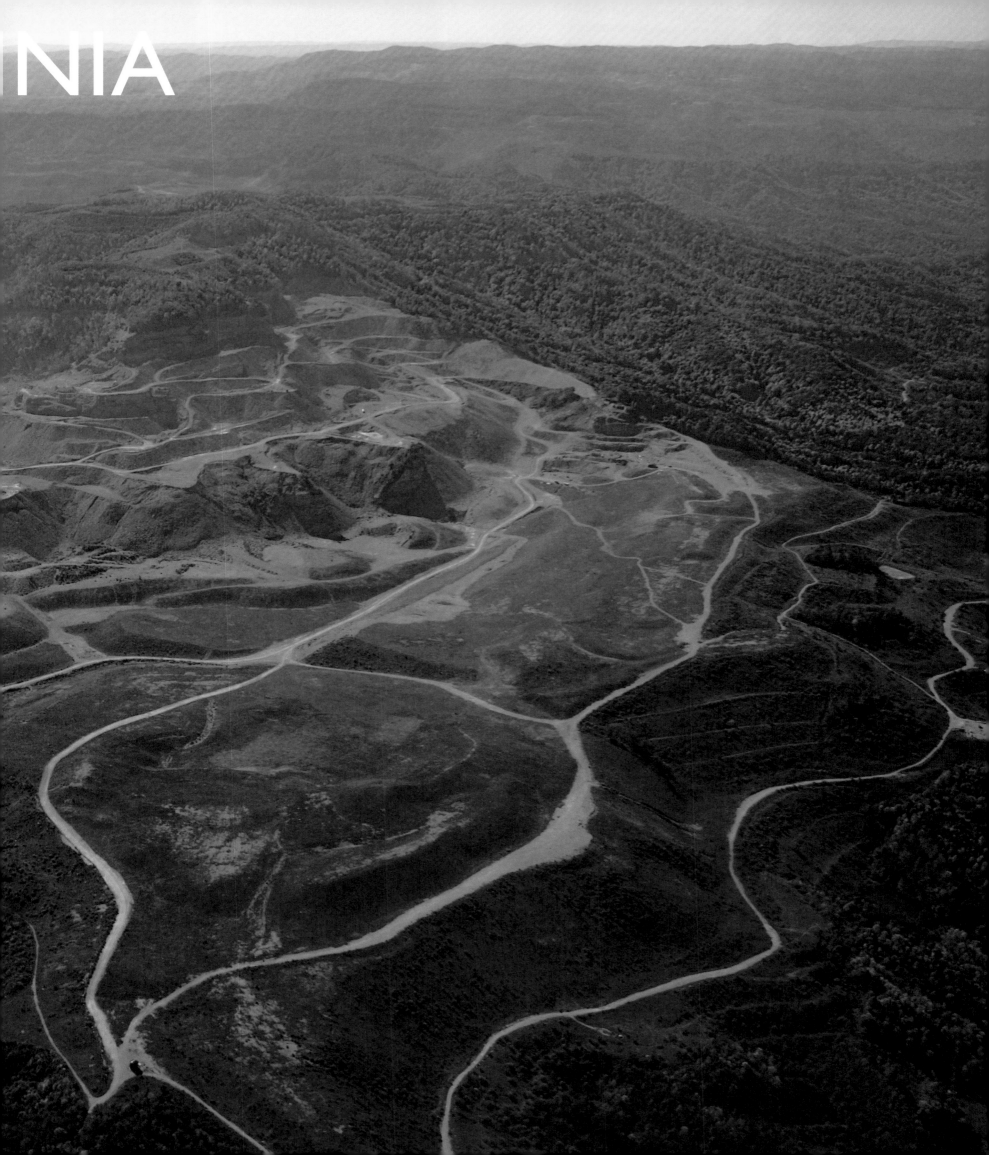

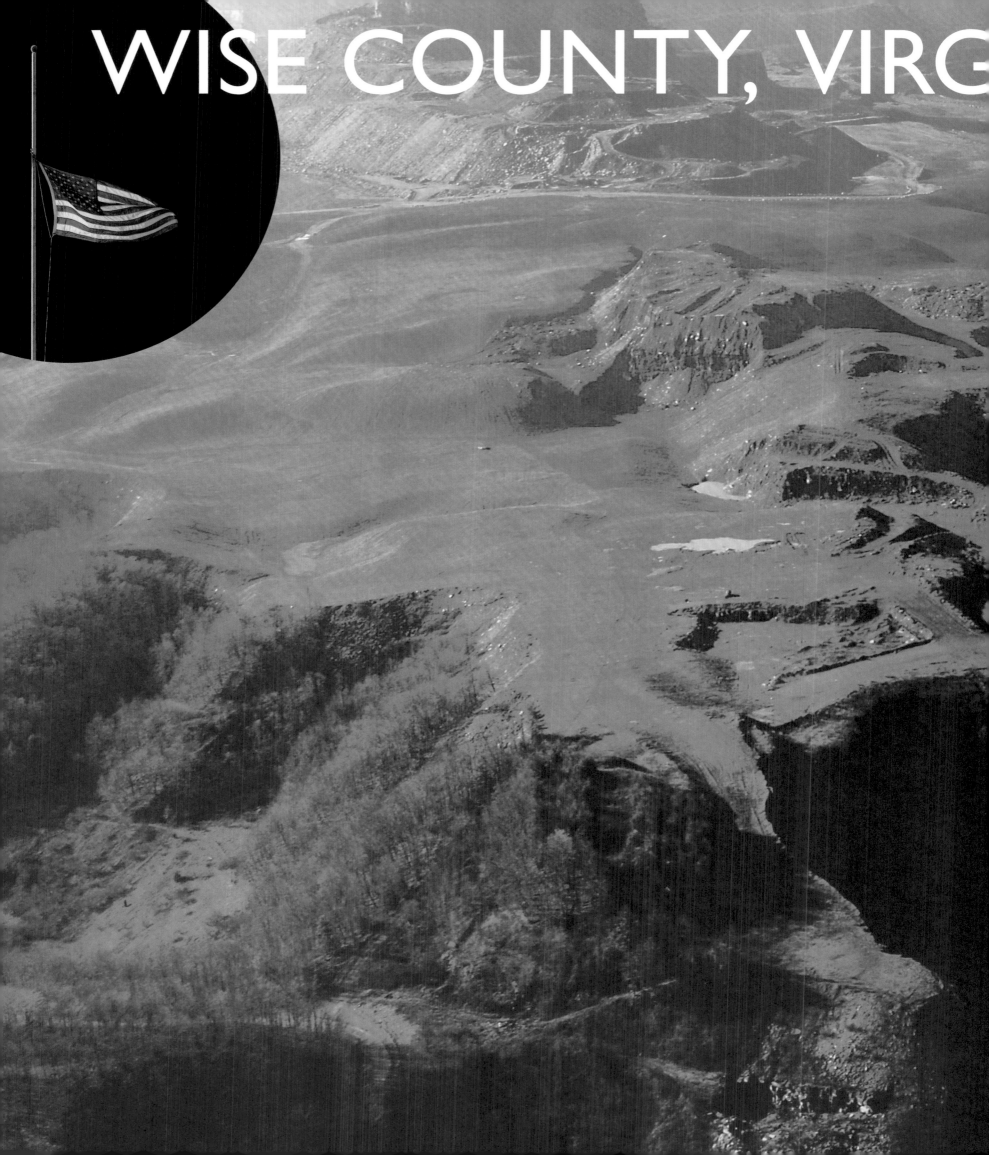

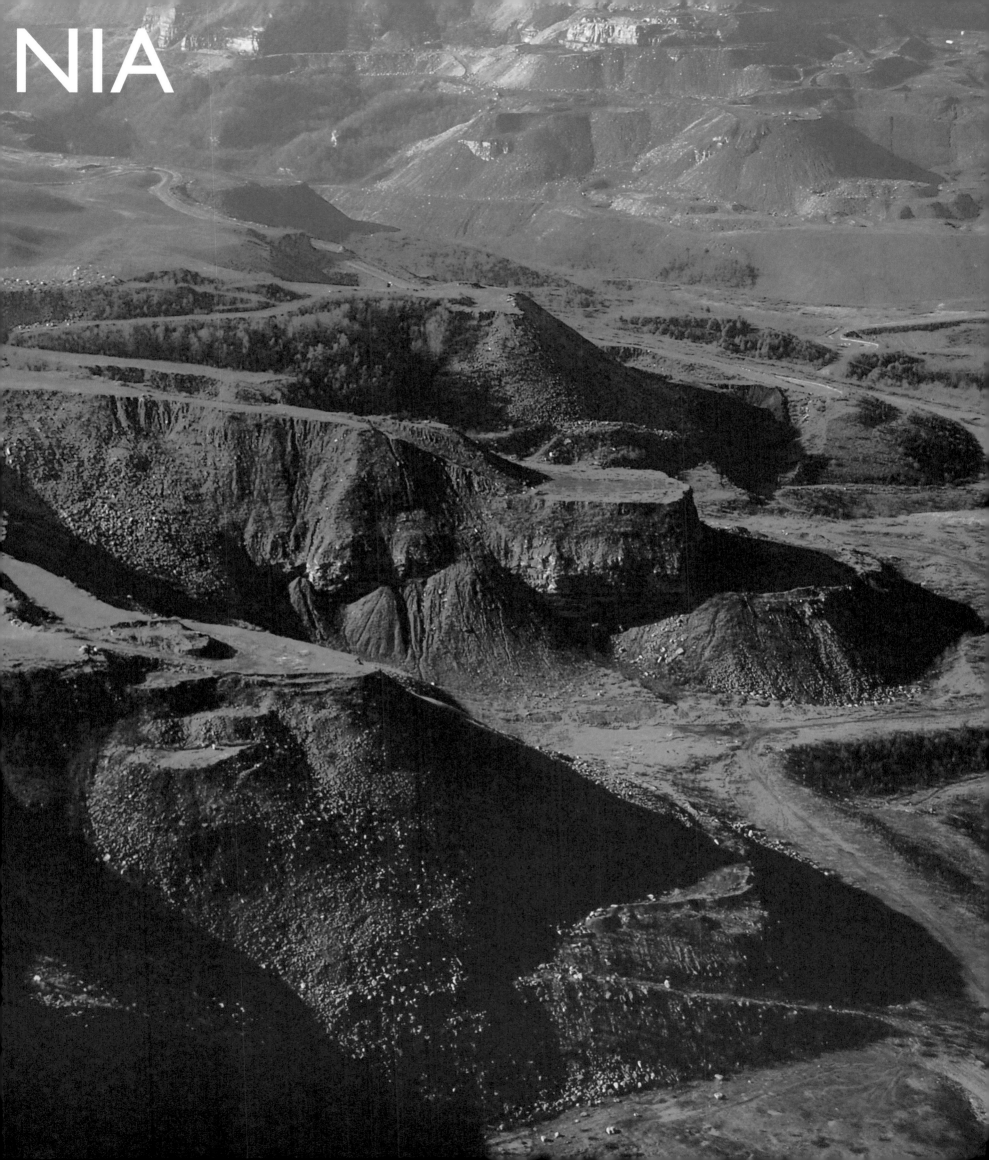

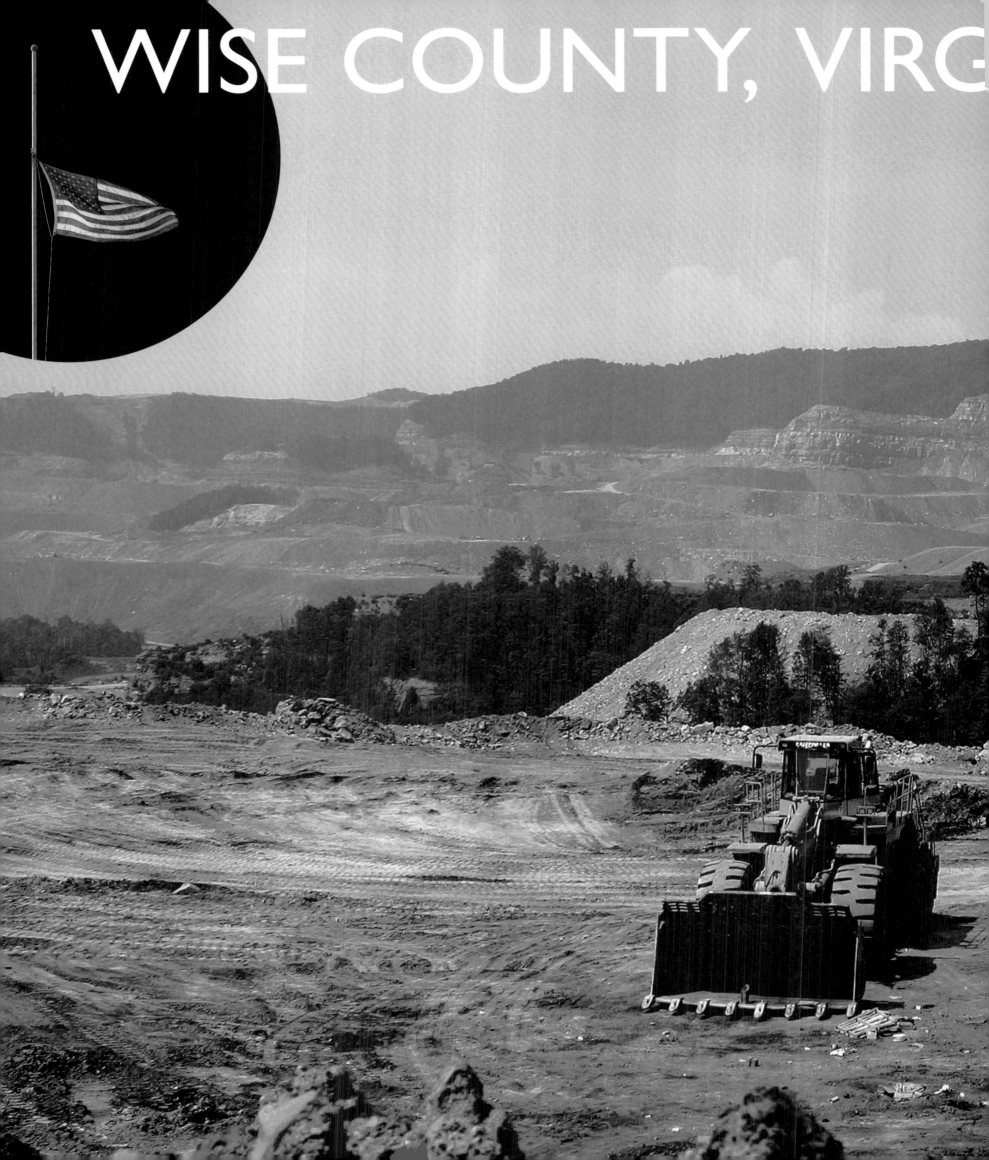

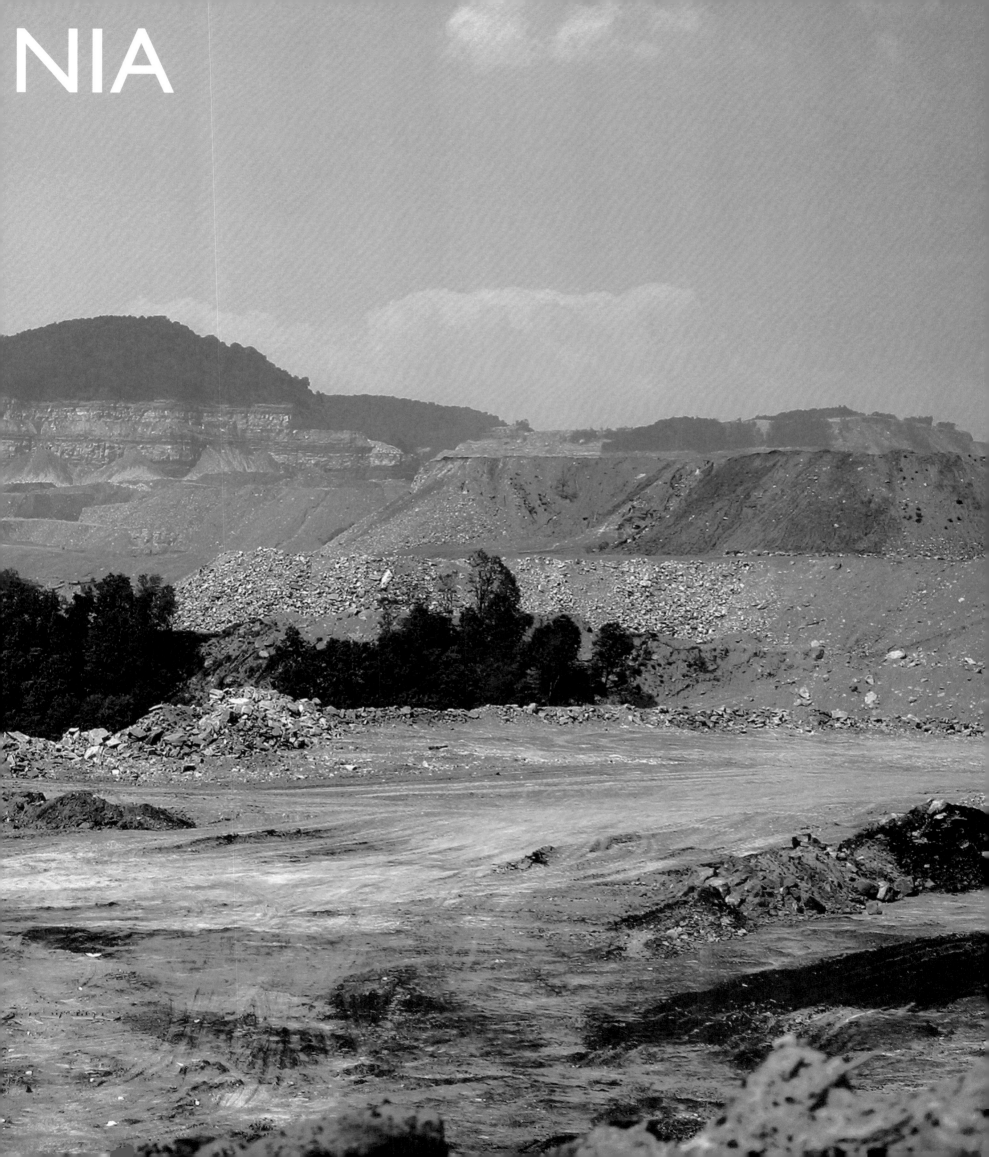

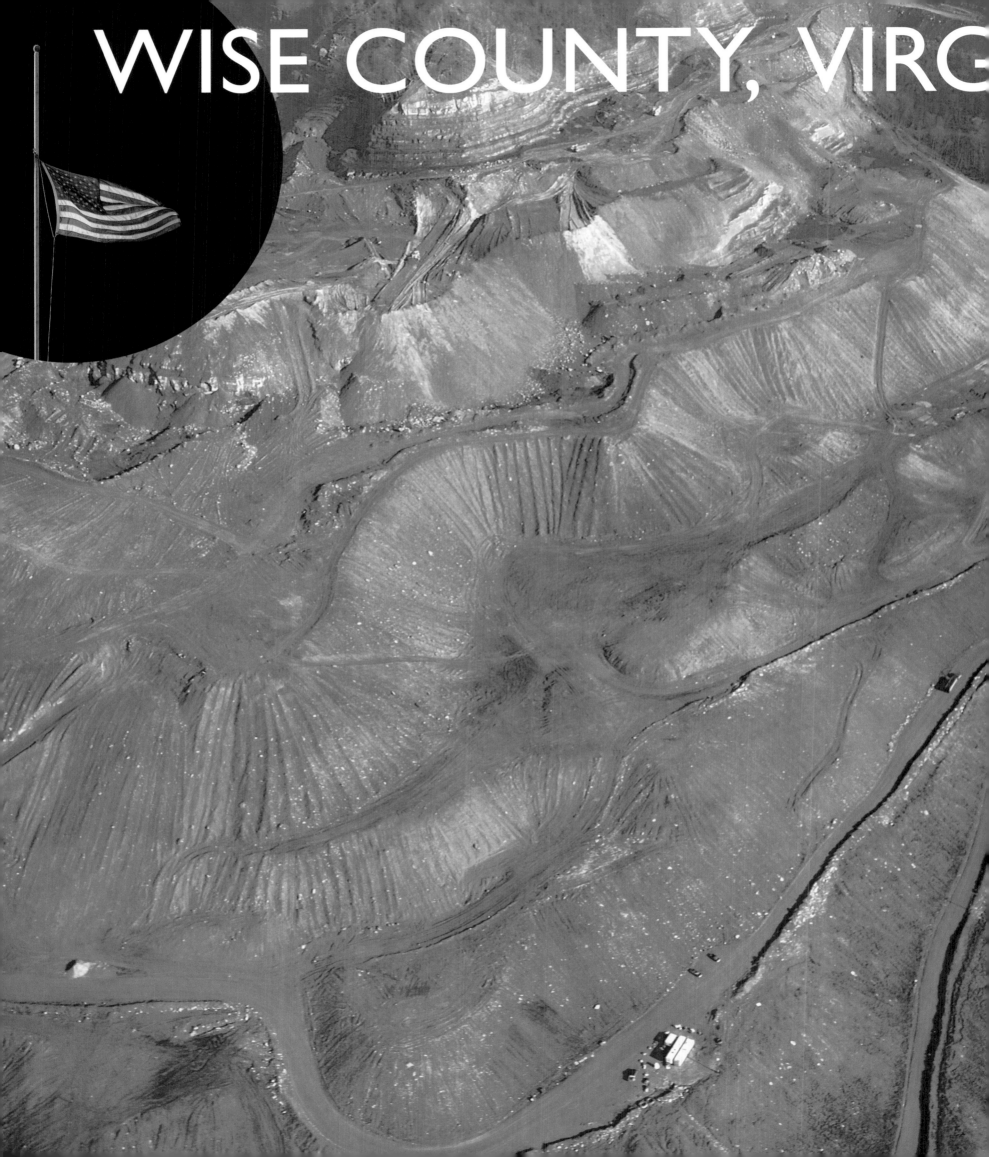

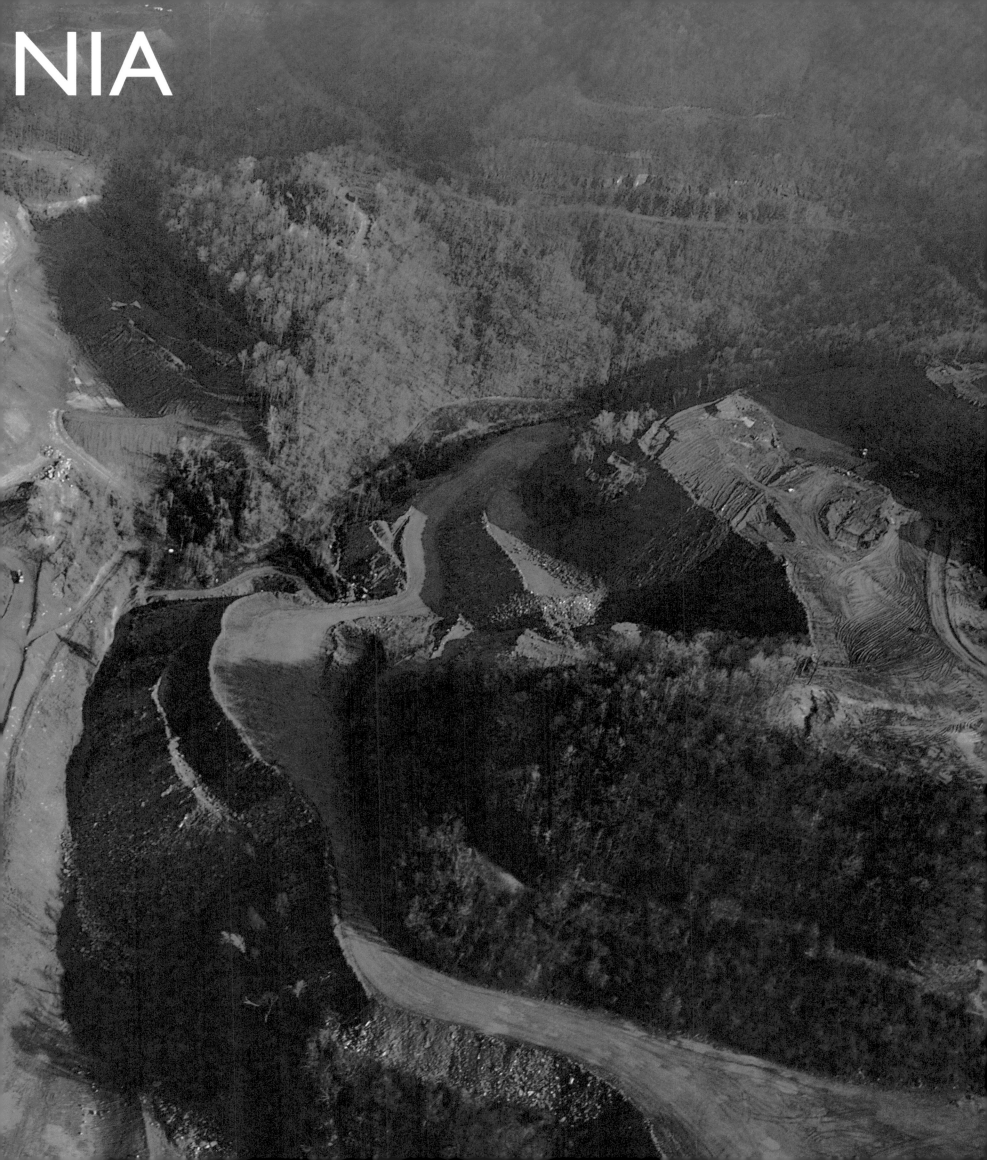

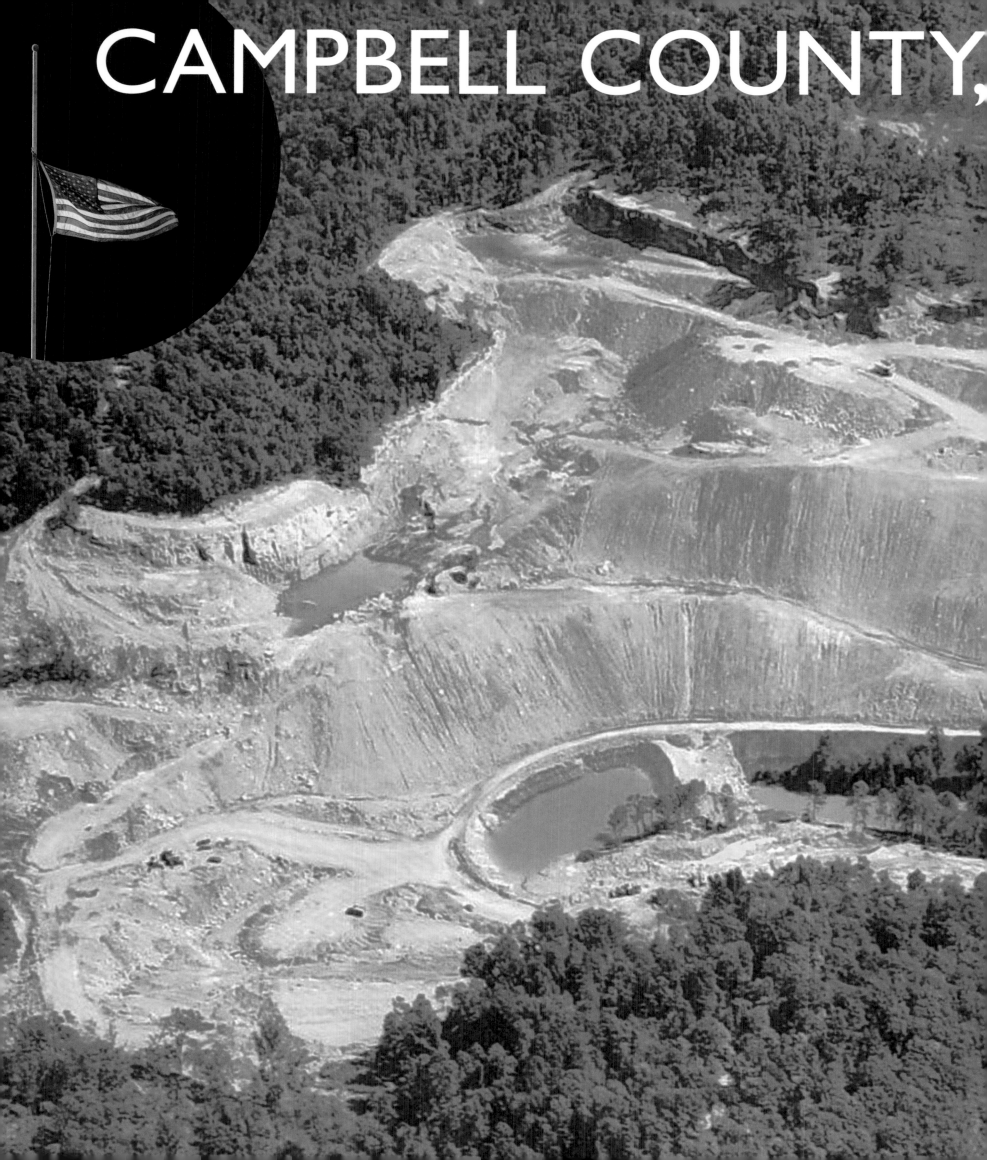

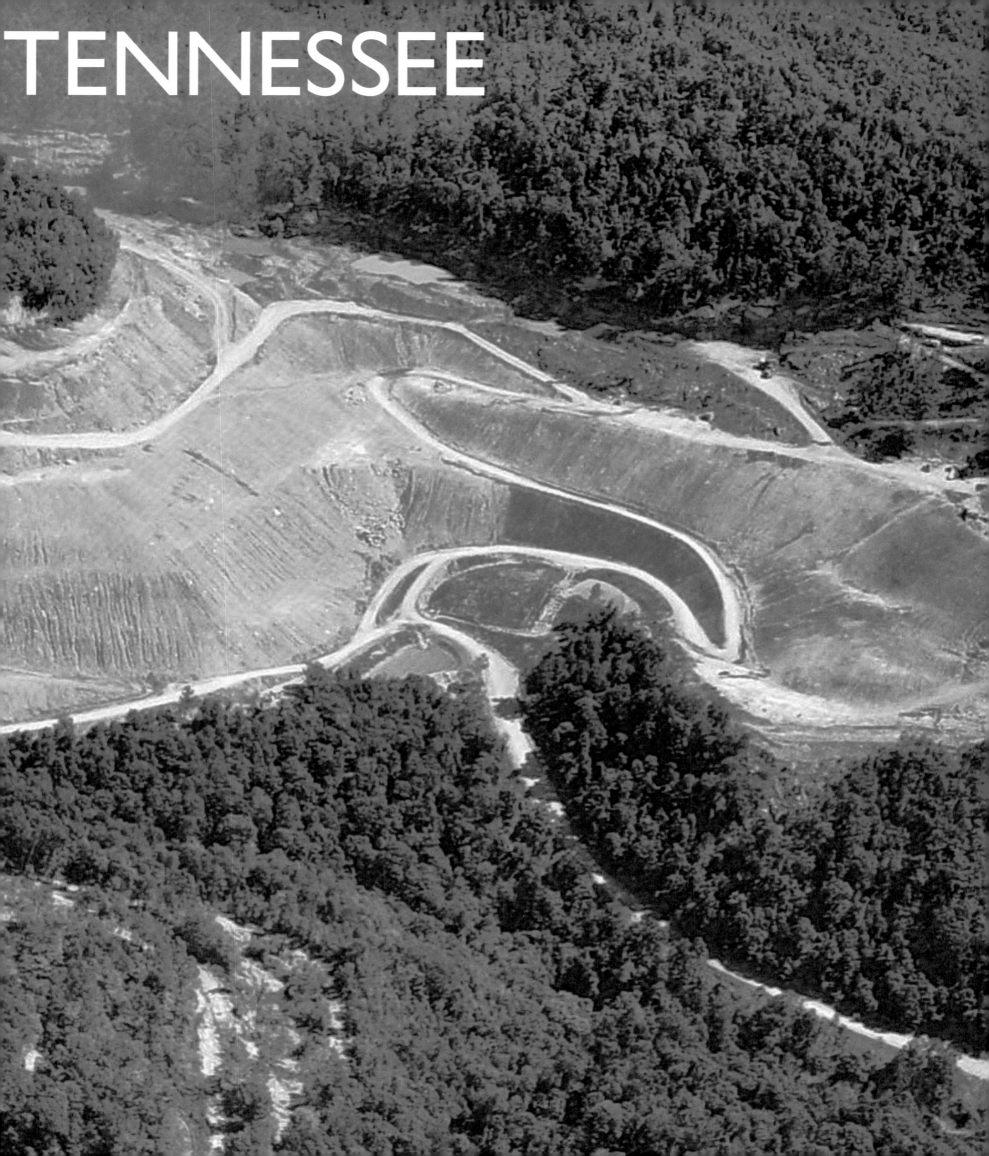

TENNESSEE

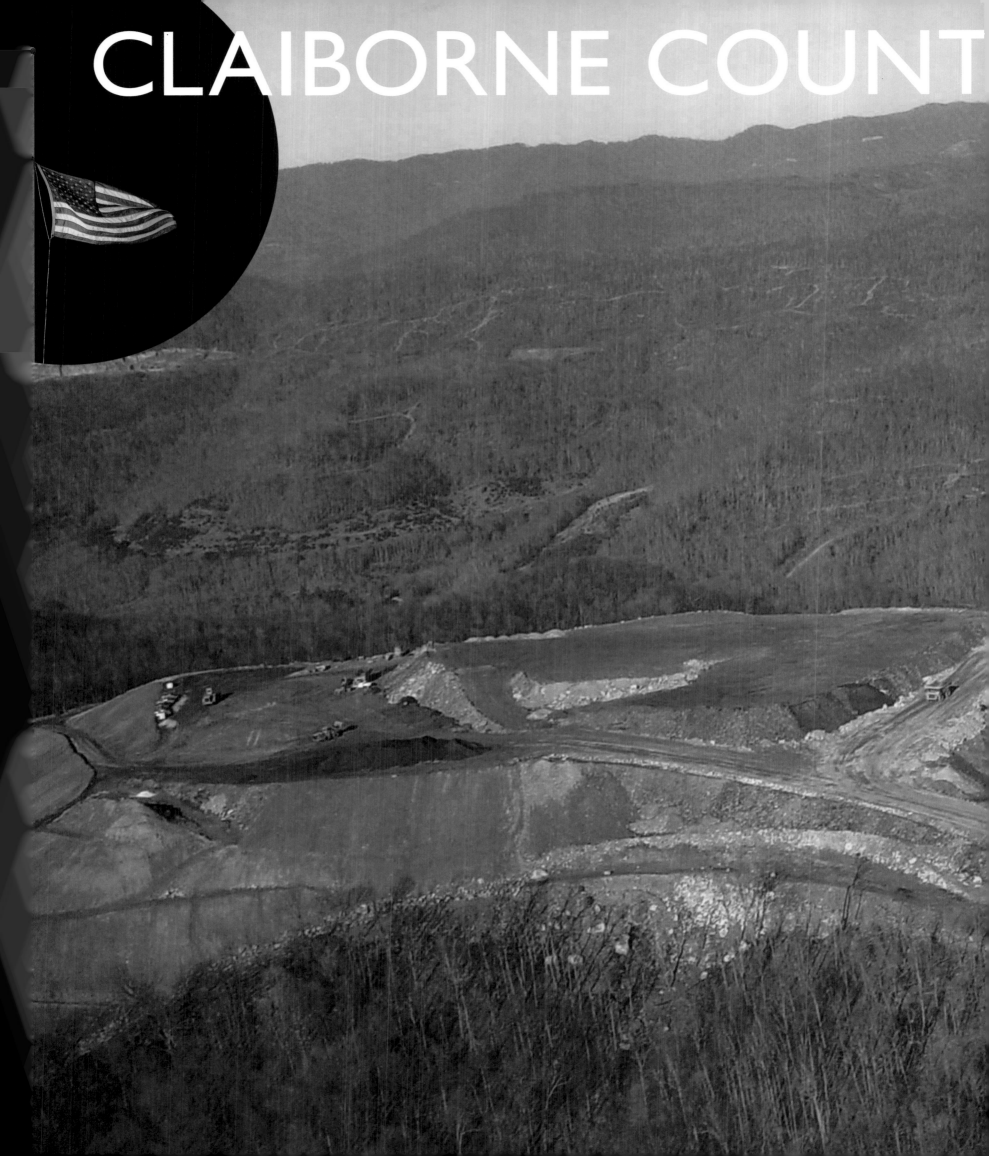

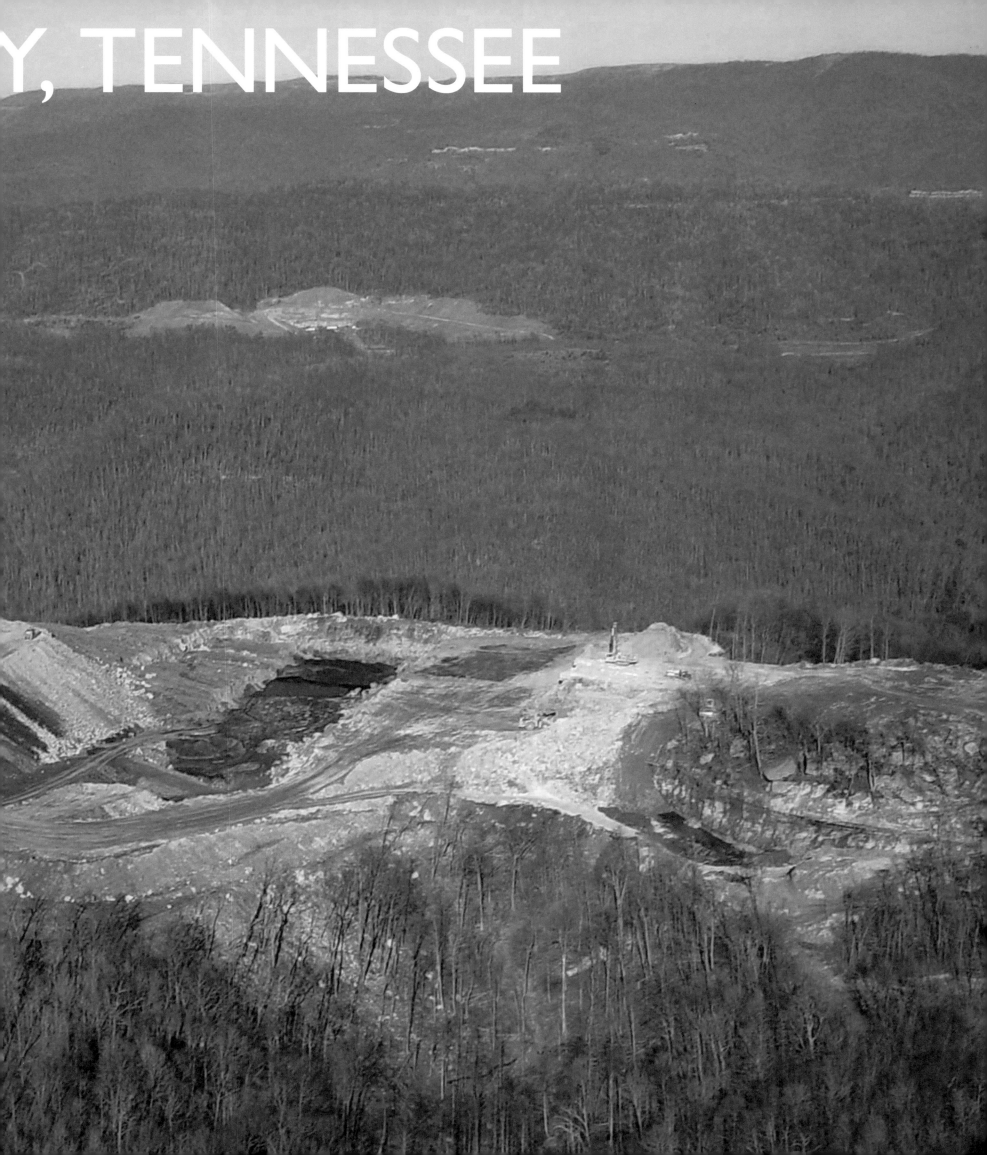

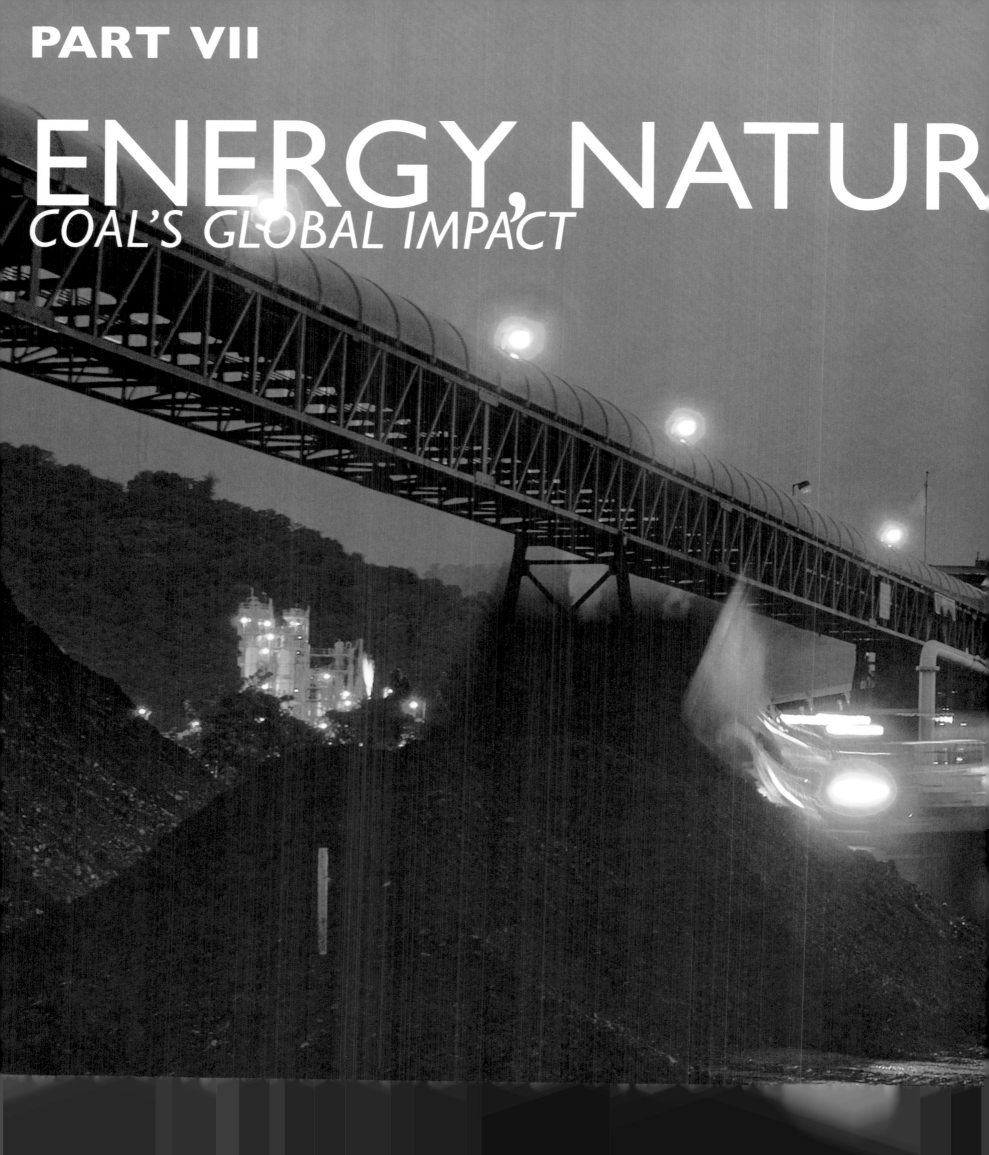

ENERGY, NATUR

COAL'S GLOBAL IMPACT

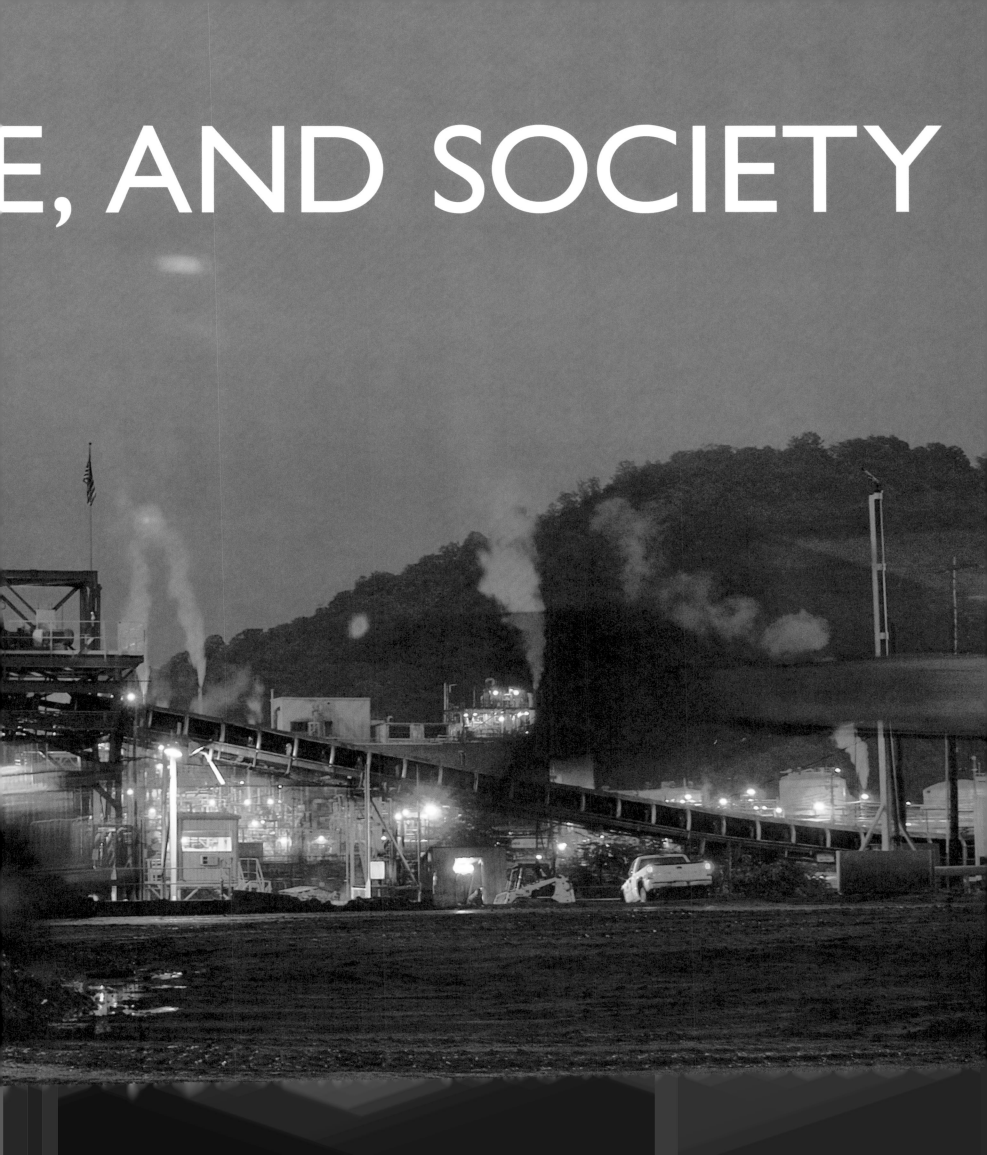

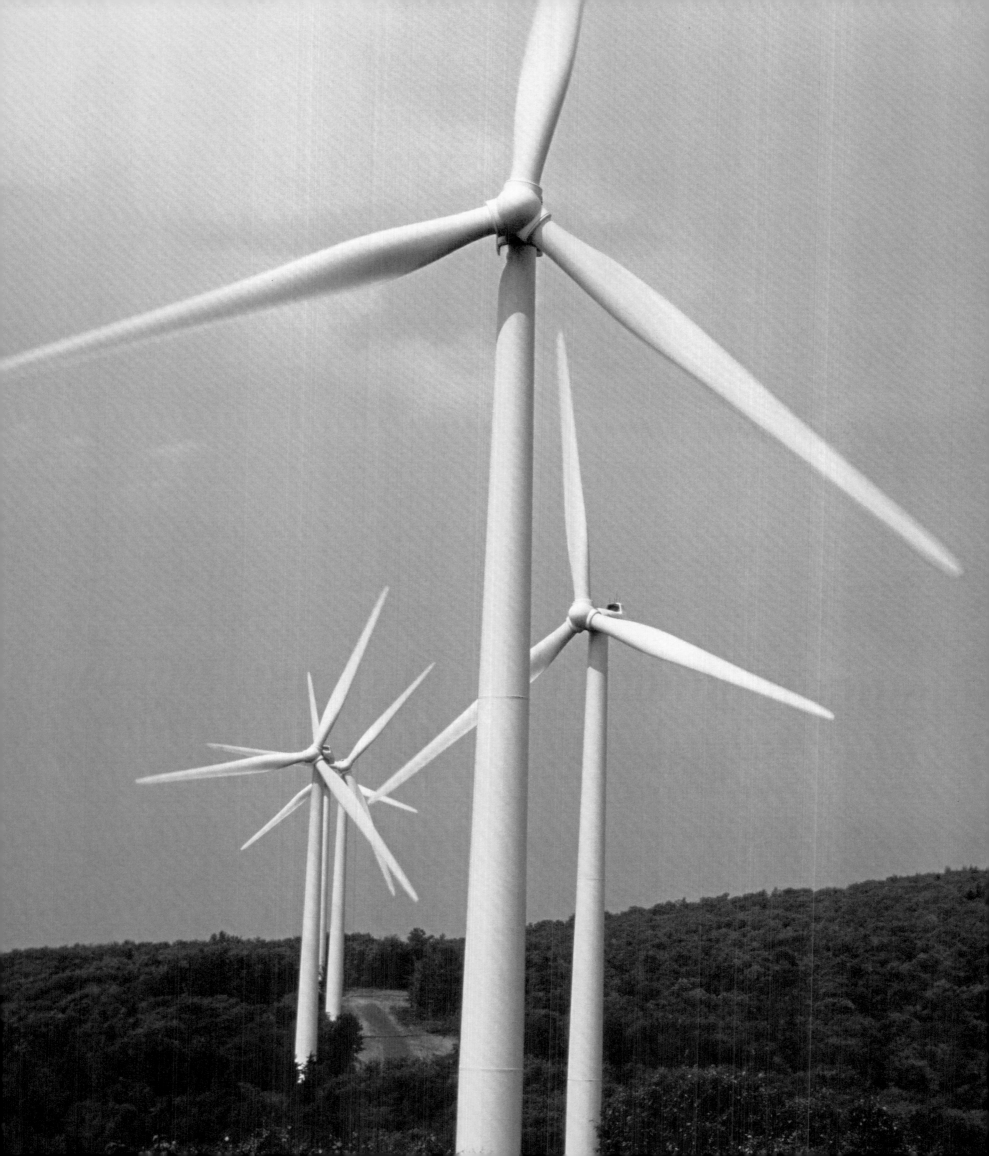

UNNECESSARY AND STUPID

An Economy Based on Ruin

DAVID W. ORR

To permanently destroy millions of acres of Appalachia in order to extract maybe twenty years of coal is not just stupid, it is a derangement at a scale for which we as yet do not have adequate words, let alone the good sense and the laws to stop it. Mountaintop-removal mining employs few workers. It is eliminating broad swaths of Appalachia's mixed mesophytic forest including habitat for dozens of endangered species. It contaminates groundwater with toxins and heavy metals and renders the land uninhabitable. Glib talk of the economic potential of flatter places for commerce of one kind or another is just that: glib talk. Coal companies' efforts to plant grass and a few trees here and there are like putting lipstick on a corpse. The fact of the matter is that one of the most diverse and beautiful ecosystems in the world is being ruined, along with the lives and culture of the people who have a fierce attachment to this place.

We justify the destruction on the grounds of necessity and cost. But it is neither necessary nor cheap. Virtually every competent independent study of energy use done in the past thirty years has concluded that we could cost-effectively eliminate half or more of our energy use and strengthen our economy, lower costs of asthma and lung disease, raise our standard of living, and improve environmental quality. Some say that if we don't burn coal, the economy will collapse and we will all have to go back to the caves. But with wind and solar power growing by more than 40 percent per year and the technology of energy efficiency advancing rapidly, we have good options that make burning coal unnecessary.

More complete accounting of the costs of coal would also include the rising tide of damage and insurance claims attributable to climate change. For every ton of coal burned, 3.6 tons of carbon dioxide eventually enters the atmosphere, raising global temperatures, warming oceans, melting ice, and raising sea levels. Before long we will wish that we had not eliminated so much of the capacity of Appalachian forests and soils to absorb carbon, which when transferred from the Earth's crust to the atmosphere makes for bigger storms and more severe heat waves and droughts.

When will political leaders begin asking the obvious questions: How far does the plume of heavy metals coming from coal-washing operations go down the Kanawha, Ohio, and Mississippi rivers and into the drinking water of communities elsewhere? Why are corporate profits valued more highly than the lives of tens of thousands of people living downwind from coal-fired power plants in the United States who die prematurely each year? What other economy, based on the sustainable use of forests, nontimber products, ecotourism, and human craft skills, might flourish in these hills? What is the true cost of "cheap" coal? Why do the great riches amassed from coal mining never seem to benefit coalfield communities? Why is so much of the land owned by absentee corporations like the Pocahontas Land Company?

Those touting "clean coal" ought to spend some time in Appalachia and talk to the residents in order to understand what those words really mean at the point of extraction. For every ton of coal extracted from the mountains, perhaps a hundred tons of "overburden" is dumped, burying steams and filling the valleys and hollows of West Virginia, Kentucky, and parts of Tennessee and Virginia. And for those who believe that technological innovation will soon allow carbon dioxide pollution from burning coal to be safely and permanently sequestered underground at an affordable cost that competes fairly with energy efficiency and renewables, I have oceanfront property to sell you in Arizona.

Like all life forms, we search out great pools of carbon to perpetuate ourselves. It is our mismanagement of carbon that threatens the human future, and this is an old story. Humans have long fought for the control of carbon found in rich soils and deep forests and later in fossil fuels. The root of all evil does not begin with money, but with the carbon in its various forms that money can buy. The exploitation of carbon is the original sin leading quite possibly to the heat death of a great portion of life on Earth including us. This is what James Lovelock calls the revenge of Gaia, which, if it comes to pass, will be hell on Earth.

COAL'S CLIMATE CONNECTION

Toward the Point of No Return

ROSS GELBSPAN

Coal has pushed the world toward a tipping point in terms of global warming—both through its continued use as a basic fuel and through a campaign of political sabotage waged by leaders of the coal industry. While emissions from coal burning have accelerated the build-up of heat-trapping gases, many leaders of the coal industry have used their economic and political influence to block any meaningful action in the United States against what is arguably the greatest threat ever confronting humanity.

An understanding of how coal burning affects the natural environment begins with a primer about global warming. No other fuel has made a bigger contribution to the ominous and escalating heating of the atmosphere. The scientific facts are simple: Carbon dioxide in the atmosphere traps in heat. For 10,000 years, we had roughly the same amount—280 parts per million—until 150 years ago, when the world began to industrialize using fossil fuels. Today that concentration is about 385 parts per million, a level that this planet has not experienced for 800,000 years. While these carbon emissions are released through humanity's use of all fossil fuels, for every unit of energy generated, coal releases about 30 percent more carbon dioxide than oil does and about 50 percent more than natural gas does.

Historically, coal has been the major driver of the world's leading economies. Coal ushered the hydro- and wood-powered economies of the United States and Europe into the industrial revolution in the nineteenth century. Most recently, it has become the engine that powers the economic boom in China and, to a lesser extent, in India. And while environmentalists raise growing concerns about the potentially irreversible effects of coal burning on the planet, China continues to build one new coal plant approximately every two weeks, according to estimates.

In the face of calls to limit, and ultimately reverse, their reliance on coal, a number of developing countries have answered by pointing squarely at the United States. They cite what they see as flagrant hypocrisy by the world's largest industrial power. Until the U.S. takes the lead in shifting its economy to renewable, noncarbon energy sources, developing countries say they will not.

The reluctance of China and other developing countries to rein in their coal-plant development is based on a simple notion of economic equity. Unless the United States cuts its use of coal and embarks on a clean-energy transformation, any cut in coal burning by developing countries would put them at an even greater competitive disadvantage economically. And given the imperative of rapid development in today's global economy, there is no way America will see a reduction in coal use abroad until it sets the pace domestically. But opposition to such a switch in the United States has been the object of a ferocious campaign by the coal industry, which has blocked all such efforts through a set of policies designed to deceive the public and influence the government's climate and energy policies.

The U.S. coal industry now touts the promise of "clean coal," based on a future program of carbon capture and storage. Under that scenario, technological innovation would allow carbon dioxide to be captured from power plant exhausts and then buried in deep mine shafts or wells. Unfortunately, the technology is largely untested. Environmentalists contend that there is no guarantee the carbon dioxide would remain permanently underground.

A far more immediate obstacle is the high cost of such technology, even if it could be perfected. As one wag pointed out, "this looks like a full employment act for companies like Halliburton and Bechtel." Adding carbon capture and sequestration could well make coal economically prohibitive as an energy source. The cost issue comes into clear relief with one simple question: How many windmills could be built for the cost of one power plant with carbon sequestration? The answer is very many indeed.

The obvious connection between coal burning and the heating of the planet is neither the fault of coal itself nor the industry that grew up around it. For centuries, much of humanity derived its energy from coal. Long before Charles Dickens, a series of writers chronicled coal's contributions to filthy air, lung disease, and the hardships of coal miners. But those impacts were tacitly deemed to be acceptable prices for the bounty of locomotion and, later, the electricity that coal provided. Early coal entrepreneurs did not intend to make sea levels rise or melt

the world's glaciers. They were, after all, just trying to provide cheap and abundant energy to make this a wealthier world.

Aside from a few relatively obscure laboratory scientists, few people realized that the explosion of coal burning in the twentieth century would jeopardize the stability of the planet's life-supporting systems. But that period of innocence was rudely ended two decades ago when we were blindsided by the onset of accelerating climate change. It was in 1988 that the United Nations formed the Intergovernmental Panel on Climate Change and NASA scientist James Hansen told Congress that global warming is at hand.

That was the point at which a segment of the coal industry morphed into criminals against humanity by deliberately concealing the fact that our continued burning of coal was beginning to upset a natural balance we had enjoyed for some ten millennia—a balance that made this planet hospitable to the development of human civilization.

As policy makers began to respond to the unnaturally rapid warming of the atmosphere, around 1990 the coal industry launched a campaign of deception and disinformation designed to persuade the public and policy makers that the issue of global warming was stuck in uncertainty. That campaign attacked the science—and in the process, it marginalized the findings of more than two thousand scientists from one hundred countries participating in the largest and most rigorously peer-reviewed scientific collaboration in history.

Through one of its trade groups, the Western Fuels Association, Big Coal paid three "skeptical" scientists more than $1 million and bought them lots of air time and media space to confuse the public about the realities of global warming. The industry's cynicism was captured in an internal memo in which the coal industry laid out a public relations strategy "to reposition global warming as theory rather than fact." In one report, Western Fuels declared: "There has been a close to universal impulse in the . . . trade association community in Washington to concede the scientific premise of global warming . . . We . . . disagree with this strategy." Western Fuels then paid $250,000 for a widely circulated video to promote the notion that "global warming is good for us." And it supported a campaign of character assassination designed to discredit some of the world's most prominent climate scientists. More recently, in 2008, a coal-industry front group, Americans for Balanced Energy Choices, announced it would spend $35 million to rally support for coal-fired electricity and stifle congressional legislation to slow climate change.

Through a well-orchestrated campaign of denial, the coal industry and ExxonMobil and other oil companies have put the United States years behind the rest of world in addressing this monumental challenge. The real question is whether Big Coal has done more damage to the global climate than it has to the democratic process—by stifling debate, undermining scientific knowledge, browbeating journalists into an inappropriate application of journalistic balance, and keeping the public in the dark about the unprecedented threat of runaway climate change.

Through its deliberate strategy of confusion, the industry kept alive a false debate over the reality of human-caused global warming and prevented a debate over the real issue: What should we do to prevent major societal calamity? As a result of the industry's elevation of self-interest above societal survival, we will see additional warming-driven crop failures, water shortages, species extinctions, and infestation outbreaks in forests around the world. Climate-driven human tragedies are also increasing, including the tragedy in Darfur in which a prolonged drought forced herders and growers into a nightmarish conflict over a shrinking patch of viable land.

Domestically, the coal industry has exerted a profound influence on our national climate and energy policies—most notably by keeping the United States out of the Kyoto process, thus obstructing meaningful progress by the rest of the world.

There is one rather eerie coincidence that joins the coal industry to the global climate. Most climate watchers are familiar with the charted rise in global temperatures. The chart's plotted data points remained relatively flat for centuries before assuming a skyrocketing—almost vertical—trajectory beginning about one hundred years ago. That same trajectory is re-created in an almost perfect geometry by the chart of the exponential increase in the revenues Peabody Energy, the country's biggest coal company, since it went public in 2001.

Today growing numbers of scientists are telling us we are at—or beyond—a point of no return in staving off climate chaos. Dr. Rajendra Pachauri, head of the UN's Intergovernmental Panel on Climate Change (IPCC), British ecologist James Lovelock, and NASA scientist James Hansen have all warned that the world is either approaching, or has already passed, a point of no return in terms of climate chaos. The IPCC panel has stated that it is virtually inevitable that the planet will suffer "rapid and irreversible changes" from our overheated atmosphere.

The ultimate truth is that we may have inadvertently begun changing the climate through our burning of fossil fuels long before the coal industry mounted its enormously destructive campaign of deception. But there is no doubt that, had the world's leading coal executives been willing to put human survival ahead of industry profits, we would have begun to address this issue—and prepare for the coming disruptions— at least twenty years ago.

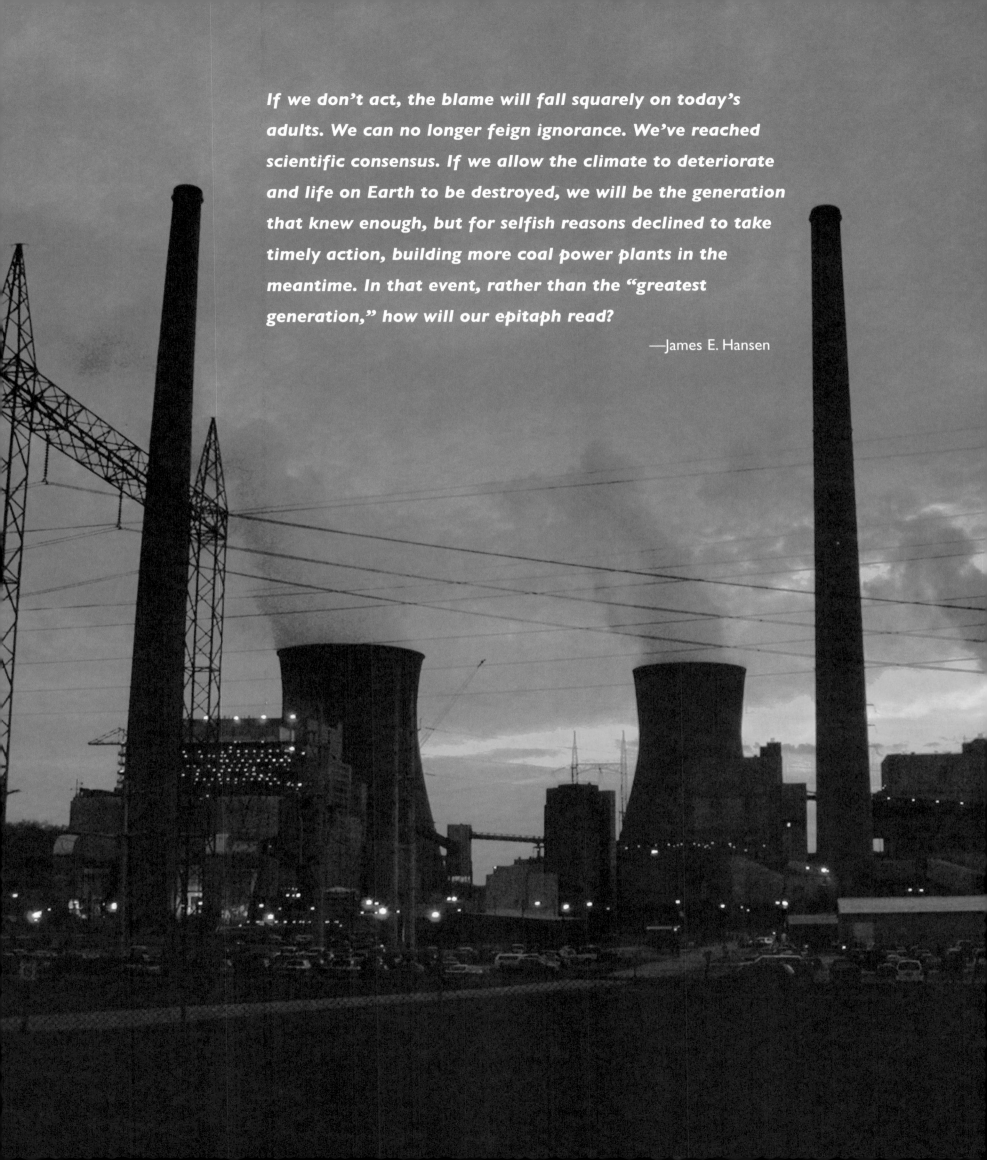

If we don't act, the blame will fall squarely on today's adults. We can no longer feign ignorance. We've reached scientific consensus. If we allow the climate to deteriorate and life on Earth to be destroyed, we will be the generation that knew enough, but for selfish reasons declined to take timely action, building more coal power plants in the meantime. In that event, rather than the "greatest generation," how will our epitaph read?

—James E. Hansen

There are three main sources of U.S. electrical power—coal, natural gas, and nuclear plants. Coal dominates; it provided 48.5 percent of all electricity production in 2007. Hydroelectric dams provided 6 percent, and other renewable energy sources including solar and wind contributed only 2.5 percent of the nation's electricity in 2007.

Mountaintop removal is being driven by the greed of coal companies, but also by the demand for "cheap" electricity. Unfortunately for the mountains and people of Appalachia, we do not see the devastation when we switch on a light or power up our computers. If we did, perhaps more of us would call for government to play a leadership role in promoting energy conservation and alternative energy development.

The ever-increasing demand for electricity outpaces even the rapid rate of U.S. population growth. Americans have far more electrical gadgets than we did a generation ago, but we are also a wasteful society. Germany and Japan, for example, enjoy a similar standard of living as the United States, but use only about half the electricity per capita.

While recent growth in renewable energy sources, especially wind, is encouraging, arguably the greatest potential in the energy business is conservation. Better insulation in buildings, more efficient appliances and lighting, and a host of other changes could dramatically reduce electrical demand and eliminate the need for strip-mined Appalachian coal. Ultimately, however, even efficiency, conservation, and renewables are a losing proposition without a rethinking of the consumer society and a concerted effort to end human population growth. There are not enough coal-filled mountains on Earth to sacrifice to provide energy for a society that refuses to recognize limits.

ENO F

TTLE CITY IN THE W

ONE WAY

RENO'S
BUFFET
VALUE PLAY N
BREAKFAST
LUNCH
DINNER

Flamingo

SAMMY
DAVIS, JR.

W
FORD
JUST

UTES

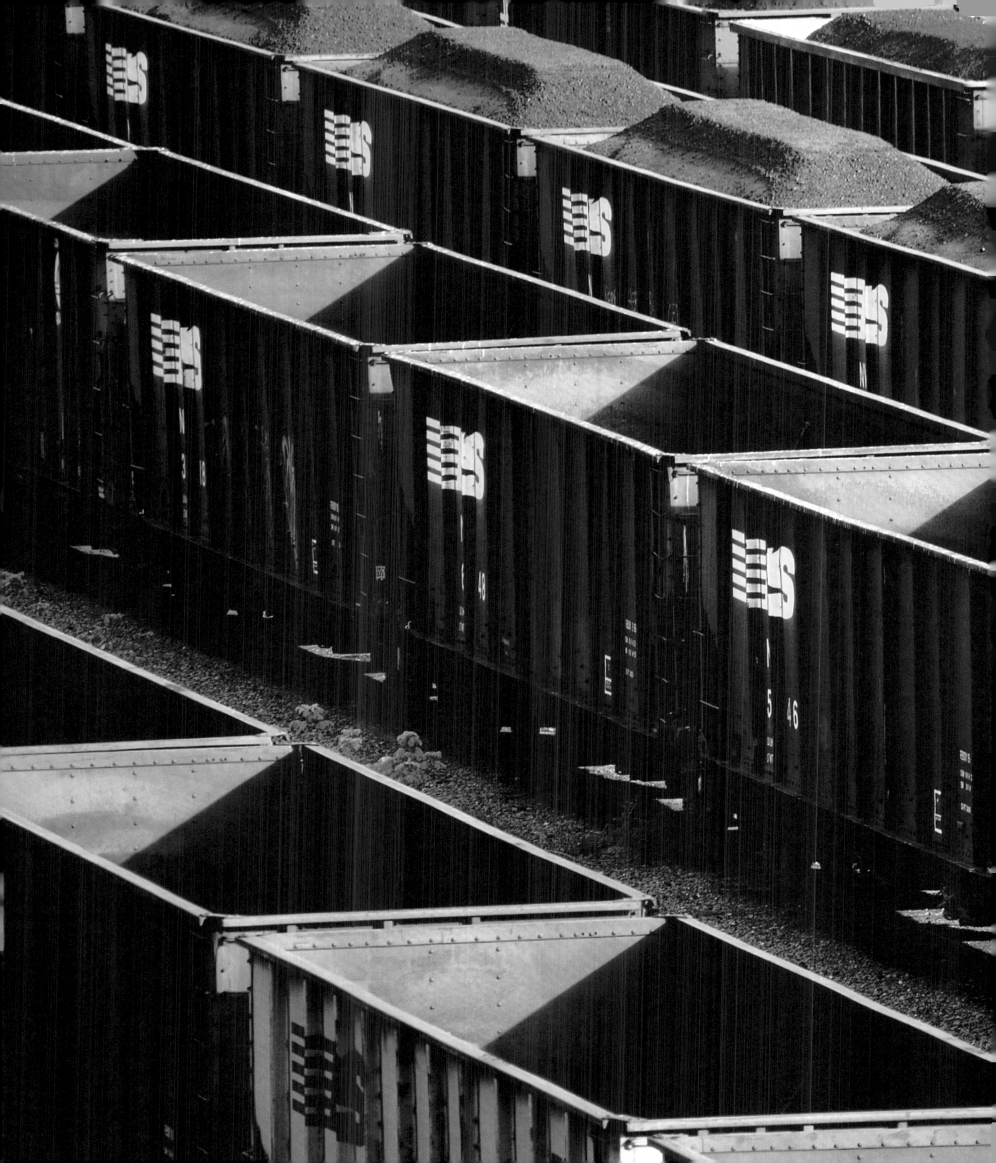

POWER DOWN

Peak Coal Coming

RICHARD HEINBERG

Virtually everyone in the fields of energy policy and analysis—as well as nearly everyone thinking about climate change—has long assumed that the world's coal endowment is so enormous that no limits would be encountered anytime this century. Two reports published in 2007 turn this assumption on its head.

Studies on global coal reserves conducted by the Energy Watch Group (EWG) and the Institute for Energy suggest that the world's reserves of coal have dwindled from 10 trillion tons of hard coal equivalent in 1980 to 4.2 trillion tons in 2005—a 60 percent downward revision in twenty-five years. Further, the former study concluded that world coal production growth will hit practical limits by about 2030 and begin gradually to decline, even if demand for the fuel remains high (the Institute for Energy study did not attempt to forecast the timing of the production peak).

The idea that minable coal reserves are much smaller than is commonly thought, and that a peak in world coal production is likely within only ten to twenty years, has profound implications. Many analysts who are concerned about emerging supply constraints for oil and gas foresee a compensating shift to lower-quality fuels. The conversion of coal to a gaseous or liquid fuel is feasible, but has high environmental and economic costs. For a world already concerned about future oil supplies, uncertainties about coal undercut one of the primary strategies—turning supposedly abundant coal into a liquid fuel—that is being touted for maintaining global transport networks. The sustainability of China's economic growth, which has largely been based on a rapid upsurge in coal consumption, is thrown into question. And the ability of the United States to maintain its coal-powered electricity grids in coming decades is also cast into doubt.

China reports fifty-five years of coal reserves at current rates of consumption. Subtracting quantities consumed since 1992 (the last year in which reserves figures were updated), this declines to forty to forty-five years. The calculation, however, assumes constant rates of usage, which is unrealistic since consumption has been increasing rapidly. China plans to expand coal production to make substantial quantities of liquid fuels; this will push production rates to their limits. Already China has shifted from being a minor coal exporter to being a net coal importer.

The EWG report's authors state: "it is likely that China will experience peak production within the next 5 to 15 years, followed by a steep decline." Only if China's reported coal reserves are in reality much larger than reported will Chinese coal production rates not peak "very soon" and drop rapidly (the peak of production typically occurs long before a resource is exhausted).

The United States is the world's second-largest producer, surpassing the two next important producer states (India and Australia) by nearly a factor of three. Its reserves are so large that America has sometimes been called "the Saudi Arabia of coal." The United States has already passed its peak of production for high-quality coal (from the Appalachian Mountains and the Illinois basin) and has seen production of bituminous coal decline since 1990. Growing extraction of sub-bituminous coal in Wyoming has more than compensated for this. Taking reserves into account, the authors of the EWG report conclude that growth in total volumes can continue for only ten to fifteen years. In terms of energy content, however, U.S. coal production peaked in 1998 at 598 million tons of oil equivalents (Mtoe); by 2005 this had fallen to 576 Mtoe.

This forecast for a near-term peak in U.S. coal extraction flies in the face of frequently repeated statements that the nation has two hundred years' worth of coal reserves at current levels of consumption. The report notes: "All of these reserves will probably not be converted into production volumes, as most of them are of low quality with high sulfur content or other restrictions."

We now have two authoritative studies reaching largely consistent conclusions with devastating implications for the global economy. If their conclusions hold, the world will need to respond quickly and with an enormous shift of investment capital toward energy conservation and developing renewable sources of electricity.

Climate concerns are already drawing some nations in these directions, but even the nations leading such efforts may not be proceeding nearly fast enough. For China and the United States, the world's two most coal-dependent countries, the message could not be clearer: Whether or not global climate concerns are taken seriously, it is time to fundamentally revise the current energy paradigm.

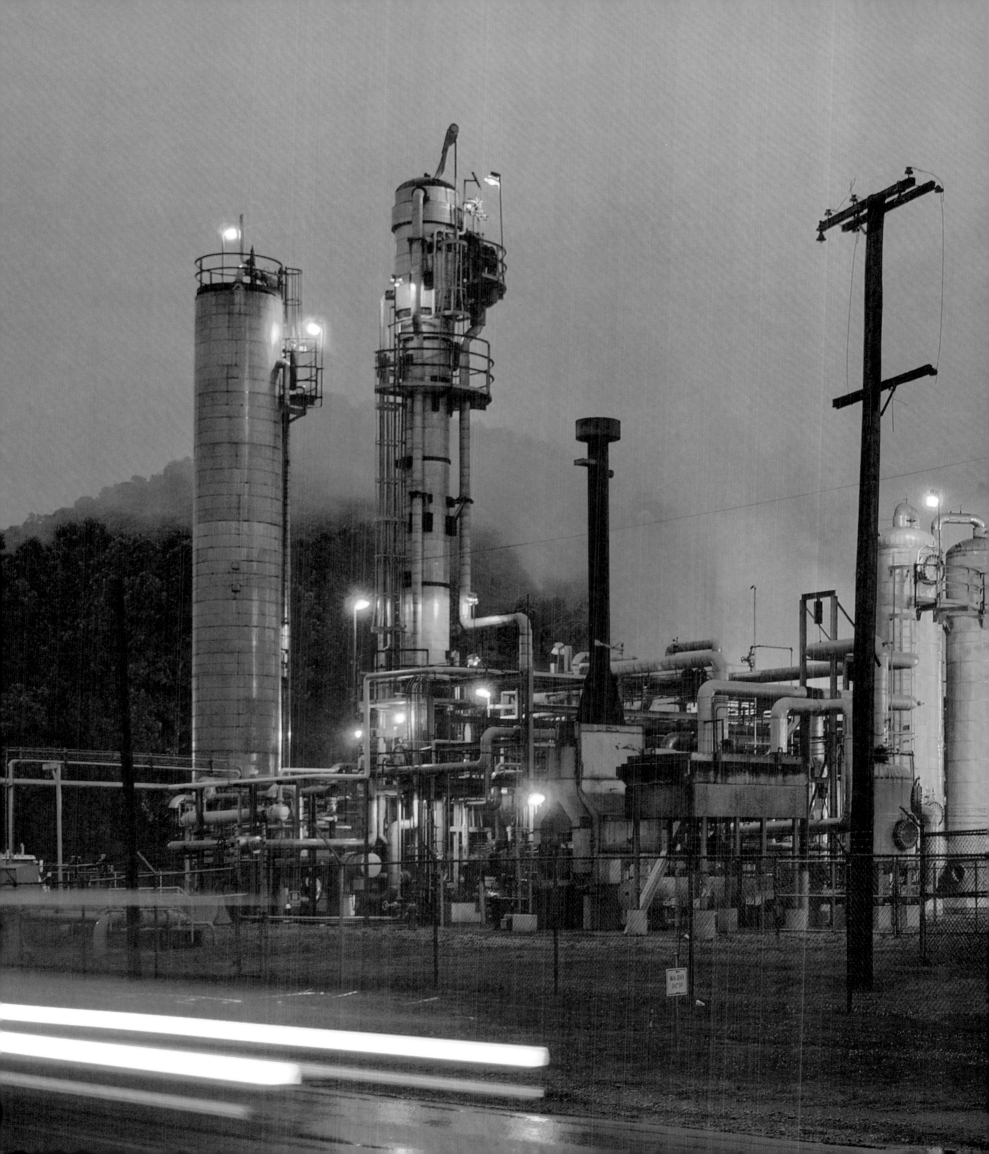

SIN FUEL

The Coal-to-Liquids Boondoggle

CARL POPE

One remarkable thing about America's energy economy is that it's firmly mired the past. We get our electricity from Coolidge-era coal-fired power plants or Khruschev-era nukes. Detroit makes most of its money selling SUVs built on twenty-year-old technology. The switches that get electricity to my office were designed forty years ago or more.

Meanwhile, when I take out my cell phone, I can call a taxi driver in Calcutta and every piece of equipment my voice travels through was designed less than a decade ago.

So we should be very, very suspicious when we are offered an opportunity to declare energy independence from Mideast oil by embracing liquid coal—a Nazi-era fuel that powered Hitler's trucks and was more recently adopted by Apartheid-era South Africa. This is, quite simply, the worst energy idea to come along since America's leaders concluded that the Shah of Iran was such wonderful friend that we ought to help him develop nuclear technology.

The idea is simple. Coal is a *solid* because it has a lot of heavy carbon and not much light hydrogen. Methane is natural *gas* because it has four hydrogen atoms and only one carbon. *Liquid* fuels—gasoline, kerosene, and diesel—*flow* because they have a lot of both elements in them.

So to make coal into a liquid, you oxidize enough carbon out of the molecule that what remains will flow. This wastes a huge amount of energy, and the total cycle produces more than twice as much greenhouse pollution per unit of energy as gasoline, which is already bad enough. (This carbon calculus, of course, doesn't reflect at all the devastation wrought by taking coal out of the ground in the first place.)

Now while this is a very bad, outmoded idea, it is currently perfectly legal. No one is stopping Peabody or Arch from trying to compete with Exxon by turning their product into a liquid fuel for your car or for Delta's jets. But no one is doing it. Why? Because it makes no economic sense at all.

So the coal industry's solution is to find a way—or, ideally, many ways—to guarantee that Americans will drive cars powered by liquid coal regardless of the enormous economic and environmental expense. They have suggested, among other nifty ploys, that the Defense Department sign long-term contracts committing to buy liquid coal for our military regardless of what it costs. They want to count liquid coal as a renewable biofuel and add the subsidies we are providing to reduce carbon dioxide emissions by making fuels from plants. (It would actually be better to classify Arabian crude as a renewable energy source.) They want tax credits, they want loan guarantees, they want it all.

Confronted with the problem that this technology will double our carbon emissions per mile driven, they have a response. Perhaps we will be able to capture the wasted carbon dioxide from the coal-to-liquids plant and sequester it underground. Yes, perhaps, with enough billions of dollars in subsidies and research funding, but even so the carbon that is emitted when you burn liquid coal in your car cannot be captured and sequestered.

And if we are going to mine coal and sequester its carbon (in the unlikely scenario that that is scalable and pencils economically), we would be much better off to simply generate electricity from a power plant, sequester the carbon, and use the electricity to charge a plug-in hybrid. At least in theory, a marriage of two twenty-first-century technologies might give you a way to mine coal and replace gasoline in a manner that didn't fry the climate and bankrupt the economy.

Back in 1979, during the Iran oil crisis, the coal industry grabbed a bunch of subsidies for what they then called "synthetic fuels." You'll notice that they never weaned us off imported oil. What actually happened was this—you and I paid a couple of companies billions of dollars for decades to run hopper cars full of coal underneath a kerosene spray, thereby making the coal, magically, a "synthetic fuel" eligible for big government payments.

I am inclined to paraphrase former vice president Cheney: Coal-to-liquids may be a personal vice, but it is not a national energy policy. That Congress is talking about it, and some coal state politicians are promoting it, should be a national scandal.

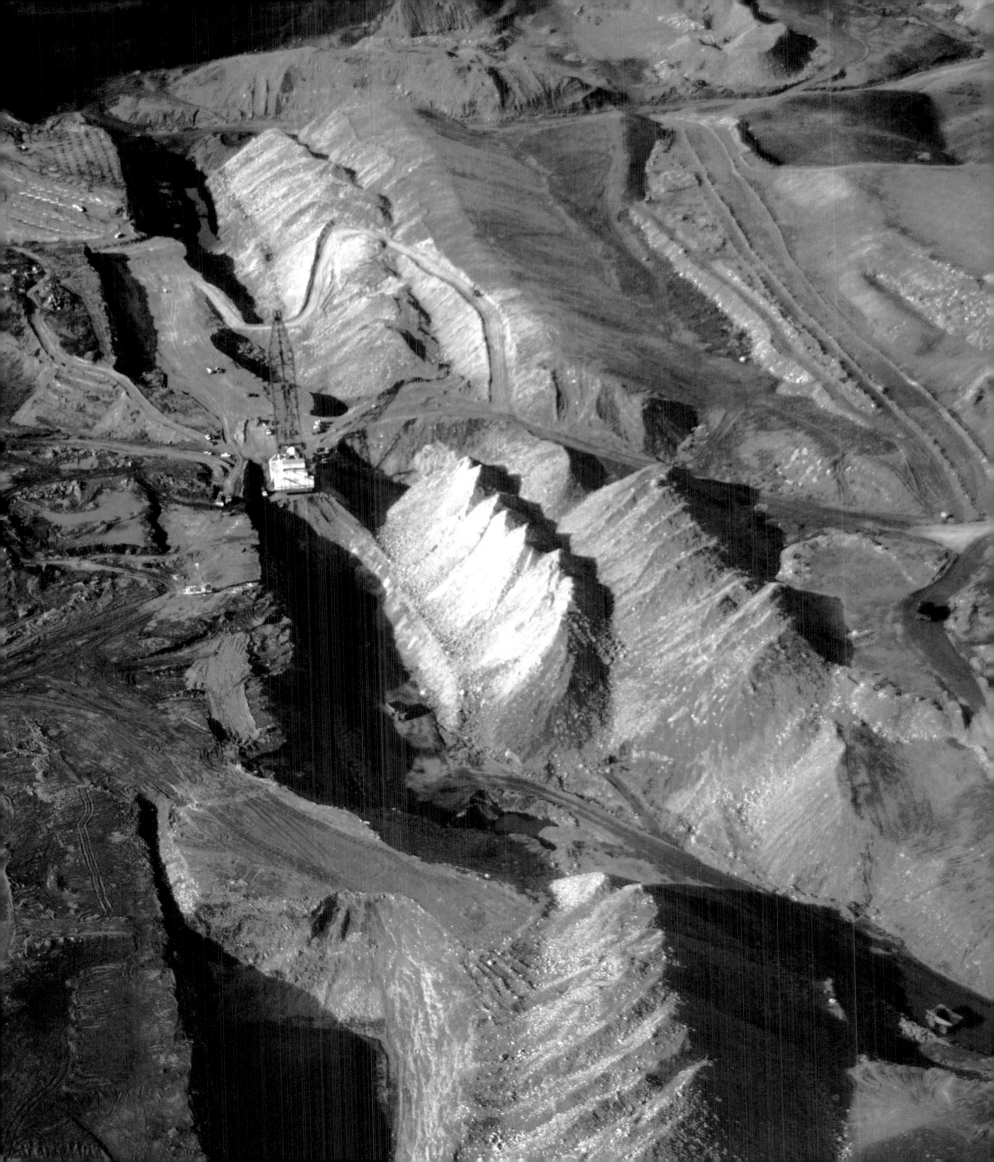

KING COAL'S SHINY NEW LIE

Clean Coal Coming (Don't Believe It)

JOHN BLAIR

The Holy Grail for coal boosters is "clean coal" technology—a new generation of integrated gasification combined cycle power plants—IGCC for short—designed to capture and permanently sequester carbon dioxide, making coal-powered electricity nearly emissions free. In a conventional plant, coal is pulverized and shot into a boiler to burn; heated water makes the steam that turns a turbine. In an IGCC plant, the coal is essentially cooked, turned into a gas, which is then burned. During the "cooking" process, it is easier to capture various pollutants such as mercury, sulfur dioxide, and greenhouse gases, rather than trying to scrub them out at the smokestacks.

Many of us who have fought the coal industry for years see IGCC as yet another technological boondoggle and think the acronym more aptly stands for "increased and growing capital costs." Reports in the popular media generally claim that IGCC is "about 20 percent more" expensive than conventional pulverized coal plants, but in reality no one knows just how high the price of building these plants might rise. Construction costs have lately grown from 20 to 50 percent per year for all kinds of power plants. Few new coal plants have been finished in the United States for decades, and estimates for IGCC plants are speculative at best.

For investors, the risk does not stop there. Carbon capture and sequestration (CCS) is a complete unknown as a practical matter. There are multiple technological, political, and legal hurdles to overcome for carbon-capture technology to be adopted on a wide enough scale to make any difference to the world's present warming trajectory, if ever. What is known is that it will take huge chunks of the energy produced by any given plant. Figures from the Department of Energy and elsewhere suggest that at least 15 percent of the plant's output (some learned projections run as high as 40 percent) will be needed to run any carbon capture facility on an IGCC plant, with capital costs as high as 50 percent more than building the plant without CCS.

For example, a utility proposed to build a 630-megawatt IGCC plant in Indiana. The April 2008 cost estimate was $2.35 billion, or $3,730,158 per megawatt capacity. Using that (already outdated) figure and adding 50 percent for CCS, the cost per megawatt jumps to $5,595,237. The plant's sponsor predicted that rates for their Indiana customers would have to increase 18 percent to pay for the plant's construction. With carbon capture and sequestration added, that figure would then rise to 27 percent, and the plant's output would decrease to 535 megawatts.

Investors are generally confused. On one hand they see governments handing out giant subsidies to the coal industry. On the other hand, they see proposed IGCC plants fail the test of perceived economic and technological viability. Even the Department of Energy's own "FutureGen" demonstration project, which was to be 75 percent funded by the federal government and 25 percent by a consortium of world coal interests—and serve as model for a "clean coal" future—had its plug pulled in 2008.

The capital markets, having been stung by nukes in the early 1980s and building a glut of unneeded natural gas capacity in the late 1990s, are wary of the entire boom-and-bust energy sector. The difference this time is that not only the capital markets, but also consumers and global warming activists are driving skepticism about coal. We know that new coal-fired generating capacity, even conventional, is already very expensive. We know that efficiency costs far less to achieve the same essential end. And we know that coal's costs are going to rise significantly when governments around the world finally tackle global warming.

Coal will not go down without a fight, and its political support is formidable. But King Coal has an extremely vulnerable soft underbelly since it is now more expensive than much of its competition. Smart money is on efficiency these days. Public service commissions nationwide are now saying no to new coal, and utilities are seeing that coal no longer represents prudent investment. Almost every week, news comes that another proposed coal plant has fallen due to high construction costs, carbon uncertainty, and community resistance.

Coupled with a massive education effort to help people conserve, coal will lose its luster even more as alternative energy—including wind, solar, and geothermal sources—powers society's response to the global warming challenge, creating huge economic opportunities along the way.

In the end, the promise of IGCC and "clean coal" is likely to be little more than a footnote to the history of the early twenty-first century, the time that concern for the future of the Earth took precedence over the private interests of those who mined and burned coal.

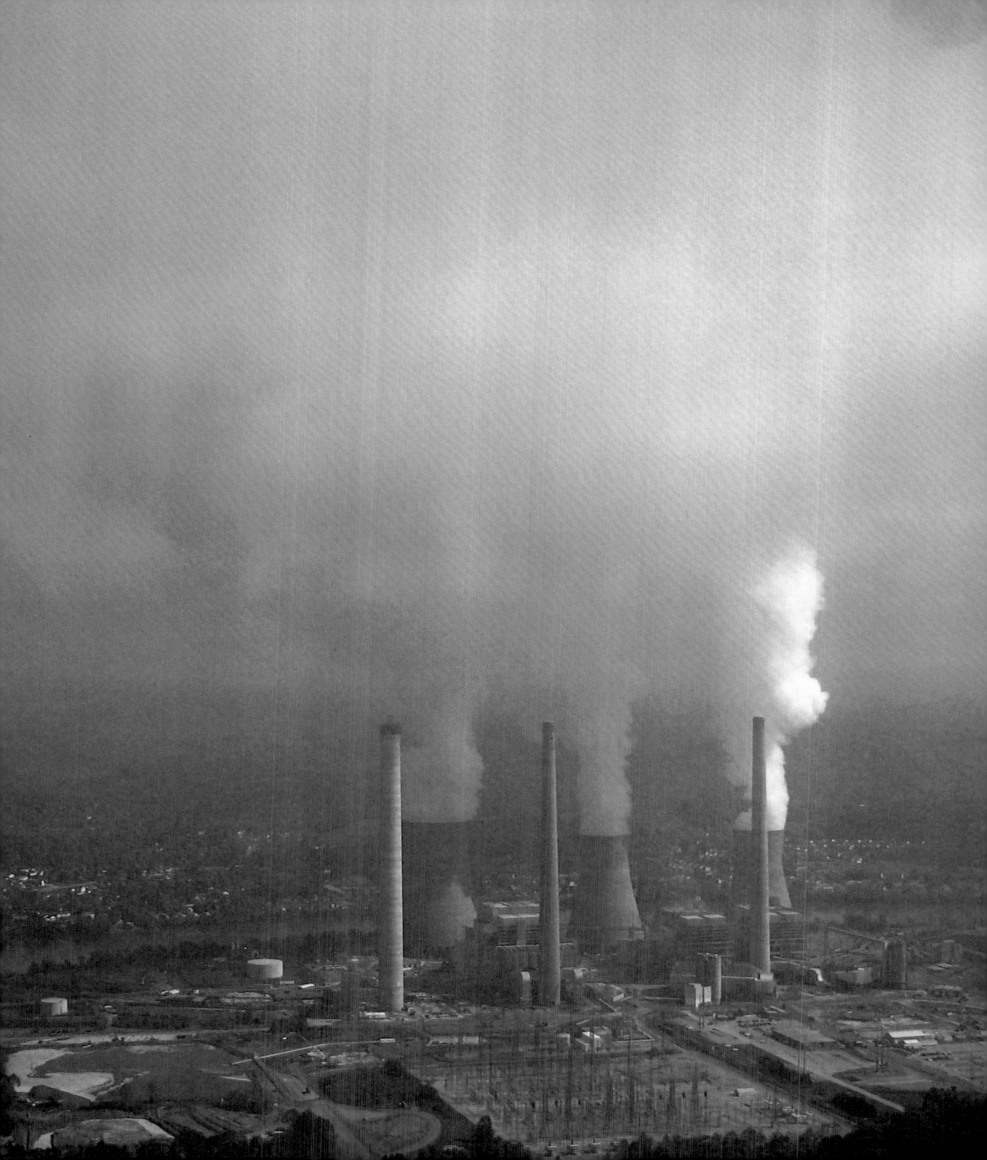

NO SUCH THING AS CLEAN COAL

Cutting Emissions Doesn't Cut It

CINDY RANK

As the coal industry ramps up its greenwashing public relations campaign, some national environmental groups are pushing back with their own coordinated media response. While such efforts are encouraging on one level, the narrow focus on curtailing carbon dioxide emissions is disheartening to some of us from coal-producing states.

The reality of global climate change absolutely demands that we reduce carbon dioxide pollution. We mustn't fool ourselves or delude the public, however, by promoting the idea that if industry can take the dirty emissions from coal-burning power plants and hide them away someplace other than in the atmosphere, that coal can somehow be made "clean."

Many coal-industry observers are highly skeptical that the technology to successfully capture and permanently store carbon dioxide underground is even possible—or economically viable on the scale that is needed. But, let's assume for the moment that success is possible, and within a decade or two, coal-burning power plants emit no greenhouse gases to add to the climate chaos. Can we then finally agree that coal is *clean*?

An emphatic NO.

Coal *can never* be considered a clean source of energy

- as long as any method of coal mining, surface or underground, violates the law, degrades the land, harms the people, or exploits the workers;

- as long as transporting coal along narrow mountain roads endangers school buses, local drivers, and communities in Appalachia;

- as long as coal trucks and trains weaken bridges, damage roads, overturn and spill their contents into streams and roadways;

- as long as washing coal produces vast quantities of toxic sludge to sit in unlined ponds or be injected underground where it can pollute water wells, streams, and coalfield communities;

- as long as burning coal produces vast quantities of toxic ash to sit in unsafe and unlined containment structures or be placed in surface-mine backfills or injected into underground mine voids where toxic metals can leach into ground and surface waters;

- as long as storing and moving coal produces excessive dust that causes asthma or black lung and coats homes and towns;

- as long as coal stockpiles leach toxins into groundwater;

- as long as blasting damages water wells and homes;

- as long as subsidence makes sinkholes out of streams, dry savannas out of farm ponds, and homes unlivable;

- as long as mining fragments our exceptionally diverse hardwood forests, eliminates wildlife habitat, buries streams with mining waste, and creates an ongoing legacy of toxic pollution;

- as long as the coal industry uses its vast profits and power to deter citizens from speaking out against destructive mining practices;

- as long as this black gold corrupts politics and politicians and regulatory agencies;

- as long as the advertising arms of the mining and power industries delude the public into thinking that coal stripped from blown-up mountains can ever be "clean" or somehow carbon neutral, or that such mining is beneficial to the communities where the devastation is allowed to occur.

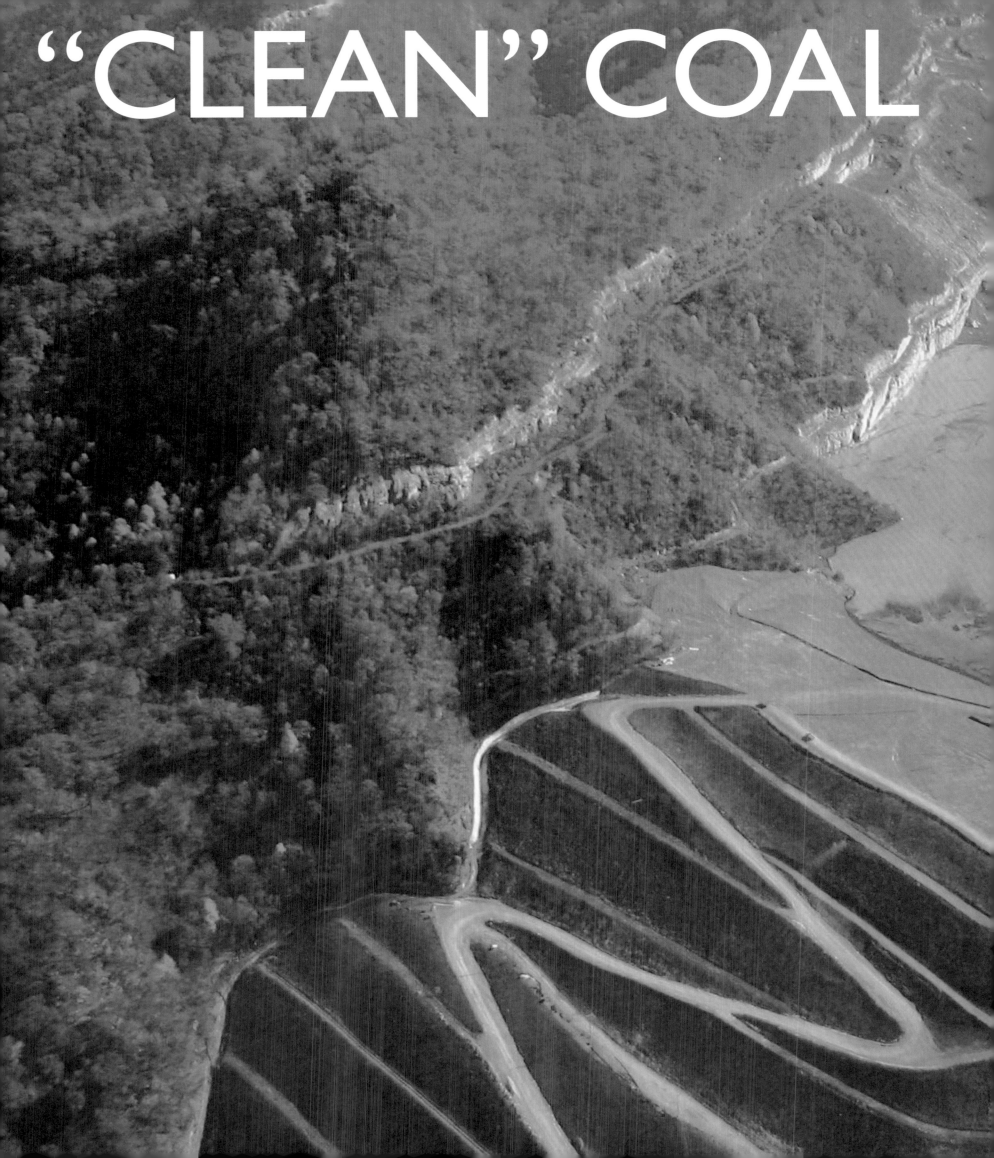

"CLEAN" COAL

A TRAGIC OXYMORON

Even if the power companies could get marshmallows to come out of the smokestacks, if you can't dig it clean, you can't burn it clean. They cannot dig the coal cleanly in Appalachia by blowing the tops off of mountains, covering up the streams, and polluting our communities.

—Judy Bonds, West Virginia activist

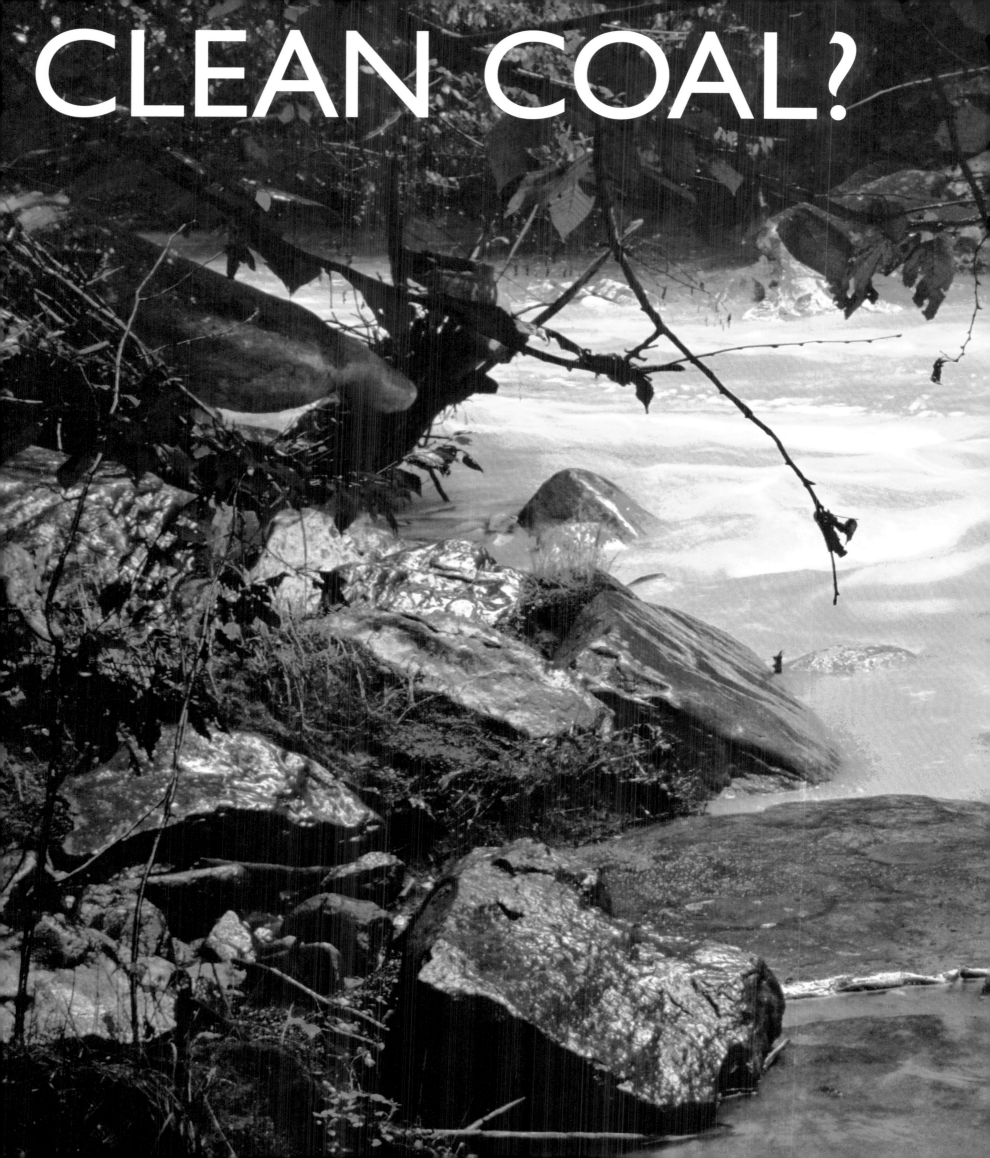

CLEAN COAL?

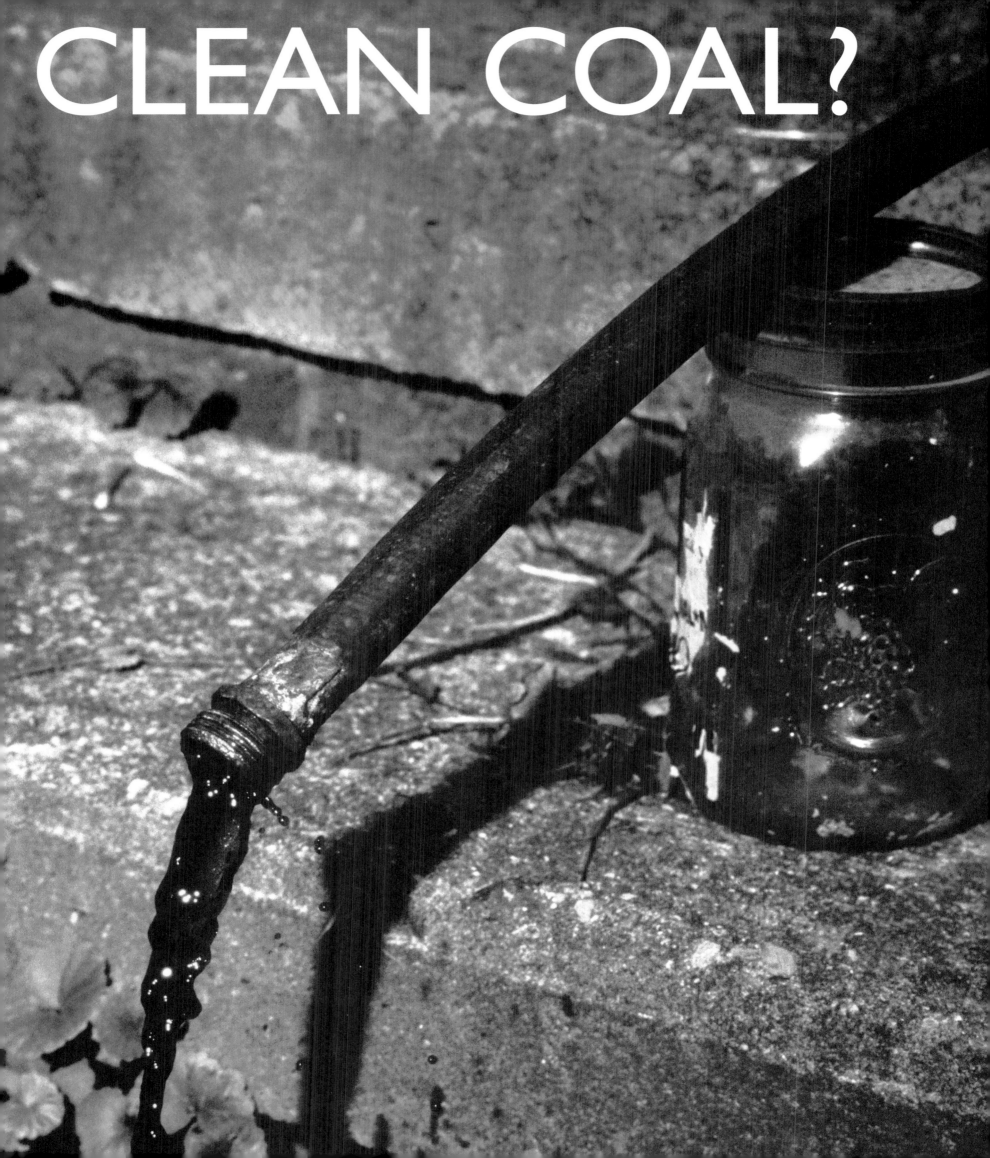

CLEAN COAL?

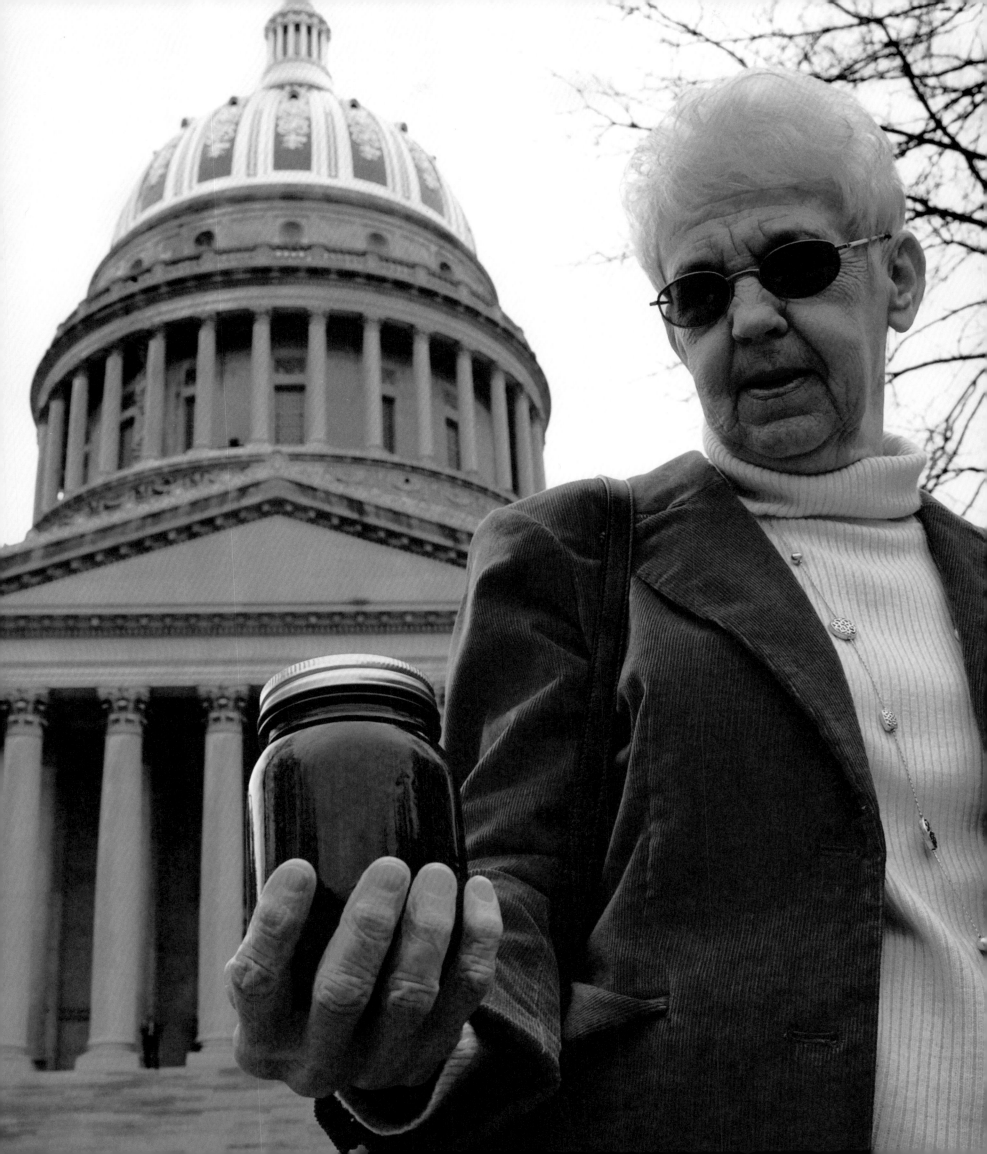

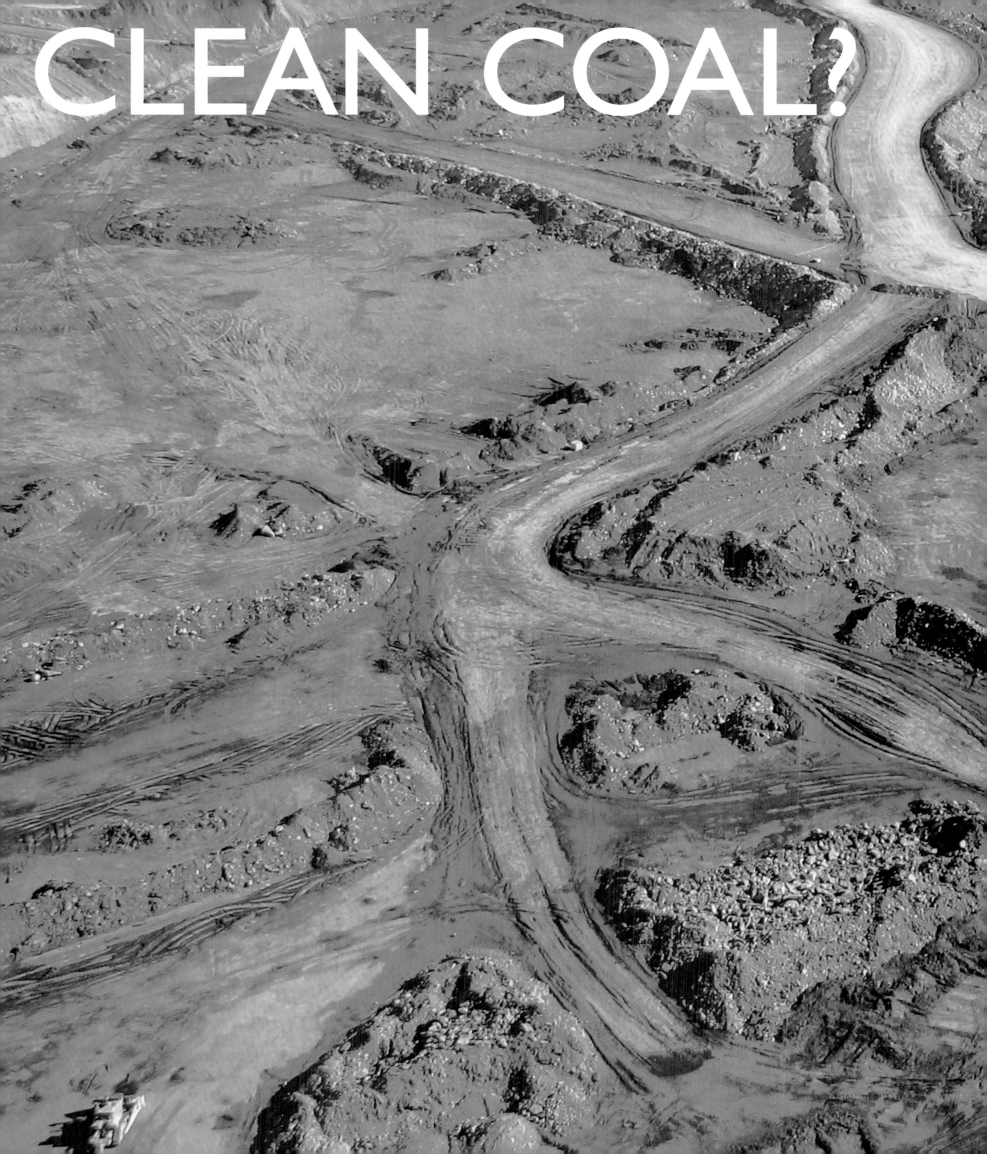

CLEAN COAL?

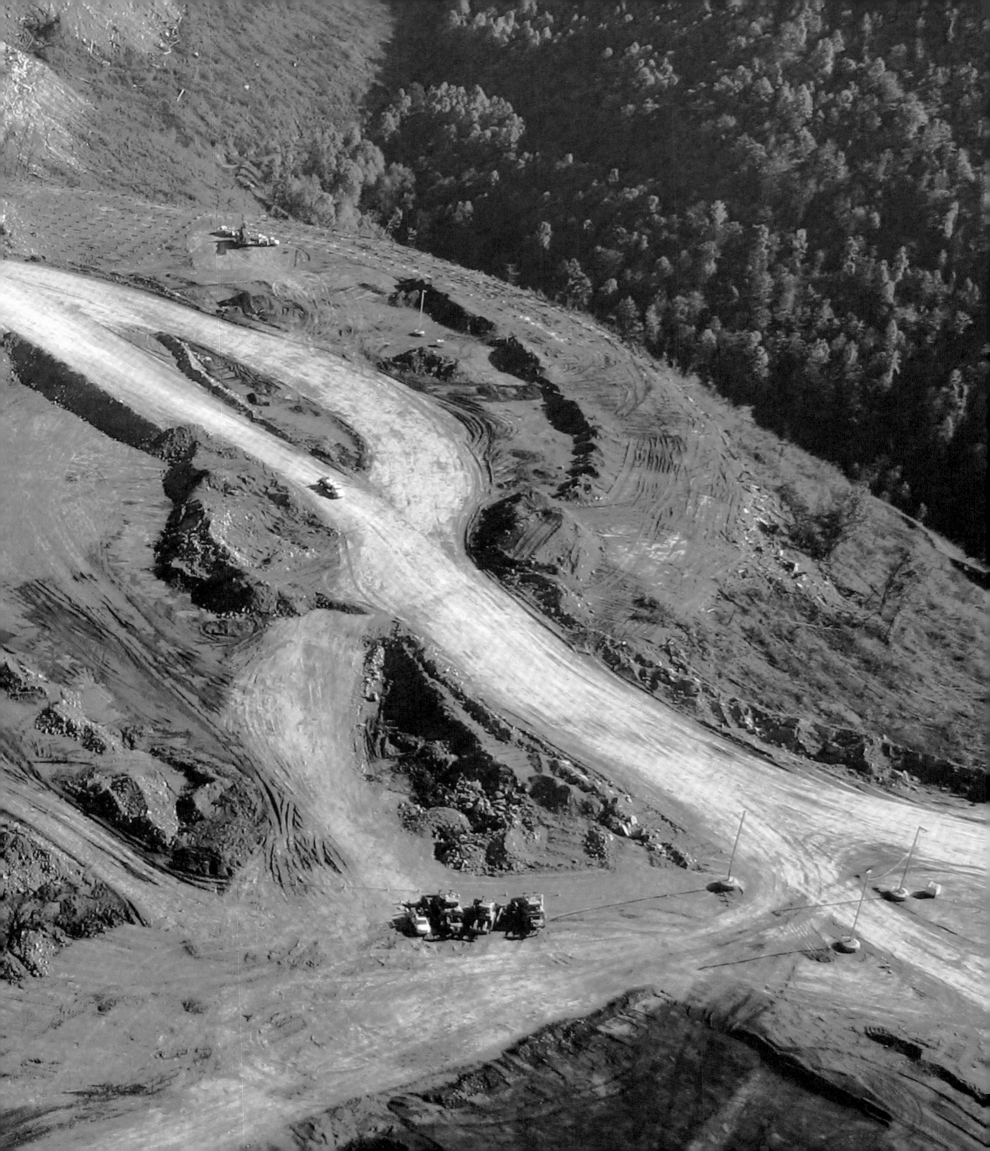

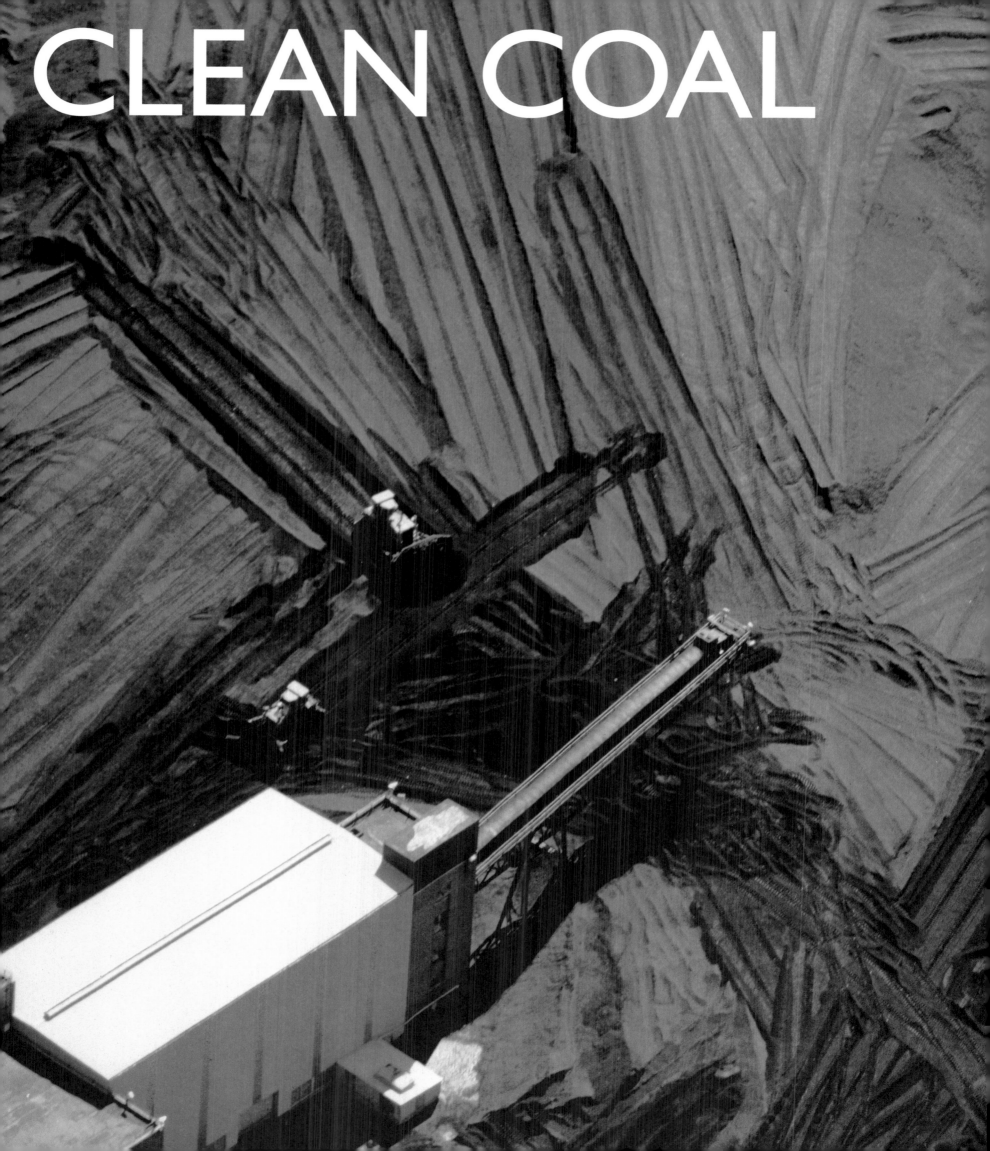

CLEAN COAL

A DANGEROUS ILLUSION

In many ways, the world's coal reserves only make our energy problems worse, because they give us a false sense of security: If we run out of gas and oil, we can just switch over to coal; if we can figure out a way to "clean" coal, we can have a cheap, plentiful source of energy. In reality, however, facing the twin challenges of the end of oil and the coming of global warming is going to require reinventing the infrastructure of modern life. The most dangerous thing about our continued dependence on coal is not what it does to our lungs, our mountains, and even our climate, but what it does to our minds: it preserves the illusion that we don't have to change our thinking.

—Jeff Goodell, from *Big Coal: The Dirty Secret Behind America's Energy Future*

RESISTANCE
THE LONG MARCH TO ABOLITION

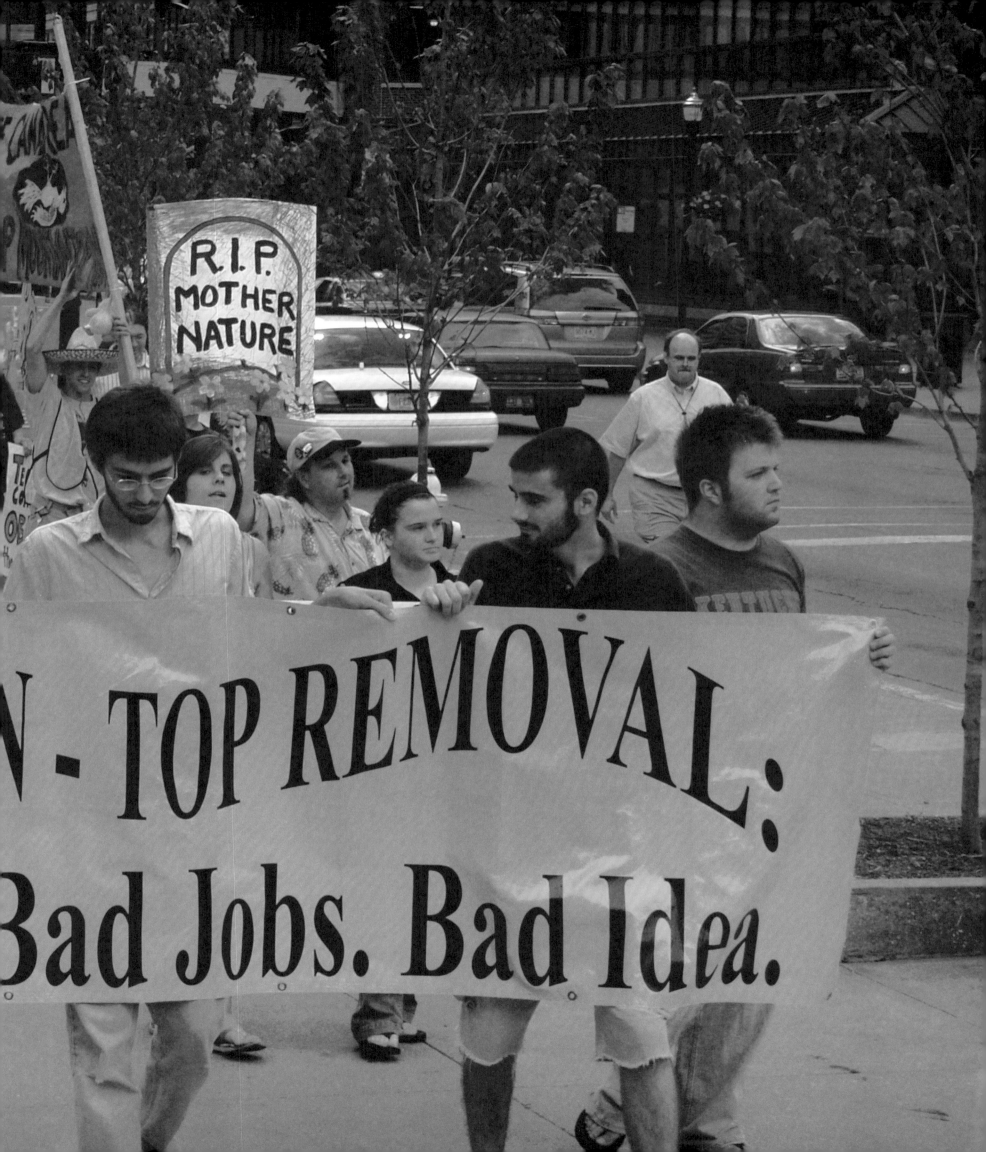

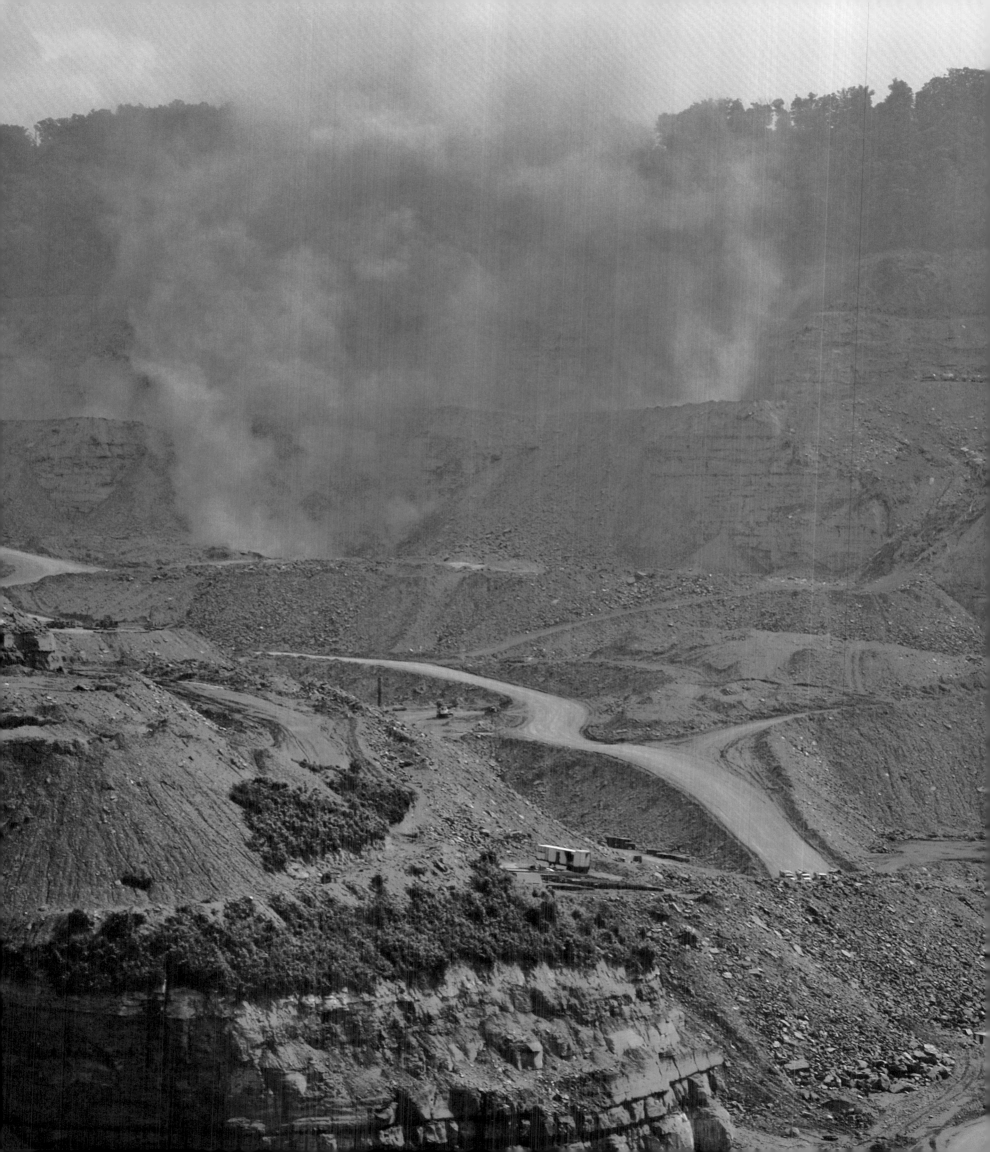

COMPROMISE, HELL!

WENDELL BERRY

We are destroying our country—I mean our country itself, our land. This is a terrible thing to know, but it is not a reason for despair unless we decide to continue the destruction. If we decide to continue the destruction, that will not be because we have no other choice. This destruction is not necessary. It is not inevitable, except that by our submissiveness we make it so.

We Americans are not usually thought to be a submissive people, but of course we are. Why else would we allow our country to be destroyed? Why else would we be rewarding its destroyers? Why else would we all—by proxies we have given to greedy corporations and corrupt politicians—be participating in its destruction? Most of us are still too sane to piss in our own cistern, but we allow others to do so and we reward them for it. We reward them so well, in fact, that those who piss in our cistern are wealthier than the rest of us.

How do we submit? By not being radical enough. Or by not being thorough enough, which is the same thing.

Since the beginning of the conservation effort in our country, conservationists have too often believed that we could protect the land without protecting the people. This has begun to change, but for a while yet we will have to reckon with the old assumption that we can preserve the natural world by protecting wilderness areas while we neglect or destroy the economic landscapes—the farms and ranches and working forests—and the people who use them. That assumption is understandable in view of the worsening threats to wilderness areas, but it is wrong. If conservationists hope to save even the wild lands and wild creatures, they are going to have to address issues of economy, which is to say issues of the health of the landscapes and the towns and cities where we do our work, and the quality of that work, and the well-being of the people who do the work.

Governments seem to be making the opposite error, believing that the people can be adequately protected without protecting the land. And here I am not talking about parties or party doctrines, but about the dominant political assumption. Sooner or later, governments will have to recognize that if the land does not prosper, nothing else can prosper for very long. We can have no industry or trade or wealth or security if we don't uphold the health of the land and the people and the people's work.

It is merely a fact that the land, here and everywhere, is suffering. We have the "dead zone" in the Gulf of Mexico and undrinkable water to attest to the toxicity of our agriculture. We know that we are carelessly and wastefully logging our forests. We know that soil erosion, air and water pollution, urban sprawl, the proliferation of highways and garbage are making our lives always less pleasant, less healthful, less sustainable, and our dwelling places more ugly.

Nearly forty years ago my state of Kentucky, like other coal-producing states, began an effort to regulate strip mining. While that effort has continued, and has imposed certain requirements of "reclamation," strip mining has become steadily more destructive of the land and the land's future. We are now permitting the destruction of entire mountains and entire watersheds. No war, so far, has done such extensive or such permanent damage. If we know that coal is an exhaustible resource, whereas the forests over it are with proper use inexhaustible, and that strip mining destroys the forest virtually forever, how can we permit this destruction? If we honor at all that fragile creature the topsoil, so long in the making, so miraculously made, so indispensable to all life, how can we destroy it? If we believe, as so many of us profess to do, that the Earth is God's property and is full of His glory, how can we do harm to any part of it?

In Kentucky, as in other unfortunate states, and again at great public cost, we have allowed—in fact we have officially encouraged—the establishment of the confined animal-feeding industry, which exploits and abuses everything involved: the land, the people, the animals, and the consumers. If we love our country, as so many of us profess to do, how can we so desecrate it?

But the economic damage is not confined just to our farms and forests. For the sake of "job creation," in Kentucky, and in other backward states, we have lavished public money on corporations that come in and stay only so long as they can exploit people here more cheaply than elsewhere. The general purpose of the present economy is to exploit, not to foster or conserve.

Look carefully, if you doubt me, at the centers of the larger towns in virtually every part of our country. You will find that they are economically dead or dying. Good buildings that used to house needful, useful, locally owned small businesses of all kinds are now empty or have evolved into junk stores or antique shops. But look at the houses, the churches, the commercial buildings, the courthouse, and you will see that more often than not they are comely and well made. And then go look at the corporate outskirts: the chain stores, the fast-food joints, the food-and-fuel stores that no longer can be called service stations, the motels. Try to find something comely or well made there.

What is the difference? The difference is that the old town centers were built by people who were proud of their place and who realized a particular value in living there. The old buildings look good because they were built by people who respected themselves and wanted the respect of their neighbors. The corporate outskirts, on the contrary, were built by people who manifestly take no pride in the place, see no value in lives lived there, and recognize no neighbors. The only value they see in the place is the money that can be siphoned out of it to more fortunate places—that is, to the wealthier suburbs of the larger cities.

Can we actually suppose that we are wasting, polluting, and making ugly this beautiful land for the sake of patriotism and the love of God? Perhaps some of us would like to think so, but in fact this destruction is taking place because we have allowed ourselves to believe, and to live, a mated pair of economic lies: that nothing has a value that is not assigned to it by the market; and that the economic life of our communities can safely be handed over to the great corporations.

We citizens have a large responsibility for our delusion and our destructiveness, and I don't want to minimize that. But I don't want to minimize, either, the large responsibility that is borne by government.

It is commonly understood that governments are instituted to provide certain protections that citizens individually cannot provide for themselves. But governments have tended to assume that this responsibility can be fulfilled mainly by the police and the military. They have used their regulatory powers reluctantly and often poorly. Our governments have only occasionally recognized the need of land and people to be protected against economic violence. It is true that economic violence is not always as swift, and is rarely as bloody, as the violence of war, but it can be devastating nonetheless. Acts of economic aggression can destroy a landscape or a community or the center of a town or city, and they routinely do so.

Such damage is justified by its corporate perpetrators and their political abettors in the name of the "free market" and "free enterprise," but this is a freedom that makes greed the dominant economic virtue, and it destroys the freedom of other people along with their communities and livelihoods. There are such things as economic weapons of massive destruction. We have allowed them to be used against us, not just by public submission and regulatory malfeasance, but also by public subsidies, incentives, and sufferances impossible to justify.

We have failed to acknowledge this threat and to act in our own defense. As a result, our once-beautiful and bountiful countryside has long been a colony of the coal, timber, and agribusiness corporations, yielding an immense wealth of energy and raw materials at an immense cost to our land and our land's people. Because of that failure also, our towns and cities have been gutted by the likes of Wal-Mart, which have had the permitted luxury of destroying locally owned small businesses by means of volume discounts.

Because as individuals or even as communities we cannot protect ourselves against these aggressions, we need our state and national governments to protect us. As the poor deserve as much justice from our courts as the rich, so the small farmer and the small merchant deserve the same economic justice, the same freedom in the market, as big farmers and chain stores. They should not suffer ruin merely because their rich competitors can afford (for a while) to undersell them.

Furthermore, to permit the smaller enterprises always to be ruined by false advantages, either at home or in the global economy, is ultimately to destroy local, regional, and even national capabilities of producing vital supplies such as food and textiles. It is impossible to understand, let alone justify, a government's willingness to allow the human sources of necessary goods to be destroyed by the "freedom" of this corporate anarchy. It is equally impossible to understand how a government can permit, and even subsidize, the destruction of the land and the land's productivity. Somehow we have lost or discarded any controlling sense of the interdependence of the Earth and the human capacity to use it well. The governmental obligation to protect these economic resources, inseparably human and natural, is the same as the obligation to protect us from hunger or from foreign invaders. In result, there is no difference between a domestic threat to the sources of our life and a foreign one.

It appears that we have fallen into the habit of compromising on issues that should not, and in fact cannot, be compromised. I have an idea that a large number of us, including even a large number of politicians, believe that it is wrong to destroy the Earth. But we have powerful political opponents who insist that an Earth-destroying economy is justified by freedom and profit. And so we compromise by agreeing to permit the destruction only of parts of the Earth, or to permit the Earth to be destroyed a little at a time—like the famous three-legged pig that was too well loved to be slaughtered all at once.

The logic of this sort of compromising is clear, and it is clearly fatal. If we continue to be economically dependent on destroying parts of the Earth, then eventually we will destroy it all.

So long a complaint accumulates a debt to hope, and I would like to end with hope. To do so I need only repeat something I said at the beginning: Our destructiveness has not been, and it is not, inevitable. People who use that excuse are morally incompetent, they are cowardly, and they are lazy. Humans don't have to live by destroying the sources of their life. People can change; they can learn to do better. All of us, regardless of

party, can be moved by love of our land to rise above the greed and contempt of our land's exploiters. This of course leads to practical problems, and I will offer a short list of practical suggestions.

We have got to learn better to respect ourselves and our dwelling places. We need to quit thinking of rural America as a colony. Too much of the economic history of our land has been that of the export of fuel, food, and raw materials that have been destructively and too cheaply produced. We must reaffirm the economic value of good stewardship and good work. For that we will need better accounting than we have had so far.

We need to reconsider the idea of solving our economic problems by "bringing in industry." Every state government appears to be scheming to lure in a large corporation from somewhere else by "tax incentives" and other squanderings of the people's money. We ought to suspend that practice until we are sure that in every state we have made the most and the best of what is already there. We need to build the local economies of our communities and regions by adding value to local products and marketing them locally before we seek markets elsewhere.

We need to confront honestly the issue of scale. Bigness has a charm and a drama that are seductive, especially to politicians and financiers; but bigness promotes greed, indifference, and damage, and often bigness is not necessary. You may need a large corporation to run an airline or to manufacture cars, but you don't need a large corporation to raise a chicken or a hog. You don't need a large corporation to process local food or local timber and market it locally.

And, finally, we need to give an absolute priority to caring well for our land—for every bit of it. There should be no compromise with the destruction of the land or of anything else that we cannot replace. We have been too tolerant of politicians who, entrusted with our country's defense, become the agents of our country's destroyers, compromising on its ruin.

And so I will end this by quoting my fellow Kentuckian, a great patriot and an indomitable foe of strip mining, Joe Begley of Blackey: "Compromise, hell!"

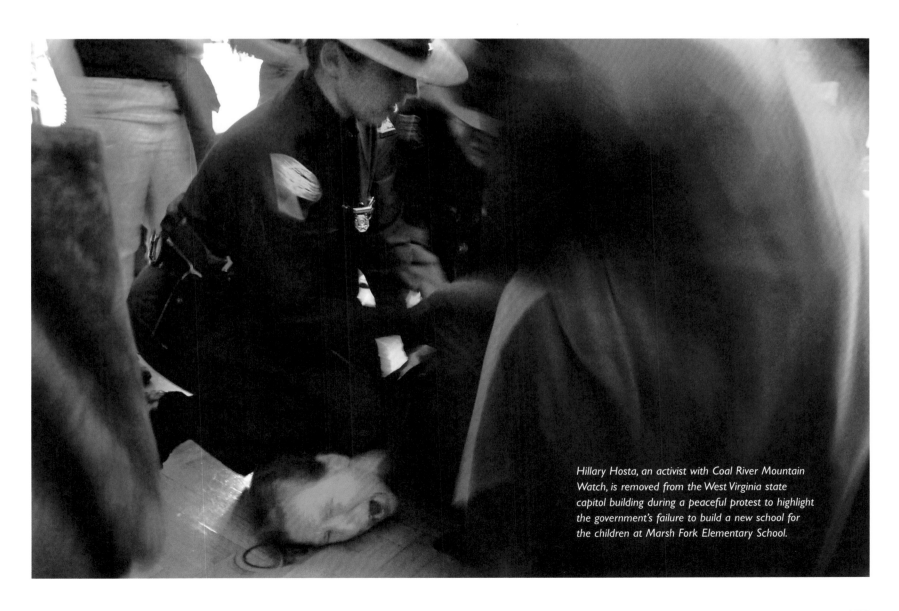

Hillary Hosta, an activist with Coal River Mountain Watch, is removed from the West Virginia state capitol building during a peaceful protest to highlight the government's failure to build a new school for the children at Marsh Fork Elementary School.

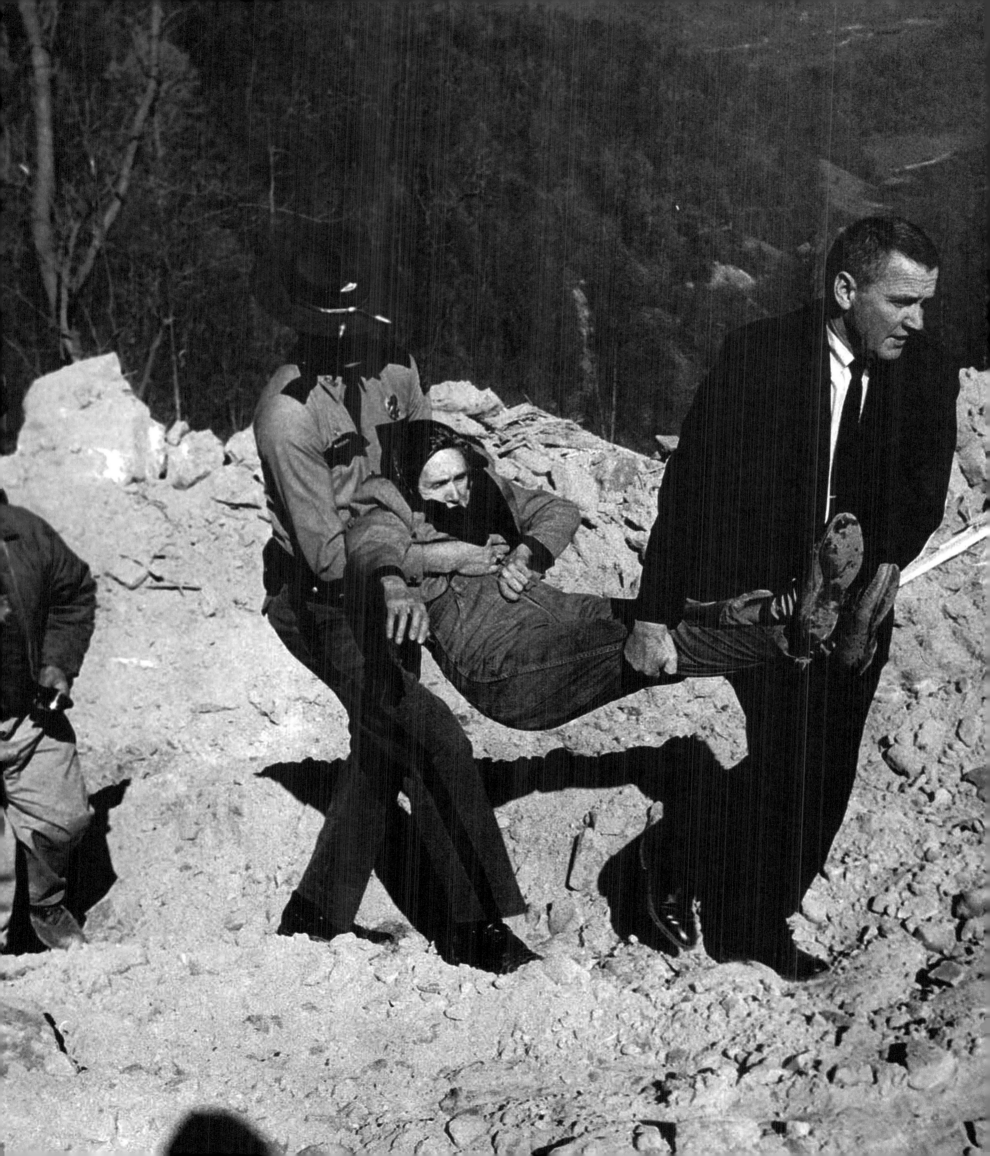

IT OUGHT TO BE OUTLAWED

The Movement to Ban Strip Mining in Appalachia, 1954–1977

CHAD MONTRIE

Ravaged by increased mountaintop-removal operations during the past two and a half decades, the hills of southern Appalachia are now witnessing a robust grassroots campaign to end this most destructive form of strip mining. Homegrown groups such as Coal River Mountain Watch, Kentuckians For The Commonwealth, and the Ohio Valley Environmental Coalition, assisted by the global justice and environmental advocates as part of Mountain Justice Summer, are forging a broad coalition against mountaintop removal. Yet this is not the first time local residents have joined together with outside activists to challenge surface coal mining. There is, in fact, a long history of opposition to stripping, a history that is instructive for understanding the present as well as charting a course for the future.

Starting in the 1950s and continuing throughout the 1960s and into the 1970s, a varied group of people organized across the southern highlands to put pressure on coal operators as well as draw the attention of state legislators and federal policy makers, and they very nearly accomplished the abolition of all strip mining. Their story is one of political radicalization and militant tactics, rocky relationships with organized labor and mainstream environmental organizations, and the power of coal companies and energy conglomerates to shape control laws and capture regulatory agencies. This abbreviated recounting tells that story, focusing on eastern Kentucky, covering the campaign to stop stripping as it gained traction from the local to federal levels. It begins in the mid-1950s, as voices of protest first sounded, and ends in 1977, when Congress passed the Surface Mining Control and Reclamation Act (SMCRA), which many activists saw not as a culmination of their work but rather as a failure, a victory for the coal industry that gave legislative legitimacy to methods of coal extraction that should have been banned.

TO SAVE THE LAND AND PEOPLE

Surface mining for coal began in the United States in the eighteenth century, when farmers, slaves, and others dug into hillsides, stream banks, or exposed pits to extract the combustible mineral, usually for local use as a fuel. It was not until the late nineteenth and early twentieth centuries, however, that rising demand for coal and an expanding system of railroad lines spurred significant interest in mechanized strip-

ping for regional markets. This happened first in midwestern states, particularly Indiana and Ohio, and then in various parts of Appalachia, from Pennsylvania to Alabama, where substantial anthracite and bituminous reserves held out the promise of even higher profits.

After World War II, with improved shovels, draglines, drills, earthmoving equipment, and trucks, operations expanded and increased. By the mid-twentieth century, surface mining rivaled deep mining in annual tonnage output, and in the early 1970s, the various forms of stripping (area, contour, and auger) surpassed underground methods of extraction (shaft, slope, and tunnel). At that time the surface mining industry was dominated by large coal companies and energy conglomerates, which had the capital to gobble up mineral rights and invest in new technology. They also had the power to influence state and federal governments, block or avoid regulation, and pass on the social and environmental costs of stripping to the public.

The impact surface coal mining had on local and regional economies, particularly southern Appalachia, was wealth for a few and impoverishment for many. Strip operators wantonly destroyed arable farmland, orchards, barns, wells, and even homes, often without compensation to landowners, following court interpretations of "broad form" deeds, which severed mineral and property rights. Since stripping required many fewer miners per ton of coal mined, lowering the cost of production, it also exacerbated the region's chronic unemployment. In addition, the coal industry traditionally enjoyed very modest levels of taxation because of underassessed coal reserves, negligible property taxes, and continuous resistance to severance taxes (which are based directly on the tonnage of extracted coal). This impaired the ability of states and local communities to maintain a public infrastructure and provide public services.

Stripping adversely affected the landscape as well. It denuded millions of acres of woodland and, subsequently, worsened soil erosion and increased surface runoff. The erosion silted streams and harmed aquatic life, while rapid runoff caused heavier flooding and brought floods where there had been none before. Acid-mine drainage also polluted streams, groundwater, and soil, poisoning peoples' drinking water supplies and making revegetation or postmining crop production difficult if not impossible. The bare slopes on unreclaimed sites posed a threat to

homes, schools, and whole towns, in some cases leading to devastating landslides that swept away buildings and buried people alive. Meanwhile, blasting at surface mines proved more than a mere nuisance, routinely cracking foundations of people's homes, sinking wells, and sending "flyrock" into the air.

These many and varied problems caused by surface coal mining prompted a wave of state regulatory legislation. West Virginia acted first, in 1939, followed by Indiana, Illinois, Pennsylvania, Ohio, and, in the mid-1950s, Kentucky. In each of the states, control laws typically established a permit system, requiring a small bond per acre, and they set up standards for reclamation. They also created regulatory agencies for enforcement. With weak regulations and often disinterested or even corrupt officials overseeing the mining, however, the state legislation was roundly criticized by farmers, homeowners, sportsmen, and others. And as early as the late 1950s, some of these surface-mining opponents began to call for the abolition of stripping.

The earliest and most active campaign to outlaw strip mining was centered in eastern Kentucky, where geography and climate, lax enforcement of a limited control law, and court interpretations of operators' rights set the stage for confrontation. In 1960 Letcher County representative Harry Caudill introduced the first bill to outlaw stripping in the legislature, supported by a petition with one thousand signatures of local residents, including the county judge, two ex-county judges, the tax commissioner, and the state senator. "Strip mining in our steep mountains," the petition's cover letter explained, "destroys the surface for agricultural purposes, throws immense amounts of loose earth into the streams, causes mud to be carried by rain down onto our gardens and crop lands, and into our wells, and destroys the natural beauty which God has so lavishly placed in our region."[1]

The bid to abolish strip mining by law in Kentucky failed, but this only encouraged people to organize, initially through long-established conservation groups, farm bureau chapters, and the like. In June 1965, however, several weeks after Knott County resident Dan Gibson dramatically faced down strip miners encroaching on his land, abolition proponents met and established the Appalachian Group to Save the Land and People (AGSLP). Drawing on the natural rights tradition embedded in the Declaration of Independence, they claimed a justification for using all means to defend their property, from petitions and lobbying and lawsuits to nonviolent civil disobedience and armed self-defense. Members included farmers, deep miners, teachers, and others who were outraged at strip operators' reckless destruction of the land and the adverse impact on the local and regional economy; these activists were increasingly frustrated by the failure of the state legislature and courts to provide redress.

Immediately after AGSLP was founded, stripping opponents traveled in a fifty-car motorcade to the state capitol to talk to the governor and deliver petitions with more than three thousand signatures calling for abolition. Later in November, though, the group demonstrated its commitment to direct action in support of Knott County resident Ollie

Combs [see accompanying photos], who was engaged in a standoff with strip operators trying to get the coal under her land. AGSLP members temporarily stopped the work when they showed up with rifles, but it resumed when they left, and Combs and her sons decided to sit down in front of the bulldozers. The three were arrested and taken to jail, and Kentucky's largest newspaper put a picture of Combs eating Thanksgiving dinner behind bars on the front page. This prompted the governor to urge all citizens to obey the law but, playing to the gathering movement, he noted how "history has sometimes shown that unyielding insistence upon the enforcement of legal rights by the rich and powerful against the humble people of a community is not always the quickest course of action." Following that, he revoked the strip operator's permit.[2]

Over the next couple of years, AGSLP members continued to employ legal methods to achieve a ban, including organizing chapters, holding public meetings, drafting petitions, filing lawsuits, and lobbying for legislation. "If an industry has to operate at the expense of the poor," declared one activist, "it ought to be outlawed."[3] But AGSLP also relied on nonviolent civil disobedience, like the well-organized and successful effort to protect the property of Jink Ray, in Pike County, by putting people in front of strip operators' bulldozers. Embracing a new tactic, a few activists began to use industrial sabotage as well, blowing up machinery at selected mines to stop operations and send a message of concerted resistance. At a Leslie County mine in August 1968, for example, four men tied up a security guard, used the Round Mountain Coal Company's explosives to destroy a diesel shovel, D-9 bulldozer, auger, conveyor belt, three hi-lifts, truck, three generators, and a jeep. Altogether, property damage totaled $750,000. The perpetrators were never found.

FAR FROM WHAT WE NEED

Confronted with gathering militancy in the coalfields of Kentucky and other states during the late 1960s and early 1970s, coal companies as well as the corrupt leadership of the United Mine Workers (UMW) became more amenable to regulations, which they previously had said would be the death knell of the industry. Their hope was to head off stronger controls or, worse, prohibition. That was not likely to happen at the state level, where the industry had much greater influence, but the U.S. Congress held the first hearings on strip-mining regulation in 1968, and West Virginia Representative Ken Hechler introduced the first bill for a ban in February 1971. The various opposition groups from Kentucky, West Virginia, Ohio, Tennessee, and Virginia formed the Appalachian Coalition in response, to demand and support passage of federal legislation outlawing surface coal mining. Coal companies and their trade associations mobilized accordingly as well.

At the same time, changes were taking place within the UMW. Plagued by dishonest and unresponsive leadership through the 1960s, a reform campaign called Miners for Democracy managed to take the union back for the membership. Their candidate for president, Arnold Miller, came

out of West Virginia's insurgent black lung movement and was an outspoken critic of strip mining. When he and the rest of the Miners for Democracy slate won in the union's 1972 elections, the victory seemed to promise an opportunity for new cooperation between the more radical opponents of surface mining and the United Mine Workers. That, however, was not to be. Surface miners were an increasingly influential part of the union membership, and they made it difficult if not impossible for the UMW to come out in support of a ban. Instead, the union lent its support to one of the stronger regulatory bills introduced in Congress, making it harder for other activists to gather and sustain momentum for outlawing stripping. As divisions within the UMW worsened and reformers lost much of their influence on the issue, in the mid-1970s the union even switched positions to once again favor weak state regulation.

Another pressure for compromise came from mainstream environmental groups including the Sierra Club and Environmental Policy Center, which worked with the Appalachian Coalition but discouraged demands for abolition and encouraged willingness to accept a federal control law. The leadership of these groups also privately colluded with one another and talked to members of Congress about supporting regulation, undermining and impeding efforts to push a prohibition bill, which at one point had a large and growing number of cosponsors. Subsequently, some abolitionists began to consider a partial ban on steep-slope surface mining, and, over time, more came around to the likelihood of compromise. When that happened, though, the coal industry and their supporters in Congress felt less compelled to accept even a strong regulatory bill; they began proposing much less stringent legislation and eventually, like the UMW, resumed advocacy for limited state level oversight. In fact, this was how the Surface Mining Control and Reclamation Act (SMCRA) passed in 1977, establishing a combination of federal and state regulatory authority.

In the days before President Carter signed SMCRA, several environmental and citizens' groups tried to dissuade him, listing their objections at a press conference. These included SMCRA's explicit recognition of mountaintop removal as an approved mining technique (rather than a variance technique requiring special approval), language allowing for variance from restoration to approximate original contour, failure to impose slope limitations (or a partial ban on contour mining), and failure to fully protect surface owner rights with a comprehensive consent clause. Brushy Ridge, Virginia, resident Ransom Meade said the law was better than no bill at all, with good provisions but "far from what we need."[4]

Later, and into the present time, of course, the various limitations codified in the Surface Mining Control and Reclamation Act allowed for continued environmental degradation by surface-mine operators. Although President Carter and others gathered for the Rose Garden signing ceremony heralded SMCRA as the successful end of a long struggle to rein in strip operators, it effectively started the era of legalized destruction.

1. Rash, Raymond, to Governor Combs, 13 September 1960, Folder 1, "Strip Mining, May 1956–Dec 27, 1960," Box 19, Harry Caudill Manuscript Collection, Special Collections, University of Kentucky.

2. Harry Caudill, *My Land is Dying* (New York: E. P. Dutton & Co., 1973); *Hazard Herald*, 15 November 1965.

3. *Daily Enterprise* [Harlan, Kentucky], 7 July 1967, Folder 1, "Strip Mining, Jan 8, 1967–July 30, 1967," Box 20, Caudill Papers.

4. *New York Times*, 4 August 1977.

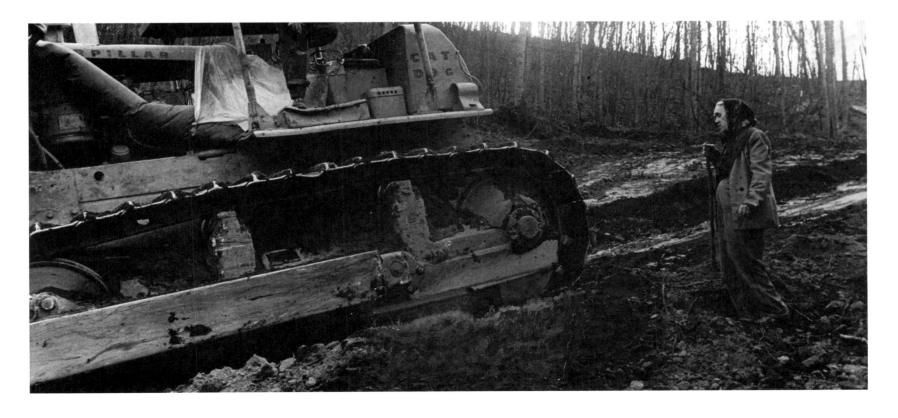

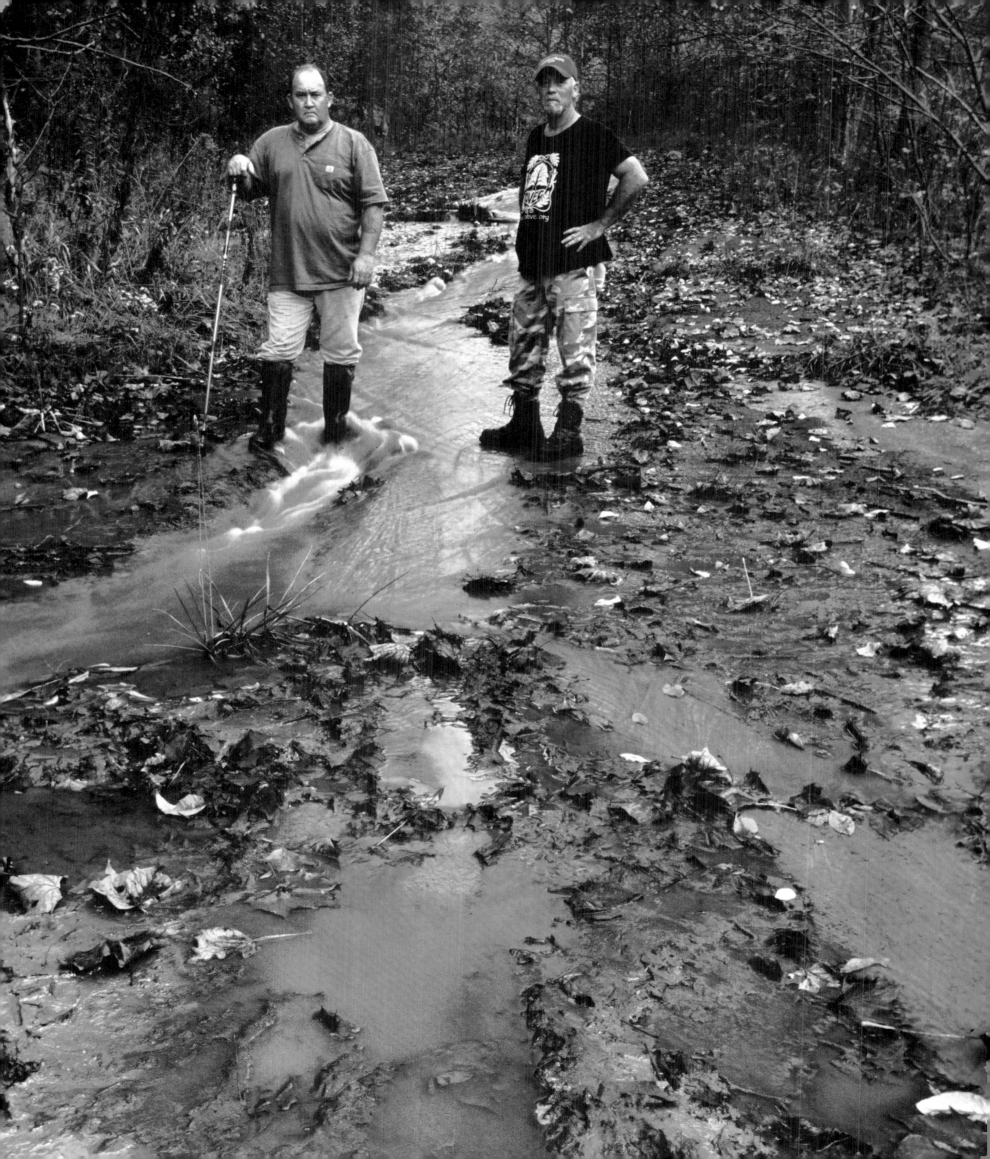

ABOLITION

The Only Solution

KEN HECHLER

In 1971 while serving the people of West Virginia in Congress, I introduced a bill to phase out and ultimately abolish strip-mining for coal. Our legislation, and a Senate companion bill offered by Gaylord Nelson and George McGovern, soon attracted ninety cosponsors. The *New York Times* editorialized in favor of our legislation, and there was growing national opposition to this destructive practice.

Various citizens' groups across Appalachia helped mobilize support for abolition, and some national environmental organizations initially were supportive. After months of agitation, the House Interior Committee finally agreed to hold hearings, but decided to also consider legislation that would regulate instead of ban surface mining.

The consideration of the Surface Mining Control and Reclamation Act (SMCRA) evolved into debate over three bills: abolition (my bill), modest regulation (supported by Rep. Morris K. Udall of Arizona), and a very mild approach to regulation (offered by Rep. Craig Hosmer of California). Udall, then chairman of the Interior Committee, was in a strategic position to argue his bill was the moderate between extremes.

The subcommittee of Mines and Mining grilled me for many hours in an attempt to undermine my bill. Members on both sides of the aisle stressed that the so-called energy crisis plus the Arab oil embargo made strip mining necessary. My solution, to increase deep mining, was ridiculed as too dangerous. It need not have been if the Nixon administration would have enforced the strict safety standards in the 1969 Federal Coal Mine Health and Safety Act, which I had authored.

Under pressure, supporters of my abolition bill declined to sixty-six. I characterized reclamation as putting lipstick on a corpse. I pointed out that many coal companies were spending excessive amounts on "showcase reclamation" on small acreages, which would be uneconomical if attempted for typical strip-mine projects.

The blackest day in the discussion of SMCRA was July 22, 1974, when Rep. Teno Roncalio of Wyoming introduced an amendment authorizing mountaintop-removal coal mining. He contended that this approach would "create a plateau with no high walls remaining." His bill was praised for authorizing "model mines" to create flat land for industrial development. I immediately jumped to my feet to deliver the following impassioned argument:

> *Mountaintop removal is the most devastating form of mining on steep slopes. Once we scalp off a mountain and the spoil runs down the mountainside and the acid runs into the water supply, there is no way to check it. This is not only esthetically bad as anyone can tell who flies over the State of West Virginia or any place where the mountaintops are scraped off but also it is devastating to those people who live below the mountain. Some of the worst effects of strip mining in Kentucky, West Virginia, and other mountainous areas result from mountaintop removal. McDowell County in WV, which has mined more coal than any other county in the nation, is getting ready right now to strip mine off four or five mountaintops. They are displacing families and moving them out of those areas because everybody downslope from where there is mountaintop mining is threatened. I certainly hope that with all the compromises that have been accepted by the committee, offered by industry in the committee, that now we do not compromise what little is left of this bill by amendments such as this.* (Congressional Record House July 22, 1974 p. 24469)

Unfortunately, the Roncalio amendment passed and remained part of the final Surface Mining Control and Reclamation Act signed by President Carter in 1977. At the time, I opposed the legislation because I believed pressure from the coal industry at both national and state levels would seriously weaken its enforcement, which is precisely what has happened. SMCRA was not just ineffective, it raised false hopes, causing many good people to leave regulatory agencies when they saw that it would be a smokescreen for an outlaw industry.

In recent years, a few temporary victories for the land and the people have been scored as the result of local circuit court decisions, but have usually been reversed by the conservative Fourth Circuit Court of Appeals in Richmond, Virginia. Meanwhile, the coal industry's trade associations and associated political action committees have stepped up their financial contributions to executive, legislative, and judicial candidates. After three decades of expanding destruction, I remain convinced that the only solution to surface coal mining is abolition.

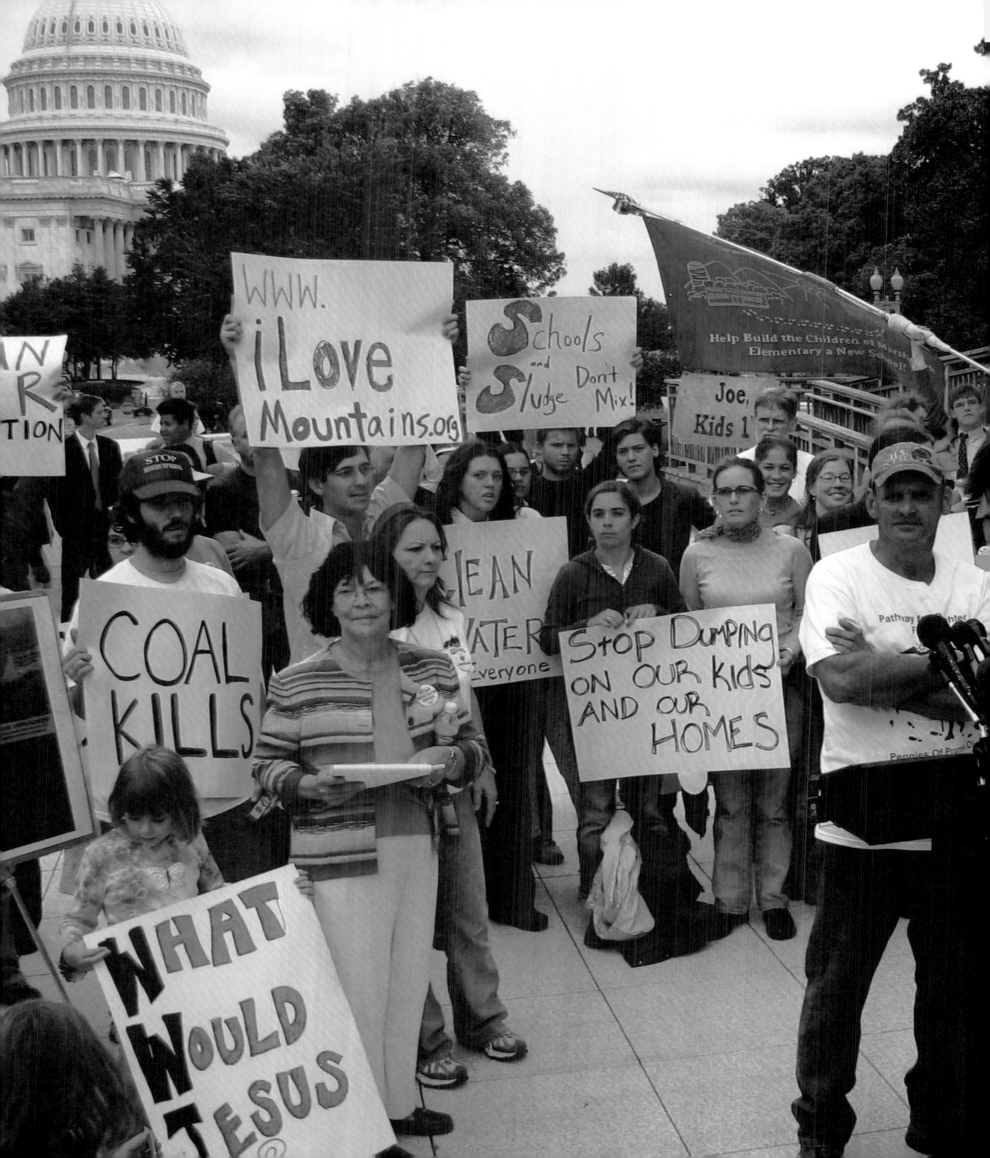

A CALL TO ACTION

Building the Movement to End Mountaintop Removal

JERRY HARDT

In November 1988, 82.5 percent of Kentuckians approved a constitutional amendment to end the worst abuses of the broad-form mineral deed. While leading that campaign, Kentuckians For The Commonwealth found that it wasn't so necessary to convince people which way to vote as it was merely of letting them know what was going on. Broad-form deeds affected residents in only about a dozen counties, and strip mining occurs in only about a third of Kentucky's 120 counties. Yet the coal companies' ability to strip mine and destroy people's land without their permission and against their wishes was such a blatant abuse of power that citizens across the state were eager to put an end to this injustice. The ballot initiative won in every county in Kentucky.

Mountaintop removal and valley fills are no less of an injustice and abuse of power. And the challenge is similar—letting people know what is happening to the natural and human communities of Appalachia. And then taking action.

The broad-form deed victory was made possible by a history of resistance going back decades. Each public action to make the coal industry more accountable built upon the organizing, educating, lobbying, and networking of citizen activists that took place over many years. Today we are building a similar movement—a campaign to end mountaintop removal and valley fills, which are unnecessary for meeting the nation's energy needs, even our specific demand for coal. These practices reflect a choice to put profits ahead of people, a choice that needs to be unmade.

We also realize that an even broader movement is needed to create an economy that is not dependent upon destroying the land and oppressing the people. More than one hundred years of industry domination have prompted a growing number of citizens to recognize that modest reforms in mining regulations and oversight do little to change the structures of oppression and poverty that are the hallmarks of the coal industry's presence in a community. Ultimately, we must build a future beyond coal.

That will require widespread support for initiatives—public, private, and legislative—to build a sustainable energy supply that moves us beyond our unhealthy dependence on coal and other fossil fuels. In this transition, we should provide economic development and diversification assistance for those coal counties that need it most, which happen also to be the ones that historically have been most overlooked.

So what can we do?

- We must vote. The way coal companies are allowed to treat the land and people must become a campaign issue. Candidates must hear our concerns and know we expect substantive answers.

- We must communicate with elected officials and hold them accountable for their actions. That means we must also stay informed ourselves.

- We must support individuals and groups who are out front organizing and those working behind the scenes building the movement.

- All people, particularly people of conscience—for this is a moral issue as well as an economic one—must speak out. Allowing mountaintop removal is a choice, one that we all participate in, knowingly and unknowingly, until we say NO. Let's say it.

- We must become conscious of the ways we use energy. It is our relentless demand for electricity, at as cheap a price as possible, that is used to justify mountaintop-removal mining.

- We must demand a green-energy option from our local utilities. If the demand is there, they will answer it.

- We must ask our electricity suppliers if any of the coal they use is mined using mountaintop removal. If so, we must ask them to stop using coal mined by this method.

- We must demand state and national energy policies and programs that emphasize renewable energy sources and conservation. Government must make available the resources to move us forward toward a green-energy future.

- We must have a vision. We must believe that mountaintop-removal mining can be stopped. Working toward that end, and articulating a positive vision for the landscape and people of Appalachia, will give us the hope and courage to move forward.

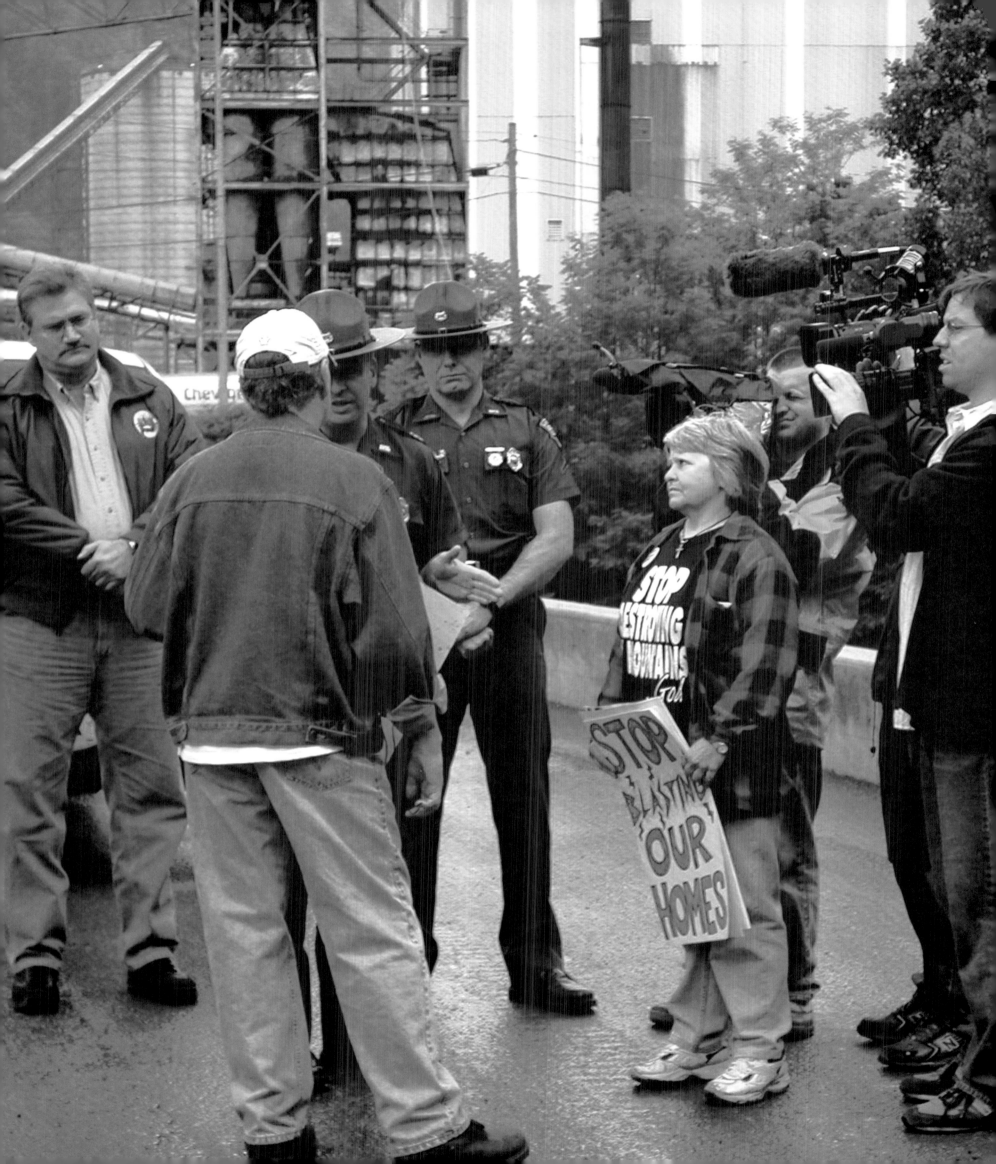

RESOURCES FOR ACTION

Numerous grassroots, regional, and national groups are engaged in the fight to end mountaintop-removal coal mining's horrific effects on the landscape and people of Appalachia. Many other non-governmental organizations are engaged in the broader but linked issues of coal burning, energy policy, and air pollution. A comprehensive list is not possible to include here, but the following resources should provide opportunities for every citizen to learn more about these issues and to join the movement for a more sustainable future for natural and human communities—across Appalachia and around the globe.

THE ALLIANCE FOR APPALACHIA

The Alliance for Appalachia is a collaboration of thirteen organizations in central Appalachia working to bring an end to mountaintop-removal coal mining. The Alliance for Appalachia also seeks to promote a just and sustainable economy and a clean, renewable energy future in the region.

THE APPALACHIAN CITIZENS LAW CENTER is a non-profit law firm that provides free legal services to persons and citizens' groups who have legal issues related to coal mining, logging, drilling, and other resource-related practices in central Appalachia.

317 Main Street
Whitesburg, KY 41858
606-633-3929
www.appalachianlawcenter.org

APPALACHIAN VOICES provides legal, scientific, and online resources to coalfield communities and partner organizations its campaigns to end mountaintop-removal coal mining, eliminate air pollution, and protect and restore native forests. Through innovative outreach and organizing strategies, Appalachian Voices is working with coalfield activists to build a nationwide base of public support for ending mountaintop removal.

191 Howard Street
Boone, NC 28607
828-262-1500
www.appalachianvoices.org

APPALSHOP is a multidisciplinary arts and education center in the heart of Appalachia producing original films, video, theater, music, spoken-word recordings, radio, photography, multimedia, and books.

91 Madison Avenue
Whitesburg, KY 41858
606-633-0108
www.appalshop.org

COAL RIVER MOUNTAIN WATCH is a small but scrappy grassroots organization founded by local residents in West Virginia's Coal River Valley, where mountaintop-removal mining and slurry impoundments affect every citizen.

P.O. Box 651
Whitesville, WV 25209
304-854-2182
www.crmw.net

HEARTWOOD is a cooperative network of grassroots groups, individuals, and businesses dedicated to the health and well-being of our nation's hardwood forests and their interdependent plant, animal, and human communities. Heartwood protects forests and supports community activism through advocacy, education, and citizen empowerment.

P.O. Box 1011
Alton, IL 62002-1011
812-337-8898
www.heartwood.org

KENTUCKIANS FOR THE COMMONWEALTH is a statewide citizens' organization that helps people and communities take action for justice through grassroots organizing and leadership development. KFTC members have led the fight for tax reform and voting rights, against the broad-form deed and destructive surface coal mining practices, and for the transition to a green energy economy.

P.O. Box 1450
London, KY 40743
606-878-2161
www.kftc.org

MOUNTAIN ASSOCIATION FOR COMMUNITY ECONOMIC DEVELOPMENT promotes "high road" development efforts in the Appalachian counties of eastern Kentucky—strategies that result in adequate wages and meaningful work, protect the environment, and make a difference to communities most in need.

433 Chestnut Street
Berea, KY 40403
859-986-2373
www.maced.org

OHIO VALLEY ENVIRONMENTAL COALITION builds leadership and forms coalitions that help shift the balance of power toward environmental protection and the public interest. A grassroots, citizen-based organization, OVEC's major program focus is to end the social and environmental injustices caused by mountaintop-removal mining, underground coal slurry injection, and coal-sludge impoundments.

P.O. Box 6753
Huntington, WV 25773-6753
304-522-0246
www.ohvec.org

SAVE OUR CUMBERLAND MOUNTAINS is a thirty-four-year-old statewide multiracial grassroots community organization in Tennessee working for environmental, economic, and social justice. SOCM organizes to stop mountaintop-removal strip mining locally and to put in place new state water-quality policies to eliminate this destructive form of mining in Tennessee.

P.O. Box 479
Lake City, TN 37769
865-426-9455
www.socm.org

SIERRA CLUB'S CENTRAL APPALACHIAN ENVIRON-MENTAL JUSTICE PROGRAM works to support coalfield activists in their struggles against the irresponsible practices of the mining industry.

726 Clinch Mountain Road
Eidson, TN 37731
423-944-3220
bill.mccabe@sierraclub.org

SOUTHERN APPALACHIAN MOUNTAIN STEWARDS is an organization of concerned citizens in rural western Virginia who are working to improve the quality of life and to stop the destruction of local communities by surface coal mining.

301 Wood Avenue
Big Stone Gap, VA 24219
276-523-4380
www.samsva.org

SOUTHWINGS is a nonprofit conservation organization that provides skilled pilots and aerial education to enhance conservation efforts across the Southeast. Working with flight partners and community groups throughout the region, SouthWings helps collect scientific data on the globally significant ecosystems of the Southeast and informs policy makers and the media about environmentally destructive practices.

35 Haywood Street, Suite 201
Asheville, NC 28801
828-225-5949
www.southwings.org

WEST VIRGINIA HIGHLANDS CONSERVANCY is the state's oldest environmental advocacy organization. Formed in 1967, the conservancy has used administrative, legal, and other means to defend the original intent of the Surface Mine Act and Clean Water Act, prevent acid-mine drainage, insist on adequate financial guarantees to cover the cost of reclamation at mined sites, and prohibit dumping of mine waste into headwater streams.

Mining Committee Chair
HC 78, Box 227
Rock Cave, WV 26234
304-924-5802
www.wvhighlands.org

OTHER GROUPS, CAMPAIGNS, AND ONLINE RESOURCES

THE APPALACHIAN CENTER FOR THE ECONOMY & THE ENVIRONMENT is an effective public interest law and policy nonprofit working to stop mountaintop-removal coal mining; to protect communities from the adverse health effects caused by water and air pollution generated by resource extraction, coal burning power plants, and other destructive practices; and to protect and restore the region's hardwood forests. Its founder, attorney Joe Lovett, has brought many of the most important legal actions challenging mountaintop removal and valley fills.

P.O. Box 507
Lewisburg, WV 24901
304-645-9006
www.appalachian-center.org

CHRISTIANS FOR THE MOUNTAINS
www.christiansforthemountains.org

EARTHJUSTICE is a nonprofit public interest law firm dedicated to protecting the magnificent places, natural resources, and wildlife of this Earth and to defending the right of all people to a healthy environment. Earthjustice has been a major player in litigation related to mountaintop removal and other coal-mining and burning issues.

426 Seventeenth Street, 6th Floor
Oakland, CA 94612
800-584-6460
www.earthjustice.org

GREENPEACE
www.greenpeace.org/usa

I LOVE MOUNTAINS is an invaluable online resource for news, education, and information about how individuals can get engaged in fighting mountaintop removal. The website has pioneered a number of innovative movement-building communication tools.

www.iLoveMountains.org

KENTUCKY RESOURCES COUNCIL
www.kyrc.org

MOUNTAINJUSTICE
www.mountainjustice.org

MOUNTAINTOP REMOVAL ROAD SHOW
www.mountainroadshow.com

NATURAL RESOURCES DEFENSE COUNCIL
www.nrdc.org

THE SIERRA CLUB, with its Move Beyond Coal campaign, is helping local citizens fight new coal plants across the country; working to retire the dirtiest old power plants; addressing the entire coal cycle, including mountaintop-removal mining; and conducting shareholder advocacy to drive investment away from coal and into clean energy alternatives.

www.sierraclub.org/coal

SLUDGE SAFETY PROJECT
www.sludgesafety.org

STOP MOUNTAINTOP REMOVAL
www.stopmountaintopremoval.org

UNITED MOUNTAIN DEFENSE is an all-volunteer citizen's action group dedicated to protecting the mountains and waters of Tennessee from surface mining.

P.O. Box 20363
Knoxville, TN 37920
www.unitedmountaindefense.org

VALLEY WATCH was formed in 1981 in reaction to numerous regional coal and nuclear power plant proposals. Its purpose is to protect the public health and environment of the lower Ohio River Valley. Valley Watch has successfully challenged numerous big-ticket pollution proposals during its history and is collaborating with other groups to fight new coal plants.

800 Adams Avenue
Evansville, IN 47713
812-464-5663
www.valleywatch.net

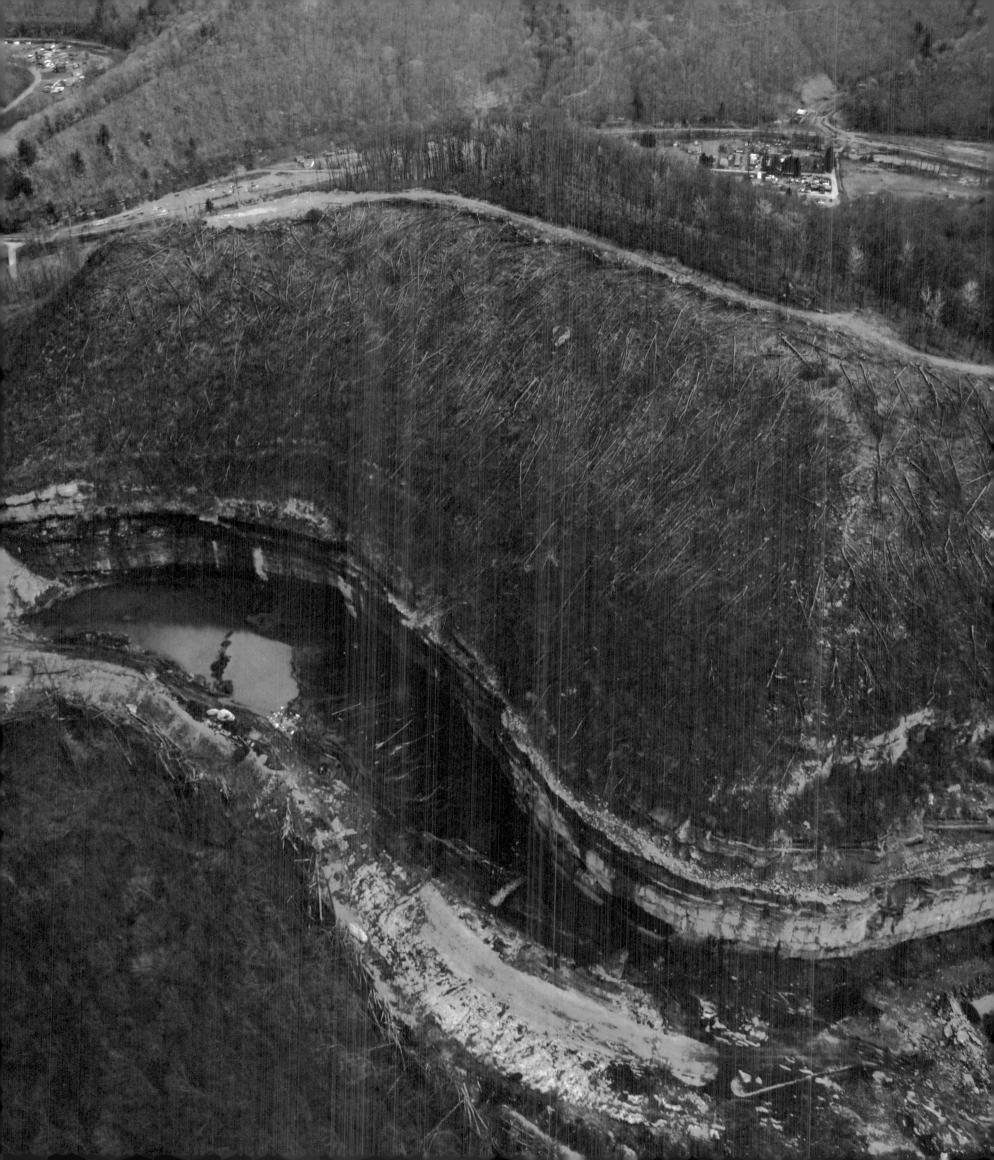

AFTERWORD

DESECRATION

DENISE GIARDINA

When people in positions of power decide to support a great evil, they must be called out and held accountable. The coal companies who use mountaintop removal—and their shills in organized labor, industry booster groups, and politics—should be held up for contempt.

I will be as blunt as I can be. Mountaintop removal is evil, and those who support it are supporting evil.

The mountains of West Virginia are God's greatest gift to West Virginia. To destroy the mountains is to spit in the face of God Almighty. Our state motto and state song are about the mountains. Our state university's football team is named after the mountains. Blowing apart these beautiful mountains is an attack upon this state, its people, and the natural wonders God has bestowed upon us.

I grew up in southern West Virginia, and I was forced to leave and to see my community annihilated, thanks to the coal industry. To those individuals who work in surface mining, claiming economic imperative, I say: You are helping to destroy what's left. It is a terribly sad situation when someone spends their time blowing up their home. And if you continue with this destructive behavior, you may be able raise your child in your home community, but your child will never be able to live there in the future. Your bosses are destroying your child's future, and they are using you to do it.

Destructive jobs should never be countenanced, much less supported by our so-called business and labor leaders. What is next? Will the Chamber of Commerce support the jobs created by drug dealers? After all, drug dealers have families to feed. Will the unions support the jobs created by prostitution? Prostitutes are also desperate for work. Perhaps we should instead go about diversifying our economy and weaning the state away from dependence upon a single, dying industry.

Let us be clear. Mountaintop removal is not about creating jobs; it is about enriching coal companies. Mountaintop removal destroys deep-mining jobs and ensures that other companies will never, ever locate here. It assures that the only future for southern West Virginia will be as a garbage dump.

The great Woody Guthrie wrote "This Land is Your Land." He also wrote a song called "Pretty Boy Floyd." The lyrics end like this: "Yes, as through this world I've wandered, I've seen lots of funny men. Some will rob you with a six-gun, and some with a fountain pen."

Just as Guthrie, during the Depression, pondered over the difference between a bank robber and a bank, I puzzle over the modern-day difference between a terrorist and someone who supports mountaintop removal. One destroys with a bomb, the other with a fountain pen, explosives, and a dragline. God help us.

ABOUT THE CONTRIBUTORS

WENDELL BERRY is a poet, essayist, novelist, and farmer who lives and works with his spouse, Tanya Berry, on their farm in Henry County, Kentucky. He is the author of more than forty books, including *The Unsettling of America* and *Life is a Miracle*, and is the recipient of numerous awards.

JOHN BLAIR serves as president of Valley Watch, Inc., an environmental health organization based in Evansville, Indiana, the center of the largest concentration of coal plants in the world. He is a Pulitzer Prize–winning photojournalist and adjunct faculty member at the University of Southern Indiana. Blair holds a bachelors degree in economics from the Kelley School of Business at Indiana University and a masters in journalism from Ball State University.

TERI BLANTON grew up in Harlan County, Kentucky, where she began volunteering as a community organizer with the Mountain Association of Community and Economic Development. While living next to a federal Superfund site in Dayhoit, Kentucky, she started a career in activism that would receive national attention. Currently Blanton is vice president of Kentucky Riverkeepers and a fellow with Kentuckians For The Commonwealth.

JULIA "JUDY" BONDS is the codirector of Coal River Mountain Watch in Whitesville, West Virginia. Daughter and granddaughter of coal miners, she and her family have lived in the Coal River Valley for ten generations. Judy has been a tenacious and creative advocate for social and environmental justice in the Appalachian coalfields; in 2003 she was awarded the Goldman Environmental Prize, the premier award for environmental activism.

TOM BUTLER is a writer, editor, and activist focused on wilderness and biodiversity. He currently serves as editorial projects director for the Foundation for Deep Ecology. He is a founding board member and current president of the Northeast Wilderness Trust, a regional land trust. His book *Wild Earth: Wild Ideas for a World Out of Balance* is a collection of essays from the conservation journal Butler edited from 1997 to 2005. His latest book, a collaboration with photographer Antonio Vizcaíno, is *Wildlands Philanthropy: The Great American Tradition.*

HARRY M. CAUDILL (1922–1990) was a lawyer, state legislator, and writer from Letcher County in the coalfields of eastern Kentucky. His landmark book, *Night Comes to the Cumberlands*, published in 1963, focused national attention on the pervasive poverty and social problems rampant in Appalachia. An early and vigorous opponent of destructive strip mining, he wrote widely for popular magazines, served three terms in the Kentucky House of Representatives, and taught for several years at the University of Kentucky.

SAMIR DOSHI is a systems ecologist specializing in restorative ecological design for Ocean Arks, International, which was recently awarded the Buckminster Fuller Challenge for a carbon-neutral design for Appalachia. He is pursuing his doctorate in natural resources at the University of Vermont and splits his time between Vermont and rural western Virginia, where he is conducting research on how to restore "reclaimed" mined landscapes and help communities transition toward a sustainable economy.

KAI T. ERIKSON is an emeritus professor of sociology and American studies at Yale University and former chair of its Department of Sociology. He is past president of the American Sociological Association and the author of several award-winning books including *Wayward Puritans* and *Everything in Its Path: Destruction of Community in the Buffalo Creek Flood*, the latter an account of the February 1972 coal waste-dam failure that killed 125 people in West Virginia.

LISA GOLLIN EVANS is an attorney specializing in waste law and has been active in hazardous waste litigation and advocacy for over twenty-five years. She is an expert on coal-ash issues and testified before Congress in 2008 and before the National Academies of Science in 2005. Prior to working at Earthjustice, Lisa worked for the Boston-based nonprofit, Clean Air Task Force, and began her career as an Assistant Regional Counsel at the Environmental Protection Agency, Region 1. She is the author of six nonfiction books, including an award-winning children's book.

ROSS GELBSPAN was a reporter and editor for thirty-one years at the *Philadelphia Bulletin*, the *Washington Post* and the *Boston Globe*.

At the *Globe*, he conceived and edited a series of articles that won a Pulitzer Prize in 1984. Following his retirement from daily journalism, he authored two landmark books on climate change, *The Heat Is On* and *Boiling Point*. His articles on the climate issue have appeared in *Harper's*, the *Atlantic Monthly*, the *Nation*, the *American Prospect*, and other periodicals. He founded the website www.heatisonline.org.

DENISE GIARDINA is an award-winning novelist who teaches at West Virginia State University. She was born in the coalfields, growing up in the mining camp of Black Wolf, West Virginia, where her parents and extended family worked for the coal mine. As a teenager, her family relocated to Charleston when the mine closed. She attended college and seminary before pursuing writing. Two of her novels, *Storming Heaven* and *The Unquiet Earth*, are set in the West Virginia coalfields. She ran unsuccessfully for governor in 2000, using the campaign to speak out about mountaintop removal and the economic injustice facing many rural citizens.

MARIA GUNNOE of Bob White, West Virginia, is an organizer with the Ohio Valley Environmental Coalition. Her family's land has been flooded repeatedly since a mountaintop-removal mine was put in above the family property, and she has been subject to harassment for her anti-surface mining-activism. Her work is featured in the film *Burning the Future: Coal in America*.

JERRY HARDT is the communications director of Kentuckians For The Commonwealth, a statewide citizens' group working toward a new balance of power and a just society. He is editor of the organization's newsletter, *Balancing the Scales*, and was a key contributor to the book *Missing Mountains: Kentuckians Write Against Mountaintop Removal*. He is a native Kentuckian and lives in Magoffin County.

KEN HECHLER was an assistant to President Harry Truman, served West Virginia in the U.S. House of Representatives from 1959 to 1977, and later was West Virginia's Secretary of State. While in Congress, Hechler was the lead author of the Coal Mine Safety and Health Act of 1969 and a key booster of unsuccessful legislation that would have banned surface coal mining in the United States. A former professor and the author of several books, Hechler lectures widely and remains a vigorous opponent of coal-mining interests that promote mountaintop removal.

RICHARD HEINBERG, a leading educator on peak oil, is a senior fellow at the Post Carbon Institute. He is the author of eight books including *Powerdown: Options and Actions for a Post-Carbon World*, *The Oil Depletion Protocol*, and *Peak Everything*. His latest book is *Blackout: Coal, Climate, and the Last Energy Crisis*.

MARY ANNE HITT is deputy director of the Sierra Club's National Coal Campaign, which is working to eliminate coal's contribution to global warming by preventing the construction of new coal-fired power plants, accelerating the retirement and replacement of existing coal plants, and ensuring that the massive coal reserves in the U.S. remain underground and out of export markets. She previously served as executive director of Appalachian Voices, where she was one of the creators of iLoveMountains.org, an online campaign to end mountaintop-removal coal mining that received national recognition for innovation and impact. She grew up in the mountains of east Tennessee and now lives in West Virginia.

REBECCA GAYLE HOWELL is a poet and documentary photographer who teaches in the creative writing program at Morehead State University in Morehead, Kentucky. Her books include *The Hatchet Buddha*, *This is Home Now: Kentucky's Holocaust Survivors Speak* (coauthor), and *The Artist as Activist*.

MARY T. HUFFORD is a folklorist and the director of the Center for Folklore and Ethnography at the University of Pennsylvania. She has published widely on folklore, cultural policy, and ecological crisis, including an edited volume, *Conserving Culture: A New Discourse on Heritage*. Her many writings on regional culture include the article "Folklore and Folklife in Appalachia: An Overview," published in the *Encyclopedia of Appalachia*.

ROBERT F. KENNEDY JR. serves as senior attorney for the Natural Resources Defense Council, chief prosecuting attorney for the Hudson Riverkeeper, and chairman of the Waterkeeper Alliance. He is also a clinical professor and supervising attorney at the Pace Environmental Litigation Clinic at Pace University School of Law in New York. A widely published author, his books include *Crimes Against Nature* and *The Riverkeepers*.

PAM MAGGARD is a special education teacher who has taught at the R. W. Combs Elementary School in Happy, Kentucky, since 1981. Her family's roots in eastern Kentucky go back generations. She lives with her family in the town of Sassafras, where they have remodeled an old coal-camp house. The daily fight to endure mining-related dirt, dust, and coal trucks through her community prompted her to become a community leader and activist with Kentuckians For The Commonwealth.

CHAD MONTRIE is an associate professor of history at the University of Massachusetts, Lowell. His research has focused on U.S. labor and environmental history. He is the author of *Making a Living: Work and Environment in the United States* and *To Save the Land and People: A History of Opposition to Surface Coal Mining in Appalachia*.

DAVID W. ORR is the Paul Sears Distinguished Professor of Environmental Studies and Politics at Oberlin College in Ohio and a James Marsh Professor at the University of Vermont. He is the recipient of numerous honorary degrees and other awards, and has lectured at hundreds of colleges and universities throughout the United States and Europe. His books include *Ecological Literacy* and *Earth in Mind*.

CARL POPE, one of America's most prominent environmentalists, has served as the executive director of the Sierra Club since 1992. Under his leadership, the Sierra Club has expanded its membership and political influence. The organization has maintained vigorous campaigns to expand wilderness, defend the Arctic National Wildlife Refuge, help local communities fight proposed coal-burning power plants, and advocate for a green-energy economic transition.

CINDY RANK was president of the West Virginia Highlands Conservancy from 1988 to 1994 and now chairs that group's mining committee. She has led research and protests on coal-mining and water-quality issues in her region since the late 1970s and in 1997 was the first to compile a map visually documenting the extent of stream loss from mountaintop-removal valley fills in West Virginia. She has testified before U.S. House and Senate Committees about matters related to the oversight and enforcement of the Surface Mining Control and Reclamation Act. Rank has received numerous awards for her environmental and social justice activism.

ERIK REECE teaches writing at the University of Kentucky in Lexington, and is the author of *Lost Mountain: Radical Strip Mining and the Devastation of Appalachia*. His work has appeared in *Harper's*, *Orion*, and the *Oxford American*, among other publications. He was the recipient of the Sierra Club's David R. Brower Award, and his *Harper's* story on which *Lost Mountain* is based won the Columbia University School of Journalism's 2005 John B. Oakes Award for Distinguished Environmental Journalism.

JACK SPADARO is a mining engineer and a leading authority on mine health and safety issues. His nearly four decades of public service included roles with both state and federal regulatory agencies. As a young engineer, he researched and wrote the report for the Governor's Commission of Inquiry into the Buffalo Creek Flood of February 1972. From 1998 to 2004, he was the superintendent of the National Mine Health and Safety Academy, the principal training facility for all federal Mine Safety and Heath Administration inspectors.

VIVIAN STOCKMAN, who has a bachelor's degree cum laude with distinction in Environmental Communications from the Ohio State University, has worked for the Huntington, West Virginia–based Ohio Valley Environmental Coalition since 1998. She previously worked for the West Virginia Highlands Conservancy on its Save the Blackwater Canyon campaign. Vivian has won the West Virginia Environmental Council's Mother Jones Award—its top honor. Her mountaintop-removal photographs have been extensively published in national newspapers, magazines, and books and on websites.

LUCIOUS THOMPSON is a retired underground coal miner from McRoberts, Kentucky. He is a veteran of the U.S. Army, served in Korea and Vietnam, and is an activist with Kentuckians For The Commonwealth, a citizens' group.

DOUGLAS R. TOMPKINS is a long-time wilderness advocate, mountaineer, skier, farmer, and conservation activist. He founded The North Face and cofounded Esprit clothing. Since retiring from the fashion industry and moving to Chile, he has worked to create large-scale protected areas. He and his wife, Kristine Tompkins, have preserved upwards of two million acres, including the eight-hundred-thousand-acre Pumalin Park in Chile. Through a family foundation, Doug Tompkins has been a key supporter of activist groups fighting various ecological outrages and has helped produce numerous campaign-related books including *Clearcut*, *Welfare Ranching*, *Fatal Harvest*, and *Thrillcraft: The Environmental Impacts of Motorized Recreation*.

CAROL WARREN is a tenth-generation West Virginian who has spent most of her adult life working for social justice in the Appalachian Mountains. Her work as the West Virginia Catholic diocese's director of the Office of Justice and Life has successfully built relationships between labor, environmental, community, and religious groups. She serves on the board of the West Virginia Environmental Council, is the chairperson of the Government Concerns Committee for the West Virginia Council of Churches, is a steering committee member of Christians for the Mountains, and coordinates the statewide Citizens for Clean Elections coalition.

MATTHEW WASSON is a conservation biologist with a PhD in ecology from Cornell University. He is the director of programs for the citizens' group Appalachian Voices in Boone, North Carolina. The author of several scientific papers about the effects of acid rain on birds and other animals, he also occasionally teaches classes, including ecology and ornithology courses, in the biology department at Appalachian State University.

GEORGE WUERTHNER is an ecologist, writer, photographer, and long-time conservation activist who has written more than thirty books on natural areas, wildlife, and environmental issues. An expert on public lands grazing issues and wildfire policy, his latest books include *Wildfire: A Century of Failed Forest Policy* and *Thrillcraft: The Environmental Consequences of Motorized Recreation*.

THE PHOTOGRAPHERS: A TRIBUTE

When a dike surrounding a coal-combustion waste lagoon next to a Tennessee power plant breached on December 22, 2008, more than a billion gallons of coal-ash slurry spilled onto surrounding farmlands and into the Emory River. It covered more than three hundred acres, damaged or destroyed dozens of houses, and partially dammed the river with toxic sludge. Photojournalist Antrim Caskey was quickly on the scene interviewing local residents and preparing to file a story and photographic exposé of the destruction. Caskey's images of the spill (see page 108, for example) were gruesome, offering an unvarnished look at the dark underside of America's energy economy.

Caskey has spent extended periods of time photographing in Afghanistan and in the Appalachian coalfields. "I saw many similarities between life in Appalachia and life in Afghanistan," she says. "The situation in Appalachia is the epitome of social injustice." Her love for the people and landscape of the region led her to move to West Virginia's Coal River Valley in 2008, the epicenter of mountaintop removal and resistance to it. Her images documenting the unfolding ecological and cultural tragedy in Appalachia appear throughout *Plundering Appalachia*.

Like Caskey, photographers both from within and outside the region have been drawn to the topic of mountaintop removal. This book would not have possible without the incredible photos of Giles Ashford, Marc Schmerling, Kent Kessinger, George Wuerthner, and many others. J. Henry Fair, whose distinctive aerial photography of industrial and mining sites combines beauty and pollution, was also a key contributor.

Vivian Stockman is not only one of the region's leading anti-surface-mining activists, but also an accomplished photographer whose work has been widely published. Her desire to communicate the reality of mountaintop removal to the broader world is reflected in the cover photo and some twenty other images throughout *Plundering Appalachia*. Stockman's help has been invaluable.

All the photographers represented in *Plundering Appalachia* offered their work at far less than commercial rates. For this, and for their incredible skill at capturing mountaintop removal on film, we are grateful. Finally, on behalf of the book's contributing photographers, we offer our deepest appreciation to Southwings, the conservation organization whose overflights made possible many of the aerial images of mountaintop removal in this book. —*the editors*

PHOTO CREDITS

Dobree Adams *opening sequence "Destroying the Future"*

Don Ament *opening sequence "Leveling Mountains," 134–135, 136–137*

Giles Ashford *opening sequence "Destruction," "Big Coal," 16 (top left and right, bottom right), 17 (top left and right, bottom left), 16–17 (center), 24–25, 52–53, 72–73, 156–157, 166, 168, 186*

AP Images *76*

Thomas Barnes *56–57*

Paul Corbit Brown *189*

Antrim Caskey *opening sequence "Desecration," "Appalachia," ii, 22, 26–27, 38, 48 (top), 60, 66–67, 68–69, 80–81, 82, 100 (top), 106, 108–109, 112–113, 116–117, 118–119, 179, 202*

The Courier-Journal *190, 193*

T. Paige Dalporto *70 (top), 71 (bottom)*

Terry Eiler *64 (courtesy American Folklife Center, Library of Congress)*

J. Henry Fair *opening sequence "Devastation," 20–21, 28–29, 96–97, 101 (top left), 110–111, 114–115, 182–183*

Melissa Farlow *opening sequence "Polluting Water"*

Thomas R. Fletcher *4–5, 10–11, 176–177*

Rebecca Howell *84, 86, 88*

Kentuckians For The Commonwealth *74, 94, 140–141, 184–185*

Kent Kessinger *opening sequence "Cooking the Planet," 18–19, 120–121, 122–123, 124, 144–145*

Lisa Graves-Marcucci *40–41*

Save Our Cumberland Mountains *152–153, 154–155*

Mark Schmerling *2, 12–13, 34–35, 42–43, 50–51, 90, 102–103, 126–127, 128–129, 130–131, 158, 178, 194*

Daniel Shea *30–32, 100 (bottom), 104*

Vivian Stockman *contents, 16 (bottom left), 17 (bottom right), 36–37, 47, 48 (center, bottom), 54–55, 70 (bottom), 71 (top left and right), 101 (top right, bottom), 132–133, 163, 172, 174–175, 180–181, 196, 198*

Chuck Summers *vi–1*

Antonio Vizcaíno *6–7, 44*

Matthew Wasson *148–149*

George Wuerthner *opposite i, v, 8–9, 14–15, 32–33, 58, 62–63, 78–79, 92–93, 98–99, 138–139, 142–143, 146–147, 150–151, 161, 164–165, 170*

ACKNOWLEDEGMENTS

We are grateful to the many people who helped make *Plundering Appalachia* possible, beginning with Susan Lapis, a volunteer pilot with Southwings who took us on our first aerial tour of the Appalachian coalfields. Susan has flown numerous journalists, activists, and politicians over the sheared-off mountains, and her skills and knowledge are making a tremendous contribution to the cause of stopping mountaintop removal. Indefatigable activist Larry Gibson (see photo on p. 80) similarly inspired us with an on-the-ground tour of his family homeplace on Kayford Mountain, West Virginia, which is surrounded by surface mining devastation. Other individuals who have informed our understanding of how the coal industry affects people and nature across the region include Judy Bonds, Maria Gunnoe, Vernon Haltom, Burt Lauderdale, Lorelei Scarbro, Kathy Selvage, Ben Stout, and Ed Wiley.

All of the book's contributing writers and photographers deserve thanks, but Mary Anne Hitt and Vivian Stockman especially have been invaluable collaborators on this project from the outset, giving generously of their time and wise counsel. They have our deepest gratitude.

For other editorial assistance we thank Rebecca Howell, Mikayla Butchart, Anne Caudill, Steve Fesenmaier, and Mary Beth Postman. Sharon Donovan, the Foundation for Deep Ecology's former publishing manager, provided crucial support and consultation when it was most helpful.

Publisher Raoul Goff, Leslie Cohen, Jake Gerli, Lucy Kee, and the entire team at Earth Aware Editions have been a pleasure to work with.

Through countless hours and iterations, book designer Kevin Cross has been consistently creative and meticulous in his coordination of the book's graphic production. His typographic attention to detail is second to none.

Finally, and most importantly, this book exists because of Douglas R. Tompkins, a rare conservation visionary who both offers an unvarnished critique of the global economic system which supports outrages like mountaintop-removal mining, and also personally demonstrates alternatives—wilderness parks and eco-friendly farming operations—that could form the basis of sustainable natural and human communities in a future economy.

—*Tom Butler and George Wuerthner*

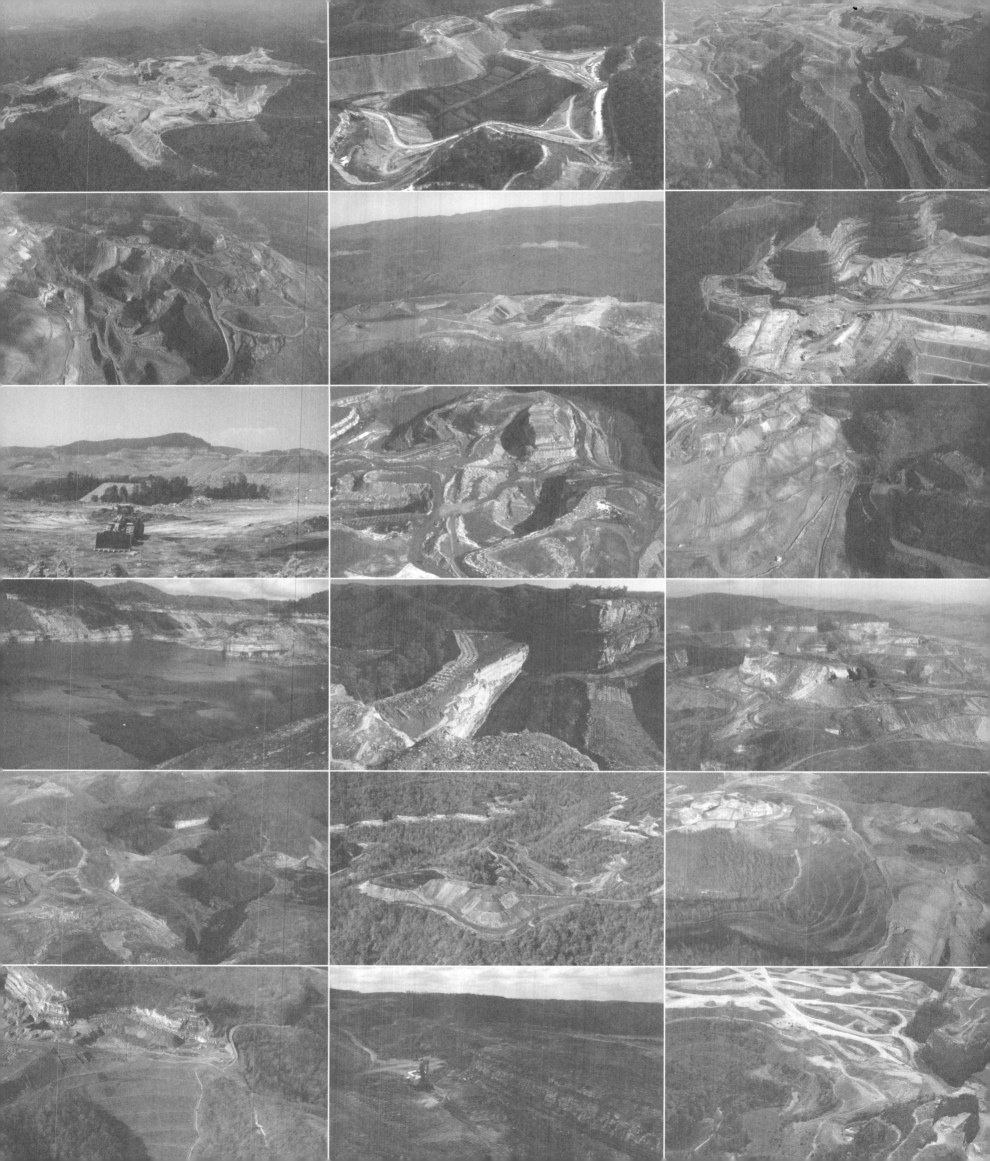